MODERN
ENGLISH PAINTERS

Volume Two Nash to Bawden

MODERN ENGLISH PAINTERS
JOHN ROTHENSTEIN

Volume Two Nash to Bawden

MACDONALD & CO

London & Sydney

A MACDONALD BOOK

© John Rothenstein 1952, 1976, 1984

First published in Great Britain in 1952.
First revised edition 1976.
This edition published in 1984
by Macdonald & Co (Publishers) Ltd
London & Sydney

A member of BPCC plc

British Library Cataloguing in Publication Data

Rothenstein, *Sir* John
 Modern English painters.
 Vol. 2: Nash to Bawden
 1. Painting, Modern—19th century
 2. Painting, Modern—20th century
 3. Painting, English
 I. Title
 759.2 ND467

ISBN 0-356-10354-4

Typeset, printed and bound in Great Britain by
Hazell Watson & Viney Limited
Member of the BPCC Group
Aylesbury, Bucks

Macdonald & Co (Publishers) Ltd
Maxwell House
74 Worship Street
London EC2A 2EN

CONTENTS

CONTENTS

LIST OF ILLUSTRATIONS

1. NASH, Paul, *Landscape of the Vernal Equinox* (1943)
2. WADSWORTH, Edward, *Requiescat* (1940)
3. BOMBERG, David, *Castle Ruins, St Hilarion, Cyprus* (1948)
4. SPENCER, Stanley, *Zacharias and Elizabeth* (1912–13)
5. GERTLER, Mark, *Gilbert Canaan at His Mill* (1916)
6. SPENCER, Gilbert, *A Cotswold Farm* (1930–31)
7. ARMSTRONG, John, *September 1940* (1941)
8. NASH, John, *A Winter Afternoon* (1945)
9. NICHOLSON, Ben, *Feb. 1960 (ice-off-blue)* (1960)
10. ROBERTS, William, *Jockeys* (1928)
11. JONES, David, *Vexilla Regis* (1947)
12. WOOD, Christopher, *Boat in Harbour, Brittany* (1929)
13. FREEDMAN, Barnett, *Sicilian Puppets* (1933)
14. HAYTER, Stanley William, *Coast of Erewhon* (1959)
15. RICHARDS, Ceri, *'Do not go gentle into that good night'* (1956)
16. BAWDEN, Edward, *Houses at Ironbridge* (1956)

(A list of the locations of works mentioned in the text [public galleries only] appears at the end of the book.)

ACKNOWLEDGMENTS

For information, for permission to reproduce pictures and to quote from letters, for assistance in collecting the necessary photographs, and for help of many kinds, I am so deeply in dept that no full list of my obligations is possible. By gracious permission of Her Majesty Queen Elizabeth the Queen Mother, I have been able to reproduce Paul Nash's *Landscape of the Vernal Equinox*. For exceptional help I am indebted to Esther Pissarro, Rachel Fourmaintraux-Winslow, Olivia Walker, Grace Gilman, E. M. O'R. Dickey, H. L. Wellington, Augustus and Dorelia John, Edwin John, Mary Gore, Frederick Turner, Matthew and Gwendolin Smith, Father Vincent Turner, Grace English, Silvia Hay, Derek Hudson, Eric Westbrook, the Matthiesen and Mayor Galleries and Messrs Arthur Tooth, Rex Nan Kivell, George Barker, John Malkin, Prunella Clough, Michael Ayrton, Robert Frame, Keith Vaughan, Sebastian Barker, Benny Creme, the Hon. Anne Ritchie, Barbara Ker-Seymer, William Chappell, Beatrice Dawson, Annette Armstrong, Catharine Chaloner, Kathleen Freedman, Tim Biggs, Anne Spalding, Ian Rogerson, Richard Macleod, Sir James Richards, Anne Williams, James and John Ravilious, Noel Carrington, Thomas Balston, Kathleen Nevinson, Kathleen Wadsworth, Kate Lechmere, Edward Bawden, Mrs Grove and Count Vanden Heuvel. Also to the members of the staff of the Tate Gallery, in particular Corinne Bellow, Elizabeth Bell and the Librarians. To the artists themselves of whom I treat and almost all of whom I was able to approach directly I owe much gratitude for their ready and kindly response to my queries and requests, also to Victoria Funk of Macdonalds.

PREFACE TO NEW EDITION

When the publication of the new edition of this book was under discussion with a friend he asked me how I made the choice of the artists to be included. I replied that it was done purely on the basis of personal conviction. But after the friend had left the relevance of the question remained.

The difference between writing about contemporary artists, even those of a century ago, and about those of a remote past is surely radical. To omit Turner and Constable from a book on early nineteenth-century British painters would be an unthinkable absurdity. With works of today and the recent past, however, there are no such certainties; it now takes time for certainties to emerge. A few decades ago, for instance, Victorian paintings were regarded widely as pretentious jokes 'only fit for provincial galleries'. Today those jokes – the best of them – are sold regularly at auctions for formidable prices. Until recently even the Pre-Raphaelites, although highly regarded by a few collectors and scholars as radical exceptions, were generally despised. 'Young women who will prattle with assurance of Pruna or Poussin' – I quote from Evelyn Waugh's *PRB: An Essay on the Pre-Raphaelite Brotherhood 1847–1854* – 'will say, should the topic ever arise, "The Pre-Raphaelites – Burne-Jones and people like that – my dear, you can't admire them" '.

The reputation of contemporaries will prove still more elusive. We regard Picasso and Moore as great masters, all but beyond criticism, but we cannot know with any precision how they will be regarded by collectors and scholars a century hence, or who, among their innumerable contemporaries, will be 'discovered' and acclaimed as masters. For example, only a few years have passed since Henry Moore was discovered and acclaimed. I remember that in 1939 The Contemporary Art Society, which acquired his *Recumbent Figure* – carved the previous year – offered it as a gift to the Tate. Both Kenneth Clark, responsible for its acquisition by the Society, and I were determined that the offer should be accepted, and both had reason to doubt the response of certain of the Gallery's Trustees, even though they showed, in the main, exceptional discernment. ('Discernment', future readers may sneer, because our opinions often coincided.) We

accordingly found occasion to express our ardent admiration for Moore, and for the *Recumbent Figure* in particular, to every Trustee. We had neither of us ever so acted before. Whether owing to our words or not I now have no idea, but to our delight the work was accepted. It today seems very strange to reflect that there was reason to doubt the acceptance – and as a gift from a Society of notable discernment – of a work which would receive unquestioning acclaim and which would cost hundreds of thousands of pounds. Yet some years hence we may be judged to have shown an enthusiasm, if not altogether misplaced, at least excessive.

I recall this event as a reminder of the fact that, while in earlier ages, such as those of ancient Greece and Rome, the Renaissance and many others, there were certain accepted qualities which enabled the public to judge works of art. The masters were accordingly afforded full recognition that has remained virtually constant: Egyptians, Greeks, Giotto, Michelangelo, Raphael, Rembrandt, Dürer, Turner, to name a few among a great number. During the last two centuries, however, reputations have been subject to radical change.

In our times – the last century or so – the qualities earlier referred to by which all works of art were authoritatively judged no longer universally apply: those of a wide-ranging variety are universally accepted. Outstanding public collections are almost all wide-ranging, their differing, often radically contrasting possessions having been acquired by the exercise of diverse concepts of quality. But where contemporary art is concerned there are no such concepts: collectors who acquire fine works by Blake, Rossetti, Rouault, Picasso, Stanley Spencer or Moore would be unlikely to be accused of inconsistency, but rather praised for the wide range of their perception.

In writing about one's contemporaries, unlike those of earlier ages, one has no incontrovertible standards by which to judge their work. The writer must form his own judgments, well aware that in the future the qualities and shortcomings of his subjects are likely to be assessed quite differently. He must also be aware of his own shortcomings.

When the question of how to organize my material arose I decided that the artists should be introduced strictly in the order of their appearance in the world. To insist upon an artist's identity with a group is to compromise his individuality; groups have a way of dissolving under scrutiny, of proving to be more fortuitous in their composition and more ephemeral than they at first appeared. Unlike the individuals who compose them, they have no hard core. In earlier, less disintegrated periods, there was some meaning in the classification of artists according to the tradition to which they belonged, but in our time the general enfeeblement and even collapse of

tradition has made the classification of original artists almost impossible: they exist by virtue of their individual selves alone. The chronological arrangement of the chapters that follow is intended to emphasize the individuality of their subjects by cutting them off from all fortuitous and ephemeral groupings.

My treatment of my various subjects has been deliberately varied. In the cases of painters who are the subjects of adequate biographies either already available or in preparation, it has been primarily critical, or else directed towards the elucidation of lesser-known aspects of their work, lives and personalities. But when my subjects are artists apt to be neglected or almost forgotten, such as Ethel Walker or Gwen John, in such cases I have tried to evoke a degree of recognition of value of their art and interest in their lives and personalities. Those artists who are included for the first time in this edition were added because they seemed to me to be inadequately served by recent scholarship.

I have called the subjects of this book English rather than British because there are notable Scottish painters whose works I have had no opportunity to study. Also because, with the exception of Gwen John, England is or was their home, and it was primarily by the intellectual, emotional, social and physical climate of England that they were all predominantly formed. Several of them were not English-born, and I have in fact dwelt in certain cases upon the effects of their country of birth and early environment: Irish in that of Orpen, Dutch in that of Houthuesen, and Scottish in that of Pryde.

The artists treated in this book are those whose work makes a strong personal appeal – in one or two cases a little less ardent than when I first put pen to paper, but only a little. There is nothing in the pages that follow, I trust, to suggest that I believe that those included are the only serious English painters of our time. I have in fact paid tribute to a number of others in a variety of publications. The volume of talent in Britain in the present century has been formidable, and I would not for a moment doubt that there is much of which I am not fully aware or else entirely ignorant.

PAUL NASH
1889 – 1946

Nearly forty years have passed since Paul Nash died, and his repu-
tation has scarcely had time to assume its final form. Yet already
touches are added, year by year, to a portrait of the artist which por-
trays him as more certain of his way, more sustained and logical in
his growth, than the facts would seem to suggest. 'Nash's develop-
ment as a painter remained singularly consistent throughout his life,'
wrote his friend E. H. Ramsden (*Paul Nash, Paintings, Drawings and
Illustrations* [1948]), and a little earlier in the same essay she alludes
to him as a watercolourist 'who must be acknowledged to have been
supreme'. Of the sequence of four pictures which were his last works,
she wrote that 'with the sublime melancholy of the first and the splen-
did exaltation of the second, the life of the painter moves to its trium-
phant close'. I think that the assured, rather Olympian genius of Miss
Ramsden's study, who belongs to the great tradition of English land-
scape painting and to whose style belongs the quality of grandeur,
differs in important respects from Paul Nash as he was. He differs
both from the Paul Nash whom I knew, well but not intimately, for
many years, and, it seems to me, from the artist as experienced in his
work. It is with some diffidence, however, that I will try to outline the
lineaments of a figure which does not strikingly resemble the hero of
Miss Ramsden's and other studies, for his personality was more com-
plicated, more allusive than clear-cut memories suggest, and his taste
was so subtle that it is not always easy to distinguish between the
works which are the outcome of deep convictions and those which he
manufactured out of a tasteful blend of experience undergone in the
shallows.

If I seemed just now to suggest that Miss Ramsden had invented a
Paul Nash larger and more perfect than Paul Nash was, I did her an
injustice. Her portrait was derived from another, namely the self-por-
trait which the artist had constantly in his mind – a portrait clear and
complete down to the smallest detail – which it was his purpose to
leave behind. But I must say at once that this self-portrait was not
conceived as a disguise. Nash was both too much of an artist and too
much a man of integrity for that. The clue to his motives is contained
in the following observation by Sir Herbert Read. After noting that

13

his clothes, although not conventional, were always well-cut, and his studio as orderly as a chart-room, he concludes: 'He always dominated his environment . . . His work was a part of his environment – not an unrelated activity relegated to some graceless workshop.' If this exceedingly just observation were understood to include not only the artist's immediate environment, such as clothes, furnishings and the like, but also his reputation as artist and man – that is to say his situation, living or dead, in the minds of his fellow men – it brings us nearer to an understanding of Nash's ambition. In her preface to the memorial volume already quoted from, the editor, Margot Eates, explaining how it came into being, wrote:

> When, therefore, the burden of increasing ill-health enforced on him considerable periods of inaction during the last two years of his life, he devoted himself in these times of unlooked for, and unwanted, leisure to the task of compiling from his photographic records a 'Picture Book' . . . which should provide a co-ordinated survey of his paintings and drawings.

According to my own understanding of Nash, he would as soon have considered leaving the world without leaving, as a lasting memorial, a picture book in which his best work would be assembled, arranged and presented, with all his resources of taste and skill, as a pharaoh would have contemplated dying without his pyramid. Nash in fact compiled a list of the pictures which he wished included in any post-humous retrospective exhibition. Nash compiled his picture book not because he was ill but because he knew that he was going to die.

Paul Nash was born on 11 May, 1889 at Ghuznee Lodge, now 2 Sunningdale Gardens, in the region of Earl's Court, London, the elder son of William Harry Nash, Recorder of Abingdon, and his wife Caroline Maud, daughter of Captain Milbourne Jackson, Royal Navy. His upbringing was strict. Their father permitted, for example, Paul and his brother Jack – John Nash the painter and illustrator – to draw on Sundays, but, in order to mark the difference from other days, forbade them to paint. In later years their father deplored their working on Sundays, troubled by the thought that a picture made on the Sabbath might then be sold. The three years, 1904–6, which Paul spent at St Paul's School were wasted. 'I was seventeen,' he has told us, 'when the long and complicated purgatory of my school life came to an end. I emerged from it impaired in body and spirit, more or less ignorant and equipped for nothing. My education,' he added, 'only began when I was at liberty to learn for myself.' He put that liberty to good use. His purposeful and inquisitive mind not only made itself master of an unusually wide range of techniques useful to an artist, but equipped itself to move easily in various intellectual spheres.

After he had failed to pass the naval entrance examination and after

his father had failed to enlist him in the respectable professions of architecture and banking (for which his inability to understand elementary mathematics disqualified him) he was allowed, and with his father's blessing, to try to earn his living as an illustrator. In order to undergo some elementary training he attended evening classes at the London County Council technical school at Bolt Court in Fleet Street. It was thus, through prolonged misery and successive failures, that Paul found his vocation – a vocation which had for some time had a vague attraction for him. There is symbolic significance, although probably no other, in that it was this same year, 1909, that on a visit to an uncle who lived near Wallingford he first saw those memorable twin grove-surmounted hills, the Wittenham Clumps, which later in his life were to become an image of compelling force. But even then they impressed. 'They were,' he said, 'the Pyramids of my small world.'

From the time he was a child Nash showed an acute responsiveness to what was strange, and began, as he has told us, 'to exaggerate forms and sounds. So many innocent things . . . began to have a sinister nature.' Of this his unfinished memoirs and his conversation afforded many instances. There was a time, for instance, when he was frightened when the light was put out at night by the sound of far-off galloping. One night he cried out to one of the maids and made her listen. Presently a distant drumming went softly thudding over their heads. 'It's the rats,' whispered the maid, 'they're hunting, have you heard their horn?' For a long time he was haunted by the sound, high, thin and faint, of the rats' horn, just as, years afterwards, he was haunted by the strange words and forms which induced the prolonged periods of agitation so fruitful for his art.

At the time when Nash may be said to have begun his life as an artist his mind was suffused not so much with the strange or sinister as with the romantic. It was, in particular, subject to the spell, which he came later to regard as disintegrating, of D. G. Rossetti. He read Tennyson and Morris, Keats, Whitman, Blake and Coleridge; and the discovery of each was a fresh, disturbing shock, but Rossetti – about whom he said he had read everything that had been written, and whose pictures and poems he knew almost without exception – remained his presiding genius. He wished to become another Rossetti, whose example led him for a time to write verse. Such a work as *The Crier by Night* (1910) and the figure with the pale rapt face of Beta Beatrix enfolded in mysterious shadows, is the work of a Rossetti-intoxicated youth. Slowly, however, Blake replaced Rossetti as the painter-poet. Beyond question Nash owed a strong imaginative impulse to Rossetti, but upon inanimate nature, the subject of almost all of Nash's work, Rossetti had little light to show.

Of recent years the word 'literary', used in reference to the plastic arts, has become an adjective so opprobrious that a writer must hesitate to use it about a painter unless he is prepared to face an outcry from the painter's friends. In the present inflamed state of opinion it would avail a writer nothing to plead the undoubted fact that many of the masters – Rembrandt and Delacroix to mention two conspicuously important examples – were literary painters. 'So you would try to *justify* yourself, would you?' he would be likely to be asked, and his offence would be long held against him. But if the truth about Nash is to be told, then there is no avoiding the currently opprobrious adjective, for he was to a marked degree a painter whose vision was directed and stimulated by literary conceptions and even by evocative phrases. It is my intention later in these pages to try to define more closely the nature of the literary incitements; for the present it is sufficient to state the fact of their existence.

Although he was born in London, Nash had his roots in the country, for the Nash family had long been established in Buckinghamshire. From about the age of twelve he lived mainly in his ancestral county, but it was not so much the country itself – responsive as he was to its beauties – that made him see it intensely as a subject for his art. This revelation he owed, characteristically, to a book. It was about 1909 or 1910 that he read *Lavengro*, and the effect of it was immediate and decisive. Paul Nash has described it in his autobiography in a passage of special insight and beauty:

> To live in those little close rooms of Rossetti's, so charged with the intense atmosphere of romantic love, produced in me a tingling sensation in sympathy with his mood. I felt the anguish of those imprisoned lovers . . . I, too, counted the heart-beats in the silence:
>
> > . . . when in the dusk hours (we two alone)
> > Close-kissed and eloquent of still replies . . .
>
> But I began to realize that my fixed attention was wandering, that with the succession of Lancelot and Guinevere, Hamlet and Ophelia, Paolo and Francesca, a feeling of constriction was invading me and that my tingle was the exquisite but crippling sensation of pins and needles. Very slowly, as one must in that predicament, I began to stretch my cramped limbs and then, very softly, for I felt a renegade, I crept from the room. I might have spared my caution. No one and no thing noticed either my presence or its departure. The lovers stayed locked in their anguished embrace, the chained monkey continued to pick the rose to pieces, the boarhound of unsure anatomy still slept by the side of the lance and the shield. On the window-sill the dove lay dead. Outside the door I passed the frenzied eavesdropper among the shadows.
>
> I emerged into open spaces. Led by the voice of Lavengro I followed on to the heath.

And on the heath he remained, representing it by day and by night,

in winter and summer, tenderly cultivated and hideously scarred, concerned sometimes with its surface, at others with some presiding spirit, ever responsive to changes in mood and season. There were several reasons why *Lavengro* should have held a fascination so strong for him as to draw him away from all his earlier preoccupations out on to the heath, but it is reasonable to suppose that the strongest was the intimations the book has of an English countryside before it had been tamed; a countryside about which there was something intractable, wild, mysterious. The book inspired at least one illustration, a drawing *Lavengro and Isopal in the Dingle* (1912), a drawing so deeply felt that the poetry of the effect far transcends the ineptness of the means apparently used to produce it. In the process of leading Nash out on to the heath *Lavengro* had an improbable ally in the shape of Sir William Richmond. When he showed one of his drawings – partly imagined and partly observed – the elderly academician suddenly exclaimed, 'My boy, you should go in for Nature.'

Like those of most artists, the earliest of Nash's drawings are essays in the manner of others, but at Bolt Court he began to see things in his own way, and to exercise his imagination. He made, among many others, a series of drawings showing a wide view of undulating fields backed by a long low range of wooded hills, above which was suspended a girl's huge face with hair streaming out like wings on either side. Nash related how one of these drawings had far-reaching effects: one evening . . . 'there seemed to be an air of excitement among the students. But before I had time to investigate, the door opened and a remarkable-looking small figure entered abruptly . . . The expression of (his) head was one of acute intelligence and the carriage almost imperious, as of a person accustomed to command . . . from the moment that wide judicial mouth opened a stream of easy, persuasive and ingenious talk flowed out, full of shrewdness and wit . . . the unerring gaze swept the room . . .' The imperious figure was my father; the result of his visit, the award of the maximum marks to Nash's drawing. Some months later he brought a sheaf of his drawings to my father, who, after a little consideration, gave his opinion: 'You should go to the Slade,' he pronounced, 'and learn to draw.' The suggestion was accepted as a sound one but Nash pointed out that he could not expect his father to pay the fees. 'Well, then, why not make them for yourself?' replied my father without hesitation. He had high expectations for the future of this beginner – truly self-described as 'without *apparent* natural talent . . .' – and a friendship grew up between them that was to last until my father's death. It was Nash's habit to turn to him frequently for help and advice. He also owed much to Selwyn Image, a late survivor of the Pre-Raphaelite movement, afterwards Slade professor of fine art at Oxford, and to the

benevolent poet Gordon Bottomley, for their encouragement in those tentative days.

Assiduity and luck enabled Nash to enter the Slade in 1910. This school, by the way, described by so many as the very fountain of bohemian life, the home of liberty, conviviality and eccentricity, 'differed very little', according to Nash, 'from St Paul's at its chilliest'. (He himself contributed to its formality by appearing in contrast to the prevailing sartorial bohemianism with close-clipped hair, dark suit, stiff collar and bowler hat.) During the time he spent there the Slade was in one of its periodic spates of talent, and Stanley Spencer, Mark Gertler, William Roberts, Edward Wadsworth and C. R. W. Nevinson were all fellow students. His first encounter with Tonks he has described admirably: 'With hooded stare and sardonic mouth, he hung in the air above me, like a tall question mark, backwards and bent over from the neck, a question mark, moreover, of a derisive, rather than an inquisitive order. In cold discouraging tones he welcomed me to the Slade. It was evident he considered that neither the Slade, nor I, was likely to derive much benefit.'

If in spirit Nash had followed Lavengro on to the heath, his body was not able to leave the 'close rooms of Rossetti's, so charged with the intense atmosphere of romantic love', in an instant. At the Slade he certainly became more and more preoccupied with nature, yet he continued for some time to lack the means to represent landscape. *Spring at the Hawk's Wood* (1911) gives the measure of his incompetence at rendering natural appearance. *The Bird Garden* of the same year, although it shows hardly more grasp of form, does give a hint of the special poetry that later on was to animate drawing after drawing.

In spite of his apparent want of talent and the downright silliness of some of his drawings – *Pyramids in the Sea* (1912), for instance, which he considered good enough to reproduce in *Outline* (1940) – the note of strange beauty that he attempted to utter, usually in vain, could occasionally be heard. And when heard it impressed and lingered in the memory. Within a year of leaving the Slade he held his first exhibition at the well-known but now long-defunct Carfax Gallery in Ryder Street. Although the purchases were mostly made by friends, it was a modest success. Of my father's purchase, Nash has given a touching account, which concludes, 'For me at that point in my career it seemed, as if by magic, to change the aspect of my first real venture from something accorded a hesitating acceptance into a distinguished triumph and one that had been recognized by the highest award.' The main acquisition, *Falling Stars* (1911), which duly took its place on our walls, was the first work by Nash that I had seen. What is more important is that, unless I am mistaken, this beautiful drawing is the

first in which the artist's extraordinary responsiveness to the peculiar character and drama of trees is fully realized. The two trees are enfolded by darkness, with which he was deeply preoccupied in his early years.

I made the acquaintance of the artist when he spent a day at my parents' house in Gloucestershire in the summer following his exhibition. I remember most clearly his cold, very blue eyes, which on first meeting seemed unfriendly – but after a few minutes his good will was evident. They were exceptional eyes: their blueness, the steadiness of their gaze, and the habitual closeness of the pupils to the upper lid gave them the far-ranging look of the eyes of sailors. His hair was so dense and wavy as almost to resemble some exotic piece of headgear. He was dressed extremely neatly. At that time there was no particular contact between us. If he had been a sailor – so far as we children were concerned – he would have had a better claim to our attention, but he was simply one more young artist, bringing his drawings to be looked at, examining the pictures on the walls, seeking advice. Besides, it was evident that he was not interested in children, and entirely intent upon fulfilling the purpose of his visit.

Later on, when I came to know him, it became apparent to me why, in the course of this visit and one or two others I vaguely recall, the relations between him and us remained so tenuous. Driven by a passionate absorption in their work, artists are more than commonly industrious. With some, intense application is followed by periods of idleness, dissipation or recreation; others merely vary their work. Corot delighted in fishing for its own sake, but when Delacroix listened to an opera or a play he deliberately subjected his imagination to the stimulus of the charm that it afforded. Nash was one of those who was constantly occupied with his work. It was not that he drew or painted for more hours at a stretch than others, but he was interested in every possible aspect of his work. When he was not drawing or painting he would photograph some subject likely to be of use in a composition, or he would study some object he had found – a twisted piece of wood, a stone worn into a fantastic shape, the skeleton of a leaf – which might serve a similar purpose; he would project albums of his works, plan for exhibitions or reproductions, or he would plan the formation or actions of groups of fellow artists. The most celebrated example was Unit One, an ephemeral, ideologically bound group of painters, sculptors and architects, including Wadsworth and Burra, of which Nash was the driving power and whose manifesto he wrote. He was endlessly occupied with such activities and many others of a like kind. With him the living of life and the pursuit of his profession were inseparably fused. His life as an artist had style: 'He carried over, with his actual career, as Sir Herbert Read aptly

observed, 'some of the swagger of the rejected career – art, for him, was to be the Senior Service.' At the time of Nash's first visit to my parents' house none of us children could have had any relevance at all. Some who read these pages may think that, if my account of him is correct, he was an ambitious man. Ambitious he undoubtedly was, but before they condemn him on that account they should reflect upon how harshly life bears upon painters and what a difficult business even the most gifted – portrait painters apart – find it, at times, even to survive.

During the few years between his departure from the Slade and his involvement in the First World War, Nash's work assumed a distinct character, almost as dissimilar from that which preceded it as from that which followed. Which of the traditional English watercolour painters pointed the way is uncertain, but during those years his work assumed a traditional character. He was too personal an artist to imitate an old master, but he did assimilate something of the spirit of Girtin, Cotman and others, and evolved a free contemporary version of traditional idioms. He seemed destined to follow closely, with intelligence and taste, a conventional course. He represented English Landscape, his chosen subject, in its most park-like aspect: green lawns, formal hedgerows and farms, and the elegant intricacies of lofty elm trees were features which he dwelt on with a peculiar tenderness and comprehension. In the best of these clearly drawn, firmly if lightly constructed, brightly but coolly coloured watercolours he struck an original note. In the less happy pictures are readily detected the facile rhythms of 'art nouveau', which produced an effusion of billowy clouds, waves and vegetation, and highly coloured bubble-like formations of undefined matter. It is odd that a man of taste, ordinarily so discerning, should have chosen one such work – *Landscape at Wood Lane* (1914) – for inclusion in his autobiography.

During the same years Nash's life opened out in a number of directions: his reputation steadily grew, he became engaged to be married, and he made many new friends. The outbreak of the First World War brought this epoch of his life and art to an abrupt end. He enlisted as a private in the Artists' Rifles in August 1914 and was detailed for service at home. In the winter of that year he married Margaret, daughter of the Revd N. Odeh. In 1916 he was gazetted 2nd Lieutenant in the 3rd Hampshire Regiment, and in February of the following year he went abroad and was stationed in the Ypres Salient. What he experienced in that place of desolation made him an artist as decisively as the scenes of his boyhood by the River Stour made Constable an artist. When he entered the Ypres Salient Nash seemed to be an artist of modest range – one who had largely outlived a somewhat boyish romanticism which expressed itself in nocturnes, with pyra-

mids, palm trees, shadows of unseen figures, falling stars and the like
– and had become a painter of park-like landscapes, to the essentially
conventional character of which he gave a poetic and stylish turn.
When we look back at the artist of those days with the knowledge we
have of his later work, this originality and stylishness are more con-
spicuous than they were to his contemporaries, but they were sorely
inadequate to ensure the most fleeting survival of his reputation.
There can be little doubt that had he been destined to take his place
among the unnumbered thousands who died in the Ypres Salient he
would not have been remembered, but surviving the bitter desolation
of the place immeasurably deepened his perceptions.

From time to time certain friends of his have expressed surprise
that an artist who had been so consistently drawn to dwell upon land-
scape in its most cultivated and most benign aspects should have
responded to such purpose to the Western Front. It was precisely this
preoccupation that prepared him so well for the fruitful contemplation
of that overwhelmingly, perhaps even uniquely, terrible spectacle. For
an artist brought up in such a time, familiar with bomb-scarred cities
and multitudes of refugees 'bombed out' or dispossessed of home and
property, wandering without hope along the unfriendly highroads of
the world, the Front would have been no more than an impressive
reminder of the evil in man. The impact upon the imagination of a
Paul Nash of this vast desolation of tortured country, churned to mud,
pitted with shell-craters, the grass scorched and trampled, was of the
utmost violence. An artist accustomed to handle nature more arbi-
trarily, or familiar with her harsher aspects, might have reacted to the
spectacle intensely, but he, who had treated her with such tender
respect, was pierced by a sense of outrage. The man who loved the
intricate tracery of elms had now to contemplate the shattered stumps
of trees without names.

From the first, therefore, almost inevitably, the idea took root in
Nash's mind that here was a subject that must be drawn and painted,
and in particular by him. It would seem that it was in the course of a
conversation with my father that he had first envisaged it as within
the bounds of the possible. On 20 May, 1916 he wrote to him:

> I have just got home and sit down at once to write to you . . . my wife . . .
> upbraided me for not jumping at your idea of drawing in France. I *did*
> jump inwardly . . . Will you let me know if you have a definite
> scheme . . . The idea has dwelt so long in my mind and always seemed
> so impossible that a hint of its realization excited me tremendously.
> Please write to me for I am really roused.

Soon after he went to the Western Front Nash began systematically
to charge his memory and, in snatched moments, to make studies.

In April 1917 he went into the front line. After three months in

France and only a few weeks at the Front he had 'the curious fortune', he reported in a letter to my father, 'to fall suddenly down a narrow trench and break my twelfth rib . . . I brought back some twenty drawings from France . . . and . . . have arranged . . . to have a show . . .' The impression made by this handful of drawings upon such persons as John Buchan, Edward Marsh, Campbell Dodgson, C. F. Masterman, and my father, as well as Nash's own unceasing and adroitly conducted campaign in support of his ambition, resulted in his being sent back to France as an Official Artist in November. At the Front again, and this time free from military duties, Nash applied the whole of his time to his work as painter and draughtsman. The Official Artists held their appointments for strictly limited periods, but during those few weeks in the autumn of 1917, densely packed with experience, he worked with extraordinary industry, making the utmost of the facilities placed miraculously but transiently at his disposition. On 13 November he wrote to his wife:

> Yesterday I made twelve drawings, nine of different aspects of one of the most famous battle-fields in the war. I just missed the battle . . . I start off directly after breakfast and do not get home until dinner-time and after that I work on my drawings until about eleven o'clock at night when I feel very sleepy and go to bed.

Yet such was his exaltation of spirit that he had the superabundant energy to write letters to his wife which are at points nothing less than verbal equivalents of his drawings. The following passage from the letter just quoted constitutes perhaps the most expressive of these verbal equivalents, and a statement, too, of what he conceived to be the current purpose of his work.

> I have just returned, last night, from a visit to Brigade Headquarters up the line, and I shall not forget it as long as I live. I have seen the most frightful nightmare of a country more conceived by Dante or Poe than by nature, unspeakable, utterly indescribable. In the fifteen drawings I have made I may give you some vague idea of its horror . . . Sunset and sunrise are blasphemous, they are mockeries to man, only the black rain out of the bruised and swollen clouds all through the bitter black of night is a fit atmosphere in such a land. The rain drives on, the stinking mud becomes more evilly yellow, the shell holes fill up with green-white water, the roads and tracks are covered in inches of slime, the black dying trees ooze and sweat and the guns never cease. They alone plunge overhead tearing away the rotting tree stumps, breaking the plank roads, striking down horses and mules, annihilating, maiming, maddening they plunge into the grave which is the land; one huge grave and cast upon it the poor dead. It is unspeakable, godless, hopeless. I am no longer an artist interested and curious. I am a messenger who will bring back word from the men who are fighting to those who want the war to go on for ever. Feeble, inarticulate will be my message, but it will have a bitter truth and may it burn their lousy souls.

The time which Nash spent at the Front, as soldier and as Official Artist, amounted to little more than two months, but during that brief spell he experienced life more deeply, more intensely than most men do during the full term of their alloted span.

When he first went to France, what touched him most was the incongruity between the hell of blasted and poisoned earth and the manifestations of an ultimately unconquerable nature, expressed in a letter to his wife:

> . . . in a wood passed on our way up, a place with an evil name, pitted and pocked with shells, the trees torn to shreds, often reeking with poison gas – a most desolate and ruinous place two months back, today was a vivid green, the most broken trees even had sprouted somewhere and, in the midst, from the depth of the wood's bruised heart poured out the throbbing song of a nightingale.

But it was the hellish aspect of things that quickly filled his mind: he became ecstatically absorbed in its sinister beauty. The contemplation of it excited in him – as in thousands of other soldiers – an insistent preoccupation with the moral issues involved. Nash never arrived at a consistent attitude towards the war. At certain moments he was sickened by its wastage and corruption, and the moral obliquity that made it possible; at others he was exalted by its terrible splendour.

In May 1918 the work he had completed as a War Artist was shown at the Leicester Galleries under the title 'Void of War'. The impact of the new works was sharper and wider than of those shown at the Goupil the year before; it was generally recognized that a new figure was now to be numbered among the foremost English artists. The workmanlike preface which Arnold Bennett contributed to the catalogue fairly reflected the impression the drawings made:

> The interpretative value is, to my mind, immense, [he wrote] Lieutenant Nash has seen the Front simply and largely. He has found the essentials of it – that is to say disfigurement, danger, desolation, ruin, chaos – and little figures of men creeping devotedly and tragically over the waste . . . Their supreme achievement is that in their sombre and dreadful savagery they are beautiful.

When Nash, led by the voice of Lavengro, had left the little close rooms of Pre-Raphaelite romanticism and emerged on to the heath, he was impelled, first and foremost, by his need to find a style. A serviceable, evocative and personal style was what he was looking for, rather than the exceedingly genteel prettiness of the heath on which he found himself. There can be no question of the genuineness of his response to the beauties of landscape. While they richly nourished his imagination, they were more important to him in that they provided the materials out of which he hoped to evolve a style; and when he arrived in France he had evolved a somewhat tentative one that

promised to become an instrument well fitted to the representation of the park- and garden-like aspects of landscape which all but monopolized his attention. The spectacle of war almost instantly transformed his whole conception of style. He was in the presence of something so vast, of such sombre magnificence, that the idea of using it as the material for a style seemed a puny blasphemy. Accordingly, in excitement and exultation, he gave himself up to the humble representation of the awful spectacle about him. He was scarcely conscious of the problems of style, but his former preoccupation with them enabled him to select, as it were instinctively, from the vast chaos extending on every side, precisely those elements that enabled him to make drawings which embody the very essence of it, and which live so vividly in the memory. I know of no works by any war artist who saw the splendours and miseries of the greatest of all theatres of war so grandly. Out of infinite horror Nash distilled a new poetry. The best of these war studies, in pastel, watercolour, ink and chalk or in a combination of them, *Canadian War Memorial, Vimy* (1918); *Spring in the Trenches, Ridge Wood* (1917); *Sunrise, Inverness Copse* (1918); *Dawn, Sanctuary Wood* (1918); *Meadow with Copse: Tower Hamlets District* (1918); *Nightfall, Zillebecke District* (1918); *Ruined Country, Old Battlefield, Vimy* (1918); and *The Menin Road* (1918), the large painting in which he elaborated in tranquillity themes stored up in his memory or else summarily noted down – these will take their place among the finest imaginative works of our time.

In a letter which he wrote from the Front there occur the words 'I have seen things . . . that would last me my lifetime as food for paintings and drawings.' Certain of the images that formed in his mind in the course of his ecstatic contemplation of these desolate, unearthly landscapes, long outlasting his preoccupation with them, became permanent features of Nash's vision. 'The headless trees white and withered, without any leaves, done, dead', which he had noted in Flanders, transformed by time and the imagination, became the megaliths, the tree-trunk monsters, fossils, fungi and other features of the still and timeless country of his later imaginings.

Chapter VII of the synopsis that he left of his uncompleted autobiography begins with the words 'struggles of a war artist without a war'. These words mark no more, perhaps, than his intention to enlarge upon the difficulties attendant upon changing from an officially sponsored artist to a demobilized artist left suddenly at large in a strange unsettled world. It is possible to read in them a deeper meaning. The change from war to peace offered no serious difficulties to a man so resourceful and determined to succeed and so newly crowned with laurels. Nash turned his hand to new kinds of work: wood-engraving, textile designing, writing; he executed designs for

Barrie's *Truth about the Russian Dancers*. These activities and many others were interrupted in 1921 by a serious illness. To recuperate he settled at Dymchurch in Dorset.

The allusion to struggles of a war artist without a war seems to me to have reference not so much to the immediate problem of finding employment as to the way in which Nash's vision, deepened and intensified by an overwhelming experience, could be realized without the magnificent subjects which had formed it. To express his response to the Western Front he had forged an instrument too powerful, too stark for the depiction of elegant elm trees, neatly fenced fields and other features of the well-ordered and smiling landscape that had engrossed him earlier. Was he to allow it insensibly to shrink, to relax? If not, upon what subjects should he direct it without incongruity? To the first question, for an artist so tenaciously aspiring, there could be only one answer; to the second I do not believe he ever discovered an answer that gave him lasting satisfaction. That is why, near the beginning of this study, I questioned E. H. Ramsden's claim that his 'development as a painter remained singularly consistent throughout his life'. To me Nash's development seems on the contrary to have been rendered erratic and fitful by a lifelong search for the inspired harmony between form and subject that marked the best of his war pictures. The search was full of difficulty, and only from time to time was it successful. The Western Front presented him with a subject which his gifts were ideally suited to interpret, but later he was preoccupied with the realization that in these favoured circumstances he had made works which perhaps bore marks of greatness, and it was therefore with anxiety as well as delight that he was driven constantly forward in search of some new illumination.

The problem did not present itself abruptly, because the principal subject of his attention – the Dorset coast about Dymchurch – although without the spectacular character of the Western Front, was a dramatic theme and one susceptible to fruitful treatment by similar methods and in a similar spirit. The watercolours he made of that nobly curving coast are to be regarded as the completion of an earlier phase rather than the beginning of a new. They are less intense in feeling, but the conditions in which they were made allowed Nash a wider choice of viewpoint and longer time for contemplation. In that the element of consciously imposed design is more strongly marked than in anything he had done previously, they give an indication of the general direction he was to follow. A whole series of watercolours came into being as a consequence of his visit to this stretch of coast, designs calculated with exquisite precision to express the rhythmic sweep of the shore, the infinite spaciousness of sea and sky. Such a work as *Dymchurch Strand* (1922), shows a power of comprehending an immense area of

landscape with the unstrained certainty of Girtin. And it does not stand alone: *Dymchurch Wall* (1923), and the more abstract *Coast Scene* (1921), and *Winter Sea* (1925–37), are surely among the finest designs of their time. How enduring the images formed in his mind during the fruitful years of preoccupation with the coast of Dymchurch can be appreciated by comparing *Winter Sea* with *Totes Meer*, another oil painting made in entirely different circumstances and fifteen years later. The cold tones, the folded and undulating forms, the informing spirit are to an extraordinary degree the same.

The bracing and elevating effect of the shore near Dymchurch in helping Nash to solve, for a time, the problem of how a war artist could adapt himself to peacetime themes became apparent when he left Dorset. He paid a two- or three-week visit to Paris – his first – in 1922, spent the winter of 1924–25 at Cros de Cagnes, near Nice, visited Florence and Siena, and, in 1925, settled at Iden near Rye. The consequence of these various moves, more especially, perhaps, than from the austere, linear coast of Dorset to the cosier region of Rye, was that his work lost both purposefulness and momentum. I would be reluctant to dogmatize about his early visit to Paris, but it is my belief that direct contacts with contemporary French art confused Nash. The great international movements in the arts – Fauvism, Cubism and the others – as they radiated outwards from Paris were all-pervasive, affecting some artists without their being aware of it and others who were fully aware. Paul Nash, it needs scarcely be said, was always aware of the movements which played upon his consciousness. For him, however, there was a difference between taking Parisian modes of seeing, as it were, out of the air, and being in immediate contact with Parisian art and artists. In the one case he was simply drawing upon what had become a common heritage; in the other he was subjecting himself to a distracting influence.

The work he did on the Western Front and at Dymchurch owed much that is most precious in it to the Cubist sentiment that strongly affected a whole generation of artists everywhere, but visits to France, contacts with French artists, even visits to exhibitions of contemporary French painting, were apt to agitate him to the disadvantage of his work. The agitation was subtle and is not easy to convey. It was as though, confronted with French painters and their works, he felt the presence of a tradition which both drew and repelled him. He was drawn to it as the tradition which was central and in comparison with which all others were in varying degree 'local'; and as a tradition which fostered audacity and sparkle and was as remote as possible from what he used to call 'the cold middle-class Sunday lunch' character that summed up all that most repelled him in the tradition of his own country. As a deeply fastidious man and artist it seemed natural

to belong to 'the best' tradition, but he had seriously meditated inhibitions. Even when most tempted, he was conscious of the depth of his English roots, of the nourishment he had drawn from the English watercolourists, the English poets, from Rossetti and Borrow and Blake, and from the sights and sounds of the English countryside. And he was, to judge from odd remarks I heard him make, afraid that all this delicate and complex English inheritance might be ironed out flat in the abstraction that so predominantly formed the character of the Parisian tradition. He used to say that he was 'for, but not with' the advocates of a wholly abstract art, and he once precisely staked the limits of his own participation in an art of this kind. In an article in *Axis*, 1935, he wrote:

> The hard cold stone, the rasping grass, the intricate architecture of trees and waves I cannot translate altogether beyond their own image, without suffering in spirit. My aim in symbolical representation *and* abstraction, although governed by a purpose with a formal end in view, seeks always to give life to a conception within the formal shell.

It was during the late 1920s and the early 1930s that Nash was most sensitive to the attraction of the abstract – an attraction that was heightened by the exhaustion of his purely visual response to nature. This exhaustion is conspicuous in such naturalistic works as *French Farm* (1926), *Balcony, Cros de Cagnes* (two versions) and *Mimosa Wood*, all three of 1927. He needed to rely more and more upon a formal structure, and his most successful works were those in which a clearcut geometric design was elicited from or imposed upon his subjects, works of which *Chestnut Waters* (1924–38) and *Pond in the Fields* (1927) are characteristic examples. Presently the geometric design came first to dominate and eventually to constitute the picture. This development may be charted by comparing *Landscape at Iden* (1928), *Kinetic Feature* (1931), and *Poised Objects* (1933). My own reading of his predicament during these years is that his vision had grown languid: bored with nature and uninventive in the field of pure abstraction, he was without compelling purpose, and it is my belief that a sentence come upon in a book would stir his imagination and momentarily restore the purpose he lacked. Today few epithets would be likely to be regarded as more derogatory than 'literary', but it is necessary to say that Paul Nash was, in the most intimate sense, a literary painter. He was haunted by fragments of prose and poetry until, as he used to say, they 'grew enormous' for him. In 1930, for instance, he began his illustrations to Sir Thomas Browne's 'Urne Buriall' and 'The Garden of Cyrus', and reading the first he came upon a sentence that became a treasured possession. I quote from *Aerial Flowers* (1947):

Before *Plato* could speak the soul had wings in *Homer* which fell not but flew out of the body into the mansions of the dead.

This idea stirred my imagination deeply. I could see the emblem of the soul – a little winged creature, perhaps not unlike the ghost moth – perched upon the airy habitations of the skies which in their turn sailed and swung from cloud to cloud and then on into space once more.

This inspiring idea gave lightness, spaciousness and an aerial poetry to the illustration in the book and the preliminary watercolour. To the works of Thomas Browne, Nash owes much more than a single compelling image. The potent strangeness of Browne's personality, projected by his solemn, fantastic, luminous prose, prose that is poetry in everything but form, impressed itself deeply upon Paul Nash's nature, already well-prepared to receive it. The sonorous sentences echoed in his head; they charged it with a teeming imagery. From his childhood, when he began to exaggerate forms and sounds, he had been peculiarly susceptible to the charm of strangeness; and who stranger than the man of whom Coleridge wrote that 'so completely does he see everything in a light of his own, reading nature neither by the sun, moon, nor candlelight, but by the light of the faery glory round his head'?

During the 1930s another incitement to Nash's delight in strangeness strengthened the spell laid upon him by the reading of Browne: the dream imagery of Surrealism. To this imagery a nature such as Nash's was inevitably responsive. He had contacts with Max Ernst, André Breton and Paul Eluard, and he took part, both as a member of the committee and as an exhibitor, in the International Surrealist Exhibition held in London in 1936. The imagery permeated his life as well as his art. Soon after he moved into a newly acquired house, 3 Eldon Road, Hampstead. That same year I went there to luncheon and, being about to sit down in a certain chair, was warned by Mrs Nash that it was already occupied, as indeed it was, by a stuffed hawk; the same bird, I think, as figures in his *Landscape from a Dream* (1938), a characteristic example of the artist's surrealist painting. Thomas Browne and the Surrealists evoked from Nash's imagination a dream world of strange juxtapositions, of cryptic symbols – the moons, tumuli, fossils, monoliths, fungi and the like – all vaguely allusive to mystic numbers, occult correspondences belonging to the veiled childhood of the world, the world devoid of organic life or the habitation of primitive man. Coleridge, writing of Browne, stated that

There is the same attention to oddities, to the remoteness and *minutiae* of vegetable objects, the same entireness of subject, you have quincunxes in earth below, and quincunxes in the water beneath the earth; quincunxes in deity, quincunxes in the mind of man, quincunxes in the optic nerves, in roots of trees, in leaves, in petals, in everything.

Add to all this the symbolism of surrealism and a perceptible Parisian accent and you will have a fair verbal equivalent of Nash's principal work during the period immediately preceding the Second World War. Characteristic examples of this odd crossing, so to say, of Thomas Browne and André Breton are *Landscape of the Megaliths*, and *Wood of the Nightmares' Tails* (1937), and *Nocturnal Landscape*, and *Circle of the Monoliths* (1938). During the same years he also made a number of paintings and watercolours of a slightly different character, in which the emphasis is upon the surrealist element in an existing landscape rather than, as in the first group, upon the incongruity of the objects represented, such as, for instance, the large wooden lattice structure in *Nocturnal Landscape*. Of these more realistic works *Stone Sea* (1937) and *Monster Field* (1939) are outstanding examples; the latter he regarded with as much satisfaction as any work of his last decade.

Early in this essay I took issue with the Paul Nash legend that has taken shape. I must now challenge one of the attributes that is being accepted as his in a supreme degree – imagination. To E. H. Ramsden he is an 'imaginative and inventive' artist who can take us 'from time into eternity, from the sensible realities of the visible world into the supersensible of a world that is above the visible'. That such might be the effect of the impact of certain of his works it would be impertinent to question; but I would suggest that the effect would be due not to imagination or invention but to some other quality. Painters are an exceptionally, even a notoriously, observant class, forever looking, constantly noting down. The habit of observation springs from the threefold necessity of stocking the mind with fruitful images, of finding inspiring subjects and of discovering the laws of nature whereby the selected images or subjects may be most convincingly represented. With different artists the emphasis is upon different aspects of this necessity: Blake, for instance, rarely took subjects from nature direct but used observation as an imaginative incitement, and Constable, little concerned with imagery, applied himself to a close study of the laws of nature with scientific detachment. But the involvement of mankind in his environment is so intimate that the most imaginative artists cannot dispense with a working knowledge of natural laws, or the most realistic with imagery distilled from the contemplation of nature.

It is generally assumed by those who have written about Nash that he belongs unequivocally to the imaginative tradition, the tradition of Blake, and that he was detached to an unusual degree from the scientific tradition of which Constable was the first and most authoritative English advocate. 'A great imaginative artist: that was established decades ago,' wrote Eric Newton in the catalogue to the Paul

Nash Memorial Exhibition at the Tate in 1948, as though it were a truism.

It is not my purpose simply to deny so much as to qualify this assumption. It is true that Nash's sympathies were ranged ardently with the imaginative tradition: his intentions were imaginative. He was not deeply concerned – and as he grew older his concern diminished – to represent aspects of nature; he was determined to create an imagery out of his inner vision. That inner vision, at its happiest moments, crystallized in pictures of a rich strangeness, glowing with the heat of the sun or of a lunar pallor. How much the poorer the art of our century would have been without Nash's last visionary landscapes! Were they to suffer destruction they would be missed, of so special a kind is the beauty they manifest. Of how few individual works can the same honestly be said! Works such as *Pillar and Moon* (1932–42), *Landscape of the Vernal Equinox* (1943), *Nocturnal Flower* (1944), and *The Eclipse of the Sunflower* (1945), most particularly the first, appear to me to be works of great and original beauty. The fact that he was able only occasionally to create works of this quality was due to the fact that unlike his masters Rossetti and Blake, Nash imagined with painful laboriousness. Neither general imaginative conceptions, nor the precise imagery in which they might most vividly and precisely be expressed, came to him without effort. To his dependence upon the incitement of the haunting fragment from poetic literature I have already alluded. The *Landscape of the Vernal Equinox* and the other sunflower pictures of the 1940s, for instance, were inspired by a literary image, for long the subject of his meditation, first come upon, I fancy, in 'Urne Buriall': 'the noble flower of the sun . . . wherein in lozenge-figured boxes nature shuts up the seeds and balsam that is about them', and intensified by Blake's memorable lines:

> Ah, Sunflower! weary of time,
> Who countest the steps of the sun.

No less was Nash's dependence upon close observation of nature for the appropriate clothing of his imagery. The most conspicuous feature of the only two of his many domiciles with which I was familiar – the house at 3 Eldon Grove, Hampstead and the flat at 106 Banbury Road, Oxford, where he lived principally from 1939 until his death – was his collection of found objects, curiously shaped stones and fragments of wood and bark, skeletons of leaves, shells and the like. These became more and more necessary as stimulants to his imagination and, more important, as providing a repertory of forms with which to express his ideas. A camera was his constant compan-

ion, and in addition he would buy and borrow photographs. I witnessed a comical encounter between him and a fellow painter with whom I stayed during 1944 in a beautiful house he rented not far from Oxford to which Nash occasionally sallied from his flat in the Banbury Road. The garden contained a shady grove of trees in which statues were romantically disposed. The sight of these lichen-covered, foliage-shrouded figures – touchingly evocative of the ancient world – stimulated a delightful agitation in him. Just as a sportsman in the presence of game instinctively brings his gun to bear, so did Paul Nash attempt to focus his camera upon stone faun and dryad. But every attempt was baffled by some adroit movement of his vigilant host. 'After all,' he explained when Nash, unable to bear his frustration, had returned prematurely home, 'it is *my* grove: I don't really see, do you, why it should be the theme of a whole series of Paul's pictures?'

So complete at times was Nash's dependence upon photographs and found objects in the making of his 'imaginative' pictures that he was unable to assimilate and transmute them even by the exercise of imagination, but instead introduced them direct on to the canvas or paper. Most of those who knew him were well aware of this procedure and there is written confirmation of it from a friend who frequented his studio. 'Natural objects, e.g. shells, wood-fragments, fungi, leaves, etc., were taken into the studio for closer examination and were there painted into the composition from direct observation,' wrote Dr Richard Seddon in his *Notes on the Technique of Paul Nash*, giving two examples of pictures, *Ballard Phantom* and *Nest of Wild Stones*, in which this procedure had been followed. There follows an observation more significant still. 'When the objects were too big to be taken home (e.g. the tree forms in *Monster Field*) they were (1) sketched *in situ* in watercolour or (2) photographed.' What this passage makes clear is the actual preference of the artist for painting found objects or photographs of them into his imaginative compositions. A picture which contains some elements painted from direct observation and others that are imagined – whether ostensibly realistic or imaginary makes no difference – is particularly liable to enfeebling tensions and to a lack of unity of style. These are, I think, the besetting weakness of the less successful of his later imaginative pictures, but that is by the way. My purpose in considering this aspect of Nash's art was not to make this criticism but to attempt to shed some light upon the larger question of the character of his imagination.

It seems to me that Nash was not in the fullest sense an imaginative artist at all, in the sense, that is to say, of possessing an innate image-making faculty, a mind from which imagery flowed naturally. Instead it was a mind which became deeply versed in and deeply devoted to

the imaginative tradition. Its leaders were the objects of his utmost veneration; its minor practitioners of his amused, acutely discerning appreciation. To this tradition he bound his most urgent emotional and intellectual preferences. Paul Nash possessed an indomitable will. In default of a natural image-making faculty he evolved – when the inspiration he derived from the Western Front had waned and left him without clear direction – the procedure already noted. He developed his intense receptivity and sytematically exposed his mind to the poetry, the prose and the visual arts that were most evocative of the earth's oldest memories, that echoed most strangely in the corridors of the mind. When there then arose a responsive ferment in him, he set about to find objects which would give lucid expression to his vague imaginings. His acute and calculating intelligence, his poetic insight and exquisite taste made Nash a wonderful vehicle for transmuting literary emotions into the most sharply defined forms, for providing perfect visual equivalents for mansions of the dead and sunflowers weary of time. Sometimes the process had a mechanical quality evident in the resulting pictures; at others that fine mind, steeled by indomitable determination, was rewarded by the power to make out of borrowed elements something most lyrical and wholly his own. The mind of an artist is a complex instrument, and in attempting to describe the creative operations of Nash's mind I am aware of having over-simplified, but I believe that my description is a little less remote from the unattainable truth than the declaration that he was a great imaginative artist.

During his latter years his will had to contend not only with imaginative dryness but with increasing ill health: from 1932 until his death thirteen years later his life was made periodically burdensome by asthma. The difficulties of these years were sensibly increased by his involvement – first as an artist attached to the Royal Air Force and later to the War Artists' Advisory Committee – in a war that made no specific appeal to his imagination. To the eye it offered nothing remotely comparable to the Western Front: his manmade monsters flying out of the moon through cloud landscapes represented no new departures but were the products of an earlier phase of seeing. The idea of *The Rose of Death*, the name the Spaniards gave to the parachute in their Civil War, haunted his mind, but to no great purpose. It was not the white flower but *Totes Meer*, the Dead Sea of crashed German bombers beneath the icy light of the moon, that suggested that in other circumstances he might have created out of the Second World War an art as memorable as that inspired by the First. But the needful effort was beyond his strength, for he had already begun to die.

There is one matter, however, which by way of conclusion I shall

the title and source of his quotation . . . There are many passages which are almost descriptions of certain pictures . . .

> In the hedge of the lane there was a gate on which he used to lean and look down south to where the hill surged up so suddenly, its summit defined on summer evenings not only by the rounded ramparts but by the ring of dense green foliage that marked the circle of oak trees . . . The image of it grew . . . as the symbol of certain hints and suggestions . . .

The book contains descriptions of trees, too, as 'forms that imitated the human shape, and faces and twining limbs that amazed him . . . here and there an oak stripped of its bark, white and haggard and leprous'. As Bertram again comments, 'these are Nash's Monster Trees and the subjects of many photographs in *Fertile Image*'.

I quote these passages not primarily because they manifest the literary nature of Nash's imaginative painting, concerned although Nash was for a time, under the influence of fashionable aesthetic theory, to deny any such literary inspiration. Still less do I quote them to his discredit. There is no suggestion that Nash took images that he used throughout his painting life from books such as these. There was, after all, something innate that responded to such literature and romantic imagery, and although such literature represented, in a sense, the most deplorable elements in romantic writing; although it was imprecise and thoroughly messy, full of what T. S. Eliot called, 'undisciplined squads of emotion', it is better to be moved even by stuff such as this than not to be moved at all. But it seems to me a remarkable and significant achievement for a man, whose early literary tastes were of this character, to be able to discipline and refine a thing so intimate as imagination into something both more clear-edged and deeply moving. The First World War did much; it helped to rinse Nash of what Bertram calls 'the pseudo-poetic and second-hand romanticism of his long adolescence'. But above all was what I have already called his indomitable will.

I have said that the Nash legend tends to obscure not only the real man but also the nature of his achievement. For what Nash achieved was to make, out of an innately slender talent, a substantial body of distinguished painting – just as out of an innately poor talent for writing English he made the excellent prose of *Outline* – and distinguished in the quality of imagination that he became so hauntingly able to express and evoke. It is an achievement of assiduous industry and discipline, and it is a considerable one.

select for an allusion, since it qualifies an incomplete statement of my own and a part of the Nash legend which, as I have complained, tends to obscure both the real man and the nature of his achievement.

On an earlier page I referred to Nash's reading, at the beginning of his career as an artist, of Rossetti, Tennyson, Morris, Keats, Whitman, Blake and Coleridge. The evidence for this was Nash's unfinished autobiography. However, in *Paul Nash: The Portrait of an Artist*, Anthony Bertram's researches into Nash's letters of the time show that these great names were not relevant until a later date. In 1909, when Nash was just short of twenty, 'there was great enthusiasm for *The Beloved Vagabond* by W. J. Locke. "I think if I failed in this life (and I don't mean to)," Nash said, "I should . . . take to the High Road . . . Think of such a glorious existence if you really loved the open air and knew about the woods and fields, as I do a very little." But of course vagabondage was not Nash's line at all, although the influence was not to disappear at once; it was later to be more respectably derived from Borrow.'

There was an enthusiasm for E. F. Benson's *Angel of Pain* and a very considerable one for the works of Algernon Blackwood. Bertram continues that 'Nash first particularly praised *John Silence*, which certainly contains a good deal of what was to be characteristic Nash imagery . . . haunted woods, Druidic circles, mystic flying and again the curtain which threatens to lift on the hidden presence.' There was an even more intense enthusiasm for *The Education of Uncle Paul* . . . 'the book has helped me and done me good' . . . 'it is amazing,' comments Bertram, 'that this twaddle should have fed an imagination so athletic as Nash's. But it certainly did: we cannot fail to be struck by that accumulation of images from nature, which is also almost a list of his themes. And the white wings were also to play their part.'

In 1912 came an admiration for, it would seem, Arthur Machen and *The Hill of Dreams*. In a letter of 5 March he quotes: 'Long, long ago, a white merle flew out of Eden. Its song had been in the world ever since but few there are who have seen the flash of its white wings thro' the green gloom of the living wood, the sun splashed, rain drenched, mist girt, storm beat wood of human life.' And he goes on: 'but today, as I came thro' the wood, under an arch of tempest and led by lightnings, I passed into a green sun splashed place. There, there I heard the singing of a rapt song of joy! here and there I saw the flash of white wings.'

Paul Nash referred to *The Hill of Dreams*, but there is no such book. '*The Hill of Dreams* by Arthur Machen,' writes Bertram, 'seemed a likely guess, but the passage is not to be found in it. And yet the book corresponds so exactly at many points to Nash's imagery and imaginative life at that time that he must certainly have read it, and confused

C. R. W. NEVINSON
1889 – 1946

As this series of studies grew the question of which painters to include and which not became more troubling. Sometimes the answer was simple: to have ignored Sickert or Augustus or Gwen John or Stanley Spencer, or, as an extraordinary intellect at work among the arts, Wyndham Lewis, would have been palpably absurd. At other times the answer was not simple at all. There are painters one aspect of whose work seems to me to have had a chance of proving durable, and the rest to have had little. There are painters whose qualities I am able to apprehend, yet with insufficient comprehension to enable me to appraise them. Ivon Hitchens, for example. I have been delighted by the glimpses he afforded into the enchanted depths of a vernal or if autumnal wood – glimpses I remember gratefully like something vividly seen in childhood or a few bars of a haunting, almost forgotten tune. But this is not enough: my mind is insufficiently attuned to be able to appraise the elusive iridescence of the art of Ivon Hitchens.

Of other painters I shall have nothing to say in these pages because the excellence that their art uniformly maintains is that of a tradition which is well understood and has been abundantly written about, so that critical explanation would be superfluous. A notable example is the portraiture and still-lifes of Allan Gwynne-Jones, who, in sharp contrast to the highly idiosyncratic subjects of these studies, worked with serene consistency in the finest academic tradition. It is an uncommon achievement. Today extremely individualistic art is almost the rule among serious independent painters in England; on the other hand, art that is popularly termed 'academic' and is described by its advocates as 'traditional' – and sometimes as that which alone is 'sane' or 'competent' or 'healthy' – is indeed far from any seriously maintained academic tradition. In fact, the genuine academic painter, the painter who is able to express himself fully within a great tradition and with a complete understanding of its possibilities and limitations, is a very rare bird indeed, and a fortunate one. Such a painter was Gwynne-Jones. With no inclination to extend the frontiers of his art or to pioneer in the forests, he cultivated the gardens of his choice with no less distinction than consistency.

C. R. W. Nevinson was a painter who belonged to the first of these three categories, a painter, that is to say, of whose work only one part seems likely to endure. During a brief period he painted pictures which demand a place in any account of English painting during the present century, and for the rest of his life paintings which, notwithstanding certain excellent qualities, seem to me to have no claim to such a place. It was Nevinson's misfortune that his finest pictures had as their subject something that everyone was under an almost irresistible compulsion to expel from their memory: the First World War's western front. The memory of mile upon mile of earth dissolved into deep slime or else burnt and torn, the scene of death on a scale without precedent, is a memory which, even for those who never saw it and even after a second and more hideous world war, cannot be recalled without a painful effort. It was a further misfortune that during the ensuing years his work acquired a repute that was widespread rather than firmly established. For Nevinson, the neglect that often follows an artist's death has been unusually severe. Few names, among those well-known in Georgian times, occur less frequently in conversation, I should say, among painters and writers about painting. If now and then Nevinson's name is mentioned by some young student of art history, it is likely that it is not the painter but the solitary English Futurist, the friend of Boccioni, and Soffici, the man who beat the drum at the Doré Galleries while Marinetti declaimed his verse, who has aroused his passing interest.

Christopher Richard Wynne Nevinson was born on 13 August, 1889, the only child of Henry Woodd Nevinson and his first wife Margaret Wynne, daughter of the Revd Timothy Jones, a Welsh-speaking Welshman and classical scholar, in John Street, Hampstead, since renamed Keats Grove. The Nevinsons occupied a house, now demolished, which stood opposite to the elegant white villa where Keats lived.

Henry Nevinson was a celebrated war correspondent, and his wife made a career in education and politics, playing an active part in the campaign for women's suffrage and the reform of the Poor Law. The home they made was a disturbing place for a boy to grow up in. The father was inclined to be a radical both in his thinking and his feeling, who yet delighted in army life. The mother, a shingled, sandalled progressive in home affairs, was also an ardent jingo, and when Mafeking was relieved she and her small son, he related in his memoirs, 'draped in red, white and blue . . . wandered from Ludgate Circus to Piccadilly ringing a dinner bell'.

This conflict in both of his remarkable parents, arising from their emotional attachment to the established order of things – represented by the Empire, the army, the older public schools and universities,

and their attachments, equally emotional, to progressive causes of many kinds – was inherited in an acute form by their son, who was at once ardently institutional in his loyalties, yet something of a revolutionary too. But the conflict in father and son took a precisely opposite course. The father, who began with traditional class sympathies and wished his son to follow him to Shrewsbury and Oxford, ended as a passionate socialist. I remember a discussion taking place at my parents' house during the General Strike of 1926, on its rights and wrongs, but nothing of what was said except Henry Nevinson's passionate exclamation: 'The People: right or wrong!' The son, after being one of the very first among English painters to be fully conscious of the revolutionary ferment on the Continent in the years just prior to the First World War, and taking a leading and energetic part both in proclaiming Futurist and Cubist ideas and in making them a part of his way of seeing, was soon declaring in *The Studio*, 1919, that 'The immediate need of the art of today is a Cézanne, a reactionary, to lead art back to the academic traditions of the old Masters, and save contemporary art from abstraction, as Cézanne saved Impressionism from "effects".' Yet just as his father continued to delight in army life so did the son preserve something of his early challenging attitude towards art and life until the end.

There was another way in which the personalities of his parents affected him, and wholly adversely. Both in their different ways were champions of underdogs and turbulent pioneers, indifferent if not contemptuous of public opinion. Unpopular causes were their vocation, and their challenging character and progressive temper were as defiantly manifest in the home as they were outside. The walls of their home were ornamented with reproductions of Italian primitives, Pre-Raphaelites and English watercolours. These departures from the prevailing taste of the middle-class neighbourhood, in which Nottingham lace curtains and a cosy profusion of knick-knacks were the rule, deepened the suspicions engendered by Mrs Nevinson's shingled hair, and, as a consequence, her son relates, he was booed in the streets. This and other manifestations of hostility implanted in Nevinson an enduring sense of being an innocent victim of the world's ill-will, indeed of its persecution. At the height of his success as a painter, with his massive figure and booming voice, Nevinson presented to the world an imposing, even a formidable aspect; yet those who knew him were, I fancy, uncomfortably aware that only just beneath the surface lay an inordinate horror of ill-will and a readiness to see it even where it was not. This vulnerability was made the more acute by unhappy experiences at school. At the age of seven he was 'publicly flogged . . . for giving away some stamps which I believed to be my own'.

After a happy interlude at University College School, Nevinson was sent in 1904 to Uppingham, where persistent ill-treatment left him, he relates, 'septic in mind and body' and led to a serious operation and his removal from school. It was after his illness, in the course of a tour in Spain, North Africa and northern Italy, that he began to draw. On his return he went back to Uppingham for one term, but his health was still so bad that it was plain that there was no longer any question of his going to Balliol as his father wished. During his tour he had decided to become a painter. When he left Uppingham he entered the St John's Wood School of Art in 1907.

It was the bicycling tours on which his mother used to take him that developed the visual side of his nature. They visited churches and colonies of artists, as he related in *The Studio*, 1919:

> In the art colonies at Pont Aven, Concarneau, Quimper, St Pol, Caudebec, and St. Michel we always associated with the painters. The name of Monet had been familiar to me for some time. As my mother had been in Paris from about 1870 she was particularly versed in the Impressionist school; and I had already devoured, by the age of fifteen, the books of Camille Mauclair on Renoir, Manet, Degas, Sisley, and Pissarro, and had heard of Gauguin and Cézanne. I had even heard of the 'mad' paintings of Van Gogh some five years before their 'discovery' by Roger Fry and the dealers.

By the time he left Uppingham he had not only a lively interest in painting. He had a point of view:

> I was a modernist. The plethora of artistic training and my revolt against public-school traditions made me bored with old masters; in Venice an international exhibition of contemporary art had interested me more than anything I had ever seen. I really was excited about it, although it is significant that now I can recall no single picture I saw there except those which introduced me to the technique of a Neo-Impressionist, Signac.

As he is writing of the time before he left Uppingham, it is unclear to what 'the plethora of artistic training' refers. The only training he appears to have had was occasional instruction from John Fulleylove, the architectural draughtsman and watercolour painter. The description of his discovery, while a student at St John's Wood, of Augustus John's and Orpen's drawings in a publication entitled *The Slade*, and of how they 'completely upset my applecart' and precipitated 'a period of doubt', suggests that his memory was at fault, and that the Continental masters whom he named had remained little more than names, or that he came upon them a little later on. Had he been, in fact, as familiar with them as he claimed, his 'apple cart' would hardly have been upset by reproductions of drawings so closely formed upon the old masters as those of John and Orpen. Nor would his

'period of doubt' have been ended as it was when Sargent, 'the god
of St John's Wood', stated that John was 'the greatest draughtsman
since the Renaissance'. To a student 'familiar with all French art,' as
he claimed to be, neither the drawings of John and Orpen nor the
opinions of Sargent, worthy of note though they be, would offer so
shaking an experience as to lead to the overthrow of all his values.

Nevinson was, I fancy, more accurate when he insisted on the
academic aspect of the school and recalled his laborious days in the
'antique', chalk stump and pointed indiarubber in hand; his drawing
from the model at night; his concentration upon head and figure
painting and the interest in the old masters which it brought,
especially in Dürer, Holbein and Antonello da Messina. The impact
of John's and Orpen's drawings showed him that the Slade tradition
had an energy and an expressive power unknown to his teachers.
Accordingly in 1909 he left St John's Wood for the Slade, where he
remained for three years.

Nevinson was fortunate in going to the Slade during one of its
liveliest periods. Stanley Spencer, Gertler, Currie and Wadsworth
were among his fellow students, and these, with Allinson, Claus,
Ihlee, Lightfoot and Nevinson himself, formed a gang which wore
uniforms of black jersey, black hat and scarlet muffler and which
roved the streets of Soho in search of trouble. They did not, according
to various accounts, have far to look. While at the Slade Nevinson
studied sculpture with Havard Thomas. Like a number of other
beginners of promise he was given his first opportunity of showing
his work by the Friday Club, in 1910, and some of it earned the
favourable notice of serious critics. Two of his urban landscapes,
paintings in the Impressionist tradition, were singled out for their
exceptional promise by *The Sunday Times*. Sickert had spoken some
words of encouragement to him and Gilman and Gore had welcomed
him into the Camden Town circle. For the first time Nevinson felt the
ground firm beneath his feet. He was happy in the consciousness of
making progress; his feeling of unhappy singularity was waning.
Then Tonks told Nevinson, as he had told Matthew Smith a few years
earlier, that he lacked talent and was unqualified to be a painter. For
students with whom he was in sympathy, and numerous others,
Tonks was a great drawing teacher – one of the few great teachers of
the time – but there were always certain students for whom he formed
inveterate dislikes and whom he harried without mercy. In certain
cases – and Nevinson was one – he pursued his victims long after
they had left the Slade. So cogently did Tonks frame his advice to
Nevinson to abandon painting that it was temporarily accepted: for
a short time the Slade student became a Fleet Street apprentice.
Nevinson enjoyed interviewing Little Tich and Marie Lloyd, but the

episode was baleful in its effects. Tonks's hostility revived and intensified Nevinson's crushing sense of the world's ill-will, a sense which from that time onwards was ever on the alert. Moreover, his brief term in Fleet Street taught him at once too much and too little about the press. From it he learnt its extraordinary power and how to harness it, but little of its attendant dangers. Even after he left Fleet Street he knew how to secure the widest publicity for his work and for his opinions. This doubtless contributed to his material success, but it also provoked the jealousy of other artists, vulgarized his reputation and involved him from time to time in situations which would have been distressing to most men but which were particularly injurious to the constitution of a man of his temperament. In spite of its undesirable consequences, press publicity appealed to Nevinson. He took a frank pleasure in being a celebrity and a popular oracle on any topic of the moment, and his Fleet Street experience suggested to him that this pleasure was not at all uncommon, especially among eminent persons who insisted that they were superior to such vulgar satisfactions. Such hypocrisy was repellent to his own candid nature. Later on he came to attach a moral sanction to his belief in publicity:

> My Futurist training had convinced me that a man who lives by the public should make his appeal to that public and meet that public, and that all hole-and-corner cliques, and scratch-a-back societies are dis-astrous to the artist and his output. A coterie becomes a tyrant, falsifying a man's standards. Consciously or unconsciously he trims. When he is dealing with a wider and perhaps a more undiscriminating public there is always the chance that his point of view may appeal to an unknown individual. In the past it has been the expert, the critic, and the 'artistic' who have been wrong, and stray members of the public always right.

A visit to Paris in 1911 – at perhaps the most creative moment in the history of modern painting – restored Nevinson's sense of vocation. In the mornings he worked at Julian's in the Rue du Dragon and at the Montmartre Julian's in the evening, and occasionally at the Circle Russe where Matisse taught. After a return to London he was back in 1912 for a further and still more fruitful stay in Paris, for it was then that he received the impact of Cubism. 'I felt the power of this first phase of Cubism,' he wrote, 'and there was a desire in me to reach that dignity which can be conveyed pictorially by the abstract rather than the particular.'

Nevinson gives a fairly extensive account of his visits to Paris, but because of the small number of his early works which have survived, and the inaccuracy of his writing, it is difficult to assess with any degree of precision the nature of the impact upon his ideas or practice. The general direction of his development was away from

the tradition of Renoir, Monet and other Impressionists towards the newer tradition which Picasso, Matisse and a crowd of others were forging out of the legacy of Cézanne; and he was conscious of the attraction of Gauguin and of Van Gogh, whose example, he has told us, encouraged him to use outline to simplify his form and to emphasize his planes; and of abstract art, especially that of Kandinsky. But these were forces that were animating a whole generation of painters. Even the influence of Cubism, which he acknowledged so explicitly and which at first glance seemed so completely to dominate the work of his most creative period, seems ambiguous under scrutiny.

The account he gives of the artist's Paris, although lively, throws no new light upon the personalities or ideas which were contributing to the formation of what was nothing less than the matrix of a new art. Nevinson was gregarious, voluble and alive to what was going on around him; he was acquainted with a number of leading artists; he even shared a studio with Modigliani. The assurance of his writing is, however, hardly justified:

> The works of Picasso, Matisse, Derain and Vlaminck were by now well known to me if to no one else. The Fauviste school, through the influence of Gauguin, was reacting against the prettiness and technical accomplishment of French art. They were trying to introduce into their work a harsher or wilder note, a more intense expression, although of course, Picasso was still swayed by Toulouse-Lautrec and was only just leaving his blue period. . . .

The year was 1912: Fauvism, far from being, as he implies, a new movement, had fulfilled its aims some four years earlier, and the former Fauves were currently engaged in adventures of a quite different kind; Picasso had left his Blue Period some eight years earlier, and he could not have been said to be 'swayed by Toulouse-Lautrec' since the beginning of the century.

Wherever he went, every manifestation of life presented itself as an object of fascination. To have his creative interest aroused, he had but to look. Whether it was the gaunt silhouette of a factory at night, brightly dressed girls in punts on the Thames, 'any London street' (the title of one of his paintings) – it scarcely mattered. Most painters' work is empty because they do not love life enough, and because a great master, on account of the burning patience of his dedication, needing a natural object which was immobile and relatively unchanging to paint, painted apples, these lesser men – however rapid their execution – made still-life a pretext for ignoring life. (I can just hear their supercilious question, 'but isn't an apple as much "life" as anything else?') Nevinson's eye was too voracious – especially of the dramatic, the exciting, the sinister and the pretty – and its voracity

tended to carry the hand with it too fast, to demean it into a mere recorder. The discipline of Cubism enabled him to impose a style upon the variegated prey of his voracious eye. For many artists who adopted Cubism it was an experiment, another set of principles; for Nevinson, at the most creative period of his life, Cubism was the thing needed to give the simplicity and dignity to his work which he desired to reach. Yet his debt to Cubism being made plain, it is necessary to draw a sharp distinction between the Cubism of the pioneers of Cubism – Picasso and Braque during the years 1910, 1911 and 1912 – and the later Cubism of Nevinson. 'Cubism,' declared Picasso, 'is an art dealing primarily with forms.' This is true both of the earlier phase of dissection and reassembly of forms generally known as Analytical, and of the later, more inventive, remoter from natural form generally known as Synthetic. Although Cubism was primarily an art of form for Picasso and Braque, it was not a wholly abstract art; it was also an art of representation. As Alfred Barr observed:

> Always there were vestiges of 'nature', whether a landscape, a figure or a still-life. And these vestiges however slight remained essentially important, for they revealed the point of departure, the degree of transformation undergone by the original image; they supplied the tense cord which anchored the picture to common reality yet gave the measure of its daring distance. In this sense a cubist picture was not only a design but a precisely controlled and far-fetched metaphor.

To Nevinson the subtle analysis of natural forms of Picasso and Braque would have been incomprehensible; he was unconcerned with the principles of Cubism or any other contemporary movement. He was an artist of superb adaptability and resource, who saw in contemporary movements expedients adapted to the representation of certain subjects. 'I maintain,' he asserted, 'that it is impossible to use the same means to express the flesh of a woman and the ferro-concrete of a sky-scraper . . .' But Picasso, for whom within a certain span of years Cubism was not an expedient but a natural evolving language, did precisely that, painting *Factory at Horta* in 1909 and *Girl With a Mandolin* the following year, in a style in all essentials the same.

During the three years before the First World War, Nevinson kept in close touch with Paris, but in 1913 London became the principal theatre of his activities. These were years when the London art world like that of Paris, was deeply but optimistically agitated by the new movements that were continually germinating, clashing, intermingling, changing direction; continually affected, too, by the ebb and flow of ideas from Paris, at that time a white-hot crucible of ideas eagerly discussed, bitterly fought over, and wafted promptly away to

the ends of the artistic earth to bring inspiration or resentment, but at all events passionate interest, wherever they lodged. Although London was not as significant a centre as Paris, a city where those concerned with the visual arts are more visual and less literary than they are apt to be in London, more audacious and more extreme in their thinking, and, above all, the place where the revolutionary masters congregated, nevertheless on the eve of the First World War London was a centre where a quite unusual number of men of talent were active in painting and sculpture, in thought about the arts, in writing and discussion, and where, in consequence, foreigners of talent such as Gaudier-Brzeska came to live and many more to propagate their ideas and to see what was in progress. The bracing and optimistic character of the climate brought forth and was in turn heightened by a series of exhibitions of the works of Continental painters and sculptors, by the inauguration of Frank Rutter's Allied Artists' Association – a London version of the Paris 'Independents' – and by the formation of more or less revolutionary exhibiting groups of many kinds.

Nevinson's adventurous predilections and his exceptional knowledge of movers and shakers of the Parisian art vortex led him quickly into its London equivalent. He contributed to the Allied Artists' exhibitions at the Albert Hall in 1910, 1913 and 1914, which, vast and inchoate though they were, generated much heat and led to fruitful associations, and he was included in the Post-Impressionist and Futurist Exhibition brought together by Frank Rutter at the Doré Galleries in the autumn of 1913, a lively survey of revolutionary painting from Pissarro, Cézanne, Van Gogh and Gauguin to the generation of Nevinson himself. Among the fine paintings contributed by Nevinson was *The Departure of the Train de Luxe*, which was a frankly Futurist work and owed much to Severini, whose paintings, more especially *The 'pan-pan' Dancers at the Monico* in the Exhibition of Works by the Italian Futurist Painters at the Sackville Gallery in March 1912, had provoked wide interest. This picture stirred Nevinson to an extraordinary degree. When he met Severini at lunch with Roger Fry and Clive Bell he was fascinated not only by the Futurist painter himself, but by the Futurist gospel in general and more particularly by its insistence upon dynamism and the beauty of modern life, especially the teeming life of great cities, of machinery. In the introduction to a catalogue of an exhibition of his works in 1913, Severini wrote:

> We choose to concentrate our attention on things in motion because our modern sensibility is particularly qualified to grasp the idea of speed. Heavy, powerful motor-cars rushing through the crowded streets of our cities, dancers reflected in the fairy ambience of light and

colour, aeroplanes flying above the heads of an excited throng. . . .
These sources of emotion satisfy our sense of the lyric and dramatic
universe, better than do two pears and an apple.

The two painters became close friends and Nevinson accompanied
Severini back to Paris where he was introduced into Futurist and
Cubist circles. When Marinetti, the founder and leader of Futurism,
told Severini that he had it in mind to revisit England, Nevinson
asked Severini to persuade him to carry out his intention. When he
arrived in the autumn of 1913, Nevinson joined Wyndham Lewis in
organizing a dinner of welcome at the Florence Restaurant. The
dinner, at which about sixty painters, writers and others were
assembled, was an event of which Nevinson has given a lively
description:

> It was an extraordinary affair. Marinetti recited a poem about the siege
> of Adrianople, with various kinds of onomatopoeic noises and crashes
> in free verse, while all the time a band downstairs played, 'You made
> me love you. I didn't want to do it.' It was grand if incoherent. I made
> a short speech in French and Lewis followed, then jealousy began to
> show its head. Marinetti knew of me through Severini and he
> understood my French better, so he paid more attention to me. He did
> not know, poor fellow, that he was wrecking a friendship that promised
> well. His French was good, having nothing of the Italian accent or
> phraseology I associated with Severini or Boccioni. It certainly was a
> funny meal. Most people had come to laugh, but there were few who
> were not overwhelmed by the dynamic personality and declamatory
> gifts of the Italian propagandist; while still the band downstairs tinkled
> on: 'You made me love you.' It seemed incapable of playing anything
> else. This was my first public appearance before the Press. It was also
> my first speech of any kind. The men who covered it for the papers
> knew little of what was said, but from a sensational point of view they
> got all they wanted, and for a time my name seemed always to be in
> print.

Some months after the long-remembered dinner in his honour
Marinetti paid a further visit to London and with Nevinson issued
Vital English Art. Futurist Manifesto. This first appeared in *The Observer*
on 7 June, 1914, but was subsequently printed in other newspapers,
and Nevinson used to shower copies of it from the galleries of
theatres. In order to distinguish it from earlier pronouncements of
the kind issued by the Futurist movement since the original Futurist
Manifesto, which was published in *Figaro* on 20 February, 1909, this
has become known as the English Futurist Manifesto. Like its
predecessors, it was a violent denunciation of the worship of
tradition, of 'the pretty-pretty . . . the sickly revivals of medievalism,
the Garden Cities with their curfews and artificial battlements, the
Maypole Morris dances, Aestheticism, Oscar Wilde, the Pre-Raphael-
ites, Neo-primitives and Paris'; against 'the sham revolutionaries of

the New English Art Club'; against 'the old grotesque idea of genius – drunken, filthy, ragged, outcast . . . the Post-Rossettis with long hair under the sombrero, and other passeist filth.' ('Passeist filth' became, for a time, a stock term of denigration applicable to any work of the past or of the present in which the influence of the past was too obviously manifest, of which the speaker wished to register disapproval.) It was not, however, its denunciations of passeist filth – lively copy though this furnished for the press – as its commendation of England's 'advance guard of artists' that provoked the uproar that followed its publication. 'So we call upon the English public', runs the final paragraph of the manifesto, 'to support, defend and glorify the genius of the great Futurist painters or pioneers and advance-forces of vital English Art – Atkinson, Bomberg, Epstein, Etchells, Hamilton, Nevinson, Roberts, Wadsworth, Wyndham Lewis.'

In appending his name to the manifesto Nevinson committed an egregious error – an error that had unhappy consequences for him. The manifesto, as the *pronunciamento* of a foreigner, would probably have been treated as a spirited display of fireworks, but, appearing over the signature of an Englishman as well, several of its targets seemed ineptly chosen. The Pre-Raphaelites, for instance, had never been less influential than they were in 1914, and people wondered which garden city was protected by artificial battlements, and were amused that anyone should see a menace to progress in the activities of the scattered tiny groups of intellectuals who were attempting, a little forlornly, to revive ancient folk dances. People wondered, too, why a statement which opened with the words, 'I am an Italian Futurist poet,' and ended with a call 'to support, defend and glorify the genius' of, among a small number of artists, Nevinson himself should have been signed by Nevinson at all. More informed readers were also aware that he was eager to have his own works accepted by the 'sham revolutionaries' of the New English Art Club. Of his election to its membership in 1929 he wrote, 'I think no honour gratified me more.' He disclosed in the same paragraph that he had allowed himself to be put up for membership 'fifteen years before', that is to say, in 1914, the year of the manifesto's issue. These errors of judgment were small matters and would have been quickly forgotten, but he was guilty of a greater. Nevinson was a bold, outspoken man, ever ready, in the best traditions of his family, to speak out in support of what he considered to be right. He was a friend of Marinetti and Severini, and a painter of precocious talent. All this gave him a deserved prominence among 'the pioneers and advance forces of Vital English art'. But it did not make him their leader, and it did not make him an art philosopher. By jointly signing a manifesto with Marinetti he made what many interpreted as an

assertion of leadership, an assertion the more explicit on account of the description of the eight other artists named in the manifesto as Futurists. If Nevinson, an avowed Futurist, had allowed no allusion to these others, the manifesto might have been regarded as an exclusively Futurist affair: as things were, it was easy for these eight to see an attempt to subordinate them to his leadership. Above all, it looked like a direct challenge to a man who was an art philosopher of extraordinary power and originality, and who was the directing power in the Rebel Art Centre, which Nevinson, with his propensity for associating himself with institutions, thoughtlessly gave as the address beneath his signature. Moreover Lewis would not have forgotten that Nevinson owed something to his early encouragement, and more to his ideas.

The reply to this real or fancied challenge was not long in coming. A week later *The Observer* published the following reply, which, considering Lewis's provocation and his formidable powers as a pamphleteer, is a document less savage than severe, and wounding chiefly by the omission of any reference to the manifesto's English signatory:

> Dear Sir, – To read or hear the praises of oneself or one's friends is always pleasant. There are forms of praise, however, which are so compounded with innuendo as to be most embarrassing. One may find oneself, for instance, so praised as to make it appear that one's opinions coincide with those of the person who praises, in which case one finds oneself in the difficult position of disclaiming the laudation or of even slightly resenting it.
>
> There are certain artists in England who do not belong to the Royal Academy nor to any of the passeist groups, and who do not on that account agree with the futurism of Signor Marinetti. An assumption of such agreement either by Signor Marinetti or by his followers is an impertinence.
>
> We, the undersigned, whose ideals were mentioned or implied, or who might, by the opinions of others, be implicated, beg to dissociate ourselves from the 'Futurist' manifesto which appeared in the pages of *The Observer* of Sunday, June 7.

> Signed:
> *Richard Aldington. Lawrence Atkinson. David Bomberg. Gaudier Brzeska.*
> *Frederick Etchells. Cuthbert Hamilton. Ezra Pound. W. Roberts.*
> *Edward Wadsworth. Wyndham Lewis.*

> P.S. The Direction of the Rebel Art Centre wishes to state that the use of their address by Signor Marinetti and Mr. Nevinson was unauthorized.
> Rebel Art Centre
> 38, Great Ormond-Street, W.C.,
> *June 8.*

The Observer printed, the following Sunday, a plaintive and not very convincing rejoinder, and the honours rested with Lewis.

On Friday 12 June, only two days before the publication of the Vorticists' disclaimer and ignorant that it was impending, Nevinson and Marinetti organized a Futurist demonstration at the Doré Galleries. Nevinson spoke first, reading his speech, which appears to have been an extended version of the English Futurist Manifesto; Marinetti followed. Wyndham Lewis has described his 'counter putsch' in *Blasting and Bombardiering*:

> I assembled a determined band of miscellaneous anti-futurists. Mr. Epstein was there; Gaudier Brzeska, T. E. Hulme, Edward Wadsworth. . . . There were about ten of us. After a hearty meal we shuffled bellicosely round to the Doré Gallery.
> Marinetti had entrenched himself upon a high lecture platform, and he put down a tremendous barrage in French as we entered. Gaudier went into action at once. He was very good at the *parlez-vous*, in fact he was a Frenchman. He was sniping him without intermission, standing up in his place in the audience all the while. The remainder of our party maintained a confused uproar.
> The Italian intruder was worsted. . . . But it was a matter for astonishment what he could do with his unaided voice. He certainly made an extraordinary amount of noise. . . . My equanimity when first subjected to the sounds of mass-bombardment in Flanders was possibly due to my marinettian preparation – it seemed 'all quiet' to me in fact, by comparison.

Noise, indeed, was Marinetti's element, the necessary accompaniment to all his actions. There was an occasion when he again lectured at the Doré Galleries and declaimed his poems. One of these required to be accompanied by the noise of bombardment, to be 'packed to the muzzle with what he called "la rage balkanique",' so Nevinson 'concealed himself somewhere in the hall, and at a signal from Marinetti belaboured a gigantic drum'. Nevinson himself has described Marinetti's supreme attempt to break the eardrums of Londoners:

> It says a great deal for Marinetti that he was able to induce Oswald Stoll to put him on at the Coliseum. Nobody else could have done it. Naturally I went to see the first performance, and I must say it was one of the funniest shows ever put on in London, provided, of course, that one looked at things from the right angle. Marinetti swaggered on to that vast stage looking about the size of a house fly, and bowed. As he spoke no English, there was no time wasted in explanations or in the preparation of his audience. Had they spoken Italian, I do believe Marinetti could have magnetized them as he did everybody else. There was nothing for it however, but to call upon his ten noise tuners to play, so they turned handles like those of a hurdy-gurdy. It must have sounded magnificent to him, for he beamed; but a little way back in the auditorium all one could hear was the faintest of buzzes. At first the

audience did not understand that this was the performance offered
them in return for their hard-earned cash, but when they did there was
one vast, deep, and long-sustained, 'Boo!'

When I went round to the back I found Marinetti in the best of spirits,
dismissing the unanimous condemnation of the audience and calmly
announcing to the Press, 'C'etait un cabal.'

I have insisted upon some of the boisterous manifestations of the
excitement and extremism with which the art world, in London as
elsewhere, was so highly charged, because of its effect upon Nevin-
son's art, both immediately and later on by way of reaction.

The last and least ephemeral of these manifestations was the
publication, thirteen days after that of the English Futurist Manifesto,
and only six after the Vorticist's rejoinder, of *Blast*, No. I, which
contained the last of the major manifestos, that of the Great London
Vortex. It appeared, too, less than two months before war was
declared. 'The months immediately preceding the declaration of war
were full of sound and fury,' Lewis wrote, 'and . . . all the artists and
men of letters had gone into action before the bank-clerks were
clapped into khaki and dispatched to the land of Flanders Poppies to
do their bit. Life was one big bloodless brawl, prior to the Great
Bloodletting.' Many artists and writers were attuned to war by the
time it came, and none more closely than Nevinson.

When the war came the urge which drew Nevinson as strongly as
it drew his father towards centres where exciting events were in
progress, promptly involved him. His health, never good – and which
deteriorated progressively – put enlistment in the armed forces out of
the question. 'Still, I was pursued by the urge to do something, to be
"in" the war,' he wrote, and it was not long before his urge was
satisfied. Hearing from his father of the shortage of ambulance drivers
in France, he joined the Red Cross and was promptly sent to Dunkirk.
The French medical service, in that area at least, had broken down. A
number of French wounded, roughly bandaged, had been packed
into cattle-trucks. By the time they had lain there neglected for three
weeks, only half of them were alive, and the train being required for
purposes more important than taking wounded men to hospital, its
contents were dumped into a shed. 'There,' wrote Nevinson, 'we
found them. They lay on dirty straw, foul with old bandages and
filth, those gaunt, bearded men, some white and still with only a faint
movement of the chests to distinguish them from the dead by their
side.' This scene, suddenly come upon in darkness, became an
unforgettable memory, and the subject of one of the three or four
paintings to which, if the reputation of Nevinson survives, it will
owe its survival, *La Patrie*. But for the moment there was no time for
painting, for making more than an occasional hasty sketch. There

were the wounded – Nevinson served not only as driver but as nurse, stretcher-bearer and interpreter as well – in ever increasing numbers; there were troubles between his unit and the French authorities for attending wounded Germans, for amputating limbs without official permission and thereby entitling those who thus suffered to a higher rate of disablement pension. At Dunkirk he saw the body of a child killed in an air-raid: a memory also retained for translation into a picture. In the meantime the French medical service had greatly improved, and Nevinson's health suffered from the strain and exposure which his duties involved, and he was sent home. After an interlude in London he joined the Royal Army Medical Corps, serving as an orderly at the Third General Hospital in London. In January 1916 he was invalided out of the Army with rheumatic fever.

Such, in brief, was the modest extent of Nevinson's military career, but the nature of his earlier duties as an ambulance driver with the Red Cross in France, involving constant journeys by road, gave him opportunities for studying long sections of the fighting line and the burnt and shattered country, as well as first-aid posts and base hospitals, that were denied to most combatants, for whom the war was often a monotonous alternation of trench and rest camp.

It was not Nevinson's opportunities for observing the Western Front, which although excellent were far from unique, but his particular temperament and the precise point which he had reached in his development as an artist that prepared him so well to represent war.

Until the last years of his life he was usually considered a 'rebel', and as a young painter he did in fact participate in revolutionary movements. But his instincts, in one essential respect, were those of a popular painter in that he wished his work to be widely and clearly intelligible; he wished its impact to be heavy; he wished, in brief, to share his own strong emotions and impressions with his fellow beings in general, and he delighted in evoking their response. Even a hostile response was more acceptable to him than none. Therefore the representation of an event so apocalyptic in the quality of its drama – drama that held every sentient being in its grip – was one to which he was eager to dedicate himself to the utmost of his powers. In this connection it is relevant to recall that a number of the artists who worked on the Western Front avoided war as a subject, and confined themselves – sometimes to good purpose – to the kinds of subject which occupied them in times of peace, 'picturesque' buildings. A modern parish church with its roof and windows blasted was not terribly different from a medieval abbey in like condition from the effects of Reformation and weather. For Nevinson it would have been an irrelevance, almost blasphemous in its frivolity, to have gone

to the western front to pick out 'picturesque bits'; for him the war was the subject, and from it he never averted his eyes. But such a disposition to address himself to a great public, and a determination to extract all that a theme of overwhelming grandeur would yield up, even supposing considerable artistic powers to have been at their service, might in the event have accomplished little. Nevinson had something besides considerable artistic powers: experience that was both recent and intense of two movements which he had the perception to adapt for his purpose – Futurism and Cubism. The first had taught not only the glory but the social utility of war, and the glory of machines in general and of those machines essential to the conduct of modern war in particular: guns, aircraft, armoured cars, warships and the supreme glory of these as parts of one great war machine. While other painters brooded in solitude over field or wood, plate of apples or naked girl, arrangements of lines and colours, the Futurists exulted in crowds, in speed, in noise, in conflict, in everything that other painters shunned. That Nevinson was fully aware of this is clear from an interview he gave in *The New York Times* after the end of the war:

> This war did not take the modern artist by surprise . . . I think it can be said that modern artists have been at war since 1912. Everything in art was a turmoil . . . the whole talk among artists was of war. They were turning their attention to boxing and fighting of various sorts. They were in love with the glory of violence. . . . The intellectuals knew that war was coming before business men . . . and when war came it found the modern artist equipped with a technique perfectly well able to express war.

Futurism awakened them to a charmed acceptance of the beauties of the age of the machines, but it did not equip them with a method of representing mechanized power. For all the talking and writing about the power, speed and noise of machines, their most character-istic paintings were not in fact representations of these; they were exuberantly gay, ballroom-bright kaleidoscopes. Their simultaneous representation of the successive stages of movements deprived them of the clarity which is an essential constituent of power. And it was not an objective art. 'It is by abandoning objective reality,' wrote Severini, 'that our Futurist painter arrives at an abstract and subjective expression.' Assuredly a painter who was a Futurist and nothing more would have had an unsuitable instrument to his hand for the representation of the gigantic clash of arms, the sombre bloodletting of the Western Front.

It was Cubism that gave Nevinson's Futurism the weight and the clarity that made it so effective an instrument for this purpose. But it was Cubism with a radical difference. As Alfred Barr has observed:

Few styles or methods in art have provoked more elaborate theories and analogies than has Cubism. Cubist works have been likened to structural steel, broken mirrors, Gothic architecture, post-Euclidian geometry, and the drawings of sufferers from dementia praecox and schizophrenia; Cubism has been praised – and used – as an academic discipline and damned for its chaotic licence . . . it has been called both a return to classic traditions and a consequence of reckless revolution.

For Nevinson, Cubism was none of these; primarily it was something simpler: a means of communicating, at its most intense, the drama of this most dramatic of all subjects. The Western Front offered to the painter's contemplation a vast yet infinitely complicated panorama, a panorama dominated by the machinery of war. Nevinson was quick to perceive that out of Cubism, with the licence it gave to stark, bold simplifications, to the substitution for curves of jagged angles, to harsh contours, could be formed an instrument in tune with the machines, which could represent modern war with shattering effect. For the Cubist pioneers, according to the foremost among them, 'Cubism is . . . an art dealing primarily with forms.' For Nevinson it was a kind of magnificent shorthand, perfectly adapted to convey the simplified essence of a mechanized apocalypse. Nothing could be more different than the subtle apprehension of the complexities of form, the severe remoteness of the early Cubists, and Nevinson's harsh eloquence. The fact that it was a vulgarization caused Nevinson's Cubism to be discounted by artists and critics, but it was, at its best, that rare thing in modern times, a popular language that could be spoken with dignity.

Nevinson began to make use of his opportunities of observing the Western Front before his discharge from the RAMC. Two of his best pictures, La Mitrailleuse and The Flooded Trench on the Yser, were painted, he has told us, in two days during the leave granted to him on the occasion of his marriage in 1915 to Cathleen Knowlman. Directly afterwards he set intensively to work, and by September 1916 he had completed sufficient work to hold a full-scale exhibition. His war pictures shown earlier in the year – La Mitrailleuse and two others at the Allied Artists' at the Grafton Galleries in March and Column on the March and The Flooded Trench on the Yser at the London Group – provoked something of a stir, but his exhibition made a deep impression upon those who saw it; to many it gave their clearest insight into the great events across the Channel – in particular almost all the critics were quick to realize that the deep, harsh note struck by these works was in harmony with the subject.

It made most of the war art they had seen appear false by comparison. Even The Nation, principal organ of the 'Bloomsburies', by whom Nevinson felt himself treated with a meanness that was a

constant subject of his talk to the end of his life, wrote with respect. 'For the first time in recent years, the pioneer seems to be seeking a manner,' its notice concluded, 'which will not be merely the amusement of a coterie, but might, by its directness, its force and its simplicity, appeal to the unsophisticated perception. I can imagine that even Tolstoy might have welcomed this rude, strong style, a reaction against the art of leisure and riches.' *The Times Literary Supplement* devoted its main article, 'Process or Person', to the elimination of the personal element in modern war, and took Nevinson's war pictures as its text, as expressing 'his sense that in war man behaves like a machine or part of a machine, that war is a process in which man is not treated as a human being but as an item in a great instrument of destruction, in which he ceases to be a person and becomes lost in a process'. This article is a fair indication of the seriousness with which Nevinson's war pictures were regarded. The painter's treatment of this respectful and fair-minded attempt to place his art in a historical and philosophic context is no less indicative of the melancholy effects of his growing suspicion of intellectuals, which was becoming a disposition to dislike not only certain intellectual coteries in London but the operations of the intellect itself. Even after two decades of reflection he could travesty the article into an expression of 'the opinion of a great many people, particularly of the old Army type, that the human element, bravery, the Union Jack, were all that mattered'.

The exhibition was crowded. All the pictures were sold. Arnold Bennett bought *La Patrie*; Sir Michael Sadler – one of the most influential collectors of contemporary British painting – bought *Column on the March* and three other pictures. Nevinson, conscious of his powers and legitimately proud of the purpose to which he had put them, elated by success, looked forward with confidence to a great career. This confidence was shared by many others, including some whose opinion counted for much. His *La Mitrailleuse* had been described by Sickert as 'the most authoritative and concentrated utterance on the war'.

Looking back it would seem now that in the autumn of 1916 Nevinson was not on the threshold of a career but at its climax. It is difficult to think of anything he made during the thirty years which remained to him that compares in energy or in conviction with what he made during the first two years of the First World War, and difficult to see the course of his life as a painter as other than a slow decline.

How did it come about that this man – industrious, gifted, resourceful, independent and deeply in earnest – should have been unable to advance beyond the point that he reached when he was

twenty-seven, and in spite of the possession of these and other qualities should have fallen progressively below it? The answer is to be found, I think, in the spiritual crisis brought upon him by the difference between his conception of what war would be like, and what he saw in the hospitals around Dunkirk. He was a humane man, singularly free from malice, let alone cruelty. Yet he was a faithful follower of Marinetti and deeply imbued with the Futurists' gospel of war and their contempt for the humanitarian sentiments to which war was abhorrent. It would be wrong to suggest that Nevinson, in the depths of his being, fully approved, still less that he hoped for, the coming of any particular war, yet as he himself declared, in the New York interview already quoted, 'Modern artists have been at war since 1912 . . . They were in love with the glory of violence . . . Some say that artists have lagged behind the war. I should say not! They were miles ahead of it. They were all ready for the great machine that is modern war.' It is significant that these words were spoken after the war, at a time when his own sentiments had changed. Significant also is the date 1912: it was the date of the Balkan War which so enchanted Marinetti; it was the date of Nevinson's own conversion to Futurism, and of the Futurist Exhibition held in London in that year.

So when the First World War came Nevinson could not miss the chance to experience war at first hand. He had heard his master imitate the thunder of the guns round Adrianople – at the siege of which he had been present – and Nevinson knew that such a sound was but a whimper compared with the thunder of the guns along the Front. He was in love with the Great Machine – scarcely more than tuning up that sunny autumn – and with noise, speed and power.

'It was dark when we arrived,' he wrote. 'There was a strong smell of gangrene, urine and French cigarettes.' That was the deepest, most personal impression he had of the war: incompetence, corruption, callousness, the whimpers of maimed and dying men . . . 'the strong smell of gangrene, urine and French cigarettes'.

In representing his early experience of the war with such directness, starkness and force, and with such particular insight, Nevinson was, as it were, expending his Futurist and Cubist capital. He was a simple man. The effect of the shock of discovery that war was not the mechanized Wagner, all thunder and speed, was not 'the hygienics of the world', was to shatter his faith not only in the Futurist glorification of war and in Futurism itself, but, by association, in Cubism – in fact in the entire revolutionary spirit in the arts. So long as he had no time for reflection, he worked, and worked brilliantly, in a tradition in which he was losing faith, in a spirit which was a habit that was being broken. All Nevinson's experience combined to

enable him to represent the war superbly, but the act of so doing involved the repudiation of that experience.

For many people progress is an inevitable process, operative in every field of human endeavour, whereby the bad is ameliorated and the good replaced by the better. This conviction springs from the belief that human nature seeks and cannot but seek the good and that but for the malevolent obstruction of a complex of inertia and vested interest in opposing the beneficent process, of 'reaction' in fact, it would quickly achieve it. For such people anything 'advanced' is of necessity better than what it replaces. So much is self-evident, and to doubt it is a betrayal of progress. It is as simple as that. When Nevinson was growing up it seemed simpler still. 'Progress' was accepted as a great self-evident fact. There had been no blood-lettings on a world-wide scale to disgrace the human species; there had been no such complicating factors as, for instance, the brusquest repudiation of 'progressive' art by States in certain respects socially progressive. In 1914 a man was either 'of his time', a progressive, or else he formed part of the menacing shadow that stood between mankind and the sun.

The young Nevinson was a simple man for whom the distinction between opposing forces was particularly sharp. On the one side was militant dynamism, 'in love with violence', the Great Machine its supreme creation; on the other, traitor pioneers 'refusing to resume the march', decadence, mediocrity, Morris-dancing, in two words, 'passeist filth'.

For all his talk of violence Nevinson was a humane man. The sight of those broken men at Dunkirk lying neglected in the stinking darkness, and the sound of their cries for their mothers, was a memory that was always with him.

According to my understanding, this experience began a process which transformed Nevinson's whole outlook on life. It was plain that Morris-dancing could not have been responsible for the mutilation of these men; it was not long before it occurred to him that they might be victims of his old love 'violence'. If 'violence' could have such degrading consequences – 'violence' that was the most glorious mark of 'dynamism' – how could Futurism remain, in his eyes, a glorious movement? He realized that if the Great Machine was to function – and in repose it was without meaning – then it needed victims: victims such as the remains of men who had lain in that dark shed. And if the Great Machine needed victims to fulfil itself, how could he not suspect that not only Futurism but the whole progressive movement had a dark side? A more analytic mind might have dissociated the purely aesthetic elements in Futurism from the bombast and the automobilism, and might have argued that Cubism

might be valid simply as a way of painting; but Nevinson was of a simplicity and a wholeheartedness to whom the weighing of pros and cons was repugnant: his was one of those natures in whom the tides run quickly in or out. His humanity, revolted by war which his master had glorified, led him first to doubt and eventually to abhor the validity of the progressive movement in all its manifestations.

As a man who has lost his religious faith may long retain habits of observance, so Nevinson retained much of the air of a progressive. It was not until after his election as an Associate of the Royal Academy in 1939, I fancy, that he altogether ceased to think of himself as a 'rebel'. By then he had long ceased to be anything but a realist of a highly conventional type, and the effects of the change which Dunkirk had set off were to be seen with remarkable promptitude.

In July 1917 he was sent to the Western Front as an Official War Artist, where he spent several months making rapid shorthand sketches, chiefly, he has told us, from memory, but also 'in the front line, behind the lines, above the lines in observation balloons'. In the following March an exhibition of his war pictures in various mediums was held in London. They are various, enterprising and accomplished, but, in comparison with the pictures shown two years before, they are the works of a man without conviction. The savage feeling of outrage, the sharp cutting edge, the sombreness, the weight, all survive only in feeble parody. The pictures shown in 1918 might be the works of a disciple of the Nevinson of 1916, so tame is their imagery. The declension may be seen at a glance by comparing one of the best of the later paintings, *Roads of France, Field Artillery and Infantry*, with the earlier *Column on the March*. The themes of the two are closely similar; yet what a difference there is between them! The second is treated with audacious resilience: under a sky of burning blue the column stretches on for ever. 'The soft thud of the men's feet as they march along the road,' wrote Sir Osbert Sitwell in his biography of the artist, 'can almost be caught by our ears, and we can almost see the shadows on the cobbles moving as they march.' The soldiers in the first kick up a little dust, but they do not compel us to listen for their footsteps; we are not interested, for they are only toy soldiers.

During his first war exhibition a reporter asked Nevinson whether he was going to repeat his success and paint more war pictures. 'No,' he replied, 'I have painted everything I saw in France, and there will be no more.' At the time he was, of course, unaware of the further opportunities shortly to be offered to him, but the words have a prophetic ring.

For almost thirty years the decline continued. From time to time he painted a picture of merit. The skyscrapers of Manhattan struck in

him a spark of the old Cubist fire; an occasional London street or twilight view of the Thames deeply stirred his interest in people and places: indeed for a painter as vivid in feeling and as rich in resource this could hardly have been otherwise. Shocked by his humanity out of the tradition, the way of seeing and the way of painting best suited to foster the gifts of this greatly gifted man, Nevinson, lost and enervated, more often made literal representations of landscape or embarrassing fantasies such as *Pan Triumphant* or *The Twentieth Century*. And as his art declined his suspicion of precise thought grew more insistent, and his hatred of 'intellectuals' tempted him to speak over their heads to the public at large, and in the role of 'outspoken rebel' he contributed his views to the popular press with increasing frequency. Articles such as 'Do Beautiful Women get away with it?', 'Pretty Women: are there any left?', 'She lived a life of Luxury', 'Making an Age of Faith', appeared at times with a regularity that would have done credit to a full-time journalist. He addressed meetings upon every kind of topic . . . 'My last appearance at that time', runs a characteristic sentence in his autobiography, 'was at a luncheon given by the Happy Thought Society . . .'

This continuous spate of vulgar publicity and his pathological touchiness made the older Nevinson an easy target. But a target at which anyone who knew him would be reluctant to aim. To be an oracle can be gratifying and remunerative, but there was something tragic in the spectacle of this man's being forced, by his life-long sense of singularity, his exacerbated sense of ill-usage by intellectuals, to cast his net so indiscriminately in search of admiration and affection. Tragic this would have been in any case, but it was particularly so in the case of Nevinson. He was not only an artist of high gifts but a kindly man and an entertaining companion, and a host of extraordinary charm, to whom Crawley's description of Mr Toogood might appropriately be applied, 'a man who conceals a warm heart, and an active spirit, and healthy sympathies, under an affected jocularity of manner, and almost with a touch of vulgarity'. With what eagerness I used to await the parties that he and his wife gave at 1 Steele's Studios, off Haverstock Hill. One entered the big room, crowded with celebrities of stage and screen, of Chelsea and Fleet Street, and made one's way to the centre of the vortex, Nevinson himself, stout, portentous, talking loudly – about himself. I well remember on the first such occasion going up to him to pay my respects, with his booming voice like a fog-horn to guide me through the crowd. 'Poor girls, poor girls,' he was saying, 'sooner or later they all tell me I'm the love of their lives! I give it up. I can't explain it. I'm fat, ugly, promiscuous and indifferent. What do you make of it?'

There was a point at which, in the planning of these studies, I decided to omit Nevinson, so little sympathy was I able to feel with the greater part of his work and so persistent my distaste for writing about that which I cannot admire. The longer I reflected, however, the clearer it became that even if the later years of his life were of little outstanding merit, the two first years or so of the First World War were years passed in a theatre of action so magnificent, apprehended with such an intensity of feeling and expressed with a power so worthy of the feeling which it conveyed that they were able to produce as many paintings of outstanding merit as other subjects of these studies produced in their entire lives. I look back with shame at the moment when I considered passing over the painter not only of *La Patrie, La Mitrailleuse, Column on the March*, but of *On the Road to Ypres* (1915), *A Dawn, 1914* (1916), *After a Push* (1916), of *From an Office Window* (1917), a group of figures in landscape, which manifest a sense of colour less conspicuous later on, such as *A Thames Regatta*, of two admirable *Self-Portraits* (1911, 1915), and a memorable view, *Barges on the Thames* (c. 1916).

EDWARD WADSWORTH
1889 – 1949

In 1914 the name of Edward Wadsworth – a young painter who had left the Slade only two years before – was flung truculently in the face of the public. *Vital English Art. Futurist Manifesto*, signed 'F. T. Marinetti, Italian Futurist Movement (Milan), C. R. W. Nevinson, Art Rebel Centre, London' concluded with the following appeal: 'So we call upon the English public to support, defend and glorify the genius of the great Futurist painters or pioneers and advance-forces of vital English Art.' To it were appended, in bold black type, the names of the nine artists in whom these 'advance forces' were personified. One of these was Wadsworth's. (The others were Atkinson, Bomberg, Epstein, Etchells, Hamilton, Nevinson, Roberts and Wyndham Lewis.)

Wadsworth's membership of the Vorticist group and his contributions to *Blast* and to the Vorticist Exhibition confirmed the impression of him as a member of the extreme advance guard in general and a disciple of Wyndham Lewis in particular. His paintings for the most part were essays, competent but undistinguished, in the Cubism that based itself upon the more formal aspects of the work of Cézanne – paintings of a kind and quality common in Paris and among all those groups outside France which looked to Paris for leadership. His drawings, especially the dynamic abstracts which were the most characteristic part of his production, closely resembled Lewis's. These drawings, as is often the case with manifestations of a new movement, are marked by an energy, in spite of his discipleship of the movement's leader, that was lacking in his academic studies in the manner of Cézanne's followers. The close resemblance between the work of Wadsworth and Lewis did not deceive at least one observer. To Ezra Pound, friend and advocate of the Vorticists, it was apparent that Wadsworth and Lewis were different kinds of men. From a distance of more than forty years and with the knowledge of their later work this is clear enough, but it took some wit to perceive it then. In 'Edward Wadsworth, Vorticist' in *The Egoist* of 15 August, 1914, Pound admirably drew this radical distinction between them:

> Mr Lewis is restless, turbulent, intelligent, bound to make himself felt. If he had not been a vorticist painter he would have been a vorticist

something else. He is a man full of sudden, illuminating antipathies . . .
a mind always full of thought, subtle, swift-moving.

A man with this kind of intelligence is bound always to be crashing
and opposing and breaking. You cannot be as intelligent in that sort of
way, without being prey to the furies.

If, on the other hand, Mr Wadsworth had not been a vorticist painter
he would have been some other kind of painter. Being a good painter,
born in England in such and such a year of our era, the time, the forces
of nature, made him a vorticist. It is as hard to conceive Mr Wadsworth
expressing himself in any other medium save paint as it is to conceive
Mr Lewis remaining unexpressed. . . . One's differentiation of [their
work] arranges itself almost as a series of antitheses. Turbulent energy:
repose. Anger: placidity.

It is natural that Mr Lewis should give us pictures of intelligence
gnashing teeth with stupidity . . . and that he should stop design and
burst into scathing criticism. . . .

I cannot recall any painting of Mr Wadsworth's where he seems to be
angry. There is a delight in mechanical beauty, a delight in the beauty
of ships, or of crocuses, or a delight in pure form. He liked this, that or
the other, and so he sat down to paint it.

This prescient appreciation, published when Wadsworth was
twenty-five, and, for less acute observers, a mute disciple of Lewis,
insists upon the important fact that Wadsworth was, before every-
thing else, a painter. It suggests that the particular form which his
painting assumed was largely a consequence of the intellectual and
emotional climate of the time and place in which he was born, and
that he chose his subjects because he happened to like them. In the
course of his contrasting sketches Pound has given an indication of
the kind of artist Wadsworth was.

Edward Alexander Wadsworth was born on 29 October, 1889, at
Highfield, Cleckheaton, in the West Riding of Yorkshire, the only
child of Fred Wadsworth and his first wife Hannah Smith. Fred
Wadsworth was the second son of Elmyas Wadsworth, who estab-
lished Broomfield Mills, an important worsted spinning concern
which bore his name. A tribute to Fred Wadsworth by the Minister
of the Westgate Congregational Church with which he was associated
for many years in several capacities, among others as voluntary
organist, records that 'his mind was of the critical and analytic type'.
It is significant that among the artist's immediate forebears we find
energy, and inventiveness, love of music and an analytic cast of mind.

Edward Wadsworth was sent to a preparatory school at Ilkley, to
Fettes College, Edinburgh, and to Munich to perfect his knowledge
of German. In his spare time he attended the Knirr Art School; for the
idea that he must become an artist and not a worsted spinner had
already taken a firm hold. He had already made the decision to

become a painter. This decision became an issue with his family, who eventually, dourly but without resentment, gave way. Wadsworth spent a few months at the Bradford School of Art where he won a scholarship to the Slade, studying there from 1908 until 1912. It was not long before the steady application and efficiency which marked all his activities justified his decision to be an artist. In 1911 he was awarded first prize for figure painting at the Slade, and he painted a *Self-portrait* with a turban – an excellently characterized representation of his own sardonic face, with its bushy and low-set eyebrows and its wide mouth habitually compressed. The taut, purposeful, rather ruthless face suggests that Wadsworth was already a man dedicated to his vocation. The portrait has often been reproduced, but I doubt whether it is generally realized that it is a portrait of the artist at twenty-two.

During his last year at the Slade and the following year, Wadsworth painted, besides the conventional post-Cézanne studies mentioned earlier, pictures in the manner of the Camden Town Group, such as *Portrait of Mrs Harold Gilman* (1912), and at least one in the manner of the Fauves, a beach-scene made at Havre in 1911.

In 1912 he married Fanny Eveleigh, a violinist. After their marriage they spent six months abroad, going first to Madeira and Las Palmas, where he painted a number of panels, none of which appear to be extant, and later to Paris where he worked daily on landscape subjects on the city's outskirts, completing another series of panels which have likewise disappeared. On their return to London they established themselves over a furniture shop at 2 Gloucester Walk, Campden Hill.

It was probably in 1913 that Wadsworth made a friend who quickened his imagination and gave him an insight into its nature. Returning home after a day's work at the Omega Workshops (where he was briefly employed, among other tasks, upon the repair of the Mantegna cartoons at Hampton Court) he said to his wife, 'I've met an interesting man; he's coming to see us.' A few days later Wyndham Lewis called. His new friend's burning preoccupation with art politics (indeed, with politics of every kind) drew Wadsworth into the Vorticist movement and its various manifestations. He contributed not only to the Vorticist Exhibition and to *Blast*, but also to Group X which represented a post-war effort to revive it. Their close association continued until 1920; thereafter the intervals between their meetings grew longer.

In spite of his refusal to become an engineer, Wadsworth had a life-long passion for machinery, and with this passion went a love of hard textures and powerful, streamlined forms. This and a frank enjoyment of the dynamic manifestations of contemporary life evoked

in him a sympathy with the Futurist movement. Thus predisposed, it was easy for Lewis to persuade him to share his own violent, but nevertheless more mature and rational, attitude towards the arts, and his contempt for 'the fuss and hysterics of the Futurists'. To his association with Lewis, Wadsworth owed the rudiments of a philosophy, which by justifying strengthened his own innate predilections, and a bracing intellectual companionship.

Without this association he might have been tempted to adopt styles and subjects imperfectly suited to his innermost needs. For a time he became a disciple: many of his drawings were tidier but less dynamic versions of his master's. Such drawings, however, were so competent and assured that he came to be regarded, next to Lewis, as the representative Vorticist. To Pound the truth was plain: Wadsworth owed his Vorticism to accidents of time and place, but he was quintessentially a painter. And in being a painter in this special sense he resembles Steer. Their paintings, of course, could hardly be more different: Steer's are atmospheric and suffused with a generous and languid poetry; Wadsworth's are metallic and sharply exact. But both men, although in their different ways intelligent, neither felt nor reasoned deeply about anything but painting. It is a commonplace that however purely aesthetic a work of art may be it expresses the outlook of the man who made it. Sometimes the maker is a man with very positive ideas to communicate, such as Leonardo, Michelangelo, David or Delacroix, and in our time Stanley Spencer or Wyndham Lewis; sometimes he is a man content simply to accept current ideas as motives for his pictures without being greatly concerned about their significance. If such ideas provide sufficient pretexts for the full exercise of his faculties as a painter, they are all he requires. Steer and Wadsworth are both notable examples of that class – to which, indeed, the great majority belongs – which simply takes from the repertory of current ideas such as they find to be, as Berenson would say, 'life enhancing'.

Steer added nothing of substance to what Turner, Constable and the Impressionists had already communicated: he selected certain ideas from their repertory to which he gave a slight personal touch and which he restated with a relaxed largeness, dignity and mastery of his mediums which gives him a foremost place among the English painters of his time. At first glance Wadsworth seems in this respect to belong to a quite different category. The complexity and precision of his compositions, his preference for specifically modern motifs, the streamlined, sophisticated look of his work, all suggest the presence of a vigorous, even an adventurous, intellect. But only at first glance. Closer examination shows that he took the ideas and motifs he needed to nourish his art from Chirico, Lurçat, Léger, Roy

and Lewis; like Steer, Wadsworth was a pure painter. I once asked his wife whether he had any interest in religion, philosophy or politics. 'None whatever, and least of all in the politics of art,' she answered; 'painting was his only interest, and with him discussion of other subjects came quickly back to painting.' 'It was the same,' she added, 'with his reading; he read various kinds of books in French and German as well as English, but the only books that absorbed him, that he returned to, were books on painting, and most of all, books on the technique of painting. As for Cennino Cennini's treatise, he read it again and again – he was always reading it.' Wadsworth's disinterest in everything other than painting extended to people – he was a steady friend and good company, but human relations played almost as little part in his scheme of things as figures played in his art.

The development of Vorticism was arrested by the First World War. Wadsworth's experiences of the war were reflected in his art. From 1915 until 1917 when he was invalided home, he served as an Intelligence Officer in the Royal Naval Volunteer Reserve in the eastern Mediterranean, and was stationed on the island of Mudros. On his recovery he was engaged with other painters on the dazzle-camouflage of ships at various ports. He worked mainly at Liverpool and Bristol, and he superintended the application of camouflage designs on over two thousand ships in less than a year, including the eight hundred foot *Aquitania*.

It is reasonable to suppose that these circumstances offered no new revelation but that they confirmed Wadsworth's innate way of seeing: the sight of classical civilization and the clear Mediterranean light confirmed his predilection for what was rational and lucid; the designing of camouflage confirmed his predilection for geometrical form; and the whole of it his passion for the sea.

An exhibition of his woodcuts held in 1919 at the Adelphi Gallery, London, of a variety of subjects – Greek towns and harbours, ships dazzle-camouflaged and pure abstractions – was received with serious attention unqualified by the hostility which might have been expected, considering how conspicuously Cubist they were. Indeed he received praise even in the popular press for the frankness of his Cubism: 'He has not halted between Cubism and Naturalism', observed *The Weekly Despatch*, or 'backed out of Cubism like C. R. W. Nevinson.' At no time did Wadsworth's work provoke the hostility which the work of artists belonging to extreme and uncompromising movements usually provokes. This circumstance seems to be worth noting, as it is not due to the chance disposition of critics but to the character of the work. It is the original idea which shocks and Wadsworth's art was never the expression of original ideas: his

disposition was to take the ideas he found useful from the common stock and to express them with a workmanlike perfection of finish which won the respect of spectators of varying principles and tastes. Such a meticulous finish suggests a willingness to take an infinity of pains which is apt to disarm the critic. Even the Vorticist *Suggestion for a Building*, which Wadsworth exhibited late the same year, was taken in good part although it could hardly have represented a more extravagant departure from any architectural tradition. His contributions to 'Works of Camoufleur Artists and Examples of Camouflage' in 1919 were regarded as outstanding.

In fact, Wadsworth was recognized as one of the most promising artists of his generation. Early in 1920 an event occurred which caused judges whose opinion counted for much to consider his promise abundantly fulfilled. This was the exhibition of a series of industrial landscape drawings entitled *The Black Country*. Arnold Bennett wrote the preface to the catalogue.

Wadsworth did not discover industry as a subject: earlier artists, Sir Charles Holmes, for instance, and Joseph Pennell, had stressed its general impressiveness and mystery, the picturesqueness of scaffolding and cranes seen through billowing smoke. But as a rule it had been represented romantically from afar, and by artists who knew little about it first hand. Wadsworth was not a romantic and since childhood had been familiar with industry; but for his firmness of purpose he would have been an industrialist himself.

He regarded his subject without illusions but with intimate knowledge; he regarded it as the dramatic and appropriate content for the forms he had evolved under Vorticist discipline. His imagination was stirred by the gloomy grandeur of this wilderness of slag: he came to it with those acute perceptions with which men return to scenes formerly familiar, and he came ideally prepared by his researches in abstract form to see a rhythmic order in smoking chaos. 'He is the fortunate man,' said one critic, 'who first made a map of the country he intended to find and then went out and found it.' These were remarkable drawings, remarkable both for the hard logic of their design and for the immediacy and sureness with which the vastness and the blighted gloom of the region, the overwhelming energy and scale of the whole industrial process, had been seized: the blast furnaces and the great flames they send upwards, the tides of lava and the endless mountains of slag, the indisposable waste. It was among the blast furnaces, Lewis considered, that the true Wadsworth was to be found. It is my own belief, too, that he made nothing finer than *The Black Country*.

It is strange that, having occupied himself with a subject to which his earlier experience had ideally attuned him, and made what he

must have known were pictures of outstanding quality, Wadsworth should have failed to continue to work in this vein, but instead have faltered and turned away. I can offer only a tentative explanation. *The Black Country* drawings were made in 1919. During 1920 and 1921 he made several paintings of industrial subjects which showed few of the qualities of *The Black Country*, and were no more than elaborate essays in the conventional Cubist manner. Gradually, first rural and then Mediterranean replaced industrial subjects, but not, I think, to the pictures' advantage. My explanation turns upon the death of Wadsworth's father, which took place at the beginning of 1921, before Wadsworth had found the means of perfecting his large industrial subjects. One consequence was that he inherited a considerable fortune, which enabled him to gratify his passion for the sea in general and the Mediterranean in particular. Subsequently he spent little time in the Midlands and the North of England, and much in Italy and the south of France. It seems to me, then, that in the early 1920s, Wadsworth lost his way. I am fortified in this opinion by the knowledge that the artist destroyed a substantial number of these Cubist essays, including industrial, rural and Mediterranean subjects.

It was not long, however, before his passion for the sea gave his development a new impetus and a new direction. Around 1922 he abandoned oil paint for tempera, a medium well-suited to those who desire clarity above all else and who are indifferent both to atmosphere and to the 'painterly' effects that can be obtained only with oil-based pigments. The new medium, especially when employed to make pictures of his chosen subject, the sea, produced bracing effects. It should be mentioned that, in spite of Wadsworth's maritime obsession, he was not in the ordinary sense a painter of the sea at all. A painter beside the sea, not of it, was what one writer called him, and this is just what he was: a painter of harbours, ships, jetties, shells, marine instruments and the like, but of the sea itself only as a background or in a subordinate place, and always dead calm.

Inspired by Turner's *The Harbours of England*, Wadsworth embarked upon a series of paintings of Britain's principal ports, but I have been unable to ascertain how far he carried it. During 1923 he painted *Seaport* and some other port subjects in which his efforts to build up complex yet closely knit compositions that should convey an effect of stability are too obvious and fail in their effect. But at the end of that year and again in 1924 he visited Dunkirk, where his earlier efforts reaped a rich and sudden reward. The result of these visits was a small group of paintings of sailing ships in port of extraordinary quality. The finest of these, *Dunkerque* (1924) shows him as a composer of exceptional resource and an impeccable craftsman in an academic style of commanding elegance.

On a number of occasions when I was Director of the Tate, the Gallery came under criticism because of alleged preoccupation with 'advanced' art to the exclusion of the academic, and when the first volume of these studies appeared the absence of certain academic painters was noted. The truth is that in this century of perpetual change the larger number of the finest talents tend to be drawn into one or other of the 'advanced' movements, so that worthy examples of academic art are very far from commonly met. But in Wadsworth's Dunkirk pictures the classical tradition lives again in all its limpid harmony.

Yet meditation upon the success of these attempts to represent the thing before the eyes in terms of an entirely classical beauty serves, it seems to me, to make one more rather than less conscious of how unfavourable the climate of the twentieth century is to traditional painting, and how positively it seems to foster change. For in the Dunkirk series we have a painter able to combine exact representation of a subject to which he responded with passion, with conformity to the severest canons of traditional design, yet free of the complacent touch which often vitiates so many academic works, and marked, indeed, with an astringent contemporary tang; yet nothing could be plainer than that this particular combination of virtues gave the painter only the most transient satisfaction. It is difficult to estimate precisely how extensive the series originally was, as one at least, and possibly more, was destroyed by the painter, but it can scarcely have extended to more than half a dozen. There was no question of his taking the series as a basis for a traditional style: as a man very much 'of his time' he was under a compulsion to press forward. It is my belief that until so many of the best artists cease to be subject to such a compulsion and become less liable to suffer, as so many do, from a sense of failure, of guilt even, unless they are forever on the move, painting cannot recover the perfection that results only from repeated attempts to attain the same objective. An objective in rapid and continuous movement may evoke an inventive, audacious, exciting art, but not one in any proper sense of the term 'classical'.

From the Dunkirk series, Wadsworth promptly moved on: first to scenes of ships in harbour of a more generalized character, upon which, to their seeming discomfort, a pattern was somewhat arbitrarily imposed. Wadsworth's interest in ships culminated in 1926 in the publication of a book, *Sailing Ships and Barges of the Western Mediterranean and Adriatic Seas*, for which he made copper engravings afterwards coloured by hand. It is a book of interest and beauty, the aim of which was primarily to serve as a fittingly exquisite record of a disappearing means of transport. The making of these engravings

fulfilled his need to represent ships, for after 1926, although his passion for the sea remained, ships figure rarely in his work.

About the same time another subject engaged his interest – a very 'period' one – the architecture, and to a limited extent the life, especially the seamy side, of southern France. This interest issued in drawings and occasional paintings of streets in Marseilles, Toulon and other ports, narrow streets of ancient fantastically intricate buildings, enlivened with festoons of washing or by flamboyant signs advertising sailors' bordels. A characteristic example is *Marseilles* (1925), a lively picture, but neither the subject nor the spirit in which it is represented is particularly Wadsworth's. The treatment of the architecture is slight and similar to that of others, to that of his friend Richard Wyndham for example, and the evocation of the life of a sailors' bistro and bordel altogether lacks the sinister insight of their younger contemporary Edward Burra.

Both formalized shipping-in-harbour (glimpsed sometimes through parted curtains) and narrow street were trivial deviations, for it was about the time when he was engaged upon such themes that Wadsworth gained a deeper insight into what he wanted to accomplish: he began the long series of still-lifes of a highly personal kind upon which he was principally engaged for the rest of his life, and which, in fact, must be regarded as his most characteristic works.

At first glance these still-lifes might be taken for examples of the kind of fantastic painting which the Surrealist movement was inspiring, but closer scrutiny reveals its personal character. Wadsworth learnt from Surrealism the practice of placing together objects which have no congruity with one another, but the element of fantasy ends with the choice of objects: his representation of them is as precise as that of a highly skilled craftsman. Not for him watches hanging limply over clotheslines; his shells, hurricane-lamps, sextants, floats, chains, coils of twine, blueprints, binoculars, propellers and other marine objects, as well as occasional ribbons, masks and flowers, are never placed in positions which, in the world of reality, they would be unable to sustain; all conform to laws of construction, gravitation and perspective; all are laid upon foundations which will bear their weight, and all are capable of function. (Even the liberties he seems to take with the scale of objects – with sea-shells, for instance, which sometimes loom enormous in his foregrounds – may be only apparent, for he is known to have collected the largest Mediterranean shells.) For the most part these assemblies of sharply incongruous objects are law-abiding citizens of a scheme of things which closely corresponds to the natural. More closely, in one important respect, to Mediterranean than to northern nature, for they are placed in a setting where the atmosphere has no density or

movement and where everything is without movement and bathed in a merciless white light. These still-lifes are the culmination of Wadsworth's steady, consistent, evolution, the final expressions of his lucid, logical and supremely unequivocal mind. One excellent example out of many is *Little Western Flower* (1928).

Law-abiding as these pictures are, they are none the less expressions of a personality. How definitely was shown by an experiment. Certain visitors to an exhibition of Wadsworth's tempera paintings held in 1929 criticized his method as 'excessively photographic'. Doubtful whether this criticism was well-founded, and eager, moreover, to demonstrate the camera's powers, two gifted photographers, Maurice Beck and Miss McGregor set up a number of still-lifes closely resembling those of Wadsworth, of which they made photographs. Three of these were reproduced in *The Graphic* magazine beside three photographs of still-life paintings by Wadsworth. The confrontation clarifies the contrast between painting and photography, and reveals once again how superior is the power of the painter, by a hundred delicate touches, to emphasize certain forms and certain contrasts and affinities, to mute others in a way that is not open to a photographer, who has the power only to select, even when, as in the present instance, he also arranged the subject. The painter's superior power of communication is particularly well-illustrated by this particular confrontation, because Wadsworth's method of tempera painting is one that reveals no brushstrokes, which for most painters are the instrument whereby accents – highlights, for instance, or contours distinguishing forms that merge in nature and the like – are emphasized.

Towards the end of the 1920s Wadsworth's interest in pure still-life waned: it shows itself subsequently most often in the foregrounds of his harbours, beaches or distant prospects of the sea. This change was followed by another, a change not of vision but of method. Around 1938 the sharply defined contours and the enamel-like quality of his colour were radically modified by the influence of Seurat: it was as though Wadsworth's earlier paintings – for the compositions altered little – were seen through a fine mesh, which at once lightened and broke their surfaces. Pictures painted in dots reflect, it seems to me, the particular character of Wadsworth's mind less immediately than those painted with sharp outlines in surfaces of clear, continuous colour. A few of the pictures, painted according to a method close to Seurat's, however, take a high place among his works, notably *Requiescat* (1940). Although Wadsworth was liable to use the Seurat method from time to time for the rest of his life, it was rarely manifest after the early 1940s in quite such forthright terms as in, for instance, *Ouistreham, Caen* (1939), which is nothing more than

an accomplished Seurat schoolpiece. I think he had reservations of
some kind about this method, and this opinion is strengthened by a
note he made beneath a photograph of a painting entitled *Harbour
Entrance* (1939), 'Repainted 1944 and spots obliterated.' In a number
of works of the 1940s the size of the dots is diminished to restore the
primacy of the sharply defined contour, for instance the two versions
of *Bronze Ballet* (1940).

My attempt to give an indication of the character and growth of
Wadsworth as a still-life painter has led me to leave behind an
important development in his art, of which his still-lifes formed the
point of departure during the late 1920s, namely his participation in
the abstract movement. There was not, I think, at work in Wadsworth
that strong innate tendency towards abstraction found in, say,
Mondrian or Ben Nicholson, but there were other reasons which
made him sympathetic to its appeal. Like the Futurists, who had
made so stimulating a din at a time when he was highly susceptible
to what was going on around him, sentimentally, as already noted,
Wadsworth was very much 'of his time', responsive to the beauty of
machinery, in particular to the big fast cars he owned, and even had
specially built. At the same susceptible age, abstract art, in the guise
of Vorticism, was demonstrated by Wyndham Lewis to be both a
powerful and an intellectually valid means of expression. When the
full force of the abstract movement struck England in the 1930s
Wadsworth was well-prepared to yield to its impact, which may be
seen in the most graphic terms in certain of his 1929 and 1930 still-
lifes. Reference was made a few pages back to the strict conformity of
Wadsworth's still-lifes to the laws of gravity and perspective. In the
still-lifes of 1929 and 1930, however, it is as though the natural laws,
especially the law of gravitation, were suspended, and a process of
disintegration had set in. A characteristic example of this kind of
still-life in which the objects represented, released from the law of
gravitation, whirl about in the void, is *Composition*. This anarchic
phase was temporary; before long 'objects' tended to disappear, to
merge into or be replaced by abstract forms, subject not to the laws of
nature but to those of pure design.

Wadsworth's abstracts, an important feature of his work of the
early 1930s, show the same meticulous workmanship and the same
power of making statements that are perfectly lucid and unequivocal
as all his paintings. I have never known a painter demand of himself
so exacting a standard of technical perfection or any to destroy so
many of his works in the belief that they fell below it. Among the
many were a number – to judge from photographs and recollection
– of the finest of these taut, energetic abstracts of the 1930s. One of
these, a near abstract, impinged suddenly upon public attention, and

became the focus of an incident which had international repercussions. In the autumn of 1938 Wadsworth was commissioned by the London Passenger Transport Board to design a poster for the Lord Mayor's Show. The procession was predominantly a military parade that year, and the artist accordingly incorporated a machine gun and a Lewis gun into his design. Six thousand copies of the poster were displayed when, a few days before the show took place, 'Cassandra', otherwise William Connor, attacked the poster in the *Daily Mirror*. 'If we are to show the beauty of engines of war to a peaceful travelling public, why not have the guts,' he asked, 'to show the effects of these instruments? Or would pictures of bullet-riddled bodies be a trifle unseemly?' An official of the Transport Board explained that they had originally planned to have a design 'embodying a golden coach', and the offending posters were taken down – barely twelve months before an all but disarmed Britain had to fight the gigantic German military machine. The incident appears to have been used widely in the German press to show that Britain was 'too tired to fight': the Berlin *Boersen Zeitung*, for instance, carried a two-column headline 'England's recruiting need – the Government has to protect itself against Marxist demagogues.'

That year Wadsworth was much before the public. He designed and carried out two paintings for the first and cabin class smoke-rooms in the new liner *Queen Mary* which were so large – they measured about 12×8 and 9×6 feet (3¾×2½ and 2¾×2 metres) respectively – that the parish hall at Maresfield – the Sussex village where he had settled ten years earlier – was the only building in the neighbourhood which would accommodate the panels. Both were completed *in situ*. The one is without interest; the other is a fair example of one of his harbour landscapes with still-life in the foreground. During the same productive year he carried out a decoration – a large still-life of heraldic character – for the new de la Warr Pavilion at Bexhill, designed by Erich Mendelsohn and Serge Chermeyeff.

The last years of Wadsworth's life – he died in a London nursing home on 21 June, 1949 – were marked by no new developments. Although he was able, when occasion required it, to expound his aesthetic, this added nothing to doctrines current among artists working in the Cubist tradition, for he was never deeply concerned with ideas. His art therefore rarely challenged, rarely even disquieted, as art of the most original order almost invariably challenges or disquiets, and he came to be accepted more and more as an advanced painter, from contact with whom no harm would be likely to result. His paintings – the verisimilitude of them, in fact – were the subject of jokes in *Punch* ('few can deny that to the sextant-lover Mr

Wadsworth's excellent painting is second only to the real thing', and so forth) and other journals and in 1944, without ever having submitted a painting to a Summer Exhibition, he was elected an Associate of the Royal Academy.

My own impression of the later Wadsworth – I neither knew him intimately nor saw him often but it is an impression that persists – is of a man whose earlier interest in ideas, never a particularly lively one, had dwindled almost away, and of a man preoccupied with the technicalities of his art to the exclusion of almost everything else. Of the many works which he destroyed, I understand that in the great majority the faults he found were not in the conception or realization but in the technique, in the narrowest sense. How otherwise account for his destruction of one of the finest of the Dunkirk series, of the abstracts, of *Still Death* (1937), a memorable still-life with a skull? It seems to me that his horror of being survived by a piece of defective workmanship became at times almost obsessive.

This horror, however, was but one manifestation of this most scrupulous of painters horror of all imperfection in his own work. His concern at the discovery that the Tate possessed a still-life picture which he considered unworthy is expressed in some correspondence which passed between us in the autumn of 1942.

> By the way, what is the *Still Life* by me to which you refer? I believe the Contemporary Art Society presented a painting of mine to the Tate a little time ago and this is no doubt the one. But what is it? I am very much afraid that it is a little picture of a couple of shells and a bit of blue ribbon which turned up at a show at the Leicester Galleries a few years ago – covered with what I can only think was Coach-Milvers' varnish and looking *dreadful*. If it *is* that one it ought not to be in the Tate at all. It was entirely experimental – painted on cardboard (of all poor things). What the experiment was I forget now – possibly something to do with demonstrating Tempera methods to Pierre Roy. In any case it is annoying and humiliating to be represented in our foremost modern National collection by a work that, in my opinion, has no merits at all. If *I* were in your position, in charge of the Tate, I should secretly destroy it – and with great enthusiasm! In these days of fuel economy it is only fit to contribute to the central-heating of the Tate! I suppose it would be out of the question to swap it for another painting.

It was eventually decided that the Tate should retain the *Still Life*, on the understanding that if deterioration became apparent it should be returned to the artist for treatment, while accepting as a gift *Bronze Ballet*, the picture for which he originally proposed to exchange it. In another letter in which he recognized this arrangement as 'in the long run, fairest to all concerned', he added these illuminating details about *Bronze Ballet*:

It is painted with yolk of egg (and powder colour) on a gessoed panel and was painted in April and May 1940 at Maresfield, Sussex – to the somewhat noisy accompaniment, as far as I remember, of the bombardment of Abbeville, Boulogne and Calais – all mingled with the call of the cuckoo! It is one of a series of many paintings done as a Le Havre series. It is in no sense a topographical view of any particular scene but all the motifs or design elements are to be found in that port and the two jetties 'place' it more or less.

There was a close-knit, all-of-a-piece consistency about Wadsworth: he was efficient, industrious, and, in spite of the readiness with which the thin-lipped smile came to the bronzed saturnine face, and in spite of his powers of enjoyment of things, there was something a little inhuman about him – yet this was, perhaps, a characteristic not unfitting this oddly rare being, a true poet of the age of the machines.

DAVID BOMBERG
1890 – 1957

During his life David Bomberg was the most neglected major British artist of his time. While he evoked the ardent admiration of a number of his fellow painters, of students who had the privilege of being taught by him, and of several friends who provided him with invaluable help in times of need – which were frequent – he never achieved the recognition merited by his work from the earliest years.

David Bomberg was born on 5 December, 1890 in Birmingham, the fifth of eleven children of Abraham Bomberg and his wife Rebecca, born Klein. Abraham Bomberg and his wife emigrated from Poland in the early 1880s, where his parents managed an inn near the Russian border. He was a leather-worker and a saddle-maker and around 1900 he worked for the outfitters Finnigans and Aspreys in Bond Street. On their arrival in England he and his wife settled in Whitechapel but the growth of their family meant several moves in search of work – to Wales, Birmingham and elsewhere – but they returned to London in 1885, settling eventually in 20 Tenter Buildings, St Mark's Street, Whitechapel. The Bombergs were Orthodox Jews and so their children went to the Jewish Free School, except David, who went to the Castle Street School. Rebecca took charge of the family, for her husband, although he remained an able craftsman, drank and gambled heavily and was liable to frequent outbreaks of aggressiveness.

David Bomberg showed his talent as a draughtsman at an early age and expressed a desire to become an artist by profession – a desire fostered by frequent visits to the British and the Victoria and Albert Museums. It was decided that he should become an apprentice in chromolithography at the Islington shop of Paul Fischer, which he did in 1906 or 1907; he also continued to visit museums and to make copies of works that he particularly admired. David's mother showed the utmost sympathy for his aspiration, setting aside a room in their flat for him to work in and bringing his meals to enable him to continue without interruption, and she and his brother and sisters would pose for him. Even before becoming an apprentice, in 1905 Bomberg attended night classes at The City and Guilds School under Walter Bayes.

Bomberg's exceptional promise as an artist and his intelligence evoked interest early on. While one day drawing at the Victoria and Albert Museum, he attracted the notice of Sargent, who invited him on several occasions in 1907 to visit his studio and introduced him to people whom he thought might prove helpful.

Determined to become an artist without further delay, in 1908 Bomberg broke his apprenticeship with Fischer, and for two years attended evening classes under Sickert at the Westminster School of Art, and on alternate evenings under W. R. Lethaby on book production and lithography at the Central School. Solomon J. Solomon, whom he met through Sargent, introduced Bomberg to Fred Brown, head of the Slade, who advised him to continue his studies before applying for a place in the School. (In Bomberg's voluminous writings – autobiographical, political and art educational – there is an account of how his meeting with Brown ended with a discussion of Berenson's theories about tactile values in painting.)

In 1911 Bomberg's application for entry into the Slade was accepted. The two years he spent there proved invaluable: he benefited from the teaching, in particular that of Tonks, but also of Steer, Lees and McEvoy. Bomberg also attended Fry's lectures, and met, or came to know, fellow students of an outstanding generation, which included Wadsworth, Stanley Spencer and Nevinson.

While at the Slade Bomberg suffered a grievous loss: his mother, who had rendered such invaluable help in realizing his aspiration to become an artist, died on 2 October, 1912, aged only forty-eight.

A drawing he made in 1913 of a fellow student, Isaac Rosenberg, entitled *Head of a Poet*, won him the Tonks Prize that year. It is an outstanding work, fine in execution and a penetrating likeness. Far more memorable are two paintings completed in 1914: *In the Hold* and *The Mud Bath*.

Those who knew Bomberg at the time when *The Mud Bath* was painted realized that it was not abstract in that its subject was Schevziks' Steam Baths in Brick Lane, Whitechapel. I doubt, however, whether anyone who did not know of Schevziks' would regard the picture as anything other than an abstract. It in fact represents a rectangular bath and the blue and white angular forms are bathing figures. *In the Hold*, however, is based on men working in the hold of a ship; Bomberg used to draw by the docks near Whitechapel. Both are masterly and the finest of all his works: the one – a major masterpiece – of a subtle simplicity, the other – a memorable work – of an extreme but superbly organized complexity. So many abstract works are seen and forgotten, but it is impossible to forget either of these two. And what astonishing works they are for an artist of twenty-four! They did not, however, stand by themselves. *Interior*

(1912) anticipates *The Mud Bath* as does *Ju Jitsu* (1913). These and other notable works briefly evoked immense admiration, but they remained unsold, were soon forgotten, rolled up, and for twenty-six years stored in a garage. Not until 1958 were they recovered.

During 1912 to 1914 Bomberg made a number of other paintings of note, including *Vision of Ezekiel* (1912), an angular, somewhat Cubist work. These two years were of an astonishing productivity, and included admirable realistic drawings and the impressive angular 'Cubistic' works; but they are not Cubist. Bomberg, of course, was well aware of the Cubist movement, knowing Wyndham Lewis and other British artists temporarily affected by it, and while on a brief visit to Paris in 1913, meeting Picasso and Derain. Without having seen Cubist works, Bomberg could not have made the works referred to, but he was never a Cubist or, indeed, a participant in any movement.

Bomberg, whose work later in life was to suffer frequent neglect, received enthusiastic recognition in 1914, although his sales were few. His first exhibition of fifty-five works was held in July of that year at the Chenil Gallery, Chelsea – a rare distinction for an artist of twenty-two. *The Mud Bath* was hung outside the gallery on the wall of the building, rained upon, baked by the sun and garlanded with flags. Bomberg was afterwards amused to recall 'how the horses drawing bus 29 used to shy at it as they came round the corner of the King's Road.'

In the Hold had already been shown at the first London Group exhibition in March, one of his five exhibits there. They were treated with particular interest in reviews by Fry, T. E. Hulme – to whose encouragement and praise he owed much – and several other influential critics. Among notable visitors were Augustus John, who was instrumental in the sale of two pictures to John Quinn, the New York collector.

Early in his life Bomberg became a fluent and frequent, although rarely published, writer. For the catalogue of the Chenil exhibition he wrote a foreword:

> I appeal to a *Sense of Form*. In some of the work I show in the first room, I completely abandon *Naturalism* and *Tradition*. I am *searching for an Intenser* expression. In other work in this room, where I use Naturalistic Form, I have *stripped it of all* irrelevant matter . . . I look upon *Nature*, while I live in a *steel city*. Where decoration happens, it is accidental. My object is the *construction of Pure Form*. I reject everything in painting that is not Pure Form. I hate the colours of the East, the Modern Mediaevalist, and the Fat Man of the Renaissance.

Besides his one-man exhibition at the Chenil, Bomberg had also shown with 'Camden Town and Others' at the Brighton Art Gallery

in 1913, with the Friday Club in 1914, and with the London Group, of which he was a founder member. He was widely praised, notably by Wyndham Lewis in *The Egoist* for his work with 'Camden Town and Others', and by John Rodker in *The Dial Monthly* for his *In The Hold* with the London Group.

Bomberg always firmly adhered to the strict principle by which he was guided, declining, for instance, the invitation by Wyndham Lewis to reproduce his works in *Blast*, and by avoiding association with 'movements'.

During the rest of his life as an artist Bomberg painted outstanding works, but never again did he enjoy the success of the two years immediately preceding the war, success not only as an artist but as a personality of exceptional intelligence and diverse activities. Many painters and writers used to visit him at Tenter Buildings, among them Wyndham Lewis, Mark Gertler and John Rodker.

This period of impressive activity, so powerful, so original, so prolific, made by this student who had only just left the Slade, was brought to a sudden end by the outbreak of the war. Bomberg promptly attempted, unsuccessfully, to enlist, but it was not until 1915 that he joined the Royal Engineers, shortly afterwards transferring to the King's Royal Rifles as a sapper. In March 1916 he married Alice Mayes; in June the following year he was sent to the front.

A number of painters derived inspiration from the war, but Bomberg was so deeply shocked by what he experienced that he could neither draw nor paint. His brother was killed in action, as were Hulme, to whose friendship and support he owed so much, and Gaudier-Brzeska whom he liked and admired. He did, however, write prose poems, such as this quotation from 'Winter Night', arbitrarily selected:

> Assassins! Figurates waiting in
> the wings! Hidden guns. And guns
> there are you cannot hear at all,
> – flashing in fast rotation –
> fantastically. Dangling behind a
> grey glass screen; jerky marionettes,
> snow-clad. Dancing a comic jig on a
> straight edge, the battle ridge.
>
> Tonight the enemy has bared both arms
> and with soft silver-shaded finger-tips
> searches in and out convulsively the
> sky for fish – our aircraft! He closes
> his hands, and, right arm motionless,
> presses one filmy finger – a single
> ray – a disc of ringed light, wickedly
> on the swollen cloud. Then slightly moves

him round its puffy edges, pattering
patiently. Stops alarmed! Out go two
hands in fright – clenching in nervous
tension – nothing.

Baffled, he blindly swings his arm
above his head – sweeping frantically
– but, by degrees subsides; while the
little flaming pellets drift up from
the leas, – silent – stringed pearls!
While the gleaming rockets drop into
our lines.
September 1918

Lilian, his second wife, wrote:

I cannot imagine David fitting in easily to the soldier pattern routine;
yet his dogged insistence on the job in hand, his trained sensitivity,
his map-drawing and his willingness to volunteer for the hot-spots –
he had a theory which he confirmed to me in the London Blitz that the
target is always the safest place . . . He worked merrily with a mate out
on No-Man's-Land sound ranging . . . On one occasion in the trenches
during a period of snatched rest, David took a sound-ranging instru-
ment from his trouser's pocket keeping his finger on the press-button.
At this time the whole command were desperately trying to locate Big
Bertha. David's ears were attuned to the guns like an orchestra so that
in his sleep when the deeper vibrations occurred, he just pressed the
button and continued to press. Along the line came the field phone:
'Who is pressing the *** button? We are getting yards and yards of
*** gun.' They traced him and woke him up.

In December 1917 Bomberg applied to the Canadian War Records
Office in London for transfer to a Canadian regiment stationed at
Passchendaele in order to make a painting for the Canadian War
Memorials Fund. In their reply the Canadian War Records asked him
whether he would be prepared to do so at his own risk, for the
committee's Art Advisor, P. G. Konody, was not acquainted with
Bomberg's realistic work and felt that a cubist work would be
inadmissible. The first two studies Bomberg submitted were never-
theless conspicuously cubist. Whether he carried out a full-sized
version based on these is doubtful. He then made at least two other
studies for the finally accepted painting, completed in 1919: *Sappers
at Work: A Canadian Tunnelling Company*.

The painting is the most austerely realistic Bomberg I have ever
seen. Had he painted more pictures marked by such searching realism
he would surely have been compelled to become an academician. I
write this without the faintest touch of irony; he would not have
been an all too commonplace realist, but one such as Orpen. *Sappers
at Work* is a realistic masterpiece – and the only major official

commission he ever received. It offers an amusing contrast to the two austerely 'cubist' preliminary studies.

The first works he made in 1919, while the Canadian painting was being completed, were a series of pen-and-wash drawings still of a 'cubist' character; to quote Bomberg:

> ... done in twelve parts, each part having twelve variations, each drawing was based on one of twelve patterns, the key to the whole. Each drawing had to be different; one might be groups of fishermen and nets, the other ballet scenes or a dancer. The problem: to expand the possibilities of one combination of forms into as many variations to exhaustion of possibilities without altering the juxtapositions, but slightly modifying and stressing the parts of the key. This was to prove that form plays one part, content another. Both can operate within one another, but [remain] basically unrelated.

This series – I have not seen the whole – and certain others made a little later, such as *Conclave* (1920–21) are the least notable and the dullest works of his hand I have ever seen. But in relation to his development they are significant as exemplifying a tentative realism. I do not refer in this connection to his *Sappers at Work*, for which realism was demanded and not yet, as the cubist preparatory studies clearly show, his 'natural' style. His last cubist picture was his masterly *Billet* (1915), a pen-and-ink, made in the spirit of 'farewell to Cubism for the duration'. Bomberg's attempt to secure an exhibition of the series in Paris failed.

It is characteristic that even at this time, when he was suffering relative neglect and was invited to join the Stijl group, of Leyden, that he should have declined. 'There was evidence,' he wrote in a letter of July 1953, 'that they were not sensing design as that which emanated from a sense of mass but depended more on juxtapositions of form that found their way to Leyden via the Cubists . . . This I felt could only lead to the Blank Page . . .'

An exhibition of some hundred and twenty-four of his rejected pen-and-wash studies was held in the autumn of 1919 at the Adelphi Gallery. It received high praise from Sir Herbert Read in the 13 September 1919 issue of *Arts Gazette*:

> ... in the case of Mr Bomberg there is no escape from the severe effort of appreciation that his individuality demands. He does, it is true (and it is one of his virtues), express the crystallized sense of modernity. He tends, that is to say, to place himself at a remove from actuality – not by interposing an unnecessary screen of personal sentiment but by rendering things in terms of a more precise and logical beauty . . .

These works are indeed abstract, but in comparison with *Mud Bath* or *In the Hold* they represent the beginnings of an approach to a consistent realism. About the same time Bomberg produced another

series of abstract works for an illustrated booklet commemorating the
return of the Russian Ballet: 'I lithographed seven printings and
printed myself . . .' he wrote, 'abstract drawings I had done on the
inspiration of Ballet. Certain adventurous forms were reproduced . . .'
These works are accomplished abstractions, but they hardly compare
with their prewar predecessors. Still in 1919, an astonishingly
productive year, he showed *Tragedians* at the London Group exhibi-
tion and *Barges*, besides four other works.

Bomberg's work was praised in the press, but he sold almost
nothing. What must have caused him particular distress was the
publication in 1919 by Ovid Press of reproductions of works by
Lewis, Gaudier-Brzeska and Wadsworth – but nothing by him – even
though the publisher had sought his help and advice.

In order to live more economically he and Alice moved to Alton,
Hampshire and lived on a farm, breeding turkeys and rabbits, but
without success. His doing so nevertheless exemplified Bomberg's
versatility. They left Alton the following year. Although barely able to
survive, he enjoyed a high reputation: one of his drawings, *The Exit*,
was reproduced in Wyndham Lewis's *Tyro I* in 1921, and in the same
year he lectured at Brasenose College, Oxford, on 'The Development
of Painting', and in 1922 at the Whitechapel Art Gallery on 'The
Modern Feeling in Painting'. During the early 1920s he exhibited
with the New English Art Club and the Friday Club and the London
Group.

Bomberg had by this time evolved his own technical procedure;
without making preliminary drawings, he would contemplate his
subject, sometimes for as long as an hour, then begin to paint quickly,
completing the picture in an hour or two. If dissatisfied he would let
the canvas dry and paint it over. A friend told me that she sat for him
for only two hours, in which time he completed three paintings of
her.

His one-man exhibition at Heal's Mansard Gallery was a failure,
although noticed with respect by *The Times* and some other papers.
Even his visit with his wife in 1922 to Ben and Winifred Nicholson's
villa in Lugano, Switzerland, according to Alice (in a letter to William
Lipke, quoted in his *Bomberg*):

> . . . was a complete fiasco; no work was done by David. It was bitterly
> cold. We were unprepared with warm clothing. Ben and Winnie were
> used to working out of doors, so there was no studio accommodation,
> and David was used to the comfort of a studio . . . from the start he was
> unhappy. David did not hesitate to speak of his discomfort and after
> talking it all over and sending all the grievances to . . . Winnie's mother,
> it was agreed that she should advance us our homeward fares and call
> it a day. We were only there a fortnight.

The melancholy of this time was relieved by his meeting in 1923 with Lilian Holt, whom he invited to a dinner-party and shortly afterwards to his exhibition at Heal's. They met on several other occasions. Not long afterwards she married Jacob Mendelson, a Russian-born art dealer, who was anxious to dissuade her from pursuing painting as a career, insisting that there was little to be earned by it. In order to confirm his opinion, and aware of his financial failure, Mendelson suggested that Bomberg should tell her that painting offered no financial security. When a meeting was arranged, Bomberg said, 'If Miss Holt is not interested in money, and is interested in painting, then I'm interested in Miss Holt.' When they met again at his exhibition at Heal's they had a long talk about her work and his.

Among those whom Bomberg consulted about the difficulties which harassed him was Muirhead Bone, who greatly admired his work. Aware of his state of mind, in particular his increasing dissatisfaction with his life in England, Bone told him that there was scarcely any buying public for work such as his, and suggested that he offer to serve as an official artist with the Zionist Organization in Palestine. There he would find fresh subjects, and among the officials there might well be some likely to show interest in his work. Bomberg responded eagerly, and immediately applied. It was in the hope of securing the necessary funds that Bomberg managed to arrange the small exhibition at Heal's already referred to. In the meantime Bone met the London director of the Zionist Organization and wrote to Bomberg saying that he felt 'very hopeful of your getting the job of being their artist in Palestine'.

The Heal's exhibition failed to bring in a sufficient sum to enable Bomberg and his wife to go to Palestine. Bone, however, had not only arranged a free passage but contributed towards his expenses. 'I cannot afford it,' he said, 'and it cripples me.' But doubts remained about Bomberg's abandonment of cubism in favour of realism, and Bone found it difficult to convince the Zionist Organization that it would be otherwise. 'It should be remembered,' Bone wrote to the director, 'that Bomberg has done with *that* and means in Palestine to do sober serious and really "record" work.' Finally, a compromise was reached: his passage was paid for in part by the Organization, but he was not attached to it in any official capacity. Accordingly, in mid-April 1923 the Bombergs embarked on a boat for Palestine.

There he remained for four years, working mainly in Jerusalem, but making expeditions to Petra, Jericho and the Wadi Kelt. Bomberg's experience in Palestine was exacting in one particular respect: Bone had drawn up an agreement between the artist and the Organization regarding the style of his work, examples of which were to be used as

illustrations for magazines, newspapers and pamphlets. Bomberg was a scrupulous man, and would in any case have adhered to the understanding; there was however, a yet more radical cause for the realistic character of the greater part of the work he made there. Only a few years earlier he had been radically abstract, and the fact that friends could discern the 'subjects' of *The Mud Bath* and *In The Hold* does not diminish their basically abstract character. So, too, were his studies for his rejected *Sappers*, made barely five years before his departure for Palestine. Even his brilliantly realistic *Barges* (1919) is also basically 'cubist'. A painting of a similar subject, made in 1921, is one of the first to have the appearance of being painted from nature. Therefore, although an artist of outstanding talent, as a 'realist' Bomberg was hardly more than a beginner, and this after four or five uncertain years. In addition, there was his sheer fascination by parts of the landscape – both rural and urban – of Palestine. He accordingly painted and drew with a particularly rigorous self-discipline: he was training himself as a 'realist'. Sir Ronald Storrs, then governor of Palestine, befriended him and bought several of his paintings. In the introduction to the catalogue of Bomberg's exhibition, 'Paintings of Palestine and Petra', at the Leicester Galleries in 1928 Storrs wrote: 'When I was in Jerusalem Bomberg was deprecated by some local talents' anaemic techniques and relaxed apprehensions as being exact and topographical. His work is indeed both and much more . . . and these things are Jerusalem . . .' Even the titles of these realistic works are precise. There was, however, an absence of one feature – with a few exceptions – the human figure.

During his first nine months, Bomberg worked in or near Jerusalem, but early in 1924 Storrs suggested that he visit Petra, 'The red rose city, half as old as time', in northern Arabia. Being geographically inaccessible and an Arab city, his visits were difficult undertakings, and would not have been possible without the help of Storrs, who financed them and provided him with escorts through hostile country. Accompanied by his wife, his first visit was brief, but they returned a few months later and remained for six months. These were memorable visits, about which Bomberg wrote an account, 'The Petra Essay', which he once used as the text for a lecture. In Petra, not being part of Palestine, he was not restricted by his agreement with the Zionist Organization, and was accordingly able to express himself as freely as he wished, producing such notable works as *Steps to a High Place on al Kubra, Petra; Early morning, The Urn Temple, Petra* and *The Outer Square, Petra*, all of 1924 and marked by rich colours, freely applied. Momentarily exhilarated by having produced them, he sent one of his Palestine paintings to the New English Art Club in 1926,

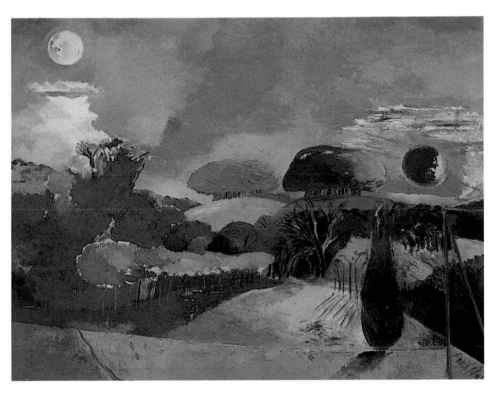

1. PAUL NASH: *Landscape of the Vernal Equinox* (1943).
Oil, 28 × 36 in (71·1 × 95 cm). Reproduced by gracious permission of
Her Majesty Queen Elizabeth the Queen Mother.

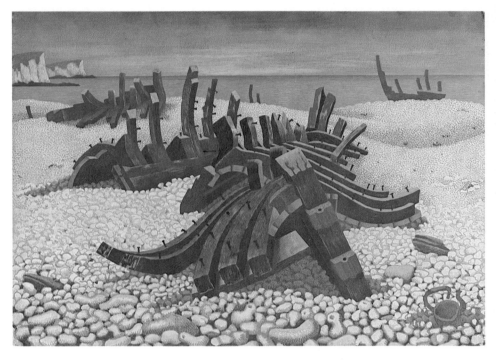

2. EDWARD WADSWORTH: *Requiescat* (1940).
Tempera on panel, 25 × 34 in (63·5 × 86·3 cm). Leeds City Art Gallery.

3. DAVID BOMBERG: *Castle Ruins, St Hilarion, Cyprus* (1948).
Oil, 39 × 40 in (99 × 101·6 cm). The Walker Art Gallery, Liverpool.

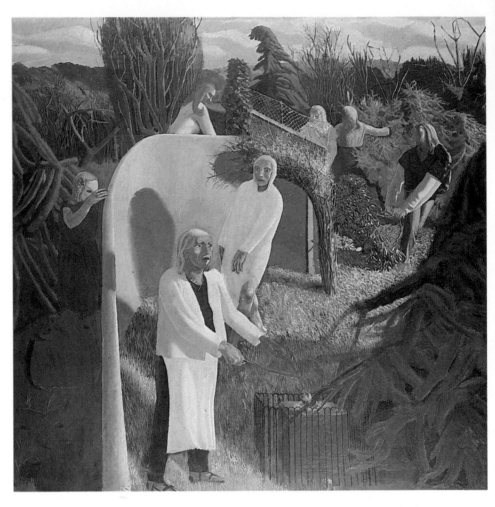

4. STANLEY SPENCER: *Zacharias and Elizabeth* (1912–13).
Oil, 60 × 60 in (152·4 × 152·4 cm). Private collection.

but the critics and public ignored it. Angered but further stimulated, he made several paintings of the monastery of Mar Saba, near Jerusalem. Confident of success he sent Lilian Mendelson to London to arrange an exhibition, but the dealers were sceptical, for whatever the critical acclaim of a number of his earlier works, they had rarely sold, and after four years' absence he was apt to be forgotten. After some eight months of intense effort she had met with no success. Alice eventually reached an agreement with the Leicester Galleries, the exhibition to open in February 1928, Muirhead Bone guaranteeing the cost of the framing. Paradoxically, Alice's anxious dedication to arranging for the exhibition resulted in growing bitterness on Bomberg's part. Their relations had already become strained and their enforced separation culminated in a crisis. Arrangements for the exhibition completed, he left Jerusalem for Paris in October 1927 remaining there until December.

Bomberg's initial optimism about his exhibition turned to pessimism, and even before his return to London he noted that England 'is no place for me'. Storrs, as always, was helpful, and, with Sir Alexander Kennedy, contributed appreciative comments to the exhibition catalogue of 'Paintings of Palestine and Petra'. To Bomberg's astonishment and delight it was received with enthusiasm by the public and given extensive notice in the press. Never before or since had an exhibition of his work attracted such attention. But, as was generally the case, he sold little – only seven works. 'I find myself over eighty pounds in debt,' he noted, '. . . the show itself had been a failure financially although a colossal success artistically.' In particular the closely observed representational paintings of exotic subjects evoked the admiration of his fellow artists.

In the hope of offsetting the financial loss involved, Bomberg leased a studio in 6 William Street, Knightsbridge where in June he held another exhibition of Palestine and Petra works. This, too, was a failure in that scarcely anything was sold; he accordingly suffered deep concern and depression. Before long he suffered yet further distress: Chinaman (1922), exhibited at the Cartwright Memorial Hall, Bradford in January 1929 evoked abusive letters in the local paper.

Another exhibition of his Palestine and Petra paintings was held at the Ruskin Gallery, Birmingham, at the invitation of the director of the City Museums and Art Galleries, S. C. Kaines Smith, who, in his introduction to the catalogue, paid tribute to the artist 'as a painter of light . . . in the most intimate association with atmospheric conditions and landscape forms . . .' Like the other shows – except that in Bradford – it evoked high praise but few sales.

A far more notable event occurred at this time. Lilian had divorced Jacob Mendelson in 1928 and settled in a house in 10 Fordwych

Road, Hampstead. There Bomberg joined her, and painted the first of his numerous portraits of her: *Woman in Sunlight, Lilian* (1937) and *The Baby Diana* (1937), her daughter and his only child. These are marked by an audacious freedom of handling, the culmination of the relative, and at times experimental, freedom of certain of his works in Palestine, in particular of those in Petra.

Eager to paint in a stronger light and unhappy in England – largely a consequence of the failures of successive exhibitions – Bomberg journeyed south for eight months during 1929–30, through Spain, Morocco and Greece. As he had before, Ronald Storrs came to his support, contributing generously towards his travelling expenses.

Before he was long in Spain – where he worked for the first six months – Bomberg produced several masterly works of a varied, some of a contrasting, character, such as *Hills in Mist, San Miguel, Toledo* and *Toledo from the Alcazar*; the one subtle, atmospheric, the other a view of the city from far above, immensely detailed, yet its simple grandeur never impaired. Both appear to have been painted with a rare serenity. Bomberg had produced outstanding works, but these and several others made on this expedition I believe to be the finest since his 'cubist' years. He went on to Morocco and Greece, where he appears to have painted nothing, and was compelled to return to England because of a severe attack of jaundice.

Again he was sunk into deep despondency, for no gallery would exhibit the 'Toledo' paintings. Well aware that these were his best, their rejection brought Bomberg near despair. Still afflicted by debts, he resorted to portraiture. His requests to various prominent people to sit for him – Virginia Woolf and Harold Laski among them – were declined, hardly surprisingly, considering that he had achieved no particular reputation as a portrait painter. Almost all the portraits he made were accordingly of his own family or close friends. Certain of those of Lilian are remarkable, such as *Woman by Sunlight* and *Portrait of Lilian* (1932), but I must confess that memorable as they are I cannot share the opinion expressed by several of his admirers – for instance Lipke's statement that 'In this portrait the artist has created one of the great twentieth-century British works of art.' Still less do I believe this to be true of Bomberg's numerous self-portraits. These, however, were painted with rare confidence and with penetrating self-perception; some show him grieving, others dreaming. An exhibition of a number of these, painted with such total freedom, revealing him in a wide variety of states of mind and spirit, would be a fascinating event.

Depressed as he was apt to be by the treatment to which his art was so frequently subject, nothing impaired Bomberg's confidence in the quality of these works, which he regarded as successful. This

confidence found extraordinary expression in the following extract, quoted in Lipke's biography:

> The humanism of Giotto, the Father of modern painting was transferred to his great inheritor Paul Cézanne and as this came down the years it gathered power from Michelangelo. Cézanne's structure broke down the ineptitudes – and stifling adhesions – gathered in the eventual decline from growth to decadence of the Visual Arts of Egypt, Greece and Rome, in the period of culmination of their civilizations transmitted to the Italian Renaissance and inaugurated for our time in the relaxes and releases. Cézanne, the precursor of our times discovers the earth is round and had a gravitational pull, initiates Cubism activated by Impressionism which nurtured Cézanne; therefore Cézanne is Father to me and the artists of the future. Giotto stands to Cézanne as Cézanne will stand to posterity; and I who am of the line and inherit the blood stream should not be treated as a stranger in my Father's House.

Bomberg's self-confidence was not impaired by his continuous inability to sell his work, and he undertook the design of advertising for the Empire Marketing Board and Shell-Mex – an undertaking which employed a number of notable artists and one that included him in a formidable enterprise: a visit in 1931 to the Dales of Derbyshire in fearful weather. He was accompanied by Lilian Holt who wrote:

> We camped for three weeks in continuous rain and cold, burning a coal fire in the centre of our tent to keep warm. We were on a meadow above Millers Dale, the vista beautiful, could we have seen it. Then one morning, the sun glimmered; we gathered all the equipment, including the tin kettle and mugs, and started off for Castleton. It was . . . a sixteen-mile tramp with canvas and painting equipment, so we were rather tired on arrival by midday, and still the sun was just flowing in a gentle uncertainty. The Cavedale rocks appeared. Then it happened: a grand flood of sunlight shafting through, throwing great forms into the shadow depth. A great excitement was on. Everything was flung down in great haste. The easel seemingly flew into position, paint streamed over the great Palette. All the happiness, the grandeur of the moment at that vista must be captured . . . While David worked feverishly, I set about gathering wood and heaping it on the fire, warming myself quietly in the tense stillness of this time of creative expectancy. And when I felt the moment of fulfilment nearing, on went the kettle. David drew back. Yes. The brushes were carefully set down. 'Come over, Lilian' (The artist was always excited, tense, yet very restrained.) 'What do you think?' Lovely. It's lovely, all there' . . . We were so very tired, too tired, to seek warmth with a fire; just able to get the canvas into cover and then drift into camp slumber. That was 'Cavedale'. Lovely, but too subtle to reproduce said Shell-Mex . . . they gave it back to David.

Still in need of money, still unable, except on rare occasions, to sell his work, Bomberg was unsuccessful in realizing various fund-raising projects. At last, in November 1932, he was able to hold an exhibition

of sixty imaginative compositions of Spanish and Scottish landscapes at the Bloomsbury Gallery. None were sold; there was negligible notice by the press.

Bomberg's resentment of his continued lack of recognition found expression in a variety of uncharacteristic political activities: he joined the Society for Cultural Relations between the British Commonwealth and the USSR, and in July 1933 went on a six-month visit to Russia. The conditions there (described in extensive writings, some of which were published in Lipke's book) express acute disillusionment: 'The theory and tactics of the Revolution is one thing, and the creation of a work of art another. They have little in common.' Although acutely disillusioned, he would have liked to return and paint there.

Still greatly dissatisfied with life in England, he and Lilian left for Spain in May 1934, hoping to spend the rest of their lives there. They lived first at Cuenca, moving on to Ronda in Andalusia and then to Linares in the Asturias mountains, returning to London in November 1935. It was in Ronda that Bomberg painted one of his finest works: *Ronda*, a range of mountains topped by a town, a rare combination of detail and grandeur. This is one of the several notable paintings Bomberg made on this visit; there were others of similar subjects, depicted in the blazing midday sun, early morning, evening and by night. Ronda made a deep and enduring impression on Bomberg; he came to know and like its people and studied its history. He also worked, and with notable success, in other parts of Spain. At the height of his powers he and his family were compelled to leave in the winter of 1935: civil war was impending.

In June of the following year an exhibition of fifty-one of Bomberg's paintings and drawings of Spain was held at the Cooling Galleries, which was opened by that most assiduous of his supporters, Ronald Storrs. Sales were few but it was fairly well received by the critics. One positive result was the inclusion of *Ronda* in a travelling exhibition sponsored by the British Council in 1936 and shown at the National Gallery of Canada.

The visit to Spain further stimulated Bomberg's fascination with landscape, which impelled him to visit North Wales. Not surprisingly, after Spain he found the landscape relatively dull, and, as it had on the Cavedale expedition, the rain poured and was swept by the wind.

As he was apt to, when suffering from the lack of recognition of his achievements, Bomberg expressed his anger over other matters. For instance, according to the minutes of the 1939 annual meeting of the London Group, he proposed that members should 'be prohibited from exhibiting with reactionary groups . . . consolidate with the AIA and Surrealist Groups in their support of anti-Fascism in politics and

art . . . Honorary membership be extended to certain left-wing poets.'
His state of mind, however, led to his making one very constructive
proposal. In a letter dated February 1937 to Kenneth Clark, then
Director of the National Gallery, he urged that Britain should adopt
the American Public Works scheme for the support of artists. In reply
he received a letter expressing Clark's cordial agreement: 'When I
was in Washington the last time I was so impressed by this that I got
all the particulars . . . with a view to submitting it here. But I am
afraid that there is not much hopes of anyone taking interest in it . . .'

Bomberg made several unsuccessful attempts to secure a teaching
post, but instead won a contract from the London Cooperative Society
Joint Education Committee to design the stage settings and costumes
for a production of Handel's *Belshazzar*. However, he had overlooked
the fact that it was without pay, and his designs were returned to
him.

On 25 March, 1938 his father, with whom Bomberg and his
daughter and step-daughter shared a house, died, aged seventy. This
left Bomberg in an even more acute financial predicament. A project
for painting in South Africa failed, and he welcomed the publisher
John Rodker's suggestion that they stay at his cottage at Strood, near
Peldon in Essex. This move had distressing consequences: Lilian
became ill and both daughters caught chickenpox and were sent to
hospital; Bomberg stayed on unhappily alone. By spring of the
following year the family, to his intense relief, was reunited. He had
become emotionally and otherwise dependent on Lilian, and he was
devoted to both Diana and to his stepdaughter Dinora.

Lilian was indeed worthy of his devotion, not only for living with
an emotionally very difficult man and devoting herself wholly to his
needs, but for abandoning her own painting, to which she was
dedicated, for long periods.

The outbreak of war in the autumn of 1939 brought further
difficulties. The sale of paintings, for Bomberg always difficult,
became impossible. Characteristically, Lilian obtained a post with the
Ministry of Supply. Bomberg applied for work with the Official War
Artists Committee, but despite his successful service for the Canadian
War Records Office in the last war, his application was declined. He
submitted applications for some three hundred teaching positions
but all were turned down. Over two years he did occasional odd-jobs.
Eventually, however, he received a small commission from the War
Artists to execute two drawings of an underground bomb store near
Burton-on-Trent, which he carried out between February and May
1942. Those I have seen compare unfavourably either with the 'cubist'
studies or the 'realistic' painting he made in the First World War, but

Henry Moore's acquisition of one of them – a discriminating collector – suggests that I may very well misjudge.

Bomberg continued, still without success, to apply for teaching positions. Then, as so often, Lilian came to his help, suggesting that he undertake some flower paintings. Of these he made several, all boldly-handled oils. 'The period,' noted Lilian, 'was extremely sad, David rarely painting, and the child soaking up the pervading gloom.'

In November 1943 an exhibition of his imaginative compositions painted in the early 1920s was held at the Leger Gallery, but it attracted neither public nor press – only members of the family, including Dinora, who purchased *The Vagrants*; his sister Kitty and one of his friends each bought a painting. The failure of his exhibitions and his inability to sell his work except to a few relatives and friends compelled Bomberg, from 1945, to teach when occasional opportunities were offered, for example part-time at the Hammersmith School of Arts and Crafts, the Katherine Low Settlement in Battersea, the Clapham LCC Institute and the Evening Institute, by Battersea Bridge. By the summer of 1944 he had saved enough to go on a painting expedition to North Wales and Anglesey with his family. The few paintings he made there are vigorous and free in their brushwork but to the sheer perception of his finest Spanish works, such as *Toledo from the Alcazar* or *Ronda*, they are hardly comparable.

Bomberg had experienced difficulties in finding teaching posts during the war, and his teaching was not considered notable. When the war was ending, however, the situation was quickly transformed: between 1945 and 1953 he held teaching posts at a school in Dagenham, the Bartlett School of Architecture and the Borough Polytechnic. At all three, but in particular at the Borough, he won almost instant success. At the Bartlett he taught architectural drawing, for which, as his depiction of buildings in Jerusalem, Spain and elsewhere show, he was exceptionally well-qualified; moreover he had found that he delighted in teaching. He took his students to Westminster Abbey, St Paul's and the Victoria and Albert Museum. Many Bartlett students attended his life-classes at the Borough, where Lilian joined him as a teacher. Bomberg's teaching was highly effective and, to many of his students, inspiring. But it was also unorthodox. Several of his conventional fellow teachers and others were critical. His classes, however, steadily grew in numbers, and from the enthusiastic recognition of his teaching he derived immense satisfaction – it temporarily atoned for the lack of it in his painting, which he had so long desired.

In 1947 Bomberg was able to take a painting holiday in Cornwall, accompanied, as always, by Lilian, and later joined by her daughter

Dinora and her husband Leslie Marr. They camped near Zennor in a big tent. Unlike his wartime works, his Cornish landscapes were zestful, his brushstrokes broad and free, as in *Trendrine in Sun* and *Sea, Sunshine and Rain*.

Early in 1947 a number of Bomberg's students met, nine members being elected and designating themselves founder members of The Borough Group, deciding that they were sufficiently mature to exhibit as representative of Bomberg's highly individual teaching. Bomberg was elected president. The first exhibition of the Group was held at the Archer Gallery in June 1947; the foreword to the catalogue was written by Bomberg, who did not exhibit. The following February Leslie Marr made available in his bookshop The Bookworm, in Newport Street, space for the permanent exhibition of the work of members of the Borough Group. In June 1946 a second exhibition was held (with Bomberg showing) at the Archer Gallery and a third in the Arcade Gallery in March 1949. Yet another exhibition of pictures by Bomberg and the Group was held that summer in the senior common room of Brasenose College, Oxford. Late in 1949, despite the admiration it had evoked, the Group suddenly collapsed. In a letter to Lipke, Lilian, also a member of the Group, described the causes:

> A deep schism appeared in the Borough Group. A conflict of person-alities took the form of fierce attacks on Bomberg by a small section of the membership, the underlying motive of which appeared to be a move to supplant Bomberg. David was suffering at that time from the early stages of what was to prove his final illness. As David was giving these artists much of his life-long experience as a painter, and his knowledge of all matters pertaining to group organization, we decided to table a motion for the dissolution of the Borough Group.

Despite Bomberg's dedication to teaching and his outstanding qualifications most of his classes were taken away from him, for his teaching did not comply with the curriculum required by the new government act awarding grants to art students. Bomberg's financial situation was again desperate. Leslie Marr offered financial help. After discussing several possibilities, including the setting up of an art gallery, Bomberg proposed renting a house with studio space which they would occupy and rent out. In 1948 an attractive house in Hampstead was found and elegantly furnished. Marr's loan, however, was soon expended; additional capital was borrowed from Marr, which did not suffice, so a mortgage was raised from a building society. Bomberg realized that the situation was disastrous, for there would be no means of recovering their expenditure of £50 a week, an immense sum in those days, obtainable from letting the seven rooms available. This farcical and distressing situation lasted until 1953.

The year that the Hampstead house was rented was also marked by an event which brought happiness to all concerned. When the long summer vacation was due, Marr generously asked Bomberg where he would like to go on a painting expedition, offering to provide funds for the whole family to accompany him. Bomberg, remembering his talk with his friend Harrison (a partner in a firm of architects which had opened a branch in Cyprus) in Palestine some twenty-five years before replied, 'Cyprus, the jewel of the East.'

So that spring, thanks to Marr's generosity, Bomberg, for the only time in his life, was able to order everything he wanted – and did so. The Cyprus expedition included, besides Bomberg, Lilian, Leslie Marr and Dinora – all artists – Dinora's half-sister Diana and her daughter Juliet. Dinora later related the trip to me:

> Getting it out to Cyprus and back was pure hell. As we left England the customs man said, 'If you ever come back, I only hope it won't be by way of this port, and if it is I hope to God I won't be on duty!' We went overland to Italy, and then by a Greek cargo ship. When we arrived there was no Harrison to meet us, but he sent a young man from his office to take us to the monastery, where we expected to find our accommodation arranged. It was late afternoon; there was no accommodation except two dirty little cells. We asked the young man who met us whether we could camp on the shore. He said yes, though there might be snakes, but along the coast there was a Cypriot seaside camp with an open-air oven. We decided to leave all our luggage and painting equipment at the monastery and trudged to the camp, and arrived very tired and hungry. We didn't like it and trudged along. At last, long after it was dark, we arrived at a Turkish holiday camp, where we were received with great kindness by a young Turk who spoke English. He explained our situation to his fellow Turks, who gave up their spotlessly clean beds for us. Next day we went back to Lapithos, found a house, and David and Leslie returned to the monastery, where we met with the utmost hostility and a demand for a huge sum for the storage of our baggage. When it was refused there was an angry scene: a door was slammed; David and Leslie broke it down, and after a struggle our baggage and painting equipment was recaptured. For a while things continued as unpleasantly.

But these happenings are recalled so that the reader may marvel at Bomberg's delight as soon as he began to paint and the enjoyment of the rest of the visit. 'It was wonderful to see David, free for once of the need for economy,' she concluded, 'painting away day after day in the intense heat and producing – to me – superb Cyprus landscapes. We all worked well on that trip, thanks to Leslie's warm and generous nature.'

Despite the acute discomforts they all suffered at Lapithos, from illness, hunger and squalid accommodation, the Cyprus expedition was as enjoyable as it was successful. All four artists were hard at

work, sometimes all together on the same site, all delighting in each other's company. The best of Bomberg's Cyprus paintings, such as *Castle Ruins*, *St Hilarion* and *The Monastery of Ay Christostomos* (all 1948), are indeed notable, with their audacious, sweeping brush-strokes, every one of them evocative.

On their return, however, Bomberg suffered renewed distress at the absence of any indication of the big retrospective exhibition of his work which he had for so long desired. Yet he resumed his teaching at the Borough as ardently as before. For the catalogue of its third annual exhibition in 1949 he contributed a brief preface:

> Our interest lies more in the
> mass than the parts;
> More in movement than the static;
> More in the plastic than the
> decorative.

Of the Borough exhibition Wyndham Lewis wrote in *The Listener*, 10 March:

> David Bomberg is the leading spirit. What happened to Bomberg after 1920? Was he one of the lost generation that really got lost? Or has he an aversion to exhibition? He ought to be one of half-dozen most prominent artists in England . . . Anything with which that fine artist, Bomberg, has to do you cannot afford to neglect.

Bomberg, moved by this praise wrote to Lewis to thank him, suggesting that he should 'go further' and write a monograph on his life and work. No such monograph was written.

Since the Cyprus expedition, Bomberg's continued distress at the lack of recognition of his achievements as an artist became so acute that he almost ceased to paint. Misfortunes accumulated; the severe financial loss resulting from his misjudgments regarding the Hampstead house, the fierce ill-will expressed by a number of the Borough students, the dissolution of the Group and, finally, the loss of his day classes at the Borough. Always liable to distress, he had never had greater cause to suffer from it. In the winter of 1952 he resumed painting, doing three portraits of Dinora, all quickly completed oils. Yet his distress eventually found expression in outbreaks of hysteria which Lilian eventually found insufferable, and she left the house, camping in the garden.

Perhaps the final blow came with an exhibition in Sweden of the work arranged by four of his former students and members of the Borough Group. A copy of the catalogue was sent to Bomberg; in its foreword he found himself referred to as the innovator of their style of painting and once their master, but with the clear implication that

he had passed his prime and the 'reputation' he once had and that he no longer painted. This rejection by his students could not have come at a worse moment. Although this implication was unjustified, the fact that he had painted little in recent years evidently made it seem justified to these students. Bomberg was in fact almost forgotten. A group of big architectural charcoal drawings, made in Paris, Chartres and Vézelay, which he made on an expedition with Lilian, together with others made in 1944 of air-bombed London, were to have been published by John Rodker in 1953 in a limited edition. There were no subscribers, or almost none, so the project had to be abandoned.

In that very year, however, there were signs of a reaction against the neglect of Bomberg, of which the most significant manifestation was the establishment of the Borough Bottega. This was a group made up of his devoted students and his family whose aim it was to support Bomberg's work and teaching. Its primary purpose was 'to make known the work of the artist David Bomberg as soon as possible'. The Bottega held its first exhibition at the Berkeley Galleries in 1953; for the catalogue Bomberg wrote a long and eloquent foreword which well expresses some of his basic beliefs:

We gladly make known our acknowledgement to the source at the mountain peak, George Berkeley Bishop of Cloyne and to Paul Cézanne, the father of the revolution of painting. We truly claim to be friends and appraisers for we knew the secrets of George Berkeley's philosophy of the metaphysic of mind and matter lay in its divinity and we could not follow in its footsteps unless we ourselves were of that. But we gathered sufficient from his theory of vision, in how we perceive distance to find our way, by the contemplation of the meaning of drawing and how it is related to the interpretation of form, to the study of its structure; gradually we were brought to comprehend how the part was not the organic whole and how the organic whole was part of the mystery of mass and this prepared for the base for the understanding of the significance of Cézanne's contribution to painting whose secret passed on his death – for he spoke to many of all things but not of this, which was deep in the recesses of his mind – therefore to Berkeley who taught us how to think is the grandeur – he derives from Plato and Newton; to Cézanne who taught us how to invent is the glory – he derives from the Italians and his colleagues the French Impressionists. . . . We are resolutely committed to the structure of the organic character of mass. We have no concern at all with the decorative properties of attractive superficialities. We do not admit a wilful distortion which is another superficial appearance on the horrific side of the attractive. We conceive of art as the incomprehensible density of cosmic forces compressed into a small space, therefore any of the manifestations to the contrary will not find a habitation with us. For we are less concerned with man's condition and more with what he thinks and feels. The strength that gave the cave-dwellers the means to express the spirit of their life is in us to express ours. We have no need to dwell on the material magnificence of man's achievement, but with

the approach of the scientific mechanization and the submerging of individuals we have urgent need of the affirmation of his spiritual significance and his individuality. Our environment is there to distract us but a sufficiency of contemporaries are concerning themselves with this aspect.

In order to avoid visitors being distracted from the work of his students, very few of Bomberg's own works were included.

The exhibition attracted little notice, but it had one fortunate result: the following year the Arts Council sponsored a Bottega exhibition at Black Hall, Oxford. But even the two exhibitions did nothing towards the realization of Bomberg's long-held desire for a retrospective exhibition of his work. The continued absence of any indication of positive recognition of his painting eventually brought him to the verge of despair. In February 1954 he and Lilian left for Spain, settling in Ronda. Besides painting he intended to establish a school of art and language for students from all over the world and to continue the work of the Borough, drawing students from England. For this purpose they rented the Villa Paz, a palatial house in the centre of Ronda, and sent hundreds of printed brochures to universities and art schools in Britain and the United States, and asked for financial support from dozens of charitable and higher educational institutes, besides engaging in constant quarrels with the local government authorities. As Lipke briskly observes, 'But it soon became apparent that one important ingredient was missing: the students'. Astonishingly in this chaotic whirl, Bomberg continued to paint, not at his best but well, as in the dramatic *Ronda, Andalusia* (1956).

In the meantime Dinora and other Bottega members were eventually successful in arranging an exhibition, 'David Bomberg, Paintings and Drawings 1915–1953 and the Borough Bottega', at the Heffer Gallery, Cambridge. It showed only thirty-seven of his works, but it was his first 'retrospective'. The visitors were deeply impressed, but since it was not held in London these were very few and there were no critics. To his friend and fellow exhibitor Anthony Hatwell he wrote '. . . when a person is getting old and no longer able to maintain the hold on a work on which his reputation has been made, another kind of work must take its place that is done with less struggle and greater enjoyment.'

Bomberg was liable to misfortune. A Borough exhibition was held at Walker's Galleries, New Bond Street, for which Lilian brought an enormous crate over from Spain containing his and her works. The exhibition coincided with a newspaper strike. He was already distressed at their having been compelled to move from the Villa Paz by its owners. (When first required to do so they refused, so the

owners cut off electricity and water; they accordingly moved to a remote and desolate place more than an hour's ride away.)

In Lipke's book I came upon a subject which distressed me: 'But the exhibition of the year which was too devastating emotionally for the exiled artist was the Tate Gallery's summer exhibition, "Wyndham Lewis and Vorticism" . . . Not only was Bomberg included . . . as one of the "Other Vorticists", but the work he had loaned was far . . . from an indication of the original . . . work . . . he had executed in 1912–15'. A letter from William Roberts – who had also been relegated by the Tate to 'Other Vorticists' – contains the words: 'If you can spare a moment to take your attention off the Rock of Gibraltar, I am sure you will be interested in what Sir John Rothenstein and Wyndham Lewis are trying to do with the rock of your reputation as a leading English Cubist in 1914 . . . the two small pamphlets are my reply so far'.

In the next eleven months Bomberg began to sift through his life, writing and rewriting his thoughts about this last dishonour and his dying reputation, which had been snatched from him in the waning years of his life. With the need to justify himself, and only himself, he spent practically all his time writing mythical, involved and lengthy letters to *The Times*.

First let me exonerate Lewis (I quote from Volume III of my autobiography): 'In view of his state of health, we assembled the exhibition with minimum recourse to Lewis himself, who did, however, write the brief foreword to the catalogue . . . at the private view, Lewis, very feeble and nearly blind, was present.' More could be quoted, but this I think, is sufficient. With regard to myself: 'I had an ardent admiration for Lewis ever since I first came to know him, and his near blindness and the poor state of his health, both of which perhaps aggravated his marked obsession about the hostility of his fellow men, determined me to propose to the trustees that we should arrange a retrospective exhibition of his work. They readily agreed. When I went to see him to discuss the exhibition I was shocked to find him aged and ill . . .' The inclusion of his fellow Vorticists had not commended itself to Lewis but he had nothing whatever to do with the selection of their exhibits. But if the Bomberg we selected – I cannot, after so many years remember what it looked like – did not worthily represent him, then the fault is mine.

No doubt the pamphlets sent to Bomberg by Roberts, who interpreted the Tate's tribute to Lewis as an attempt 'to minimize the standing of Lewis's former associates', were primarily responsible for the isolated Bomberg's acute distress. The cause for my own distress is simple: a primary responsibility of the Tate – or of any gallery of contemporary art – is to do all it can to ensure the

satisfaction of the artists represented in its collection and exhibitions, so to cause them distress is accordingly distressing. To read about having done so to one for whom I had particular admiration, and at a time of his multiple affliction, is particularly so. Bomberg's tragic state of mind is expressed in his last *Self-Portrait* (1956–57) – not a great work of art, but a moving one, especially to those aware of the circumstances of its creation.

Equally distraught by the continuous accumulation of tragic circumstances was, inevitably, his devoted wife. Lilian and David urged each other to take a holiday and rest. He continued with his writing, she, realizing that she was becoming seriously ill, left Gibraltar on a ship to England, collapsing on board. On her return Dinora took care of her until she recovered. In March 1953 Bomberg received a letter from Helen Lessore, the director of the Beaux-Arts Gallery, telling him that it was time a big retrospective exhibition of his work was held. He replied, however, that it was time for official recognition, but an exhibition that would adequately survey the complex development of his art would have to be organized by the Tate or the Arts Council. Only then could the proper facilities and documentation reveal what he had known for so long: that he was the most important British painter of the twentieth century.

In the meantime, in a state of increasing hysteria over his lack of recognition, Bomberg was working all night, writing and rewriting his life and accounts of his achievements. Eventually, in May, he collapsed, becoming seriously ill. Lilian flew out to take him to a hospital in Gibraltar where he spent three months in delirium, and when the end was imminent he was taken to St Thomas's Hospital, London. There he died on 19 August, 1957. Few artists of his time suffered a more tragic end: broken in spirit by successive misfortune, above all by neglect.

Within a decade the works of an almost forgotten artist were widely recognized as being of outstanding achievement. In 1967 a retrospective exhibition was organized by the Arts Council and held at the Tate. (One retrospective that had previously been held in 1958, also by the Arts Council, although excellent, was premature: it did not, for instance, include *The Mud Bath*, *In the Hold* and several other of his finest works.) The exhibition of 1967 included one-hundred-and-thirteen paintings and two books Bomberg had illustrated, with enthusiastic forewords by Andrew Forge and William Lipke, whose admirably informative *Bomberg* appeared the same year. The exhibition evoked wide-ranging admiration. It was the first occasion that anything approaching the full range of Bomberg's highly varied achievement could be seen, from *The Mud Bath* and *In the Hold*, to

those with the Canadian Army in the First World War; in Petra in 1924, Spain in 1934–35, Cyprus in 1948 and again Spain from 1954.

Bomberg's work is wide-ranging, apart from a number of those works done of Palestine which were straightforwardly realistic, partly to satisfy the Zionist Organization but also, I believe, to discipline his own evolving realism. This realism, always highly personal, evolved from the massive realism of his work in Petra, Toledo and Ronda (of his first visit) to the broader, more generalized yet no less impressively convincing Rondas of his final years. The finest are marked by a grandeur of form and charged with a rare energy.

The admiration with which the exhibition was received was intensified by astonishment. Although his several exhibitions had evoked interest, very few people, except his family and close friends, had any conception of the range and variety of his subjects and his treatment of them, mainly because no full retrospective exhibition of his work had ever been held. Moreover, his long absences from London caused him to be forgotten and, as noted earlier, *The Mud Bath* and *In the Hold* had long been forgotten to the extent that Bomberg was not mentioned in Sir Herbert Read's *Contemporary British Art* (1951), and only referred to in a footnote in his *Art Since 1945* (1958), and I myself failed to include a chapter on him in the previous editions of these volumes. The Tate, under my directorship, had hardly done him justice, having only acquired five works, one of which was a gift from Lilian and the family.

The Arts Council exhibition at the Tate was an impressive revelation of his achievement; it received wide-ranging praise and accorded Bomberg the recognition that he had merited long ago, but in his lifetime had never received. Nor has it diminished. To cite one example: David Silvester happened to visit Lilian to look at Bomberg's work and, seeing *Ju-Jitsu* he asked her to put it in a taxi. It was bought for the Tate under the terms of the Chantrey Bequest.

Bomberg suffered several grievous misfortunes, but in one respect he was immensely fortunate: in his coming to know Lilian Holt, who devoted herself to Bomberg throughout their lives together, through the utmost hardship and successive disappointments and, after his death, during her remaining years. Not only to Bomberg but, in the face of the utmost and continuous difficulty, to her own art as well.

STANLEY SPENCER
1891 – 1959

I cannot remember what chance first sent me to Stanley Spencer's studio, but I well remember the visit. The studio was at the top of the Vale Hotel, a big public house overlooking the pond in the Vale of Health in Hampstead. The room was barely large enough to accommodate the immense canvas, which leaned against the longest wall. Up against the canvas stood a small table – which, with two kitchen chairs and a small tin bath, was the room's only furniture – and upon it a large teapot, half a dozen unwashed plates and some white marmalade jars, some containing paintbrushes and others marmalade.

Stanley Spencer was a tiny figure with a long fringe of dark hair hanging low over a face of extraordinary earnestness and animation. The least observant would have been aware of being in the presence of a person of unusual energy and originality. After the minimum of preliminaries he began to speak with the utmost candour of what most deeply concerned him.

Sometimes the process of getting to know a person is the process, so minutely described by Proust, of stripping layer after layer of deceptive appearance and discerning at last the unexpected and irreducible core of personality. During the years following that first visit I had day-long and night-long talks with Stanley Spencer about aspects of his painting, but he never said anything so illuminating about the innermost springs of his creativity as what were almost his first words. At that time he had had no exhibitions, and, so far as I am aware, little or nothing had been written about him, but I had the good fortune to know two of his finest paintings *Zacharias and Elizabeth* (1912–13), which I had seen in Sir Muirhead Bone's house near Oxford, and his *Self-Portrait* (1913), in Sir Edward Marsh's flat in Gray's Inn. When I spoke of my admiration for these he said:

> Those pictures have something that I have lost. When I left the Slade and went back to Cookham I entered a kind of earthly paradise. Everything seemed fresh and to belong to the morning. My ideas were beginning to unfold in fine order when along comes the war and smashes everything. When I came home the divine sequence had gone.

I just opened a shutter in my side and out rushed my pictures anyhow. Nothing was ever the same again.

I spoke of the beauty of the glimpse of the river in the top left corner of the big canvas against the wall – one of a few meticulously finished islets in a wide sea of white priming; 'sometimes,' he said, 'I get a plain glimpse of that earthly paradise, but it's only a fragmentary glimpse'. These words of his were in no sense a personal confidence; they were repeated in one form and another at that time, I suppose, to anybody with whom he engaged in serious conversation; they give a luminous insight into a spiritual predicament that did not cease to harrow and drive him. This first great *Resurrection*, he told me, was undertaken in 1923 and, to judge from the fact that it was scarcely begun, this visit of mine probably took place towards the end of that year. When he met people he was prepared to treat them as friends, and he so treated me from my first visit, on which indeed he gave me the splendid pen drawing of himself which he made in preparation for the Tate *Self-Portrait*.

During the years following I saw him on other occasions. I recall, in particular, a later visit made in the spring of 1926, when *The Resurrection* was almost complete. Shirin, the Spencers' first child, had been born in November 1925. Mrs Spencer was bathing Shirin, and I had a momentary distraction from her husband's conversation by my impression that the water was too hot. Shirin yelled, but appeared to suffer no harm. I remember, too, that a boiling kettle which stood upon a small iron stove filled the room with steam, which condensed and streamed down the spacious surface of the canvas. A quarter of a century later, when certain of the greens showed a tendency to liquefy, I invited the artist to come to the Tate to examine the picture. He was as puzzled as I about the cause of this liquefaction until we recalled the baleful perpetually steaming kettle, which, he became persuaded, was the cause of the instability of areas of the paint.

The great canvas, which I had first seen blank except for a few minutely finished islets, and – at longish intervals – seen fill gradually with figures resurrecting among gravestones and tombs and become suffused with simple, potent, highly personal poetry, moved me so much that I wrote an article on the artist. This was accepted by *Apollo* but remained unpublished. The following year the gift of *The Resurrection* to the Tate Gallery by Sir Joseph, afterwards Lord, Duveen made the picture a focus of widespread controversy. It was violently attacked and warmly praised. Stanley Spencer became a public figure – and my immature pages of eulogy became 'news' and were promptly published in April 1927.

A friendship had begun to grow between us when in the spring of 1927 he went to live in Burghclere, near Newbury, to carry out wall paintings in the war memorial chapel specially built to house them by Lionel Pearson. (I will speak of these extraordinary paintings in the appropriate place.) The work occupied four years. In the late summer of the same year I emigrated to the United States.

It was not until twelve years later that I came to know Spencer well. In the intervening years we met from time to time, and I was responsible for the acquisition, in 1933, of his *Separating Fighting Swans*, of the same year, by the Leeds City Art Gallery, the first example of his work, I fancy, to go into a public art collection outside London. In the early autumn of 1938 my wife and I gave a party to which Stanley Spencer came. There were difficulties about his catching the last train to Cookham, and so he stayed the night. Next day a toothbrush was bought, and he remained with us all that autumn. In the evenings, returning from the Tate, I used to find him, in the half-light of the drawing-room, curled up on the floor like a twig. He showed no impulse to draw or paint, but seemed content to live quietly, to meet our friends and above all to talk. On the first evening he was sitting on a small couch between my wife, who spoke of his *Zacharias and Elizabeth*, and Sir Kenneth Clark, to whom he said 'It is astonishing that an American should see most into my mind and painting', and thereafter he used to talk to my wife with particular candour. He was prepared to talk, often at prodigious length, upon any topic, but upon the slightest pretext he would revert to two, which are closely interwoven: his early life in Cookham and the subjects of his paintings.

From these conversations we learnt many things about Spencer, many comic and tragic things, but by far the most important and the most relevant to this study was a deeper insight into what he said to me on my first visit about his earthly paradise and the smashing of it by the war.

In her book on the artist, my wife explains how in Cookham, the Berkshire village where Stanley Spencer was born,

> he saw Jerusalem in England's green and pleasant land. The church-yard would surely be the scene of the final resurrection of man; the river was radiant and serene like the heavenly Jordan, though there was something of the Styx about it too. In the streets when he saw his father, bearded, and venerable, it might have been St. Peter walking there, or one of the Prophets.

Spencer was born on 30 June, 1891, the seventh son among the nine children of William Spencer, a music teacher and organist, and Annie, born Slacke, his wife. Earlier, generations of the family had been in the building trade.

Most men and women experience moments of exaltation in the contemplation of a May morning, or the starlit heavens, in performing a heroic act, most often and most intensely in romantic love – but these moments are rarely prolonged. To certain men and women is given the capacity for sustained exaltation – a capacity, I am inclined to think, that is a sign of superior nature, just as the capacity for boredom may be that of inferior. And one of the signs by which the artist of exceptional creative power may sometimes be recognized is the capacity for prolonged exaltation over things that to others are entirely commonplace.

From the time when he grew into a sentient being until the First World War, Stanley Spencer experienced exaltation in regard to his native village. To the dispassionate traveller's eye Cookham is a delightful village, but with no more beauty or character than five hundred others scattered up and down the country; but Stanley Spencer's upbringing was one that gave particular opportunity for the growth of a deep and enduring sentiment of locality. His father, a man of high character and patriarchal appearance, who, if at heart something of an agnostic, had a passionate love for the Bible. 'In the evenings, with his children gathered round him,' Stanley Spencer told my wife, 'he read to them from the Old Testament with such conviction that he made it as real to them as Cookham itself, and indeed it seemed as if the story of the Bible had been enacted in their own familiar streets.' A vague sense of the events related in the Bible having taken place in the region where he was born took a hold upon the young Stanley Spencer's imagination and attaches him to the tradition in which Milton, and more militantly Blake, were sharers, according to which the British Isles were the centre of all primitive and patriarchal goodness. 'Jerusalem the Emanation of the Giant Albion! Can it be? Is it a truth that the Learned have explored? Was Britain the Primitive Seat of the Patriarchal Religion?' asked Blake in his 'Jerusalem'.

There are no grounds for supposing that in Spencer's mind there was anything approaching an explicit historical identification of these Islands with the Garden of Eden, but he was altogether free from the current heresy that the Christian religion is something which belongs irrevocably to the past. Indeed, it was one of the most pronounced features of Spencer's mind that past and present, the living and the dead, good and evil all existed together in a vast undifferentiated flux. There was nothing either analytic or sceptical: he was deeply conscious of the continuity of things, and one might say that what Blake said of Mr B. applies equally to Mr S. 'Mr B.,' wrote Blake, 'has done as all the ancients did, and as all the moderns who are worthy of fame, given the historical fact in its poetical vigour so as it always

happens, and not in the dull way that some Historians pretend who, being weakly organized themselves, cannot see either miracle or prodigy.' Whether because of the benign atmosphere of their church-yard or from some other cause it would seem that to Cookham people the dead have not gone very far from their homes. My wife recalls Spencer's delight at hearing a lady of Cookham call over the fence to her neighbour, 'I'm just going across to the churchyard to give mother a clip round.' He, who always remained very much of a village boy, shared this sense of the nearness of the dead, and it is apparent in all his *Resurrections*.

Stanley Spencer's exaltation at the beauty of the life surrounding him was heightened by his father's love of music. The three eldest sons were also musicians, and with their father they made up a family quartet. When he and his brother Gilbert, afterwards the painter, were put to bed, they could hear the strains of music coming from the room below, such music as they would never forget. He told, too, how one Sunday, Will, his eldest brother, took him to the church and played Bach's 'St Anne Prelude and Fugue' on the organ for him, and how, when the last tremendous echoes had died, Will had asked him, 'What did it sound like to you?' 'Like angels shrieking with joy,' Stanley answered, and recalled the pleasure that this answer gave. Both my wife and I listened for many hours to his talk of his early life in Cookham, walking with him sometimes along its lanes and beside its poetic reach of the Thames, but the essence of what he told us is conveyed in a letter he wrote from Salonika in 1917 for Eric Gill's magazine *The Game*. Acute homesickness and the limits of space gave this poignant and evocative letter an intensity and succinctness not paralleled – at any rate in my experience – in either his vivid talk or in his other writings. The following selections, made by my wife, are a microcosm of his early Cookham life, more particularly of the two years between his departure from the Slade in 1912 and the beginning of the First World War.

> I remember how happy I felt when one afternoon I went up to Mrs Shergold's and drew her little girl. After I had finished I went into the kitchen which was just such another as our own (only their kitchen table and chairs are thicker and whiter) with Mrs Shergold and Cecily. I nearly ran home after that visit. I felt I could paint a picture and that feeling quickened my steps. This visit made me happy because it induced me to produce something which would make me walk with God. 'And Enoch walked with God and was not.' To return to the dining room, I remained looking out of the big window at the yew tree, and then turning to Sydney asking him to play some of the Preludes. He does so, though haltingly, yet with true understanding. And now for 2 or 3 hours of meditation. I go upstairs to my room and sit down at the table by the window and think about the resurrection, then I get

my big bible out and read the book of Tobit: the gentle evening breeze coming through the open window slightly lifts the heavy pages. I will go out for a walk through Cookham churchyard, I will walk along the path which runs under the hedge. I do so and pause to look at a tombstone which rises out of the midst of a small privet hedge which grows over the grave and is railed around with iron railings. I return to our house and put it down on paper. I go to supper not over satisfied with the evenings thought, but know that tomorrow will see the light, tomorrow 'in my flesh shall I see God' . . . after two or three hours' reading I blow out the candle, and whisper a word to myself 'Tomorrow' I say and fall asleep. . . . I do not remember the exact moment of waking up any more than I know when sleep comes. But although the moment of waking is not known, yet the moment when you become aware that it is morning, when you say 'it's morning', is the most wide awake moment of the day. How everything seems fresh and to belong definitely to the morning. . . . I go and call Gil in the little bedroom. I go downstairs . . . and out into the street and call a friend; we all go down to Odney Weir for a bathe and swim. I feel fresh awake and alive; this is the time for visitations. . . . I swim right in the pathway of sunlight; I go home thinking of the beautiful wholeness of the day. During the morning I am visited and walk about in that visitation. How at this time everything seems more definite and to put on a new meaning and freshness you never noticed. In the afternoon I set out my work and begin the picture. I leave off at dusk feeling delighted with the spiritual work I have done.

Stanley Spencer was connected with his birthplace by ties more intimate and numerous than is usually the case in a population which ever since its vast uprooting by the Industrial Revolution has, through necessity or disposition, become increasingly inclined to move and increasingly forgetful of local ties. The Spencer family seems to have been long established in Cookham. Stanley's grandfather, he once told me, began as a bricklayer and showed sufficient enterprise to enable him to set up as a builder and he built several of the kilns which, many years later, were represented with exceptional sympathy in the paintings of his two grandsons. He had a passion for astronomy, and the little local singing club that he founded long survived him. It was from him that his son William, and two grandsons, inherited their musical talents. The two grandsons became musicians of note. Stanley Spencer's maternal grandfather, a man named Slacke, who came from the Isle of Wight, was the foreman in a small boot factory and he owned a grocer's shop. The Spencers conformed to the rites of the Established Church, the Slackes were active Wesleyans, and Stanley was very much aware of the dual nature of his religious inheritance. I often heard him speak of a projected Resurrection in which the people would ascend the Hill of Zion in two great streams, the Anglican and the Chapel, the last with their red-brick and tin-roofed bethels in the background. As a child he sometimes went to

the parish church, at others to the Wesleyan chapel. His early education could not have been more local. In a tiny cottage adjoining the garden of Fernlea, the house where he was born and spent his early life, was a school in which first a Miss George and later Annie, his eldest sister, taught a small class of local children. There he was able to learn almost nothing. Eventually, in despair, Annie told him to write his entire life in a notebook and show it to his father, who glanced at it with resignation, and threw it aside.

The place that epitomized 'the lovely holy feeling' which pervaded all his early life was not Fernlea, happy although its associations were, but the churchyard, 'the holy suburb of Heaven', where his grandparents were buried. It was here that he and his brothers played, it was here that his footsteps turned in times of loneliness and grief, and it was here that his first serious drawings were made.

Even attendance at the Slade School, from 1908 until 1912, did not shift Spencer's centre of gravity away from Cookham. Like Constable a little more than a century before, he went to school in London simply to find a technique to express a way of seeing already, in its essential character, in being. The sociable, interested village boy, after a period when he was the victim of bullies, enjoyed the companion-ship of fellow students and his heightened proficiency; he gained a distant acquaintance, just perceptible in one or two early works, with Cubism, and, more important, he came to know the work of certain Italian primitives. On one occasion, an exciting one both for himself and his brother Gilbert, he brought home a reproduction of a Masaccio – The Tribute Money, I think, from the Slade. But these experiences, vivifying as they were, were peripheral. Compared with Cookham, where his heart and mind lay, London and the Slade were 'like ships that pass in the night'. When his last afternoon class at the Slade was finished, 'Cookham', as Stanley Spencer was called by his fellow students, used to go straight to Paddington, where he sat on the platform waiting for the first train to his Celestial City.

On one of my last visits to Spencer at Cliveden View, the tiny cottage on the fringe of Cookham which he occupied from 1945, we had some matters of consequence to discuss in connection with a forthcoming retrospective exhibition of his work at the Tate. We had not talked for more than a few minutes when, with an appealing look, he said, 'Come on, let's go into the village.' And away we went into the churchyard, deciphered inscriptions on the tombstones, and so into the church, to look at the pew, the fourth back in the left aisle, facing the organ, where he used to sit with his family, and to examine faded photographs of Victorian vicars. In 1954 Stanley Spencer visited China. As the bus carried him from London to the airport, he pointed with his small brown-paper parcel – his only luggage – along

the Great West Road and said to a companion: 'That's the way I go to Cookham.' In China, Chou En-Lai gave a speech on the New China and at its conclusion silence fell on the party. The silence was broken by Spencer's voice. 'Yes,' he said, 'we ought to know the New China better. And the New China ought to know Cookham better. I feel at home in China, because I feel that Cookham is somewhere near, only just round the corner.'

Those who show themselves friends to artists in their years of need and obscurity are rarer than might be supposed. It should therefore be mentioned that a neighbour, Lady Boston, wife of a generous patron of Spencer's father, not only taught Stanley the elements of drawing, but paid for his first two years at the Slade, after which he won a scholarship which enabled him to remain for two further years.

The time between his departure from the Slade in 1912 and his enlistment three years later in the Royal Army Medical Corps was, beyond comparison, the most intensely creative time of his life. During those three years he made a number of paintings and drawings which, although of varying quality, manifest an exalted spirituality rarely found outside the great periods of religious art.

This extraordinary group of works did not come into being unheralded. While still a Slade student Spencer painted *Two Girls and a Beehive* (1910), *John Donne arriving in Heaven* (1911) – in which, virtually alone in this artist's works, there is a suggestion, in the massive, generalized character of the figures, that he had looked with attention at contemporary Continental painting, in this case, that of the Cubists – and *The Nativity* (1912). As the qualities which make them notable are still more impressively present in the chief works among the later group, I will say no more than that they are astonishing productions for a student.

Not all the pictures in the later group represent explicitly religious subjects, but they do all manifest the vision of a man living in an earthly paradise in which all things, whether trees, buildings or people, are holy and God's presence is mysteriously manifest. A number, and among these the finest, represent events related or foretold in the Old Testament and the Gospels: the *Apple Gatherers* (1912–13), *Swan Upping* (1914), and even *Mending Cowls – Cookham* (1914), in which at first glance the human figures, or the people, as the artist preferred to call them, seem to take a subordinate place, are the works of a man to whom his surroundings are sacred. When he represented religious subjects Spencer was perceived to have been a God-centred man, a man for whom God, the Holy Family, the Saints and Prophets were even more real than the streets and fields of Cookham, and the sacredness of Cookham is perceived to derive from his imagining this place to have been the theatre of their acts. There

was never any question of Spencer's putting them into contemporary costume to make them more convincing. He always represented what he knew. He knew Cookham and its people. The world beyond its fields was a shadowy place and the people strangers. The idea of situating God and his Mother, his Son and his Saints elsewhere, or of clothing them in the clothes of strangers is one he would not have entertained. (Not that their clothes are insistently contemporary. In *The Visitation* (1913), Our Lady, a shy awkward village girl, wears a freshly-laundered dress; in *Joachim among the Shepherds* (1912), and *Zacharias and Elizabeth* (1912–13), the clothes have a timeless character.)

Besides the three just mentioned, the other principal religious paintings belonging to these years of single-minded creativity are *The Centurion's Servant* (1914–15), and *The Resurrection of Good and Bad* (1913), the first versions of a theme that had a stronger and more tenacious hold upon Spencer's imagination than any other. Of all these, beyond comparison the most exalted, in my opinion, is *Zacharias and Elizabeth*. In terms that are at the same time local and universal, and with a wonderful radiant gravity, here is expressed the story of how an angel of the Lord appeared to a priest named Zacharias as he was sacrificing in the temple. Zacharias, seeing the Angel standing on the right side of the altar, was troubled, and the Angel said to him, 'Fear not, Zacharias, for thy prayer is heard; and thy wife Elizabeth shall bear thee a son, and thou shalt call his name John.' We cannot see the Angel, only the bright light of his presence on the far side of the altar, but we can see the blameless priest's troubled face as he asks, 'Whereby shall I know this? For I am an old man, and my wife is advanced in years.' And we can see Elizabeth, her face lit by the brightness of the unseen Angel, and the look of intense stillness that it wears.

The story is familiar enough, but Spencer did not rely upon our knowledge of more than the barest facts. The exalted character of the scene he constructed compels us to recognize, as though the story were new to us, the momentousness of the announcement that the elderly wife of an elderly clergyman is to give birth to a first child. Each of the figures has a dignity that is inherent and owes nothing to any conventional posture, a serenity remote from relaxation. The figures are related by a simple, closely knit design, of which the spine, so to speak, is the all but symbolic wall of the temple. Perhaps the noblest feature of this work is the face of Elizabeth, so manifestly alive, so intently waiting, yet so still as to fill the whole picture with its stillness. Certain anonymous critics of the first volume of these studies, incensed by my questioning the commonplace criticism that an immeasurable gulf still separates the painting of England and that

of France, attempted to associate the attitude that prompted this questioning with chauvinism, parochialism and a number of absurd ideas that I have never defended nor presupposed. I will now, however, give these critics an authentic target by offering the opinion that, provided the weakness of the artistic and religious traditions of the twentieth century compared with the thirteenth is taken into account, this little picture may be compared without absurdity to a work by Giotto, so astonishingly has Spencer here (and very occasionally elsewhere) transcended, as a religious painter, the standards of his age.

Although smaller and slighter, *Joachim among the Shepherds* has something of the same character. *The Resurrection of Good and Bad*, a diptych showing in one panel the 'good' who rise serenely from flowers and grass, and in the other the earthbound 'bad' who look despairingly out from jaws of turf from which they struggle to free themselves, are grim pictures in which the artist shows himself a highly original painter, but he has envisaged his subject in traditional terms. The paintings were planned with the idea that they might be placed above the chancel arch in Cookham Church. But as the Resurrection motif took hold of Spencer's imagination with an almost obsessional intensity, his conception of it – without ever losing its traditional meaning – widened: a few figures became a host; a graveyard became an all-embracing panorama; and the distinction between good and bad disappeared.

When the First World War began, shattering his mood of exaltation, Spencer had completed the lower two-thirds of *Swan Upping*. In 1915 he joined the Royal Army Medical Corps, and was sent to Salonika the following year. During his two years of service in Macedonia, a country entirely unlike his own, his capacity for forming deep attachments for places brought him a strange and fruitful experience. When he first went to Macedonia he used to lie awake at nights thinking about Cookham, in particular about his abandoned landscape *Swan Upping* and his plans for its completion. One day in 1917, he told my wife, when marching, they came upon a place in the hills, whose mysterious quality struck him so forcibly that it, too, came to haunt him at nights so that he found it impossible to sleep. By day he used to look back, longing to return. Apart from going home, to go there was the one thing he desired. Hearing that his own county regiment, the Royal Berkshires, were stationed there, he applied for transfer so that he might go back to this place in the hills. Darkness was falling when he came to the place again, and he hardly dared look at it for fear the strange vision that had haunted him was some trick of memory, but the mystery was indeed there, even stranger and more significant in the dying light. He lay down and slept, he

said, as if he had reached a haven. From the emotion stirred in him by this valley in the Macedonian hills – a kind of compensation for his love of home – sprang the most ambitious of Spencer's works, the work by which his stature may most accurately be measured. Although he stored away every contour and shadow of it, and its sombre colouring, in his capacious memory, the time for its translation into a picture, or, more strictly, a series of pictures, lay some years ahead.

In December 1919 he returned to England, went straight to Fernlea and up the stairs to his bedroom where he found *Swan Upping* leaning against a wall, just where he had left it more than three years before. He completed it without hesitation.

The war shocked Spencer to the depths of his being and impaired his imagination, but did not affect its extraordinary continuity. I know of no artist of any age whose imagination was more consistent. The fruits of it are garnered in a long series of big, cheap notebooks, filled with drawings for innumerable projects, any one of which – even one belonging to his earliest years as an artist – he could take up and carry out unaltered. He was a generous man, without a strong sense of possession, but I never knew him to part with any of these projects, however slight, without grief. They are simple, almost childish-looking drawings, these studies of the people of his imagination, but they are less simple than they seem: he was able to adumbrate a large and complicated composition upon a series of small sheets of paper, so that when eventually they were put together, everything was precisely where he intended and the same scale preserved throughout. Nor is it an easy feat to design with such precision upon a single surface, let alone upon a multitude of small ones, in a painting room so small that they could not be assembled.

The drawings Spencer made of the people seen by his outward eye, on the other hand, are obviously most accomplished. These he drew fast, with entire sureness, beginning at some arbitrarily chosen point and completing, usually, each feature before passing to the next. I remember seeing a drawing of myself in 1951 shortly after he had begun it; there, quite alone in the middle of an otherwise virgin sheet of paper, was a minutely finished eye. His ability to plan large and complicated compositions upon small sheets of paper and to begin a portrait with a minutely delineated eye sprang from his power to envisage the completed work continuously and exactly. He employed the method he considered best suited for a given undertaking, and he who had theories about most things had few, I fancy, about technical procedures. His attitude towards these is illustrated by his reply to Cecil Collins, who objected to his use of linseed oil as a medium on the grounds that the paint would come off. 'It won't

come off,' he said; 'if you kiss a whore with love you won't get the pox, and if you put on your paint with love, it won't come off.'

Nobody who knew Stanley Spencer could be unaware of the effects of the First World War upon his personality and his art. They have been considered by those who have written of him, and I have already noted that just as all his ideas were unfolding the war came, and when it ended the divine sequence had gone. (I recall his speaking, in a moment of despair, of suing the War Office for the destruction of his peace of mind and of his talents.)

That his work lost certain of the qualities for which it is most valued, and that it showed other and unexpected qualities in the years immediately following the end of the First World War is beyond question. But unlike other writers, and unlike the artist himself, I am inclined to question the conclusion that it was the war which brought about this radical change. Wars are more apt to hasten changes already in process and to reveal developments which might otherwise remain hidden for a time rather than to bring about developments entirely unforeseen. The war carried Stanley Spencer away from his Celestial City; it broke the holy spell; it interrupted the rhythm of inspired and concentrated work; it subjected him to agonizing experiences; but I do not believe that these ordeals, shattering although of course they were, were sufficient to modify a vision of such serene power. It seems to me that by uprooting, shaking and hurting the finely adjusted creative faculties of the artist, they weakened his resistance to inevitable changes. But the change that largely transformed the character of his art would have taken place, I believe, perhaps later, but none the less inevitably.

Making the fullest allowance for the effects of the war, Spencer's art seems to me to owe its transformation not to them but to a widening of the range of his vital preoccupations, to which no doubt it contributed, but which belonged, quite simply, to the process of growth or of exposure to some current ideas. During his early life, most particularly during the period closed by his involvement in the war, Spencer was a God-centred boy. He was aware of little beyond his family – which by an easy process of assimilation included the inhabitants of Cookham – and the beloved place in which he had been born. And he was intensely aware of the luminously presiding presence of God, upon whom his deepest thinking and imaginings were focused. In representing 'the holy suburb of Heaven' he was praising his Creator. Then came the war and its uprooting, and in 1925 marriage, which contributed far more, I think, than war to the transformation of his personality. Marriage, in fact, was a cardinal event in his life as an artist, for this most intimate of human relations had the effect of inspiring in him an absorbed preoccupation not

with his wife alone, but through her with the human beings he came to know. There followed preoccupation with evil as well as good, with ugliness as well as beauty, and with sensual love as well as the love of God. The change was radical, and as it took effect the emphasis of his art was no longer upon the Creator but upon the created; there came, in fact, to be less and less emphasis of any kind, as it grew more and more comprehensive. Of the encumbering effects of such baggage Stanley Spencer was very much aware:

> You can't include all that without its taking away from your vision of God; but once you have all that baggage you can't just throw it away. It belongs to you and you've got to bring it with you. After I married Hilda and my work began to include so much besides the divine vision, I've been incapable of painting a religious picture, religious in the sense of *Zacharias* and some of my early pictures. The fact that many of them are of religious subjects makes no difference. I no longer have a clear vision of God; I'm somehow involved in the created. Sometimes I feel I were showing his creations to God. Take an Edwardian old lady. Five feet high. Bloated. Purple dress. Ridiculous little feet pinched in ridiculous little shoes. I feel that in my painting I'm lifting her up, saying to God 'Look! Isn't she bloody wonderful?'

The change came about gradually. As far as I am aware, Spencer never had an important experience that was not reflected in his work, and it was inevitable that the war, with the loneliness, the warm, unsentimental companionship, the unfamiliar scenes and the intermittent threat of extinction that it brought, should demand imperatively to be expressed. As soon as he was back in Cookham he completed *Swan Upping*, and resumed his series of religious subjects with *The Last Supper* and *Christ Carrying the Cross* (both 1920), *The Sword of the Lord and of Gideon* (1921), and *The Betrayal* (1923). Had he not painted *Zacharias and Elizabeth*, I would regard these – more particularly *Christ Carrying the Cross* and *The Betrayal* – as among the finest religious pictures of the age. But compared with the passionate, luminously direct response that inspired the earlier pictures, the later seem to be the products of artifice. They lack the mysterious power to move us, but we cannot withhold our admiration for the extraordinary dramatic power that the artist has brought to bear in order to bring home the momentousness of the events he has represented. These later works have a calculated eloquence that makes them seem almost Baroque beside the primitive simplicity of the earlier. The early Italian and Flemish masters were, usually in reproduction, Spencer's constant companions, but the cloaked Christ of *The Betrayal* suggests at least a passing glance at El Greco. I know of no contemporary work in which buildings are used with such effect to enforce our sense of awe: the menacing roofs against a lowering sky; the abrupt reminder,

in the form of a corrugated iron wall, that what is taking place is not a dream but something that concerns us here and now.

At the same time he produced a number of the almost purely retinal landscapes, of Durweston, Petersfield, or wherever he happened to be, that occupied him intermittently throughout his life. The contrast between the pedestrian efficiency of many of these and the vaulting imagination manifest in his religious pictures has often been remarked with surprise. Religious pictures, in particular very large religious pictures (indeed large pictures of any kind), are extremely expensive undertakings. Spencer had no source of income except painting and he could not survive, let alone paint huge Resurrections unless he painted saleable landscapes. These landscapes vary greatly in quality between such beautiful works as, for instance, *The Harrow, Durweston* (1920), *May Tree, Cookham* (1932), *Cedar Tree, Cookham* (1935), *Gardens in the Pound, Cookham* and *View from Cookham Bridge* (both 1936), and some very dry mechanical performances indeed. It is a mistake, however, to dismiss the landscapes, even the more pedestrian, as a manual equivalent of colour photography undertaken with an eye to immediate sale, for they serve at least three other purposes. They gave him hours of respite from the fearful effort involved in the production of large pictures, packed with incident and deeply felt; they refreshed his vision by constantly renewing his intimate contacts with nature; and they charged his fabulous memory.

During the years following his return home from Macedonia, the painting of the group of religious pictures, *The Betrayal* and the others of which I spoke just now, and still more the landscapes, were inadequate to express the grand conception that was taking shape in Spencer's mind. This was the expression, in a series of related pictures, of his experiences of the war, culminating in a Resurrection far larger and more complex than anything he had attempted, conceived as a series of paintings designed to embellish a chapel. As there seemed to be no prospect of its being realized, he used to call it 'the chapel in the air'. During a stay in 1922 with his friend Henry Lamb, the painter, at Poole in Dorset, in the course of two weeks the project assumed the form of a big cartoon, in pencil and ink, of the two side walls of a chapel, each divided into four panels, in turn divided into two and surmounted by continuous friezes. Mr and Mrs J. L. Behrend, who had already shown an interest in Spencer by buying *Swan Upping*, came to visit Lamb. Mrs Behrend's brother had been killed in the war, and they were considering the erection of a memorial of some kind to his memory. The visitors looked at Spencer's cartoons, admired them and afterwards made an offer to commission him to carry them out. 'Not good enough' was his reply. ('Our offer *wasn't* good enough,' Mrs Behrend said to me years

afterwards.) It was revised, renewed and accepted. On my first visit to Vale Studio the following year I saw a number of larger studies for the same project, together with one for the missing end wall. This was a *Resurrection* set in Kalinova, the gloomy Macedonian valley that had so irresistibly drawn him.

Nothing so convincingly illustrates the prodigality of Spencer's imagination or his unremitting industry as the fact that, having obtained a commission which would enable him to give expression to his most grandiose conceptions, he immediately began the Tate *Resurrection*, by far the biggest picture he had attempted. Few who saw it were aware that this immense picture was a sideshow. In the succession of Spencer's works it occupies rather the position of *The Painter's Studio* in that of Courbet's: an immense repertory of everything that had gone before. There was Cookham churchyard, depicted on a great scale yet with a wealth of detail: 'the holy suburb of Heaven' densely populated with figures rising from their tombs, the artist himself among them. A lyrical glimpse of the Thames and its park-like banks summarizes the country round about. There is one innovation: the presence of the first two Persons of the Trinity in the shadow of the church porch. Into this great canvas the artist poured the abundance of his loving knowledge of this place which meant more to him than any other; of this place which he loved not in a general way, but inch by inch of stone, plaster, brick, railing, tile, foliage, flower and grass, as though he had made it all himself. With Spencer it was always the people and the places that were known and loved, never the paint, and he painted them, for all his love, a little severely. Never, like Renoir nor Gainsborough, did he caress them into being, and his harsh, brisk treatment of paint often makes his work repellent to other painters. It is as though he saw the people and places of his pictures so completely in his mind's eye, with such sharp, final definition, that all he required was to transfer them, without modification and without embellishment, to his canvas. It is always *they* rather than their painted images who are the real subjects of his pictures. Although the Tate *Resurrection* is a summing-up of the artist's past achievement, it has one characteristic that marks it as belonging to the later period of Spencer's growth when his art had lost its God-centred simplicity and had become comprehensive. This picture is full of beauties, full even of splendours. It seems to me to be one of the great pictures of this century. Yet, in comparison with the best of the artist's earlier works, it is over-crowded, loosely composed, imperfectly focused.

In comparing the *Resurrection* which forms part of the memorial commissioned by Mr and Mrs Behrend, which was not begun until 1927, with the Tate picture, which was completed early the same

year, it should be borne in mind that in certain respects the picture carried out last was the first conceived, and is therefore nearer in spirit to the earlier works. This memorial, which is situated in the Berkshire village of Burghclere, consists of two ranges of almshouses flanking the Oratory of All Souls, the interior of which was designed to meet the requirements of the artist. The buildings were completed in 1927. From that year until his paintings were completed in 1931, the artist lived with his wife and two children at a nearby cottage. He completed the work without assistance.

When Spencer was able to begin work in the oratory, eight years had passed since he had made his first drawings, and five since the working drawings of the side walls had been completed. His experience of the war was too overwhelming to be expressed in paintings on an ordinary scale, admirable as some were, in particular *Travoys arriving with wounded at a dressing station, Smol, Macedonia* (1919). It began to crystallize around the Kalinova valley when he first saw it, and after ten years' meditation it expressed itself in a prolonged outburst of spiritual energy. The side walls of the oratory are scenes of military life: soldiers checking laundry, scrubbing floors; the arrival of wounded in hospital; wounded pointing out their kit-bags to orderlies and such. The artist makes us aware that these scenes are not mere records made by a detached observer, but records of his own intensely felt experience, shared by a crowd of other young men of his own age. There is, in fact, nothing peculiar, still less eccentric, about the experiences recorded; they are the common experience of soldiers. They are shown doing almost everything that soldiers do except fighting. So positive was Spencer's horror of violence that it would have been unnatural for him to represent it; but fighting occupies a smaller part of the time of fewer soldiers than civilians suppose. The irregularly shaped friezes above the series of panels are filled by two panoramic scenes, one of them the great tented camp at Kalinova at night. The culmination, not only of the paintings at Burghclere but, I believe, of the artist's life work, is the painting on the end wall of the oratory, behind the altar, *The Resurrection of Soldiers*. I quote my wife's description of it:

> Here he has painted the awakened soldiers holding their crosses. At first they only handle them, exploring them unknowingly. He shows the growth of understanding in all its various stages until at last in the full light of revelation the soldiers know that in suffering and death they have triumphed, and they are shown embracing their crosses in ecstasy.

The design is a great recumbent cross: its base a forest of crosses, and the extremity of the upright shows scattered crosses disappearing into the endless bleakness of the Macedonian hills. The crosspieces

extend from a solid nucleus of alert but recumbent mules, who we are sure will not be excluded from the Resurrection; just above is the figure of Christ, who receives the crosses the soldiers hand him or lay at his feet. I draw attention to the design because this picture, panoramic in its scope, crowded with figures, full of incident and subtle spiritual observation, forms a design as closely knit and delicately adjusted as it is magnificent. In contrast to many of Spencer's later works, which could, it would seem, be extended indefinitely in any direction, the Burghclere *Resurrection* has clearly defined limits, and the mass of detail, lovingly observed and meticulously set down, is severely subordinate to the principal theme.

The wall-paintings at Burghclere – inspired by a vast and lofty conception and carried out with mastery to the last detail – are generally regarded with respect, and from time to time they are acclaimed as a major work. But how trifling the stir they make compared with, say, the Chapel of the Rosary designed by Matisse for the Dominican Nuns of Venice. In a letter to the Bishop of Nice, the most illustrious French artist of our time wrote, 'This work has taken me four years of exclusive and assiduous work and it represents the result of my entire active life. I consider it, in spite of its imperfections, to be my masterpiece.' It scarcely needs to be said that a building designed (in association with the distinguished architect Auguste Perret) by Matisse and embellished by his wall-paintings – or, more properly, mural drawings on glazed tiles – and with a crucifix, an altar with its furniture, carved-wood confessional door, metal spire and certain vestments all designed by the artist, is a work of very great originality and distinction. Still less need it be said that it stands in brilliant contrast to the shabby and meretricious art so widely patronized by the Catholic Church today – an art which tends to substitute conventional pieties for religious truth. But one of the functions of a church is to fill those who worship in it with the sense of being in the house of God. In spite of every beauty that shining talent assiduously employed and was able to lavish upon it, the Vence Chapel remains spiritually thin. There is a story according to which the Communist poet Louis Aragon said to Matisse, after looking at the working model, 'Very pretty – very gay – in fact, when we take over we'll turn it into a dance hall.' Aragon's words may have been prompted by malice, but they were not spoken in jest. Of greater significance is the serious and extended statement in a booklet on the Chapel published in 1951 at the time of its consecration, in which Matisse declared: 'In the chapel my chief aim has been to balance a surface of light and colour against a solid white wall covered with black drawings.' I do not believe that Aragon would propose making the Burghclere Oratory into a dance hall, or that Matisse would have

described it as an essay in aesthetics; yet the chapel at Vence was a legend almost as soon as it was begun and the Oratory at Burghclere remains relatively unknown.

My comparison might draw from an admirer of Matisse the comment that, whatever the artist may have said about the Vence Chapel being his masterpiece, Matisse was not, in any specific sense, a religious artist nor one who expressed himself most naturally upon a grand scale. With such a comment I would not disagree. My comparison is not between two artists but between two works of art, and I believe that today's critical standards, according to which Matisse is a widely acclaimed master and Stanley Spencer a 'village Pre-Raphaelite' with an uncertain reputation in one country only, his own, will be regarded as very odd by future generations.

In the preceding volume I commented that Augustus John was 'on the way to become "the forgotten man" of English painting'. After I wrote those words he emerged from the shadows to become the somewhat undependable 'grand old man'. Still more obnoxious to fashionable opinion, cast as John's successor in the part of 'forgotten man', Stanley Spencer refused to submit, and from time to time engaged national attention with a canvas too large, too tumultuous and too intensely alive to be ignored. But it would be disingenuous to suggest that his work is unsympathetic only to fashionable opinion. Instances abound of the cruel sayings of illustrious artists about the work of their peers, yet among serious artists there is apt to be something approaching recognition, although this may be grudging or even tacit, of the qualities in one another's work. This may be so even between bitter rivals. Witness the Fourteenth Discourse of Sir Joshua Reynolds and the famous encounter between Delacroix and Ingres. In the case of Spencer this recognition is minimal. A few artists and critics have testified consistently to their belief that he was a major painter, but even these are mostly dead or belong to an older generation. The artists active today, whose work seems to me most likely to withstand the erosion of time, have expressed their small regard for his work, and, with a few notable exceptions, others, too, whose judgment I most respect share this disregard. Most of them admit to some respect for Spencer's early works; it is the later that provoke their positive aversion. I share their preference for the earlier works, the best of which, however, seem to me to occupy places so outstanding among the paintings of the age that the later, even though they do not rival them, may yet be of extraordinary interest.

The paintings at Burghclere I regard as the last of these earlier paintings, and, even if they lack the radiant purity of spirit that shines out of *Zacharias and Elizabeth*, as the greatest. Once his art ceased to be, in an intimate sense, a religious art, once it ceased to be

God-centred, Spencer's voracious interests ranged unchecked. Every-thing became grist to his mill, and his later pictures often give the impression of having been stopped only by the margin of the canvas; that, were a strip added, he would have filled it without premedita-tion. A comment of my wife's upon his conversation is peculiarly applicable to his later painting. After we had engaged in several hours' talk, I said to her that there were few subjects, however remote from his habitual interests, on which Spencer could not shed light. 'The trouble with Stanley,' she replied, 'is that he sheds too much light; and everything is so brightly lit that there isn't either light or shadow.' So in his painting; his passionate love of whatever he happened to see, abetted by an extraordinary skill, robbed his painting of emphasis, and there are in consequence pictures which have the monotonous look of a surface covered by some fantastic mechanical process. I once said to him that he'd be happy painting a white sheet, and he replied that this was so, and that a plain brick wall would keep him occupied for weeks. I do not suggest that he directed his powerful talents to trivial ends. On the contrary, he painted Resurrections and other religious subjects as well as others of deep human significance; but it does seem to me that in so doing he treated every object represented, every inch of the canvas, with an almost equal intensity, thereby robbing the whole of a great part of the intensity that is one of the greatest qualities of his earlier pictures. (It will not, I hope, be inferred from the foregoing that I regard Tintoretto as a greater painter than Chardin simply because he treated greater subjects. I mean no more, in effect, than that it would have been a misuse of his particular talents had Tintoretto artistically foregathered exclusively with loaves of bread.)

After the intense and long-sustained efforts required for the completion of the paintings at Burghclere Spencer returned to Cookham, living at Lindworth, a largish house he purchased. For the first year and a half his wife and their two children were with him, but later he was alone. Of all the people he knew Hilda Anne Carline, his first wife, whom he married in February 1925, commanded the largest share of his devotion. This did not, however, allay tensions that ultimately brought his marriage to an end, but his devotion to Hilda outlasted his marriage and endured until her death in 1950. The tenderness with which he nursed her during a last illness, made the more terrible by mental derangement, forms one of several heroic incidents in Spencer's life. In May 1937 he married Patricia Preece.

During these years he was mainly occupied with landscapes of Cookham – *Cedar Tree, Cookham* (1935) is a fine example – and the country round about, and occasionally with a religious subject. Although many of them appear to be the products of a hand of

extraordinary skill guided by an intensely keen but wholly unreflec-
tive eye – commonplace images mechanically transferred to canvas –
the landscapes rarely fail to reveal a quality that makes them less
unremarkable. This is his comprehending love of his native place,
and, by a process of extension, of all places. There is a compulsive
force about this love: those who look at Spencer's paintings of
Cookham and who might have been disposed to regard the place as
a slightly vulgarized 'up-river' resort, whose pleasant but urbane
traditional architecture is being steadily displaced by a species of
poor man's 'stockbroker's Tudor', are forced – however reluctantly –
to see it as a place very much on its own, the product of special social
and historical impulses, and, taken all in all, a very likeable place.
Spencer compels us to look closely at Cookham, just as Sir John
Betjeman compels us to be aware of Victorian churches and villas –
previously dismissed as monotonous eyesores, unworthy of serious
attention and differing from one another in little except in their
degrees of ugliness or absurdity – as *architecture*, subject to the same
laws as architecture of any other kind.

For the time being Spencer's huge exertions at Burghclere had
exhausted, and his widening interests in life had diluted, his religious
impulse. But something of it remained and proclaimed itself in his
occasional religious pictures, of which *Sarah Tubb and the Angels*,
Villagers and Saints (both 1933), and *St Francis and the Birds* (1935) are
characteristic examples. Indeed in some personal comments on his
work Spencer recorded that on the completion of the Burghclere
paintings he planned another chapel in 1933 'built also in the air as
was first the Burghclere Chapel, that is to say not commissioned'. He
planned according to an enormous scheme in which figure paintings
of the last twenty years, that one had regarded as independent works,
all had their place. 'All the figure pictures done after 1932 were part
of some scheme, the whole of which scheme when completed would
have given the part the meaning I know it had. Having completed a
memorial chapel in which I seek to express the joys of peace in spite
of being in the midst of war, I then hoped to express the same peace
in its more positive state in times of peace.' In this scheme 'the
Village Street of Cookham was to be the Nave and the river which
runs behind the street was a side aisle. The *Promenade of Women* and
the *Sarah Tubb and the Heavenly Visitors* and the *St Francis and the Birds*
and *Villagers and Saints* are fragments of the street scenes, and the
quite recent *Listening from Punts* Regatta scheme is a river aisle
fragment.' *Sarah Tubb, Villagers and Saints* belong to a cycle that he
called the Pentecost scheme, as does *Separating Fighting Swans* (1933),
'in which saints and angels visit Cookham, making trips round the
village and performing various acts of a benevolent kind'.

Dusting Shelves (1936), *Workmen in the House* (1935), *Love among the Nations* (1935–36), are also, according to the artist's account, part of the same scheme; he called them the 'Cana' cycle – it was begun in 1935 – and designed them to stress the value of friendliness and love and the importance of everyday actions. 'He called them the "Cana" scheme because the idea originated while he was working on a picture of *The Marriage at Cana*, in which women handling a trousseau played a major part.'

Let it be said at once that these pictures of 1933–35, and others of a like kind, express in varying degrees authentic religious feeling and contain passages of unusual beauty and power. But Spencer had set himself towering standards as a religious painter, and according to them the three pictures just mentioned cannot be accounted as more than minor works. Their minor character, in fact, is manifest throughout, but in nothing so much as the manifestations they exhibit of a desire to shock, even to outrage – a desire nowhere apparent in the earlier works, even though these abound in examples of the most idiosyncratic treatment of the human figure. There is, for instance, something clamoring for attention in the figure of St Francis, bloated, hunch-backed and supported by the atrophied legs of a lazy old man. (According to the artist, the figure of St Francis is large and spreading to signify that the teaching of St Francis spread far and wide. He adds that 'the composition was developed from a drawing made in 1924 of Hilda Carline reading in a haystack. The ducks and poultry were taken over almost unchanged, while St Francis and the roof were fitted into the main lines of what was originally the haystack.') This turbulent undercurrent no doubt sprang from the painful consciousness that his religious impulse was less vigorous and less elevated than it had been.

Since the time of the Burghclere wall-paintings Spencer's imagination would appear to have been dogged by certain obsessions, and in particular by sexual obsessions of an extraordinary character. Unlike the roseate fantasies of most men, these obsessions were concerned with relations between the ugly, the infirm, and, above all, the aged. I do not pretend to be able to cast much light upon this. Spencer's mind was always opposed, in one important respect, to the classical mind, to which there is almost always vividly present the conception of the perfect thing – be it the human face and figure, bird, beast and even tree – towards which it is one of the functions of classical art to evolve slowly. Anything approaching the perfect type of anything, and almost all manifestations of conventional beauty, always repelled Spencer; he showed a preference, which hardened with the passage of time into a grim determination, for beauty of a very personal sort mined from shafts sunk in unpromising or even

forbidding places. It is therefore hardly to be expected that in his erotic imaginings either the classical beauty or her popular equivalent, the 'cover girl' – the lowest common denominator of feminine desirability – should play any part; but his preoccupation with the sexual relations of the aged – for such is the focus of these imaginings – is something for which I know no precise parallel. Singular though this preoccupation may be, it accords with certain of his innate predilections. It accords, as I suggested just now, with his rejection of idealization: for the old, whether battered, worn, corrupted or ennobled by their journey through life, are of all humanity the farthest removed from 'perfect types'; of all humanity they are most conspicuously personifications of their virtues and their vices, the most vividly revealing of themselves. If at times they may disgust us, these aged lechers who figure, for example, in *Adoration of Old Men* (1937), it would be a serious error to forget the inclusiveness of Spencer's love, a love which embraces virtually everything he saw – certainly his old lechers – except ideal types of humanity or of anything else. Although he rejected all idealization, I do not believe that he ever saw a man or woman who was, in the classical sense, ideal; but had he been commissioned to paint a portrait of Adonis he would have emphasized a lopsidedness in his face, and a strange look in his eyes which nobody had ever noticed before. Spencer's predilection was heightened, I think, by his enthralled identification, in those early and radically formative years at home in Cookham, of his parents with sex, which persisted in the form of an identification of sex at its most active with persons older than himself.

Whether this time of absorption in singular manifestations of sex had abated by the Second World War I am not certain, even though I saw him more continuously on the eve of it than at any previous time, for it was in 1938 that he spent the autumn at our house. My impression was that the acute tensions that stimulated his sexual imaginings until they acquired a peculiar domination over his work had begun to relax. It was an almost invariable habit with him to speak about what was uppermost in his mind, and although, in the course of the months he spent with us, his conversation ranged over a vast variety of subjects, the one to which he most often returned was a project for a series of paintings representing Christ in the Wilderness. This series of paintings, each measuring twenty-two inches (fifty-six centimetres) square, he planned to extend to forty, and he spoke of his wish that each in turn should be shown somewhere on a successive day in Lent, or else all together in the hexagonal or octagonal vault of a church, where the figures, in dirty white, would have the appearance of clouds in a 'mackerel' sky. The series was begun with *Christ in the Wilderness; 'The Foxes have Holes'*

in the rooms which my wife found for him in nearby Adelaide Road, and which he occupied from Christmas 1938 until 1940. He often used to speak of the way in which Thoreau's *Walden*, and to a lesser extent the writings of Richard Jefferies, gave him a deeper understanding of the relation of men with nature, and in particular of the possibilities of living a passionate life alone in a wilderness:

Spencer wrote an account of this series for Dudley Tooth, who kindly put a copy at my disposal:

> Christ may have felt as I have sometimes felt when I have revisited after many years a corner of a field where I had painted a clump of stinging nettles, and have found them there again, hardly altered. I want to show Christ in the Wilderness happy to see His early creations again and to be intimate with them: through Christ God again beholds His creation and this time has a mysterious occasion to associate Himself with it. In this visitation he contemplates the many familiar, humble objects and places: the declivities, holes, pits, banks, boulders, rocks, hills, fields, ditches, and so on. The thought of Christ considering all these seems to me to fulfil and consummate the life of wishes and meaning of all these things.

The second of the series, *Christ praying in the Wilderness*, also constantly occupied his mind. This he intended as a dual revelation of God under two aspects, Himself and surrounding nature. The form of the praying Christ would have its complement in the altar-like boulder before which he would kneel, but without having to change its natural form. He stressed at this time, as often before and after, that he never wilfully distorted nature. 'People who are not painters,' he said, 'never see how complicated nature is, a group of moving people, for example. I want to express certain ideas, certain feelings I have about people, or about places. If I could express myself clearly and forcefully without any distortion of nature I would do so, but to do that I would have to draw as well as Michelangelo. It's too bad that I don't draw as well as Michelangelo, because it means that in order to say what I want I have sometimes to pull and push nature this way and that.' But in this picture, he said, 'I hope there will be no such strain: Christ's desire to pray and a boulder's roughly assuming the shape of an altar would come inevitably together.' Here and there he intended to introduce features that had a special meaning for him, such as a place beside a stream where the water had worn away the bank and made a little bay with a shingle beach. Such little bays along the Thames, with steep sides and shingle beaches, were favourite places to play in when he was a child. The idea sometimes troubled him that Christ should be thought of as speaking in a derogatory sense of anything in nature, of a scorpion or a fig-tree for example, and in this series of pictures he wished to show Christ's loving

intimacy with all nature, and his being entertained by his creation 'as I sometimes am by my pictures'. If Christ ever referred in such a sense to anything he had created, he would only have meant it in the sense described in the particular instance rather than in general. Therefore he had it in mind to show Our Lord's affectionate contemplation of a scorpion. He was more preoccupied, however, with the theme of Christ's contemplation of a stone, and often spoke of the many references to a stone in the Old and New Testaments and in particular of 'the mysterious words about a stone in "Revelations" which I have long wondered about. "To him that overcometh will I give to eat of the hidden manna, and will give him a white stone, and in the stone a new name written which no man knoweth save he that receiveth it." ' These words held a special meaning for Spencer, and he said that they revealed how he found his identity in the variety of places and objects he came to know. It was clear from his frequent talks about this project that it was not part of his aim to draw a distinction between man and the rest of nature, but rather to reveal, by a kind of analogy, Christ's love for mankind by showing 'how He lived in the wildernesses and forests, the fleshy lands of mankind'.

However, long before *The Forty Days in the Wilderness* was completed he left London to live for a while at Leonards Stanley, a village near Stroud in Gloucestershire, where I saw him from time to time occupied mainly with landscape. By the following year, 1940, he was committed to a project far greater in scale than *The Forty Days* and of infinitely greater complexity, a project that called for the fullest use of all his powers. The War Artists' Advisory Committee – set up in order to organize the making of the most comprehensive possible record of the multifarious exertions of the British people – decided to send Spencer to Port Glasgow to make paintings of shipbuilding. At first he applied himself dutifully and to some purpose, the principal product of this application being the *Shipbuilding Series* (1940–45), a series of big pictures lacking focus, the area of which might have been added to indefinitely without significant addition to their impressiveness. They contain representations of people and things of unusual clarity and energy, but they are the least impressive of Spencer's big works. The arid mechanical character that stamps them is due to the gradual reversion of his attraction from the shipyards which he was commissioned to record to the inevitable objects of his uncommissioned interest: people and places. That the shipyards proved sufficient, or almost sufficient for a time, the big composite picture testifies. But, as Spencer wrote in his notebook,

> I soon found that the shipyard at Port Glasgow is only one aspect of the life there. There were rows of men and women hurrying in the streets, and high sunlit factory walls with men sitting or standing or leaning

back against them, and early shoppers going to and fro; one day through the crack of a factory door I glimpsed a cascade of brass taps; in a roadway (a very trafficky one) I saw children lying on the ground using the road as their drawing-board and making drawings in coloured chalk; and there was a long seat on which old men sat removed from the passers-by like statues . . . all this [he continued] seemed to me full of some inward surging meaning, a kind of joy, that I longed to get closer to and understand and in some way fulfil.

And then it came about, as it had come about before, that the recording of all this interest in the life about him, panoramic and minute, impassioned and vivid as it was, was a work that, by itself, failed to bring his highest faculties into play. All this various teeming life had to be drawn together and related by being made subordinate to some large idea. The number of large ideas to which even the most versatile of artists can respond with the whole of their being is very limited. In this Spencer was no exception. It was therefore, as I heard him say, and later read in his notebook:

Back to the Bottle again: I had to paint another Resurrection.

I felt that all this life and meaning somehow grouped round and in some way led up to the cemetery on the hill outside the town, an oval saucer-upside-down-shaped hill hedged in by high red brick tenements looking down on it; a sort of green mound in a nest of red. . . . And I began to see the Port Glasgow *Resurrection* that I have drawn and painted in the last five years. As it has worked out this hillside cemetery has become The Hill of Sion.

An identical emotion can affect different people in different ways. Love of his own country, for example, can make one man hostile to foreign countries yet give another a heightened appreciation of them. Spencer's love for his native place was not an exclusive one and it stimulated his delight in other places, and on particular occasions it brought him to fall in love with them, and when he loved them he was liable to celebrate the relationship by making them the scene of a Resurrection. There was the particular place among the Macedonian hills, and there was Port Glasgow. At Leonards Stanley in 1940, where he was mostly occupied with landscape of a relatively conventional character, there came a moment when he was moved to imagine a Resurrection in the small nearby town of Stonehouse. The result of this imagining was the triptych *Resurrection: Raising of Jairus's Daughter* (1947), of which the two outer panels were drawn in 1940 at Leonards Stanley, although the work was finished in Port Glasgow. Despite its inspiration by a photograph seen in the house where he lodged at Leonards Stanley, and the representation of Stonehouse Church in the left panel, this picture may be placed in the Port Glasgow group, and indeed as one of the best. Spencer's relationship with Port

Glasgow was more passionate and of longer duration than that with the Gloucestershire valley. That Port Glasgow, lived in during the bracing climate of the war, stirred his imagination as no other place since Macedonia, the pictures clearly testify; but these pictures – impressive in scale and quality as they are – form only fragments of the gigantic picture he originally conceived, which called for a canvas fifty feet wide. In fact, of all the Port Glasgow pictures, only *The Resurrection: Port Glasgow* (1947–50), and *The Hill of Sion* (1946), are on the scale of his original project.

In considering this vast interrelated group that grew up about *The Resurrection: Port Glasgow* – to which, were the painter still alive he would doubtless be adding panel by panel still – the mind inevitably turns back to the only two works in the art of modern England with which they can be at all closely compared: their predecessors, the *Resurrections* at Cookham and in Macedonia. From these two the later group differs so importantly in one respect as to compel us to assign it to an inferior place among his works. Let it be said at once that the Port Glasgow group are works of an extraordinary character. I know of no painter in England, or indeed Europe, who could express himself, with perfect naturalness, upon so gigantic a scale, who could so easily pack so huge a space with a harvest of such intense and original imaginings and such sustained and minute observation that his constant need was for more space and still more space.

Nothing, for instance, could be more unlike the authentic bigness of Stanley Spencer's conceptions than those of Sir Frank Brangwyn, the other English painter who habitually painted large. To Brangwyn belonged big, bold, indeed a somewhat swaggering, handwriting and abundant physical energy, which misled him and other persons and corporate bodies into supposing him to have been a painter who worked naturally upon a heroic scale. But even a superficial examination of a big picture by Brangwyn will show that, at a loss as to how to fill the space he claimed, he introduced exotic heaps of fruit, bubblelike clouds and other romantic stage properties to garrison, so to speak, areas which he lacked the power to colonize.

The power of genuine expression upon a great scale is an indication of exceptional creative power, but it is not a proof of it. However heroic in scale, however packed with intense, closely related incident, a work may yet fail, and I believe that the qualities of the Port Glasgow pictures – for all their notable characteristics – do fail according to the standard set by their two great precursors. The chief cause is that they fail fully to perform their function, the representation of the Resurrection. No matter the variations of emphasis that differing traditions may place upon the event, there is no question of the awfulness of the call, coming like a thunderclap, that will end for

ever the daily round of the living and will bring from their graves the countless millions who are now dead, and will be a warning momentous beyond reckoning – the most momentous warning any man has ever heard – that they must shortly face the ultimate ordeal of human existence, the Last Judgment. In order to represent the Resurrection it is necessary to represent the people, called and rising from their graves, but it is also necessary to show that they are entering, in a uniquely intimate yet awful fashion, into the presence of their Creator. In the Cookham and Macedonian *Resurrections*, despite the loving and minute way in which the artist has dwelt upon the resurrecting people, he has also charged the atmosphere with momentousness, which compels us to listen, as it were, to hold our breath, to await intently what is to follow. In the Port Glasgow pictures the artist has concerned himself only with the people: their rich variety, their distinct personalities and conditions, the touching relations between them; but what he failed to give is any sense of their doing anything beyond emerging from their graves. Of the imminence of the Last Judgment, or even that there is anything momentous – as distinct from extraordinary – about what they are doing, he did not give the slightest hint.

What he gave instead is anecdote: anecdote grandly, at points even splendidly, conceived, but anecdote none the less. Always conscious of the presence of the dead, ubiquitously buried underground, the Port Glasgow *Resurrection* is a gigantic Cookham conversation-piece; the presence of God and the significance of the Resurrection are elbowed out by the surging crowds of the quick and the dead, the throng of Cookham villagers lustily shoving and pushing, meeting and embracing, doing this, that and the other, and endlessly gossiping. Absorbed as Spencer was in the day-to-day life about him, the holy suburb of heaven became an uncelestial suburb of London, and he himself much more a village Rowlandson than a village Giotto. The difference between the two earlier works and this one corresponds to the difference between the related scenes from the Old and New Testaments represented by the painters of the twelfth and thirteenth centuries, and the episodic popular moralities and fables favoured by those of the later Middle Ages. The light that Spencer was able to throw upon any great matter falls too uniformly, illuminating everything well, yet illuminating nothing with the intense brightness that belongs to his most inspired moments.

Like Constable and Wordsworth, Spencer received his most powerful and his most fruitful impressions in childhood. The joy of being able to perceive the essence of a particular place or situation in all the fulness of its meaning is the motive power of his art. And this joy really belonged, he wrote, 'to all the happy and benigne (*sic*) religious

elements of my early days ... In fact nothing has (for me) any meaning of form and shape excepting it is perceived in this religious joy.' It is a melancholy intractable fact that this artist whose mind was stored with so great an abundance of visual images, and who was so generously responsive to his surroundings, in the course of more than forty years of painting moved far from the original source of his inspiration, and, inevitably, something was lost. Two things, however, were not lost, or even weakened – the prodigality of his imagination and the urgency of his effort to express 'a particular meaningfulness' inherent in a place or situation.

I must add, however, that Spencer himself, who was the first to confess the fading of a vision in 1922–23, also underlined the adverse effect of his inability to see or to complete the whole of the painting schemes that he conceived. In connection with the pictures of 1933 to 1935 and with the later *Listening from Punts*, for instance, all conceived, as already noted, as parts of one whole, he wrote in his draft introduction to the catalogue of the retrospective exhibition at the Tate Gallery, 1955, that:

> the whole work was far too big for me to undertake unless I could devote the whole of my time to it and this I was far from being able to do. The not being able to see the *whole* of my way had the same effect on the way I painted as occurred if and when I painted in a state of doubt.

In consequence, as he continues,

> as and when I painted them, I never felt the joy I needed to experience in doing this work that I should have felt had I known that I could complete the scheme. The work suffered. They have not the conviction that comes with joy. As I have done them the knowledge that the final meaning may never be done has had a crushing effect.

When *The Resurrection: Port Glasgow* was exhibited in 1950 the artists whose work I most admired and whose opinions I generally respected were among its severest critics. When the canvas proposed for the Tate came under consideration, their murmurings against it grew in volume and acerbity. It was acquired, in consequence, only after many difficulties had been overcome. But there were others besides professional painters whose antipathies it provoked. At the Academy Banquet that same year I took an opportunity of inviting the opinion of Sir Winston Churchill. In response to a request for my opinion, I pointed to the backstretching arm of a figure in the left foreground, saying that if the critics of the picture saw, for instance, such an arm on the murky wall of some church in Italy they would recognize it as masterly. 'But it is incorrectly articulated,' he objected, extending his own left arm in a similar position, 'you must admit

that.' 'I don't admit it,' I had to reply, 'and I have the advantage of being able to see both arms.' 'I concede that,' he said sternly, 'but I still don't like the picture; and moreover, if that is the Resurrection, then give me eternal sleep.'

Although it does not constitute an excuse for some of the picture's shortcomings, it is relevant to mention that the artist never had a room large enough to accommodate the whole work, and that he never saw it until the pieces were put together at Burlington House. Not long before its exhibition, I paid a visit to Cliveden View, his tiny house at Cookham. Disjointed fragments of the picture stood in various rooms, the largest of which no wall was able to accommodate, and it covered a part of the floor as well. Spencer, brush in hand, feet in socks, walked with loving circumspection about its surface.

In the summer of 1952, while I was engaged upon these pages and meditating upon the extraordinary power which continuously emanated from the tiny person of Stanley Spencer, manifest in his painting, drawing, conversation, in the endless succession of his ideas, in the energy to give them substance and form, he himself arrived. 'Back at the bottle,' he announced, opening a portfolio. 'This time it's Christ preaching from a boat at Cookham Regatta.' Kneeling on the floor he laid drawing against drawing until it was all but covered with them. He confessed to his jubilation at being able to see, on our own drawing-room floor, all the sketches for this project together, and described the several ways in which he had tried unsuccessfully at home to gain this comprehensive view. As he talked, he created out of sixty or so slight but careful pencil studies, the compelling image of Christ speaking to multitudes who stood pressing towards Him on the lawn of a Thameside hotel and who sat in innumerable boats; a vast multifarious repertory of the life of Cookham focused on the figure preaching from a boat.

Spencer continued to paint until the end of his life. On 14 December, 1959 he died at Taplow. Retrospective exhibitions of his work were held at Temple Newsam, Leeds, in 1947 and at the Tate Gallery in 1955. The Stanley Spencer Gallery was opened in Cookham in 1962. He was made a CBE in 1950 and in 1959 received a knighthood.

MARK GERTLER
1891 – 1939

Two contradictory views prevail about Mark Gertler: the one is held by those disposed to favour art that is produced near the centre from which the dominant style of the time radiates; to the other incline those who are disposed to believe that the only way for an art to be universal is for it to be local and particular. Gertler became a painter with a style of his own, the product of a highly personal character and of an immediate environment that offered the strongest contrast to the rest of the society in which it was set, and narrowly circumscribed. He emerged from the environment that had so largely formed him early in life, and was drawn within the orbit of Post-Impressionism. To some, therefore, Gertler was a gifted provincial whose art ripened as it moved ever nearer to the Parisian sun; to others he seemed an inspired provincial whose art lost its savour as it became more metropolitan. The despair with which the painter was afflicted at intervals throughout his life sprang from doubts about the road he had taken, as well as the genuineness of his talent.

Both views are extreme, and when I visited the discerningly selected memorial exhibition at the Whitechapel Art Gallery in 1949 – where it was possible for the first time to see the whole range of the artist's work – it seemed to me that while neither view was fully confirmed by the pictures, something of an impressive and even startling rarity died gradually away as his art conformed more and more closely to the accepted canons of Post-Impressionism, although certain gains, notably in solidity and concentration in design, were also apparent.

The spirit and form of a work of art are indissolubly interconnected, for the first can find expression only through the second, and yet it is a commonplace that there are works simple, even elementary, in form which touch deeper chords than others more elaborate and accomplished. The impression left by the exhibition was that in the course of his life as a painter Gertler's powers of expression grew but that what he had to express diminished: with him, it was, so to speak, youth that knew, and age – middle-age at least – that could. If Gertler had been an abstract painter, or even an exponent of the then fashionable doctrine of 'significant form', the increase in his powers

of composition, of giving weight and solidity to his forms, might have compensated for the ultimate weakening and coarsening of his sense of actuality, his sense of the dramatic element in life. But Gertler was not solely, not even primarily, concerned with the making of coloured forms which should be their own justification; he was a man whose art was deeply implicated in life. It therefore seems to me that in spite of the indisputable aesthetic qualities of his later work, it was the work of his youth that expressed what was finest in him and what was most intimately his. It is for this reason that I propose to give most of my attention to this painter's beginnings.

Gertler was born on 9 December, 1891, although he always gave 1892 as the year of his birth. (It is an odd coincidence that Stanley Spencer, who was born that year, also supposed 1892 to be the year of his birth, and did not discover his error until he was past fifty.) He was the third son and fifth child of Louis Gertler, master furrier, and his wife Golda, born Berenbaum, of a family of emigrants from Przemysl in Galicia. Shortly before the artist's birth his family decided to 'try their luck' in London, but the foothold they gained there was a precarious one and only a year afterwards they were returned with the help of the Jewish Board of Guardians to their native country 'with only me, as it were', the artist wrote many years later, 'to show for it'. Although he was born in London, at 16 Gun Street, Spitalfields, he lived from 1893 until 1898 in Galicia.

After the artist's death a typescript was found in his studio. This proved to be an autobiographical fragment he had written covering his earliest years, and of this document I have been permitted to make use.

Because of their obscurity and poverty, the Gertler family belonged to an order of society the members of which leave behind few records or none at all. There is, therefore, no way of checking the accuracy of these fragments, but they affected me not only as a truthful but as a singularly candid narrative, yet free from any trace of exhibitionism. They are written in a lucid, informal style, and it is to be regretted that Gertler did not live to complete the annals of his full but troubled life.

This candour is manifest on the first page of the typescript. A constant and affectionate friend, the friend, in fact, who had given him the most encouragement for his projected autobiography, gave, on a formal occasion, a considered judgment of Gertler's character. 'It would be nonsense to call him a good man,' wrote Sylvia Lynd in her introduction to the catalogue of a posthumous exhibition, '. . . and I doubt if his behaviour was ever consciously influenced by any moral consideration.' Mitigating considerations follow this downright declaration, and these I will take into account later on. But for the present

my purpose is to show with what frankness and promptitude Gertler acknowledges the freedom of his family and himself from moral scruples. 'I don't know exactly how old I was and unfortunately I cannot ask my family to help me,' runs the first sentence of his autobiographical fragment, 'because the first incident I remember with clarity contains a certain amount of deception, even slyness on my part.' He is four years old and the family is still in Austria. It is winter and his mother incites an elder brother to steal a warm coat from the factory where he works so that the little boy may be protected from the cold. The mother promises, if he is successful, that she will pretend that the coat is a present from his father, who is in the United States. Pretending to sleep the little boy listens to the conversation between his mother and brother. In due course the brother brings back the stolen coat. This is his only clear memory, he tells us, of the five years he spent with his family in Austria.

In relating this incident he does not justify his mother's and brother's conduct on the grounds of their desperate poverty: he treats it as a commonplace occurrence, and the only moral consideration he voices relates not to the incitement to steal and the resulting theft, but to his own deception in pretending not to hear what in fact he heard. Throughout his life Gertler had a hatred of deceit and was particularly straightforward about money: if he needed £5, say, he would ask to be given £5; he would not pretend he was borrowing it. He had a strong sense, too, of human dignity which mitigated deficiencies of moral conscience in the conduct of daily life. Consciously or not, I think that his love of what seemed real to him and his revulsion from what seemed unreal impelled him to proclaim, in this first paragraph, his detachment from moral considerations.

If Gertler's family had been miserably poor in their brief stay in London, in Austria their plight became desperate. Their relations clubbed together to buy them a little inn on the outskirts of Przemysl, frequented mostly by drunken soldiers, but the inn failed and his father tried hawking boots, then buttons . . . 'he actually went out into the market-place, with both my brothers – he, a very, very proud man – and in that market-place where he was so well-known – and managed to articulate in a sort of shy undertone, "Buttons, Buttons".' But nobody bought his buttons, and, unable to support the misery of his family, he became determined to try his fortune in the New World. 'Let me have a clean shirt, Golda,' he said, 'for this evening I go to America.' During his absence his family suffered the direst poverty: at one time their mother worked in a restaurant, her only wages being scraps of left-over food. But after about four years word came from their father that things had gone well – it seems that he had entered the fur trade and learnt some new process – and that

they were to meet him in London. Although Gertler's memories of Przemysl remained vague, from the time of the journey to England 'the kernel of each event remains vivid, and the essentials connected and alive'. The arrival is vividly recalled: 'I am standing surrounded by my family all ready with heavy packages straining from their necks, pressing their backs. All available limbs are grasping rebellious packages. My mother strains her eyes and says, "Oh woe is me, but I cannot see your father. He is not there, he is not there . . ." ' Later he caught sight of a bright-coloured shop – Gardiner's of Whitechapel. 'Mother, does the king live here?' he enquired. It was then, he wrote, at the age of six, with Yiddish his only language, that his true life began. This life was hardly begun when he suffered one of those fits of acute depression which afflicted him throughout his life and at last cut it short. The Gertler family – all seven of them – spent their first night in one of the two tenement rooms in Shoreditch of a friend from Przemysl, and the sight of them lying in a row on a floor covered by sacks brought on a fit of depression that he always remembered as the first which he consciously suffered.

They lived with the friend from Przemysl until their father found work sandpapering walking-sticks at 12/6 a week which enabled them to set up a home of their own. At this point Gertler breaks off his narrative in order to describe an expedition to the scenes of his childhood made with his wife in the mid-1930s. He notes 'the greater vitality' of the life there, the way in which 'the rich dark-complexioned boys and girls seemed to move and talk with unusual intensity, as if life was fearfully important', and finally he describes their visit to the ancient, dilapidated synagogue he had formerly attended. On first entering, scarcely able any longer to talk Yiddish, he felt extremely uncomfortable, almost a stranger, but by degrees he was drawn momentarily back to the observances of his earlier years. How admirably he describes their visit! The preliminary conversation with the 'shumm', a sort of verger – who, puzzled by their wishing to visit this derelict place, tries to persuade them to go to a smarter synagogue where, he assures them, there are 'well-to-do people' – is related with economy and humour. But the best part of the entire account, to my thinking, is the description of their entry into the building.

> Yes, it was impressive, the same as ever – scattered here and there, sometimes in groups, sometimes single were these same magnificent old men I used to know. The long silver beards and curls, looking like princes in their rags and praying shawls – swaying, bending, moaning, groaning at their prayer. Passionate, ecstatic, yet casual and mechanical. Lucky old Rembrandt to have lived in a time when such subject matter was still fresh, when it was *right* to paint these men. They look magnificent; but I do not want to paint them. As soon as we entered they noticed our presence, and began slowly but surely to make their

gyrations more towards our direction, so that, at last, it seemed almost as if their prayers were directed at us. Meanwhile, one praying man near me pushed a prayer-book into my hand, and looking down at its opened pages, I found that I had even more completely forgotten my Hebrew than my Yiddish. However, I too began to bend a little, moan a little, and sway taking care to do so in the direction of the main group at the far end of the synagogue – whose curiosity had made them turn towards ours . . .

In part it was, perhaps, a reassertion of old habits, but – for Gertler was always quick at mimicry – in part it was an exercise of his ready and abundant gift of mimicking what struck his imagination.

Before resuming the narrative of his childhood, he made another excursion to the near present: this time to speak of an old cat – a 'visiting' cat of which he had grown fond. But his wife was away, and the neighbours to whom the cat belonged left, and then the tenants from downstairs, and with them most of the animal's means of subsistence.

How much older, decrepit, shabby and down-at-heel he was looking! Then yesterday – the final blow – an empty house, just he and I . . . At about 3 o'clock yesterday afternoon I got panicky. How silent the house was . . . But I have another whole month here . . . I am suddenly frightened, I don't even know how to get through the next 3 hours, till my teaching . . . Damn! the cat is getting on my nerves. All right, all right, we'll have tea. Heavens, there's no milk . . . The cat is still meowing and looking me straight in the eye. I can stand it no longer. I kick him down the stairs! Yes, I kicked him. This morning the man came with the brown basket. Goodbye cat . . .

This small drama of the lonely man and the plaintive cat left alone in the empty house sheds as clear a light upon Gertler's character as the episode of the stolen jacket. There is a touching quality in his sorrow because 'the old cat has been carried off in a basket to be "put to sleep" . . . I shall never see him again,' a sorrow uncomplicated by his own capricious responsibility for the cat's death, and the truthfulness with which it is all related. The power to feel keenly, moral irresponsibility and innate candour – all are richly manifest.

When he resumes his narrative it is to describe his school days. When he was seven years old he was sent to 'Chaida', or Hebrew class, taught by an old rabbi who used to read out the Old Testament in Hebrew, translating into Yiddish 'in a rapid, hardly intelligible, monotone, and we had to drone on after him, repeating the parts we could catch, and filling up the rest with noises that meant nothing whatsoever'. One day this harmless if unfruitful curriculum was ended abruptly. His parents, who lived in an almost closed society of eastern European emigrants, rarely moving far from their home and with few contacts with the larger society about them, knew nothing

of their obligation to send their children to school. The visit of an angry inspector led to Gertler's enrolment at the nearby Deal Lane School which he thus describes:

> It was a hot day, and as soon as we joined the queue, my mother for some reason lifted me into her arms and held me there in a manner she used when I was younger. I felt uncomfortable but did not protest, and soon I began to notice beads of sweat gathering, like pearls, on her forehead and temples, then join and trickle down her cheeks in thin glistening streams. Then I heard a woman saying, 'Why do you carry such a big boy in your arms, Mrs? Ain't he old enough to stand?' I felt ashamed and tried to wriggle down, but my mother gathered her arms around me tighter, and held me there, not deigning even to answer the woman.
>
> At last our turn came to approach the desk, at which a man was sitting, very stern and angry, making us feel from the start that we were somehow in the wrong, and that he jolly well meant to 'let us have it'.
>
> 'Put that boy down, *at once.* He's not a babe! Name of Gertler, I see. What's his *christian* name?'
>
> Of course my mother could make nothing of it at all, until some woman at the back came to the rescue. 'Mux,' she said.
>
> 'Mux,' said the man, 'never heard such a name – no such name in *this* country. We'll call him *Mark* Gertler.'

Towards the end of this autobiographical fragment (which covers only thirty-two small typewritten sheets) he mentions various circumstances of his upbringing which afford further insight into his character and situation. In desolation at finding himself at a strange school,

> I glanced at the children nearest me, as if to discover whether I dare give way to the tears that were choking me, but realized instantly that here was a new situation; that here, in this atmosphere one must try *not* to cry, and I succeeded in controlling my emotions – perhaps for the first time in my short life.

Both the total absence of any parental training in self-control and the sobering impact of a strange society in which a measure of self-control was the rule clearly emerge from his description of his entry into school. And both these circumstances coloured his relations with the society into which he shortly emerged, a society in which, in spite of much success and many friendships, he felt himself at heart a stranger who continually exposed himself by his inability to control his feelings, and therefore at a perpetual disadvantage among people cooler and more disciplined. Self-control was made the more difficult by continual lack of sleep. Golda Gertler, completely self-sacrificing although she was, used him unwisely:

> unfortunately like most people . . . some of the most important things in connection with the upbringing of a child were quite unknown to

her, and I consider the most disastrous of these was the fact that we
were allowed to go to bed at any old hour . . . I was a very nervous,
highly-strung and emotional child, somewhat undersized, thin and
pale, yet I would hardly ever be put to bed before . . . midnight, and at
weekends . . . long past that hour.

This constant lack of sleep in his childhood no doubt played its
part in weakening his nervous system, and in particular in darkening
and prolonging his fits of depression.

While he was at Deal Lane there occurred what was beyond
comparison the most important event of his life. He noticed a poster
advertising beef extract; the impression it made was heightened by
the sight of some still-lifes by a pavement artist, and he began to
draw still-lifes on the pavement beside his parents' house. Encour-
aged by the oil paints and watercolours that his family gave him and
– according to a persistent tradition – by the reading, on long-
continued daily visits to a bookshop, of *My Autobiography and
Reminiscences* by W. P. Frith, he determined to be an artist. At the age
of fifteen he briefly attended classes at the Regent Street Polytechnic,
and in December 1907 he started work for five shillings a week (with
the promise of 7/6 after the completion of six months satisfactory
service) with Clayton and Bell, glass painters, at 311 Regent Street.

In October of the following year I had a glimpse of him. My parents
were living at that time at 11 Oakhill Park, Hampstead, and here, on
hearing the front-door bell ring, I used occasionally to hurry to the
hall and open the door before the maid arrived. Doing so that day I
was confronted by a shortish, handsome boy with apricot-coloured
skin and a dense mop of dark brown hair so stiff that it stood on end.
I took him for a barrow boy, but he said he had been sent to see my
father. I was seven years old, but I still remember his nervous, sullen
look. Years later I was told that he was accompanied by his elder
brother Jack, who used to carry his paintings and slip away upon
arrival. I would not, of course, have known the year let alone the date
when this unimportant encounter took place had I not seen, quite
recently, the letter, dated 8 October, which my father wrote to
Gertler's father. 'Your son,' it runs, 'as you know came here yester-
day . . . I do sincerely believe that your son has gifts of a high order,
and that if he will cultivate them with love and care . . . you will one
day have reason to be proud of him . . .' His parents framed this letter
and hung it up in their house, and he preserved it after their deaths.

The educational society which had sent Gertler to see my father,
acting on the advice he gave, sent him to the Slade, where he
remained from 1908 until 1912. His precocious abilities won him
immediate success: he was awarded the Slade Scholarship for the
sessions 1908–09 and 1909–10, a first prize for head painting, and a

second prize for painting from the cast, and in 1909 a certificate for painting: an outstanding record. But besides jumping through all the hoops, he became, in the warm yet invigorating air of the Slade, a painter of impressive powers. Some of the pictures he painted while still a student take their place among his finest works; and surely among the finest painted by a student during the period considered in these pages. Of these *The Artist's Mother* (1911) has a place apart. I saw this portrait in 1944, and proposed it for purchase by the Tate under the terms of the Chantrey Bequest; this work, by an artist not yet twenty years old, emerged without discredit from the searching criticism of my Academy colleagues on the recommending committee. *The Artist's Mother* possesses in abundance the essential quality of a portrait: the power of evoking an entirely convincing presence. In the presence of a self-portrait by Rembrandt we are in the presence not of paint and canvas but, miraculously, of Rembrandt, a silent and immobile Rembrandt, but of Rembrandt himself. So, lower in the scale of creation, does Gertler evoke the presence of Golda, his mother, who without the rudiments of education, without having seen a picture, from the first apprehended a mysterious difference between her youngest child and his brothers and sisters, and even the importance of the strange calling to which her son was dedicated. In his mother's reassuring presence, in her little kitchen, he felt a confidence that enabled him to paint. But it is not for the evocation of a personality that this picture is most remarkable, but for the artist's sheer capacity to paint. The patient, devoted face, the sturdy figure, are indeed impressively represented, but the weight and texture of the heavy silk of the voluminous, fusty dress, and above all, the folded hands, solidly realized, modelled with extreme subtlety, and, more impressively still, instinct with life. The painting of those hands is masterly by any standards, and in the twentieth century masterly painting is rarer than at other times.

I quoted a phrase just now from Gertler's autobiographical fragment about the way in which the East End boys and girls 'seemed to move and talk with unusual intensity, as if life was fearfully important – momentous'. The description perfectly fits Gertler's own way of seeing. And, as the painters of the Low Countries developed a heightened realism by their long winters spent indoors, hedged in by familiar faces, the subjects of daily scrutiny, so was Gertler's exuberant yet searching vision intensified by its strict confinement within narrow limits. He lived his life in a tiny alien enclave utterly cut off from the encircling population by religious observance, prejudice, and, during these first years, by the barrier of language; and within that alien enclave there was the family circle, if not precisely closed, at any rate exclusive. An eye accustomed to take horizons within its

sweep would be less likely to focus so avidly upon small things and to treat them as 'fearfully important – momentous'. Take even *The Teapot*, painted seven years after the portrait, when Gertler's eye had accustomed itself to rather wider prospects: how authoritatively he compels us to recognize the uniqueness of its shape, its colours, its density, in a word its momentousness. Nothing could be more remote from the casual glance ordinarily bestowed upon an ordinary teapot than the absorbed and loving scrutiny in which Gertler held it until it became 'momentous'. The absorption and love of his scrutiny did not make for pedantry of any kind, for an over-concern with detail, for instance; on the contrary, it gave him the assurance to represent his subjects largely. *The Teapot*, indeed, does not stand quite foursquare on the tray, and it has a lid with a knob imperfectly related to it, but neither of these defects disturbs our sense of its 'momentousness'.

At the beginning of this study I mentioned the contradictory opinions held about Gertler's development, and commented that I myself inclined – with certain reservations – to regard his earlier work as that most likely to survive. To me the quality, beyond all others, that makes it precious is this power of making the subjects he represented appear 'momentous'. It springs partly from youth, more susceptible than maturity or age to see intensely, but also from the peculiar narrowness of the artist's early surroundings. This narrowness, amounting almost to isolation, imposed a discipline upon his emotions that precluded their dissipation and focused them upon a few loved and familiar things and people. It is in the early works, drawn and painted before his horizon opened out, that this 'momentousness' is most luminous. Something of it appears in *The Apple Woman and Her Husband* (1912), which represents his mother and his wistful little father. Although richer, clearer and more varied in colour, and more ambitious as a design than *The Artist's Mother*, there is just a suggestion of self-conscious artistry about it, and its impact is a little lighter. But in the small group of these early works nowhere is 'momentousness' so poignantly present as it is in *Rabbi and Rabbitzen* (1914), an old couple seen with extraordinary insight through eyes at once wise yet innocent, searching yet affectionate. If all Gertler's work were to perish except this, it would serve as a microcosm of the precisely focused intensity that gives the best of his early work a glowing actuality in the company of which most others seem the lifeless products of indifference.

It was the intimate contact with the things that he saw and experienced for himself – before he emerged out of the confined existence of a member of a little, isolated group of foreign immigrants – that excited all his faculties to their highest pitch. The capital, so to

speak, that he accumulated during those early years lasted for some time after he left the Slade, but his sudden exposure as a student to pressures of every kind tried and sometimes compromised the integrity of his way of seeing. The circumstance of his having come from a class in which none of the arts were practised or even thought of made him the more susceptible to such pressures. Emergence from what, for an artist, was penitential bleakness into a world where the arts were practised on all hands and where the evidences of their having been practised for centuries abounded in galleries, churches and private homes must have been intoxicating; and considering how radically uncertain he always was of the validity of his art, it must be a matter for gratitude that he resisted so strongly and preserved so much.

Evidence of outside pressure is evident from the moment of his emergence. *The Artist's Sister* (1912), the late Deborah Atelson, an exuberant figure exuberantly dressed, has energy and largeness of form, but it clearly reveals, particularly in its colour, the influence of Brown and Steer, his teachers at the Slade. This is a handsome painting; but one made the following year, *Portrait of a Girl* shows how debilitating these pressures could be. Here there is no trace of the weight and exuberance, or yet of the close, affectionate scrutiny that marked all the works mentioned above; it is a languid essay in the manner of Augustus John or Henry Lamb: but these artists, so to speak, tidied up, and the girl is dressed for the occasion in fashionably 'bohemian' clothes. Ironically, the spotted kerchief on her head is that worn by his mother in *The Apple Woman and her Husband*. This feeblest of the artist's early paintings, in which – fortunately only for the moment – he turned his back upon everything in his past that had made him an artist, was presented to the Tate in 1923 and remained for seventeen years the Gallery's sole representation of Gertler's art. A painting of the following year reveals susceptibility to influence from another direction, for *The Jewish Family* testifies to his close study of Picasso. In this picture he attempted to represent one of his traditional subjects with the pathos and attenuated delicacy of a work of this painter's Blue or Pink period. In spite of his continuing admiration, this remained, so far as I am aware, a solitary experiment. Gertler's development took a different direction. Sometime about the beginning of the First World War a new and fruitful element made its appearance in his painting, an element more easily recognized than described. It was as though life presented itself less as a kind of reality perceptible to the ordinary eye than as a kind of puppet-show at a fair. This is an overstatement, but it indicates something of the impersonal character, the simplified forms, the robust colours, the humour that marked the finest of his paintings after he left the Slade

and that gave them something of the character of products of a sophisticated and expressive folk-art. Whether the emergence of this element was due to something he had recently seen, to something innate, or to some childhood or even inherited memory of folk-art in Eastern Europe, I cannot say; but it is perhaps relevant to recall that it was through popular art, a poster advertising a meat extract, that he was first moved to draw.

The first important painting known to me with this folk-art overtone is *Mr Gilbert Cannan at his Mill* (1914–15), in which the novelist is shown standing with his dog outside the windmill in which he lived at Cholesbury in Hertfordshire, the scene, incidentally, of one of the lamentable occasions of the artist's life. The interest of the scene itself, the odd man beside his strange home, the upright converging Gothic forms, all treated with a robustness, almost, one might say, a heartiness, that makes sinister overtones, naturally contribute to the picture's momentousness. The subject had obvious dramatic possibilities, but it is the skill with which the highly original composition has been worked out and the intense energy with which every small feature has been painted, and not the subject itself, to which the picture's impressiveness is due. I am able to state this categorically, for although I have never visited Cholesbury I came upon a photograph, which the artist no doubt used and had preserved among his papers, and this I had an opportunity of comparing with the painting. The photograph bears the same relation to the painting as a score does to the performance of a symphony.

The second of these pictures is *The Roundabout* (1916). In this extraordinary picture the folk-art figures express, although in a more sophisticated fashion, the brutality that the boisterous jollity of the traditional Punch scarcely masks. The artist sent a photograph of it to D. H. Lawrence, whom it moved to admiration and horror, and in a letter dated 9 October, 1916 he wrote:

> My dear Gertler: Your terrible and beautiful picture has just come. This is the first picture you have ever painted: it is the best *modern* picture I have seen: I think it is great and true. But it is horrible and terrifying. I'm not sure I wouldn't be too frightened to come and look at the original . . .

Never again, as far as I am aware, did Gertler's folk-art figures assume so grand or so sinister a form. Indeed the folk-art element in him usually found expression through subjects – Staffordshire figures and the like – already perfectly adapted to it.

Gertler had reached maturity as a painter before he was twenty: the impressive character of his art and his exhilarating personality combined to make him a considerable figure even before he left the

Slade. In spite of its palpable hyperbole at certain points, a description of him by his friend, the barrister St John Hutchinson, conveys something of the effect he made. 'There has seldom been a more exciting personality than he was when young . . . with amazing gifts of draughtsmanship, amazing vitality and sense of humour and of mimicry unique to himself – a shock of hair, the vivid eyes of genius and consumption . . .'

On leaving the Slade he quickly took his place among the most gifted of the younger painters. He was immediately elected to membership of the New English Art Club, and of his *Fruit Sorters*, which he showed there two years later, Sickert wrote in *The New Age*, 1914 that '. . . the picture is justified by a sort of intensity and raciness . . . (it) is important also because it is a masterly piece of painting in well-supported and consistent illumination, and the work of a colourist at the same time rich and sober'. He received some commissions for portraits, too, of which one of the best is *Sir George Darwin*. As a draughtsman he had the power of giving weight and dignity and a kind of rugged tragic character, well exemplified in *Head of an Old Man* (1912), which, however remote in the order of creation from Leonardo's heads of old men, has something in common with them.

To Gertler's precocious talents as painter and draughtsman were joined social qualities of the order – although not, perhaps, to the degree – which St John Hutchinson claimed for him. It was not long, therefore, before he became a personality in the intellectual and, more conspicuously, the bohemian life of London. D. H. Lawrence and Lytton Strachey were numbered among his friends, and he became a member of the circle which frequented Lady Ottoline Morrell's house at Garsington.

Gertler had little of the snob in him, and no ambition to enter fashionable society, although he derived some amusement from the swiftness of his graduation from Whitechapel tenement to Mayfair drawing-room. But it was not the drawing-room but the café – in particular the Café Royal – that provided the setting in which he was most at home. The company of writers gave him more satisfaction than that of painters; he was not deeply interested in ideas and his acquaintance with literature was superficial, but he liked to read books by his friends. For a brief period during the First World War he showed signs of intellectual ambition, but his efforts at learning and at reading Nietzsche yielded insignificant results.

The sense that everything that the great world offered had suddenly been made free to him, a slum boy, through his extraordinary talent he found intoxicating, and he indulged to the full his exorbitant sociability – a sociability so exacting, however, that he could be dull company if alone for long with a single companion. The sudden enrichment of his

life afforded him more excitement and gratification than happiness. His success did little to diminish his apprehension that he was and would remain a stranger in this larger world. This apprehension was not entirely unfounded, but the mistrust and dislike which he often discovered in those whom he regarded as friends was not due, as he was inclined to suppose, to social but to personal characteristics. Lack of self-control allowed him to sacrifice even considerations of prudence for the satisfaction of the moment. If he wished, for instance, to shine at some social occasion, the ridiculing and wounding of his closest friends was a price habitually paid without hesitation or regret. The standards generally observed in the society he had entered seemed to him as irrelevant to the circumstances of life as the rules of heraldry, and he compared them to their disadvantage with the less artificial, less complicated standards of Whitechapel, especially as regards self-assertion, avarice, lust and the rest. But he never wanted to return to the miserable squalor, the hysterical quarrels, and above all the lack of understanding of the art that he cared for above everything else, that marked his early life.

It was not long before he had more than a vague sense of isolation and insecurity to temper his exuberant enjoyment of his new life: he became involved in situations in which he inflicted and suffered distress.

Hard work and what was once charitably described as 'sociability' began to affect his health before long, and in the summer of 1914 he retired to his friend Cannan's windmill home at Cholesbury, which he revisited at intervals. One consequence of these visits was the splendid portrait, already mentioned, of the novelist by the painter; the lamentable portrait of the painter by the novelist was another. This was a novel, published in 1916, entitled *Mendel*, in which Gertler is the principal character and his life the theme. In a letter to Catherine Carswell, D. H. Lawrence wrote of *Mendel*: 'It is a bad book – statement without creation – really journalism. Gertler . . . has told every detail of his life to Gilbert – Gilbert has a lawyer's memory and he has put it all down, and so ridiculously when it comes to the love affair. We never recognized ourselves . . .' It is scarcely possible to disagree with Lawrence's opinion. The novel is indeed a shoddy production, lacking a single spark of creativity; it lacks, too, any value as a record, so closely is fact intertwined with fiction.

It has always been assumed that the responsibility for this novel rested entirely with the author. Gertler certainly claimed that he was unaware that his stories of his life in Whitechapel – which he always delighted in telling – were being memorized and daily set down by Cannan without his knowledge. Balston accepted this disclaimer. 'Unknown to Gertler,' he wrote, 'Cannan was writing the novel . . .'

An unpublished letter dated 10 May, 1916 from Lytton Strachey, however, makes it virtually certain that Gertler knew that a novel was being written. 'I imagine you may be at Cholesbury,' it runs, 'working hard by day, and talking with Cannan by night. Is it true that he's writing a novel about you?' This letter shows that a novel by Cannan based upon Gertler's nightly talks with him was common talk, and had Gertler, by some extraordinary chance, been unaware of what was evidently known to others, the letter would have appraised him of it. That it reached him may be regarded as certain, as it was found among his papers after his death. It is very unlikely, however, that he ever saw Cannan's manuscript.

The description of Gertler's visit to my parents' house caused my father to write to him: 'You wrong both of us by giving so sordid and untruthful an account of your feelings and mine.' But although it inflicted a gratuitous wrong upon someone from whom he had received nothing but disinterested kindness at a time when he was in urgent need of it, this description was a small matter compared with his damaging stories about his own family, stories, however, that he would tell without the slightest doubt cast on his affection or his respect for them. And whatever their shortcomings, his family showed an exemplary loyalty towards him.

The other difficulty in which Gertler's temperament involved him was of a less blameworthy but a more harrowing kind. Among his friends at the Slade was a girl of exceptional talent with whom he eventually fell in love, and his relation with her was the most deeply felt one of his life. The girl was fond of Gertler, but hers was a complex and highly independent nature, and she was repelled by his selfishness, which expressed itself in an obsessive desire for complete possession and a reluctance to commit himself. That harmony between them was impossible so long as Gertler was obstinately possessive and preoccupied only with himself was apparent to D. H. Lawrence. 'If you could only give yourself up in love,' he wrote to Gertler, 'she would be much happier. You always want to dominate her, which is no good. One must learn to relinquish oneself, not to bother about oneself, but to love the other person. You hold too closely to yourself, for her to be free to love you.'

Despite his periodic fits of despair about his work, he was not self-critical and could not see the truth of Lawrence's words. The conclusion to which his own feverish and even hysterical reflections led was that the young woman – herself a highly gifted painter and an acute critic – did not sufficiently respect him as an artist. This conclusion was almost certainly erroneous. If the value of his work and his seriousness of purpose could only be authoritatively impressed upon her, he came to believe, her complicated reserve

would be overcome. The proper person to effect this change was obviously Lytton Strachey, a man of extraordinary intelligence, of a manner and aspect wholly unfrivolous, of a temperament which made it unlikely that he would wish to replace Gertler in her affections. In 1916 there was a meeting between her and Strachey. It is probable that nobody knows what took place, however the result was decisive. The girl fell passionately in love with Strachey, and resolved to devote her life to his interests, and when he left London to live in the country she went with him. She was as conscious of his faults as of Gertler's – in a letter to Gertler written in 1917 she refers to 'Lytton's cynical frigidity' – but she remained devoted until, years later, she ended her own life.

The turn of events reduced Gertler to a frenzy of bitterness, and in September 1916 he wrote to her:

> I am afraid that I cannot support you over your love for Lytton; because I love *you*, I need not necessarily love what *you* love. I do believe in *you* but nothing on earth will make me believe in Lytton as a fit object for your love – the whole thing in fact is most disappointing to me . . . I only hope soon that the nausea of this wretched relationship of yours will poison the spirit of my love for you and so diminish the stink of it all. Never would I have contemplated such a nauseous thing. Believe me the whole of these years of struggle have been turned into ridicule for me by this sudden reversal of yours to dead withered (undecipherable). Also he arranges all your life – I must wait with my arrangements for him. Why do you not at least control yourself a bit, must you be so slavish and abject? Surely there is in me also something to study, if only my art, you sicken me with your abject devotion . . .

The girl's new relationship had an unlooked-for result: instead of separating her from Gertler it brought them for a time to a closer, although not happier, intimacy. 'It is not that I don't love you,' she wrote to him in January 1917. 'It is that I was sad. When one is in sorrow one feels isolated curiously and to be forced into another's animal possessions suddenly makes it almost a nightmare.' And the same month, 'But you must know it is not that I dislike you. It is something between us, that is hateful.'

In 1915 Gertler left Whitechapel for good, and helped by his family, who had prospered, he established himself at Penn Studio, Rudall Crescent, Hampstead, where he remained for fifteen years, lodging latterly at 19 Worsley Road. Although its effect was not immediately apparent, the move corresponded with a change in his art. He moved away from daily experience of the scenes that had made him a painter. The two Post-Impressionist exhibitions had caused him, the least confident of painters, to doubt the validity of his art. A first visit to Paris in 1919 satisfied him that his doubt was justified, that his art was too dependent upon the interest of his subjects and too little

upon purely formal qualities. During the years immediately following he visited the south of France. In his own eyes, in about 1920 his art ceased to be 'provincial' and began to belong to the tradition forged by Renoir and Cézanne. 'He has naturally chosen work from this latest period since about 1920 to represent him here,' wrote Hubert Wellington, in his preface to a small volume of reproductions of Gertler's works, published in 1925. 'It shows,' the author noted with approval, 'a determination to realize the form, colour and texture of his subject matter with the greatest possible completeness. Forms are made full and continuous, local colour kept rich and undisturbed . . .' But he found it necessary to utter a muted warning: '. . . a very personal technique of small accumulated touches yields very handsome surface qualities and renders varied textures with an almost disquieting realism: disquieting because it tends to obscure the interest in pattern and "architectural" design.'

This discerning critic – even though writing rather more to subject the then fashionable doctrine of the overriding importance of 'significant form' than he would today – has divined the two conflicting impulses in Gertler's temperament, the desire, excited by the example of French painting, to excel in purely aesthetic fields, and a fascinated interest in the life around him. Gertler, who could scarcely draw a line but in the presence of his subject was inevitably aware of the fundamental character of the realistic impulse in himself. 'I have made up my mind,' he wrote to a friend, 'that if I am to deviate from nature it must be only to add discoveries of my own . . .' It need hardly be said that these two impulses are not necessarily irreconcilable, or that many artists have found the means to represent the subjects which interest them most deeply in entirely satisfying aesthetic terms. But this, after he left Whitechapel, Gertler was rarely able to accomplish. The people and the things which impressed themselves most deeply upon his imagination were those that belonged to his early life. He was innately and strongly realistic in his way of seeing: he was, in fact, scarcely capable of envisaging anything that was not before his eyes, and he worked invariably from his subject direct. 'All his later landscapes,' we are told by Balston, 'were done through windows.'

After he left Whitechapel the subjects that had called forth his most intense emotion, being no longer before him, faded from his imagination. They were largely replaced by still-life, the objects of daily use in his studio or ornaments such as Staffordshire figures, but unlike Cézanne, Gertler was incapable of responding with his whole mind and his whole heart to a plate of apples. Generally incapable, would be a juster way of putting it, for from time to time he painted a still-life of so splendid a quality as to rank among the finest still-lifes of the century, such, for instance, as the large *Basket of Fruit*

(1925). He continued to paint nudes, with beauty and conviction, until the mid-1920s. *Young Girlhood* (1913, 1925), are closely observed and taut in handling, but *Sleeping Nude* (1928), shows a falling off, and worse were to follow. All the while, as the memories of his early subjects waned under the influence of Paris, he became more and more preoccupied with the search for such purely aesthetic qualities as 'architecture' and design. The change was not due to a sudden conversion, but to the steady pressure of such concepts as architecture, significant form and the like, and the example, of course, of modern French masters, upon a painter made susceptible to such pressure by the progressive enfeeblement of his own intensely personal and convinced vision of things. For a long time something of its former character remained: until late in his life he was able to endow his subjects with a fullness and warmth that was almost haunting. But as the years passed his subjects were too often mere counters chosen to exemplify 'volume' or some other fashionable concept, for its own sake. An example – one, alas, of many – of a subject treated thus is *The Mandolinist* (1934), which has neither more nor less merit than scores of other similar paintings made in London and Paris that year by imitators of Derain and other leading Post-Impressionists.

Gertler was not an intellectual like Duncan Grant or Paul Nash, still less did he command such powers of thought as Wyndham Lewis wielded, but he was aware of something amiss with his later work, and this awareness brought with it recurrent distress. I do not pretend to know at all precisely how his self-criticism was directed, but in the absence of conclusive evidence I believe that his despair sprang from his consciousness of maladjustment between his failing vision and his growing executive ability. Not that technical problems ceased to absorb him. Like many other painters he made notes for his own guidance. One of these, headed 'Latest system and its advantages' and dated 24 August, 1928, tabulates proposed modifications of method and the results expected. 'Contours more varied and lost – working right across and not at any stage defined, advantage – a greater flow and continuation – no stoppage,' reads one. Others of the same date prescribe methods for attaining 'more colour in shadows and more air generally', 'freshness and light', and presenting the same surface from whichever angle it is looked at, 'unity and general realizations'. 'Form and design realized by light and shade seems a deep unalterable characteristic – why try and alter it?' he reflects.

As he grew older the fits of depression from which he had suffered since boyhood became more desperate, more frequent and prolonged. His recurrent loneliness and the sporadically inharmonious character of his most intimate relationships contributed to this, but their principal source was his work. In times of distress he used to write

to friends or set down his thoughts simply for his own relief. For the light it sheds on his thought and feeling processes, above all upon his lack of confidence in himself as an artist, I here give, in part, what may, perhaps, be the most extensive of his writings of this nature, from pages of notes found in his studio after his death:

> You ask what is the matter with me? Well it is something serious – the greatest crisis of my life – and you know what I have already suffered in the past. In fact – for the time being I see no solution – the trouble is – *my work* – what is my value as an artist? What have I in me after all? Is there anything there worth while after all? That is the point – I doubt myself – I doubt myself terribly – after all these years of labour and you know how I worked – so so hard – with my blood and I have lived and fed up my work – my work was by faith – my purpose – But – as I find now to my acute discomfort – an essential part of that faith |and| that purpose – was not just to work alone – but the hope that I will – some day – at least produce pictures that will *stand* that will have some place among work that counts – Well have I . . . achieved anything of the sort so far? I doubt it very much. Do I stand a chance of succeeding in the future? *That* is the point! My doubt on this point is what is causing me this acute misery. Oh, I cannot tell you how much I suffer – I hardly dare – My past works keep floating through my mind's eye – awful ghosts that torture me – I cannot bear to go to a house that contain|s| any of my pictures – for at once I am flooded with misery and despair! seeing any good picture or reproduction does the same thing to me – I feel inferior – inferior to all! . . . – of course I contemplate death – over and over again – sometimes it even seeming the logical solution – for you must know – and I frankly confess it – that I cannot live without that *purpose – to create real work* – It seems to me that it is either one of two things – Either I regain sufficient faith in my 'purpose' or I die – . . . sometimes I think of finding something else to do – but what? To kill myself – there *is* the dreadful selfishness of it – think of my mother – Marjorie and perhaps a few others! . . .

In his latter years, more particularly after 1920, gay as he generally was in company, and happy often when he had a brush in his hand, he was rarely free for long from the shadows of depression. For in that year he was seriously ill with tuberculosis and was compelled to spend five months in a sanatorium at Banchory; the threat of a renewal of this trouble sent him into the sanatorium at Mundesley in Norfolk in 1925, 1929, and 1936. It is clear that ill-health or the threat of it aggravated his fits of depression. These were eventually accompanied by suicidal gestures or attempts. On his last visit to Mundesley he cut his throat and a vein – then promptly rang for the nurse.

Gertler's last years provided many occasions for his prevailing melancholy. In 1930 he married Marjorie Greatorex, daughter of George Edmund Hodgkinson, a London solicitor, and a son was born two years later. But the friendship of many had become hostility or indifference. His ill-health gave increasing cause for anxiety and,

most painful of all, the relative neglect of his work – although it still held the respect of many painters and lovers of painting – further increased his painful self-mistrust.

Whether he looked within himself or at the world outside he saw – or fancied he saw – causes for distress. Not long after I came to the Tate I remember Sir Edward Marsh's saying to me, in that almost inaudibly high voice of his, 'I saw Mark last night. He was terribly depressed. He thinks you don't like his work. I told him you did, but it was no good.'

During these years Gertler was dependent upon social occasions for pleasure, when he became for an hour the entertaining prodigy he had once been. (On one occasion, meeting Charlie Chaplin at an evening party, the two of them did a comic dance together.) But he led the most regular – the most monotonous it might almost be said – of lives. From ten until midday he painted; then until lunch – which he took alone – he walked. After a rest he painted for a further hour. For the rest of the day he needed amusements, although even in the evenings he preferred a regular routine. On Thursdays and Saturdays he entertained his friends and on Fridays he visited his family. 'His conversation,' a friend told me, 'was trivial, founded upon oddments he had read in the *Daily Mail*.' To an old familiar over long periods he had almost nothing to say, but 'one person to tea and his depression lifted and he was soon up to all his social tricks'. The flatness of his life was occasionally broken by an interlude of macabre drama. There was a girl, for instance, who paid him a visit which he described to a friend in a letter dated 3 September, 1935: this girl 'who has a passion for me', it runs, 'turned up when I was alone in the house and proved to be quite mad . . . I lost my nerve and began to beat and kick her, but she kept returning through some window. *Just* like some nightmare . . .'

In June 1939 he was more than usually depressed by Hitler's vilification of Jews and the failure of his exhibition at the Lefevre Gallery the previous month. One night he swallowed a hundred aspirins and turned on the gas, but he had left the window open. On the night of the 22nd he did not forget and the next morning he was found dead. He was buried in Willesden Jewish Cemetery. Because he was unorthodox, he lay in an unmarked grave, but some prophetic words from a letter written to him by his friend D. H. Lawrence will serve as a sort of epitaph for the talent that for a while shone with so brilliant a light: 'Only take care, or you will burn your flame so fast, it will suddenly go out. It is all spending and no getting of strength.'

GILBERT SPENCER
1892 – 1979

The most influential element in the formation of Gilbert Spencer as an artist was his relationship with his brother Stanley. It was Stanley who first encouraged him to be a painter; it was the heat of Stanley's creative fervour that supplied the motive power to his beginnings; yet it was Stanley who involved him in a predicament that remained unresolved over many years of his life as an artist. Stanley had something of the character of a force of nature. If every night the fairies had woven a large area of canvas and added it to the picture upon which he worked, he would have covered it with scarcely more awareness of the addition than a feeling of gratitude. Paintings by Stanley Spencer did not end, they were brought to an end by some material circumstance. The artist's imagination, his powers of eye and hand did not flag. Likewise his conversation: morning came or there was a train to be caught, but – except for a brief rest after lunch – neither the originality of his ideas nor the sweep or pungency of their expression was affected by the passage of the hours. Supposing you happen to be the younger brother of such a force, and you follow the same calling. You may be driven to become either a disciple or an eccentric, or you may be driven to abandon your calling altogether, but it will be difficult for you to seek, diligently and with an unruffled mind, the corner of the field you are best equipped to cultivate. That Gilbert Spencer found his way to such a corner without ever losing his reverence for his brother, and that he cultivated it with sobriety and blitheness of spirit, is a measure of his quality as a man, a quality that in happy moments was manifested in his art.

Gilbert Spencer was the ninth and youngest of the Spencer children and was born on 4 August, 1892 at Fernlea, Cookham-on-Thames, the house in which all his brothers and sisters were born. The creative urge, so common in his family, first took the form of toy-making. Carts were Gilbert's favourite models, and he used to go out into the village to study the construction and the colours of all the carts he could find, carts belonging to his family and neighbours or strange carts passing through. Of these toys one example at least, a yellow cart, has been preserved, and it is fine in workmanship and feeling.

It is characteristic of the continuity of his interests that similar carts are the central feature of his single most ambitious composition.

While Gilbert briskly hammered and planed, Stanley would bring branches and twigs into the house, tie the branches onto bedheads, plant avenues of twigs along the floorboards, and then, imagining that he had made a forest, would creep and peer among them. Stanley was not content that Gilbert, making toys, should forgo the deeper, more various satisfactions that painting affords, and he persuaded him to share his vocation. 'Stanley had become a real painter before I began: he showed me painting, held it up for me to see, then he handed it to me on a plate,' Gilbert told me. 'I was attracted by it, but if it hadn't been for him, I might have gone on simply wondering about it.' The moment of revelation came when Stanley brought back from the Slade a book on Masaccio, and showed him *The Tribute Money*. Another moment of revelation followed when he heard Bach's 'St Matthew Passion' in St George's Chapel, Windsor Castle. These moments showed him that he could not be content only with toy-making.

Gilbert received his general education at the Ruskin School at Maidenhead which he attended from 1909 until 1911. The following year he spent at the art school at Camberwell, and the year after that learning wood-carving at the South Kensington Schools. When it was decided that he should become a painter he went to the Slade, remaining there from the autumn of 1913 until the spring of 1915. Being able to afford only three days a week at the school, he spent the other four painting on his own at Cookham.

At the Slade he made quick progress: he won a first prize for figure drawing, Professor Brown's prize for the drawing of the head, and he shared the Summer Composition prize in 1914 with T. T. Baxter, a fellow student. The subject, *Summer*, painted at Cookham, has a clumsy, archaic look, from which something lyrical shines out incongruously. His narrowly missing the Summer Composition prize the previous year led to his becoming known outside the Slade. The painting submitted, *The Seven Ages of Man*, was a large work also painted at Cookham, which, in spite of the rawness of the handling and the awkwardness of many passages, has intimations of something noble and impressive. The picture was seen and admired by a new friend, Henry Lamb, who, with another painter Darsie Japp, had visited Gilbert in Cookham not long before. Lamb asked whether Gilbert was willing to sell it: the painter was willing and the price asked £20. 'Do you object,' Lamb asked him shortly afterwards, 'to having £100?' The buyer was Lady Ottoline Morrell, a friend and patron of Lamb's and of the most gifted of a generation of painters and writers. She bought it for the Contemporary Art Society. This

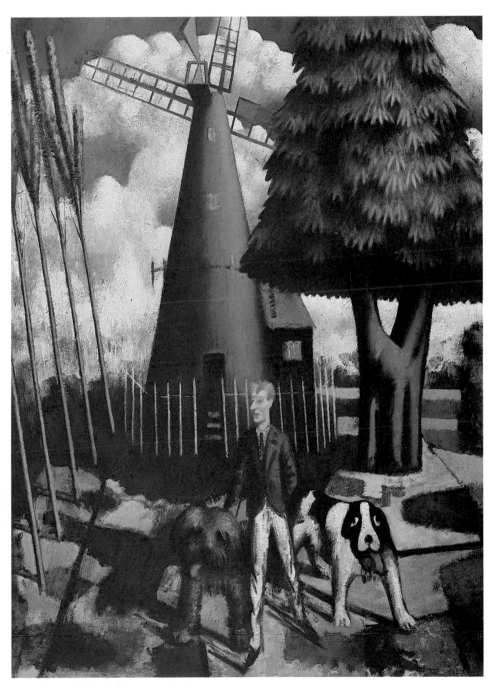

5. MARK GERTLER: *Gilbert Canaan at His Mill* (1916).
Oil, 39½ × 28¼ in (99 × 71 cm). The Ashmolean Museum, Oxford.

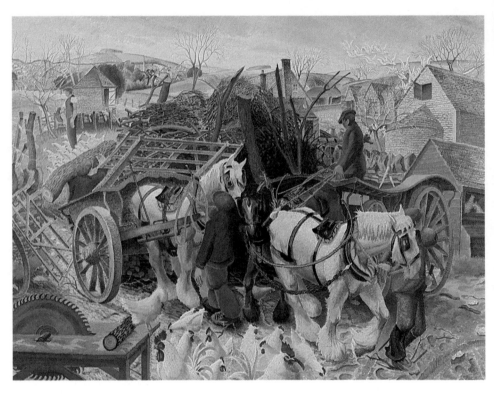

6. GILBERT SPENCER: *A Cotswold Farm* (1930–31).
Oil, 55 × 72¾ in (139·7 × 184·7 cm). The Tate Gallery, London.

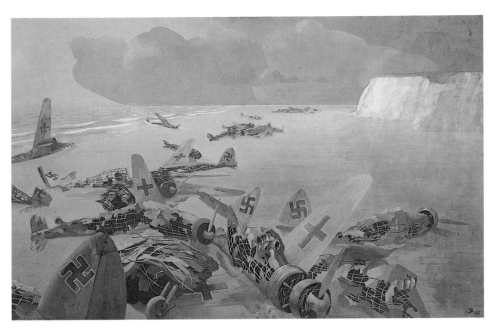

7. JOHN ARMSTRONG: *September 1940* (1941).
Oil on panel, 18¾ × 30 in (47·6 × 76·2 cm). City of Manchester
Art Galleries.

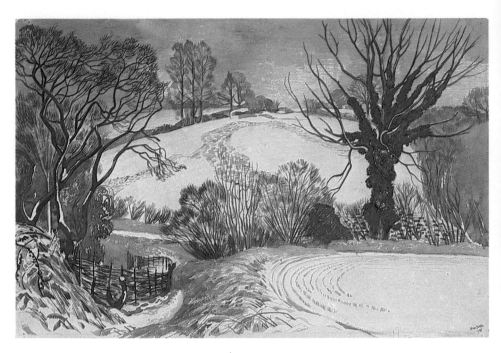

8. JOHN NASH: *A Winter Afternoon* (1945).
Watercolour, 14⅞ × 21⅞ in (37·3 × 55 cm). By courtesy of Birmingham
Museums and Art Gallery.

triumph was naturally the talk of the Slade. When Henry Tonks next went round the studios, Gilbert awaited his approach with modest complacency, which, however, the demeanour of his master soon dispelled. Stopping abruptly at a distance, he said, 'So you've sold your picture, have you? Early success invariably leads to ruin,' and turned his back. The incident, however, did not alter Tonks's encouraging disposition towards his successful student. This picture, to my thinking remarkable in spite of its manifold faults and crudities, is still without a permanent home. In 1933, when I was director, I secured its acceptance by the City Art Gallery at Leeds, but I left soon afterwards and it was exchanged for *Shepherds Amazed* (1920), a more mature work but one which was painted somewhat under the spell of his brother's Biblical pictures.

The Seven Ages of Man, although the most ambitious of the pictures Gilbert painted before the First World War, does not stand alone in announcing a new painter of unusual talent. An unfinished *Self-Portrait* painted in Cookham in 1914, a bold and assured study, owing little to the work of any other painter, is strongly marked by the quality of genuineness – the word is a vague one but I will try to justify its use in this context presently – that distinguishes the best works of Gilbert Spencer.

In May 1915 the artist enlisted in the Royal Army Medical Corps and later transferred to the 2/22 London Regiment, with which he served in the Middle East. On active service he made a number of studies – one of which, representing a ward in the stationary hospital at Mahemdia, Sinai, formed the basis of his large painting, *New Arrivals* (1919) – but his war experience did not add significantly to his experience as an artist. His mind was fixed upon the country round his home. There exists a Cookham landscape, *Sashes Meadow*, which spans the war, for it was begun and largely completed in August 1914, but the large tree on the right was not put in until just after Gilbert's demobilization in 1919. The contrast that this picture offers between the sombreness of wood and field and the silvery luminosity of rippling water puts one in mind of contrasts of the same kind in the work of Constable. This small picture is a work of dignity and authority and one of the finest of the painter's early landscapes.

The consequence of renewed association with his brother Stanley was that Gilbert painted several biblical subjects, of which the most impressive is *The Sermon on the Mount* (1921–22), a large picture showing an assembly of bearded, white-robed figures (the one seated in the right foreground appears to represent Augustus John) of a massive amplitude. It has dignity and purity and must count among the serious religious paintings made in England between the wars.

But religious painting, with the exception of Stanley Spencer's wall-paintings at Burghclere and a very few other works, was not of a high level. *The Sermon on the Mount* falls short not on account of its archaism (the rocks, for instance, are those of Italian painting), but because the painter is without deep religious insight. The scene conveys no hint of the giving of a momentous message; it represents nothing but an assembly of prophetic-looking elderly men, almost identically wigged and bearded, in vaguely monastic garments. Nothing in the design leads the eye towards the Saviour. As an exercise in religious painting it is worthy of praise, but it is not religious painting; and in any case the painter, never so religious as Stanley, was losing his faith while he was engaged upon the picture. Fearful of a cynical conformity, a man as honest and as positive as Gilbert Spencer recognized his loss, when he felt his faith ebbing away, and after about 1923 he confessed himself an agnostic. Discussing this with me, he once said:

> I'm a horizontalist, and Stanley's a verticalist. I don't believe I was ever truly religious, but for a time Stanley was able to impart his religious sense to me, partly by his words, partly by paintings like *The Visitation* and *Zacharias and Elizabeth*. But I rarely had much to do with the deeper levels – religion and philosophy – I just loved painting and he was the painter I admired most; so painting was the real link between us.
>
> The Spencers, you know, contrary to what many people think, were *not* a religious family. We went to chapel – until the old chapel was replaced by a new one, which made bad blood with our family – and then to church. No blasphemy was allowed, but my father used often to say 'Christ was a *man*, like anybody else'. But it was the preachers in the chapel who inspired so many of Stanley's figures, which are all portraits of a kind, you know. I can recognize their likenesses.

Landscape, not figure painting, was the principal business of Gilbert Spencer's life, although he painted a few fine portraits and made a long series of portrait drawings of remarkable beauty. His first one-man exhibition in January 1923 at the Goupil Gallery was received with mild interest by the critics, but little more. 'Both (Spencer) brothers,' wrote Frank Rutter in *The Sunday Times*, who was usually responsive to serious new talent, 'in my opinion have done some very good work, and have also painted some foolish, affected pictures; therefore, I have been inclined to sit on the fence.' He slipped off it so cautiously that it is a little difficult to see at this distance upon which side he came down. The landscapes were praised, as also some of the drawings; the figure compositions, more especially *The Seven Ages of Man*, were ridiculed. *The Times* was amiable but uncommitted; the warmest praise came from the *Daily Mail*. However, the exhibition was warmly welcomed by painters and collectors. My father had bought a landscape from the Grosvenor Gallery the year before, and presently Gilbert himself appeared at our house, an irrepressibly gay

and breezy presence: sartorially, compared with his brother Stanley, a dandy; compared with anyone else, a tramp.

Gilbert Spencer's landscapes were made mostly in the Thames valley, in his native Berkshire; in and around the Oxfordshire villages of Garsington and Little Milton where he spent the years 1925 to 1928; but also in Dorset and, during the Second World War, in the Lake District. In 1931 he bought Yew Tree Cottage, at Upper Basildon, Berkshire, to which, in spite of enforced wanderings, he constantly returned. These landscapes are of two kinds: pictures of particular places, which were begun and completed in front of the subject, and compositions which are not pure inventions but assemblies of features brought together from particular neighbourhoods. The first are by far the more numerous. 'Stanley's painting could be judged from a small group of masterpieces,' the artist observed, 'mine is like a chain with a lot of small links.' There is much truth in this modest comparison, especially in so far as it refers to the realistic landscapes. The series is long, the standard high, but while it includes many pictures of great beauty it includes none, I think, which by itself shows the full stature of the artist. Besides *Sashes Meadow, Emmer Green,* and *Garsington Village* (both 1924), *Home Close, Garsington* (1924), *Stour Valley* (1927), *Little Milton, Burdens* (both 1933), *From my Studio* (1949), all afford intimations of that genuineness referred to a few lines above. By genuineness I mean that nothing, no line, no brushstroke, is set down except as the immediate response to perception or to feeling. This quality is rarer than may be supposed. Some painters, when perception or feeling fails them, carry on as though nothing is amiss, and thereby practise a deception; others, impelled by a sense of duty, paint stubbornly on when they neither perceive nor feel, in the hope that the act of painting will restore them. Others again rely on a style that has won approval to disguise their want of anything to communicate. Gilbert Spencer set down nothing not fully experienced, so that his series of landscapes is a precious record of the response to landscape of a warm and constant love of the English country. Since he first began to paint, the artist's view of things underwent few changes and only one that need be mentioned in so brief a study. When he began, his brother, Masaccio and other early Florentines were his masters: his style was linear; his colour, radiant but subdued, ministered to his drawn shapes with dignified subservience. Very slowly, at times scarcely perceptibly, a transforming idea asserted itself: the idea of colour's existing not as subservient to form but as a part of it. The idea came to him from the most obvious source. 'I always loved the French Impressionists,' he said, speaking to me of his debt to them, 'they were a *lovely* crowd, particularly Pissarro, and Cézanne as well. I look at a Michelangelo

and I marvel; I look at a Pissarro and I somehow share it. I owe it to them that my aims, as I've gone along, have emerged, more and more definitely, as light and tone and atmosphere.'

Different aims called for different methods. The early landscapes were painted over meticulous drawings, made direct upon the canvas. Summary indications as to form and colour, notes, gradually took the place of meticulous drawings, and enabled him to attain a greater freedom of handling. All these processes were invariably carried out in front of the subject. When I questioned him upon this matter, he said, 'I have occasionally put in a bit of extra grass. But I haven't really got any method,' he added. 'I start everything I do from scratch, and I never believe I can do anything until I've done it.' In these landscapes done from nature he never deliberately altered any feature of the scene before him. 'You see *me* moving around, in search of the best viewpoint, but you don't see me moving *trees* around,' he said. 'My imaginary things are entirely imaginary. I couldn't *imagine* something in a real place.'

The landscape compositions, of which a good example is *A Memory of Whithall, Gloucestershire* (1948), are less successful than those made directly from nature. The absence of nature tended to weaken his conviction, or rather the partial absence of nature. In the landscape composition he used drawings made from nature; his imagination showed itself stronger when it had no prop. Of greater merit than his landscape compositions are his figure compositions. Of these, with *The Sermon on the Mount*, far the finest is *A Cotswold Farm*, painted during 1930 and 1931 from studies made in the Cotswolds. It represents no particular place, but many of the studies were made at Andoversford, at a farm belonging to Dr Austin Lane Poole, Principal of St John's College, Oxford. The landscape in works of this kind differs radically from that in the landscape compositions, for it is designed, the artist told me, 'not so much as an end in itself, as to fit the people'.

Neither Gilbert's temperament – an essentially *plein aireist* temperament, happiest in the presence of nature – nor his brief professional training equipped him for composition on a large scale; in any case it is a rare faculty in these times when there is little demand for monumental public painting. The immense pains he gave himself in working out, in a long series of studies, the composition of *A Cotswold Farm* enabled him to overcome his handicap to a considerable extent, and although at points it falls short of academic perfection it is an impressive picture and one which it is not easy to forget. Although its themes are taken from the Cotswolds rather than the Thames valley, it constitutes almost a repertory of the themes of Gilbert Spencer's art: the farm buildings, the ploughed fields, the labourers,

above all the carts, are all there – and even the grove-crowned hill is reminiscent of Berkshire rather than of the Cotswolds. If the composition has had to be struggled for, the innumerable details have been put in with familiar ease: the whole crowded, indeed overcrowded, assembly of facts is knit together not mainly by the composition but by a warm consistency of feeling into a coherent whole in which interest is combined with dignity and transparent candour. The picture enhanced Gilbert's professional reputation and won a wide popularity as soon as it was shown in February 1932 at an exhibition of his paintings and drawings at the Goupil Gallery. *The Times* described it as 'a sort of rustic equivalent of Madox Brown's *Work*'; Frank Rutter as 'a great painting'; *The Morning Post*, whose critic was in general reluctant to see merit in the less conventional artists, as 'a magnificent achievement'; while to *The Scotsman* it was 'one of the liveliest compositions of recent years, and should find a place in the Tate Gallery' – in which it indeed found a place before February was out. *A Cotswold Farm* lives with a greater fullness than *Hebridean Memory* (1948–54), an equally ambitious composition based upon studies made on the Island of Canna, which he visited during his residence in Glasgow from 1948 until 1950 as head of the department of painting and drawing at the College of Art.

Allied to these two large compositions are the wall paintings in Holywell Manor, Oxford, an annexe to Balliol, which the painter began in 1934 and completed two years later. These paintings, in oil upon a prepared plaster surface, extend in a continuous band of about seven feet (two metres) in height round the upper part of the four walls of the anteroom to the junior common room, a room about fifteen feet (four and one-half metres) square. The foundation of Balliol College is the legend which the paintings illustrate – briefly, that John Balliol, intent upon seizing lands belonging to the Bishop of Durham, ambushed him when he was crossing a ford. For this offence he was arrested, tied to a tree and thrashed. Dervorguilla, his wife, considering that he had got off too lightly, gave money to enable sixteen poor students to study at Oxford. A wit said at the time that the painter's treatment was Chaucerian rather than Spenserian. There is some truth in this observation, for the drama is played out in a spirit of gentle rustic humour. At first glance Gilbert's interpretation seems rather too rustic, the actors to have too uniformly the character and tempo of agricultural labourers, but closer scrutiny reveals subtleties not at once apparent. Of these the most moving is the way in which the scholars' dedication to learning is expressed in their manifest joy in their first distant sight of Oxford, and in the intentness with which, having reached it, they peruse the books in the chained library, and the eagerness with which their upraised hands flutter

along the shelves. The landscape background is continuous, the earlier panels showing the craggy character of the Border country – where the painter had recourse to the Italian primitives – the later the undulating character of Oxfordshire where he had no need to look beyond his own memories. The painter responded finely to Balliol's imaginative commission.

One further field of Gilbert's activity remains to be mentioned, namely portraiture, which he pursued intermittently from his student days until his death. The best of the oil portraits known to me are *Portrait of a Man, Reading Boy* (both 1922), *Professor Oliver de Selincourt* (1953), and *The Artist's Wife* (1954). The first is a powerful, archaic-looking full-length, in which the painter's delight in homely objects is almost as manifest in his treatment of the black iron cottage stove before which his subject is seated as in the cloth-capped, heavily moustached figure itself. The other three are notable for the quality of the insight into character that they show – an insight in which remorseless candour is tempered by the warmest affection – and for the fineness of the heads' construction. But nothing that the artist did is finer, to my thinking, than the best of his portrait drawings, and these best are numerous. In them line defines form in its plenitude, form perfectly expressive of the character of the subject. To name but a few, almost at random: *French Girl* (1920), *Dorset Girl* (1921), *Little Girl in Spectacles* (1922) and *Mabel Nash* (1923), *Mrs Keep* (1930), and *Hebridean* (1947). These are drawings that could hang in any company.

He was an able teacher, serving as head of the department of painting and drawing at the Glasgow School of Art from 1948 until 1950, and head of the department of painting and drawing at the Camberwell School of Arts and Crafts from 1950 until 1957. He wrote two books, both of them lively and informative: *Stanley Spencer* (1961) and *Memoirs of a Painter* (1974).

Margaret Ursula Bradshaw, whom he married in 1930, died in 1959, and after the death of their daughter he moved from Yew Tree Cottage, where he had lived for many years, and settled in Church Rise Cottage, Walsham-le-Willows, Suffolk. He died on 14 January, 1979.

When Gilbert Spencer was a young painter, the novelty of his work, with its engaging blend of simplicity and skill, won him a place among the leaders of his generation. For some years, without loss of respect, his work has been first taken for granted, and then over-looked. I think that the sober genuineness of which I have written, and the charm which sprang from the irrepressible gaiety of the painter, will enable the best of it to survive the coming holocaust of reputations.

JOHN ARMSTRONG
1893 – 1973

It is singular that the highly personal character of John Armstrong's painting should have evolved so slowly. There are features about his early works which to anyone conversant with that of his maturity will see its being just perceptibly foreshadowed – but only just.

John Armstrong was born on 14 November, 1893 at 6 Priory Gardens, Hastings, the third son of the Revd William Armstrong and his wife Emily Mary, born Cripps. Four years after his birth the family moved to the small Sussex village of West Dean, near Goodwood. Here John delighted in the landscape, which he was encouraged to draw by his younger sister Dorothy, who became an illustrator of books, and by his parents, particularly his mother. He developed an eclectic interest in painting early in life. He later recalled that, as a child, his 'gallery of photographs included works by Landseer and Botticelli, Millais and Masaccio, certain German academic painters of dead cows and chariot-races, nudes by Etty and leaves from the *Book of the Dead*: anything, that is, that we sanctified by age or current taste.'

His interest in painting was lively and sophisticated. While still a schoolboy at St Paul's, he began to visit the British Museum, and while at St John's College, Oxford – where he studied law between 1912 and 1913 without apparent interest and made his first paintings – he frequently visited the Ashmolean Museum, delighting in its paintings and drawings. Such great collections and his classical education were the foundation of his enduring interest in the art, drama and philosophy of ancient Greece.

When he came down, Armstrong attended the St John's Wood School of Art, remaining there until the outbreak of war. He enjoyed the opportunity of painting murals in tempera, but disliked the regulation drawings of classical figures with a stump. Friends have described him as spending much of his time walking about, looking at things rather than drawing.

During the war Armstrong served from August 1914 until December 1918 as an officer in the Cavalry and the Royal Field Artillery, first in Egypt, where he spent several months – with ample opportunities to explore the pyramids and visit the Cairo museum – and

eventually in Salonika. In Greece, on the contrary, he had little opportunity to study works of art. He returned home suffering from malaria, and was laid up for several months. On his recovery he briefly returned to the St John's Wood School of Art and after he left he experienced several years of poverty. However, from his mid-twenties he was able to support himself by painting, together with a variety of jobs.

Then Armstrong met Elsa Lanchester and they became intimate friends. He assisted her in decorating her theatre club, the Cave of Harmony, and in her book *Charles Laughton and I* she gives the following affectionate tribute to Armstrong's help and versatility:

> No one expected to get paid properly, but everyone was glad of the pocket money to be made. John Armstrong was at that time an unknown painter. He had from the earliest days helped with the scenery, designing, costumes and envelope-addressing. He also wrote us a play called *The Brigand's Daughter* which was a great success. When the Cave moved to Gower Street John Armstrong, never loath to try out a new talent, took over the catering . . . John always decorated a copy of each new menu with the most fabulous pictures, and over the coffee stall itself he painted a cornucopia. Standing in this abundant niche John became almost more important than the entertainments.

It was in 1926 that *Riverside Nights*, a revue by A. P. Herbert and Nigel Playfair, was staged at the Lyric Theatre, Hammersmith, for which Armstrong designed the sets and costumes, and in the published version are several of his illustrations. He also designed sets for *Midnight Follies*, a highbrow revue in which Elsa Lanchester performed, but the show failed. He remained close friends with Elsa and was a witness at her marriage in 1929 to Charles Laughton, who also became a friend. She acted with Laughton in two films, *The Private Life of Henry VIII* (1933) and *Rembrandt* (1936), both of which were produced by Alexander Korda. Armstrong designed the costumes for these two and eight other Korda films. He also carried out extensive decorative paintings in the 1930s for Tom Laughton's Royal Hotel in Scarborough. (In the 1960s he painted portraits of Tom Laughton and Esme his wife, which they presented to that city's art gallery.) Armstrong also carried out commissions for the decoration of interiors, among them for the house of Samuel Courtauld, 20 Portman Square, London, now the Courtauld Institute; for Sir Geoffrey Fry's dining-room in Portman Court and a frieze round the ballroom at 1 Kensington Palace Gardens, the house of George Strauss, MP.

In the meantime Armstrong was achieving recognition as an easel painter and examples of his work were acquired by such notable collectors as Edward Marsh and Lord Howard de Walden. In 1928 his first one-man exhibition was held at the Leicester Galleries (the other

exhibitor being Matisse) and nineteen of the thirty-six exhibited works, mostly temperas, were sold. A second, held the following year at the same galleries, was also well received. Although most of the works manifested a well-travelled, well-read, highly intelligent artist's varied attempts to find his way, the success of these exhibitions was deserved. And very varied indeed they were in concepts and style. Several, however, clearly show that Armstrong was evolving a personal style, although a number in both exhibitions were clearly experimental. But such works as *Psyche on the Styx* (*c.* 1927), and *The Rape of Persephone* (1927) – which was highly praised at the 1928 Venice Biennale – and several others, revealed a maturity of a high degree.

I well remember the delight with which, together with many others, I took in Armstrong's work of the late 1930s and early 1940s, and I recommended the purchase of his gently surrealist *Dreaming Head* (1938) for the Tate and *Icarus* (1940), both recently completed. (His first *Icarus* had been painted two years before.) *Icarus*, Armstrong wrote to the Tate, 'has always been a symbol to me of the world flying too close to the sun of knowledge, and getting destroyed in the process.' It was probably the second of the numerous versions which he continued to produce until 1963. 'The *Dreaming Head*,' wrote T. W. Earp, the eminent critic, in *The Daily Telegraph*, 'is the chief attraction of this year's Tate Gallery purchases . . . It confirms his title as our foremost surrealist painter.' Both have their place among Armstrong's most notable works. *Dreaming Head*, a poetic dream, and *Icarus*, a fantastic subject, are both realized with delicate precision. Another work of the same year, *The Farm in Wales*, has the same exquisite precision, but represents the reality of a farmhouse in ruins rather than a dream. It is a rare combination of minute detail with grandeur of composition. Armstrong's theoretical hostility to realism makes it the more remarkable.

At the same time Armstrong was producing works of an entirely different character: Greek and Egyptian human figures, animals and birds, all of which derived from works he had seen during the First World War in Egypt and northern Greece. A singular feature in Armstrong's outlook was his occasional lack of artistic confidence in *Dreaming Head*, *The Farm in Wales* and kindred works which, although skilful, decorative and elegant, are relatively conventional. But his paintings of Graeco-Egyptian character derived from other motives: he enjoyed a wide variety of subjects and was undoubtedly nostalgic for his days in Egypt and northern Greece.

There was also, I believe, another motive for Armstrong's wide-ranging interests, for painting these and a number of conspicuously nonrealistic works. Like many artists, in particular those of younger

generations whose work had not reached consistent maturity, Armstrong was affected by the widespread changes of outlook resulting primarily from the two Post-Impressionist exhibitions. Above all these evoked prejudice against 'realistic' and 'literary' painting. For a time these very words became terms of the severest denigration. To Armstrong, who was approaching maturity relatively late and so was deeply admiring of Greek and Egyptian art, as well as 'of Landseer and Botticelli' and 'certain German painters of dead cows', Post-Impressionism offered only a menacing element. In his contribution to Sir Herbert Read's book *Unit One* (1934), Armstrong refers to his having tried to 'blend the qualities of my diverse favourites into an impossible eclecticism'.

Never a conforming adherent of any movement, Armstrong was nevertheless influenced for a time by the eerie, massive and suave work of De Chirico who, without being a Surrealist himself, exercised a marked influence on that movement. For several years Surrealism radically affected Armstrong's way of seeing. The International Surrealist exhibition was held in London in 1936 and for several years his work became increasingly surrealist in character, although compared with that of the Surrealists in general Armstrong's paintings were gently dreamlike. Characteristic examples are *Heaviness of Sleep* (1938) and the Tate's *Dreaming Head*.

His invitation to join Unit One in 1938 was a clear indication of the reputation Armstrong had achieved as an 'advanced' artist. Unit One brought prestige: among his fellow members were Barbara Hepworth, Henry Moore, Paul Nash, John Bigge, Edward Burra, Tristram Hillier, Ben Nicholson and Edward Wadsworth. But beyond a letter in *The Times* from Nash, an exhibition at the Mayor Gallery and the lively book also called *Unit One*, with contributions from its members, the group proved of little practical consequence.

Always versatile, in the 1930s Armstrong undertook a number of paintings for Shell advertisements – several of them striking – including *Artists Prefer Shell*. For the dining-room of Shell-Mex House he also painted eight wall-panels, depicting 'Transport through the Ages', which he considered his most successful murals. His final establishment as a stage designer came with his scenery and costumes for Edith Sitwell's and William Walton's *Façade* when it was performed with Frederick Ashton's choreography on 26 April, 1931 at the Cambridge Theatre, London. For these Armstrong was paid £5. Between October 1933 and June 1934 he designed the costumes for the Old Vic/Sadler's Wells season of *The Cherry Orchard* and six other productions, and costumes for *Much Ado About Nothing* at the Aldwych Theatre in 1946. At that time he was widely regarded primarily as a theatrical designer. Preoccupation with films and advertisements did

not, however, seriously interfere with his painting. Such works as *Sunrise*, mentioned earlier, and *Forsaken Street* (1938), as well as several others of similar ruined buildings portrayed with delicate precision, are expressive of his distress caused by the Spanish Civil War and his hatred of Italian fascism. One, *Phoenix* (c. 1938), is surrealistic in character, the realistic ruins being framed by a classical feature.

In 1940 Armstrong was appointed an Official War Artist, so serving for the following four years. A notable war painting, and one of his first, is *Coggeshall Church, Essex* (1940). When he heard of the peculiar effect of a bomb on the church tower, Armstrong suggested it as a subject to the War Artists' Committee, who commissioned him to paint it. The explosion had blown away half the front and sides of the tower, leaving its beams and rafters exposed intact. Coincidentally, while on exhibition the painting was itself damaged by bomb splinters, and returned to Armstrong for repairs. Another of his outstanding war paintings is *Making Templates for Gliders* (1942), in which he represented a highly complex subject – ten elaborate wheels, each one with a man working at it – all lucidly portrayed. He also carried out paintings for reproduction for Imperial Chemical Industries, some of which are highly dramatic, such as *Explosion!*, of the early 1940s.

It was shortly after the war that this artist of such varied talent painted several works which showed his greatest originality. Among them are five nocturnal land- or seascapes. All are inhabited by strange forms. In *Nocturne* and *The Purple Sea* they are in the air, while in *The Pleasure of Flying* they stand windblown, as in *The Heralds*, or else, in what seems to me the most notable, *The Embrace of the Shadow*, just standing, three treelike forms, the shadow of one falling on another. These five paintings of 1947 are all highly complex, although at first glance simple, and have a haunting aura. They relate closely to *Classical Landscapes*, *Icarus* and *Dreaming Head*, but contrast – except in technique – with the penetrating realism of *The Farm in Wales*. Armstrong has never received the recognition due for these highly original works.

Even for an artist as versatile as Armstrong, the 1950s was a period of rare variety. He painted realistic still-lifes with exceptional accomplishment. Among his most notable achievements ranging from the late 1930s to the early 1950s were his works of fervent propaganda. Outstanding are *Pro Patria* (1937), an antifascist work which followed a visit to Rome, *Battle of Nothing* (1949), *The Battle of Propaganda* (1950), *Umbrella Men* (c. 1950), *Storm* (1951), *Struggle For Faith* (1951) and *Battle of Religion* (1953). *The Battle of Propaganda* and the hardly less complex *Battle of Religion* are both oils, a medium he began to use

from the late 1930s and with increasing frequency during the 1950s until it became virtually his sole medium. All these, and a number of others, are expressive of Armstrong's passionate political convictions: antifascist, antinuclear, pacifist, radical. They also show that Armstrong's ideas for paintings came to him very clearly, sometimes, as for example, *The Somnambulist*, in dreams. He described how he kept them in his mind for a long time, and that the closer he kept to the original image the more satisfactory the result.

Armstrong had long been attracted by symbolism. In his foreword to the catalogue of his exhibition at the Lefevre Gallery in November 1951, he refers to the symbolism in these and other paintings:

> Since a common field of reference no longer exists, it is appropriate for a painter to explain the symbolism he uses. The aesthetic and the emotional both being of importance in the present case, symbols have a double value. For example, umbrellas are interesting objects in themselves to paint, but they symbolize also the inadequate beliefs under which men attempt to shelter from the growing storm of despair. The clown gives an excuse for full draperies and the varied colours and patterns of the circus. He is, as well, the image of frustration, fighting battles of nothing, attempting a leap forward but doing a back-somersault instead. He may assume other aspects of humanity in its predicament and in *The Funeral of Harlequin* the supporting figures have something in them of the judge, the physician and the priest. The women and flowers express states of love. The flowers are of simple types and suitable to the play of light which, from association with the theatre, has been imagined coming as from footlights. Equally this may be the light of dawn or dusk, the end or the beginning of an era – we are uncertain which.

In his fifties he began to paint more abstracts but without deep conviction. I believe it likely that the wide range of his subjects, each one treated with such profuse detail and such intensity, so largely satisfied his need for political expression that he turned to abstraction, such as *Brown Abstract* (1965), or else simple still-lifes, such as *Plato* (1972) – a jug and some oddments, one of his last paintings – and *The Straw Hat* (1957).

In the mid-1950s Armstrong (who was a member of the Society of Mural Painters) carried out a work of character and dimensions which differed from anything he painted either before or after – apart from his panels for Shell-Mex. He and Thomas Monnington were each commissioned to paint a vast decoration for the New Council House at Bristol, to be opened by the Queen on 17 April, 1956. These two works were the ceilings of the Council Chamber and the Conference Room. It was with the painting of the former that Armstrong was entrusted, a ceiling measuring 75 by 45 feet (23 by 14 metres). Set round the four sides of the frieze he depicted a succession of

celebrated Bristol buildings, mostly ancient, their spires and church towers breaking the skyline at intervals, with the exception of the side above the Lord Mayor's rostrum where subjects of the present day are represented by the New Council House and dockside cranes. Four symbolic figures occupy the corners: Wisdom, taking a book from the shelf; Enterprise, breaking the chains upon his wrists; Industry, seated among cranes and other machinery; and Navigation, taking a bearing by the stars. Strangely, while the centre of the ceiling is occupied by the sea on which are four small fleets of sailing ships, apart from a few small tugs there is no sign of a steamship, which would have been a symbolic tribute to Bristol's greatness as a port. This ceiling, imaginative and efficiently carried out on a series of large panels, is a notable achievement; especially as the work of a man with limited experience of comparable work.

One characteristic which increasingly marks Armstrong's painting during the 1950s, particularly his still-lifes, is a radically altered technique. His earlier works, and the more complex subjects of the 1950s, are marked by a rare precision, but the later still-lifes have a mosaic character. In all of his painting, however, his technique underwent a gradual change, away from delicate precision towards a greater freedom. The character of this change may be seen by comparing the *Icarus* of 1940 already referred to, with *Icarus* and *Sunset Icarus* of twenty-three years later. The direct precision of the earlier is replaced by a rare technique which imparts a sense of freedom absent from the first, yet with rare accomplishment combines precision with a subtler sense of form and luminosity. In *Sunset Icarus* in particular the smallest detail is lucidly portrayed without a loss of unity.

By the 1940s Armstrong's technique had become exceptional: he rarely made preparatory studies but painted directly, whether onto paper, wood or canvas, occasionally with a slight mark of charcoal here and there. He worked on a dark background which was still wet, with contrasting colours, always using square-tipped brushes of varying sizes. Each stroke was complete and never retouched. The effect became less linear, more 'painterly'. However, to generalize about changes in Armstrong's painting can easily be misleading, for he constantly sought change, both of subject and its treatment. He was extraordinarily versatile, because he delighted in change and because for all his talent and eventual success he was occasionally troubled by an element of self-mistrust. This was one of the deleterious effects of the influence of the various movements, from Post-Impressionism onwards, on a number of his contemporaries. He felt these influences led to the diversion, sometimes even the erosion, of their particular talents. Armstrong worked in a wide variety of styles

but avoided enslavement by any. Few of his contemporaries produced works so extraordinarily varied as, for instance, *The Battle of Propaganda*, the vast decoration of Bristol's New Council House, the admirable still-life *Concave and Convex* (1957) and, in addition, a number of abstracts – all painted within a few years of one another.

By the early 1960s Armstrong's production had been so wide-ranging in character and subject, so technically varied, had given such full expression to his ideas, his sentiments, his view of his particular world, that what remained was limited. No less serious, in 1962 he was attacked by Parkinson's Disease, which increasingly diminished his capacity for work, not long after he had completed his last mural at the Royal Marsden Hospital in Sutton, Surrey.

Over his last years he painted many abstracts and still-lifes – many of fruit and vegetables with pots, several very competent – and yet again returned to the theme of Icarus, depicting in 1963 some six at least. Two of them, *Fallen Icarus* and *Icarus with Shattered Wings*, are outstanding and comparable with his best depictions of the subject of Icarus, the myth he used for the image of impending catastrophe, with its half-shattered global form borne on the wings of despair.

Despite steadily declining health, Armstrong remained active in support of the Labour Party, contributing articles and occasionally poems to left-wing publications. He had become deeply pessimistic about the state of the world, expressed in his four *Tocsins* (1967) and a dramatic work, *The Bell* (1967) tolling for a lost world.

In 1970 he suffered a stroke, but it was only when he could no longer control his right hand that he ceased to paint, in 1972. His condition became precarious. His wife took him to Italy, visiting Venice, Florence, Ravenna, and Arezzo, where he had never been before. The following year, on 19 May, 1973, he died of viral pneumonia in hospital in London.

Armstrong was an artist of rare versatility and technical accomplishment. His work was uneven, but an artist should be judged by his best works, and most of those I have referred to here I believe to reflect both his imagination and his technical accomplishments.

JOHN NASH
1893 – 1977

Biographies of landscape painters often convey the impression that nature was their subject's inspiration and that their art was founded upon the study of landscape itself. The art of most landscape painters, like that of most painters in fact, derives principally from the example of other painters.

Landscape, especially landscape undisciplined by man, poses particular difficulties to painting. Confronted by nature, as it stretches away to the horizon in every direction in infinite complexity, the untaught eye is baffled. Whether it contemplates the scale of nature as it stretches away to the infinitely vast in the one direction or the infinitely minute in the other, it faces the baffling problem of giving order and a finite form to a phenomenon which in its infinite complexity has neither – neither, at all events, discernible to the untaught eye. Most artists, before they can look profitably at landscape, must first learn what to look for by reference, conscious or not, to the work of other artists. Their human experience may offer them some guidance where a human face or body is in question, but guidance of a more specialized kind is necessary if they are not to be altogether lost in the contemplation of the intricate disorder and the immensity of nature. Reason alone would suggest that this could hardly be otherwise; the landscape paintings of the period with which these pages are concerned tend to confirm it. These seem to me to reveal, to a greater degree than portraits or still-lifes, say, reliance upon art rather than nature. All painters, whatever their pretensions to innovation, draw largely upon the experience of their predecessors, but a glance at an assemblage of modern landscape paintings is a particularly forcible reminder of how frankly their makers have taken either Constable, or Turner, or the Barbizon School, or the Impressionists, or Cézanne or his followers, if not invariably as models, then almost invariably as a point of departure. The very intractability of landscape as a subject would seem to demand a rather closer-knit tradition than subjects smaller and less various.

Of the subjects of these essays who have directed their chief efforts towards landscape, all have looked harder at art in the earlier part of

159

their lives as painters than they have at nature – with the exception of John Nash.

There is nothing spectacular, nothing even strikingly personal, about his landscape because the personality of the painter was quiet, reticent and serene; but it owes little to the example of others, for John Nash seldom looked at a painting and paid no attention to theories: he read little about painting, and as a subject for reflection took no interest in it at all. The example of his friends is certainly discernible in his beginnings; so inevitably is something of the climate of the time in which he grew up, but the real source of his landscape painting, to a degree for which I can think of no parallel among his contemporaries, is landscape itself. John Nash lived in the country; he was an impassioned gardener and botanist and a life-long and single-minded lover of landscape.

The principal facts of his uneventful life are soon told. John Northcote Nash was born at Ghuznee Lodge, Earl's Court, on 11 April, 1893, the younger of the two sons (Paul being the elder) of William Harry Nash, and educated at Langley Place, Slough, and at Wellington College. He left school without definite ideas about how to spend his life, but was willing to try any kind of work. The possibility of his entering a solicitor's office was considered, but his father found it difficult to provide the necessary premium. He eventually joined the staff of *The Middlesex & Bucks Reporter* as an apprentice. Finding that his activities as a reporter were circumscribed by lack of transport, he asked for sufficient money to buy a bicycle. For this importunity he was reprimanded and given notice; his career in journalism was at an end, and he was without occupation or prospects.

Casting about as to what his brother had best do, Paul urged him to try his hand at painting. John Nash once said to me that

> I must have been a very malleable character for I'd never thought of being a painter, but I at once agreed, and set about making landscapes in watercolour and comic drawings. Paul was not happy at the Slade and he opposed my going there or to any school of art, and he used to tell me how lucky I was to begin free from the disadvantages of conventional training. All the same, I wish I'd had the advantage of training of some kind.

Paul had sent a packet of John's drawings to his friend Gordon Bottomley, who wrote, on 7 July, 1912, that:

> he has not only a good sense of decorative disposition of his masses, but his blacks have a beautiful quality, and his pen-touch is crisp and clear and delicate and exquisitely balanced. . . . In facility and lucidity and directness of expression, and in his faculty of keeping his material untroubled, he has advantages over you; but of course it remains to be

seen if he can preserve these qualities when he has as much to say as
you have.

Paul's informative reply, written about 13 July, shows John as a very
tentative beginner both as a draughtsman (the spirited comic draw-
ings with which he had illustrated his letters from Wellington had
delighted his family) and as a writer.

Jack is very 'set up for the rest of 'is natural' as the vulgar have it, upon
your high praise – I don't mean he has swollen his head-piece for he
ever expresses a mild surprise at any appreciation upon his drawings,
which he does at odd times on odd bits of paper when he has nothing
else to do. I, from time to time, raid his desk or the wastepaper basket
or the corners of the room & collect the odd bits of paper rather like a
park-keeper in Kensington Gardens, and after a sorting of chaff from
grain tho' to be sure it's all 'chaff' I select the best & cut them into a
decent shape & mount them. At first Jack used to be so delighted at the
good appearance of his drawings when mounted that he fully believed
it was entirely owing to the way I set them up & drew lines round
them; gradually it has dawned on him tho' that it must be he has done
a good drawing – this is a pity because he now becomes a little too
conscious & careful, with the result his designs are not so naive &
simple. At present he is working on the staff of a country paper &
gaining experience for a journalistic career. All his abilities lie in that
direction and he will tell you his ambition is to be 'a man of letters'.
These drawings are as yet his only expression of himself. He is very
observant and writes excellent descriptions of things that strike him,
always with the same quaint touch you see in these designs. He has so
far done very little actual writing save a few articles in the paper &
some essays when he was at Wellington. The work for the paper takes
all his time & he is riding about & reporting all over the county & at all
times of day & night. Unfortunately his time is up in August for this
has been experience & work quite unpaid as regards salary, and then
I really don't know what happens – a London paper I suppose is the
next thing – he likes regular work & routine, unlike me, & works well;
at the same time he is not constitutionally robust & v. hard work in
London would not be good for him I fear. I myself have no doubt he
has a most interesting self to develop, & work to produce, but how &
in what direction I really am not certain.

A curious encounter I had with Paul years later leads me to think
that the doubts he voiced to Bottomley about 'how and in what
direction' his brother should express himself still persisted, in spite
of the blossoming of John's powers.

Just before the Second World War I was commissioned to write an
introductory essay on John Nash for a portfolio of reproductions
(which was not published) similar to one that had recently appeared
on Paul. When I had completed the essay I told Paul that I would
value any comments he might care to make on it, and he accordingly
invited my wife and myself to lunch. After I had read the essay aloud
to him, he said, with deliberation, 'It was I who encouraged Jack to

be a painter; and I'm still not sure that I did rightly: I don't know whether he has a painter's imagination.' These words astonished me, and I might have doubted having heard them, although they were several times repeated in slightly differing form, had my wife not heard them also.

Not much more than a year after John Nash began his series of landscapes, the brothers held a joint exhibition at the small and long-defunct Dorien Leigh Galleries in Pelham Street, South Kensington; its success confirmed him in his choice of a vocation. The exhibition was a success not only because of the number of works sold, but because of the favourable impression it made among painters. Among those who went to see it were Gilman, Bevan, Sickert, as well as my father, who had known Paul – as a Slade student Paul used occasionally to show him John's satirical drawings of suburban life – since 1910. As a consequence of the success of the exhibition, and of the acceptance, also in 1913, of a watercolour by the New English Art Club – a success which resounded far more influentially than it would today – John Nash was drawn for a brief period into one of the vortices of London's art world. In 1914 he accepted an invitation to become a member of the newly founded London Group, and the following year, on Gilman's invitation, he joined the Cumberland Market Group, and he became associated with the young painters who used to gather at 19 Fitzroy Street. It is significant, however, of his essential detachment from the curious, turbulent little world which revolved about these groups that he did not dream, as he told me, 'of visiting the Second Post-Impressionist Exhibition, which was held while I was constantly in London'.

The first visit he paid to 19 Fitzroy Street he recalled with a particular vividness. The spectacle of such an assemblage – seen on arrival through the studio door – Pissarro, Gilman and Gore were present – so overawed him that he had turned to descend the stairs when Gore, watchful and genial, hailed him and drew him inside. This was when he first met Gilman, who began to impart to him on the spot his theories about painting. It was then that Gilman uttered a warning, often repeated, against the mixing of paint with oil: 'There's enough oil in the paint anyhow, without adding more of the treacherous stuff.' John Nash heeded the warning, and like Gilman and his friends Ginner and Bevan he never diluted his paint with oil. There was a further and more important respect in which Gilman's teachings affected John Nash's methods; he urged him not to make his paintings from nature but from drawings. This injunction he mostly followed, partly owing to the force of Gilman's argument, but partly because he found it difficult to carry his landscapes in oils to completion directly from nature. These, with few exceptions, were

therefore painted in the studio from drawings made on the spot; his watercolours were carried far towards completion in front of the subject, but worked on afterwards indoors. Gilman's advice carried particular weight with John Nash, as he had been painting in oils for only about a year before his first meeting with him early in 1915. The two previous years he had spent in making landscapes in watercolour round his home in Buckinghamshire and in Berkshire, Norfolk and Dorset. In May 1915 he joined Gilman and two other members of the Cumberland Market Group – Ginner and Bevan – in an exhibition at the Goupil Gallery. A watercolour, *Trees in a Flood*, was presented that same year to the City Art Gallery, Leeds, by Sir Michael Sadler, one of his earliest admirers. It was the first of his works to enter a public collection.

In spite of his fruitful and pleasurable London associations – he enjoyed in particular the weekly meetings 'for tea and picture showing' held by the Cumberland Market Group in Bevan's house overlooking the market – the true centre of John Nash's life, then and at all times, was the country. In view of the intimate association between his painting and the places he lived in, it seems to me that there is little in an account of his life more relevant than the record of these places. From 1901, when his family moved from Kensington to Buckinghamshire, until the First World War, he lived at home at Iver Heath. After serving in the Ministry of Munitions, in the 28th London Regiment, Artists' Rifles, with whom he was on active service in France from November 1916 until January 1918, and in the spring of that year, as an Official War Artist, he lived at Chalfont Common, Buckinghamshire. In the autumn of the following year he settled in Gerrards Cross, but spent that summer at not far distant Whiteleaf, Princes Risborough, and the following at Sapperton, Gloucestershire. In 1921, while looking for a house to buy, he went to Monks Risborough, establishing himself at Meadle, near Princes Risborough, where, except for summer painting excursions, he remained until the second year of the Second World War. All these places except Sapperton were in Buckinghamshire. In the autumn of 1944 he took Bottengoms Farm, at Wormingford in Essex, where he lived until his death.

Considering that he was without formal training of any kind and that the First World War disrupted his life and work before he was able to establish himself, John Nash's growth to maturity was extremely rapid. His watercolours were marked by an assurance and a sense of style almost from the start: *Landscape near Sheringham*, for instance, was probably made on a visit to Norfolk in 1912 with an artist friend, when he decided to devote himself to painting. With his oils it was otherwise. For two or three years his understanding of

technique was so elementary that at first glance his earliest paintings have a look of conscious archaism, an uncandid simplicity; only upon close examination is it apparent that they are expressions of a mind with a personal sensibility and inventiveness struggling for clarity and fullness of statement. I have in mind such paintings as *Threshing* (1914), in which the painter was vividly aware of the relations between the ascending member of the machine, the twisting column of smoke, the woods behind and the cloudy sky above, yet painfully unable to give these relations a logical and fully expressive coherence. Yet these and other paintings of the same unsophisticated character found a warm response among several lovers of painting. 'His railway viaduct also and the wood of slim trees are most beautiful,' wrote Gordon Bottomley to Paul Nash (11 June, 1919); the first of these pictures promptly found a place in the collection of Sir Osbert Sitwell, and I recall my father's constant praise of the works of both brothers.

The struggles of this untaught, untravelled painter with his medium were rewarded with a success which came quickly. In 1918 he painted *The Cornfield*, a picture in which strength of construction is united with an exhilarating rhythmic harmony. A Buckinghamshire field and its bounding woods are here realized simply and grandly, all detail merging in a large glowing unity – a vision so direct and solid and so burning that, sharing it in the presence of this picture, it affects one as the work of some humble primitive master. This remarkable painting was bought by Sir Edward Marsh, who early befriended the two brothers, and I remember with what dignity it held its place, year after year, on the walls, ever more densely crowded with the works of young contemporaries, of 5 Raymond Buildings, his chambers in Gray's Inn, and how much it continued to delight him. He made a gift of it to Ivor Novello, his most intimate friend, on condition that he bequeathed it, through the Contemporary Art Society, to the Tate Gallery. It entered the collection in this way after his death in 1952.

Early in 1918 John Nash was commissioned as an Official War Artist to make paintings and drawings of war subjects for the Ministry of Information, with which he was occupied for the larger part of that year and the next. During this time he shared a shed which served as a studio with his brother at Chalfont Common. Paul wrote a spirited description to Gordon Bottomley of the life which the brothers led there:

> We have taken a large shed, formerly used for drying herbs. It is a roomy place with large windows down both sides, an ample studio – here we work. Jack is lately married – a charming girl whom we all adore. . . . They live in rooms in a little house next the shed & Bunty and I have a room in the old farm – a charming place with a wonderful

cherry orchard & fine old barns & sheep and rabbits & all that sort of thing. We all lunch together in the studio where there is a piano so our wives enchant us with music at times thro' the day. A phantastic existence as all lives seem these days but good while it lasts & should produce something worth while I suppose. France and the trenches would be a mere dream if our minds were not perpetually bent upon those scenes.

While he was on active service in France, John Nash had made numerous sketches, from which he was able to execute his various commissions. Of these the most ambitious was a large painting, *Oppy Wood, Evening, 1917* (1919). Neither for dramatic intensity nor for insight into the war does this picture compare with the best of the war pictures of Paul Nash. In *Oppy Wood* the quiet, modest, peaceful man, the gardener, the botanist, has taken as his theme a moment when war has receded. The earth in front of the trench is shell-pitted, the blasted trees have no branches, yet a great quiet has taken possession of the scene, a quiet so potent as to still even the sound of the two shells exploding on the left; a quiet that is the harbinger of a larger quiet that will eventually still the voices of the guns and in which nations will be reconciled, and sanity come again, and gardening and botany resume their proper places among the pursuits of men. Such, more or less, are the sentiments which have gone to the formation of *Oppy Wood*. Like many of the best works of the Official War Artists (as of the best artists who have represented war) this is not a war but a peace picture. John Nash also painted some war pictures in the most positive sense. One of the best of these, *Over the Top: The 1st Artists' Rifles at Marcoing* (1918–19), shows men of the regiment in which he served climbing out of their trench and walking, heads down, into the smoke of the barrage. The slow upward and forward movement is powerfully conveyed; so too the tension between fear and determination in the advancing men. The dramatic moment, and death itself, although represented with a fitting sombreness, are represented without even a hint of melodrama, but in due proportion to the drama as a whole. While he was engaged upon these two important pictures, the War Office having neglected to inform his regiment of his appointment as an Official War Artist, he was posted as a deserter and an escort sent to apprehend him.

Nash's apprenticeship ended with *The Cornfield* and the war pictures; the primitive look disappeared from his art and he painted with a modest consciousness of command. I have the impression that in spite of these auspicious beginnings as a mature oil painter John Nash succeeded more often in conveying his special insights into nature in watercolour. This may be due to the circumstance that his art is primarily an art of observation and selection, the child of a

creative impulse roused to its highest pitch by the presence, rather than by the subsequent contemplation, of the subject. The relative laboriousness of oil painting, the degree of organization which it demands, offers a hard choice to those who use it in the representation of landscape. They may complete their pictures in front of the subject and run the risk of being 'put out by nature', of being distracted by the subject from the work of art, of being prevented by changing light, by wind and other difficulties attendant on working outdoors, from giving to the work the intense concentration which for most painters is possible only in the studio. Or they may take them away from the subject to complete indoors, and thereby run the risk attendant upon being cut off from the source of their inspiration. As related earlier, John Nash occasionally began his oils in front of the subject, carried them as far as he could, and took them indoors for completion, but more usually he painted them entirely in the studio. To a man as immediately dependent as he was upon the heightened feelings he derived from the sight of field and wood, the smell of ploughed earth and corn under a hot sun, the deprivation of such impressions accounts, it seems to me, for a listlessness, a fluffy indeterminacy sometimes noticeable in his landscapes in oils but in relatively few of those in watercolour. The lighter medium allowed him to complete pictures in the full enjoyment of the impressions that furnish the motive power of his art, so that in his watercolours signs of waning interest, signs of attempts to rely instead upon sense of duty, are rarely seen.

But John Nash's occasional proneness to boredom in his oils should not cause us to forget that he interpreted the landscape in every one of the places where he lived and in every season of the year (although it was winter, I think, that most often called forth his highest faculties), in oils as well as watercolour, with a combination of acute observation and poetic insight that is very rare. His pictures give pleasure not only to lovers of the fine arts, but to lovers of the country as well, especially to informed lovers, such as farmers, gardeners, botanists, and to other landscape painters.

Once rid of the archaism of the untaught, his work altered little, and his best works are to be found throughout all his active years. We find the same qualities, for instance, in *The Deserted Sheep Pen* (1938), and *Farmyard in the Snow* (1947), *Winter Afternoon* (1945) and *Snow at Wormingford* (1946), and *Pond at Little Horkesley* (1953); and *The Moat, Grange Farm, Kimble* (1922). We find, that is to say, firm, logical structure, deeply informed observation, modest, unaffected candour and poetic insight. They are pictures that one cannot contemplate without a sense of enhanced life.

If there was a change, I would say that the broad generalizations,

the bold forthright structure of his earlier years, were enriched by new subtleties of colour and design and a growing inclination towards a 'close-up' view of things. 'Half a haystack interests me now,' I recall his telling me in 1938, 'just as much as a wide stretch of country.' This heightened preoccupation with the intimate and the near – with the foregrounds of landscape – was an expression of his interest in horticulture. This interest was first stirred in 1922 by his possession, with his cottage at Princes Risborough, for the first time, of a garden; it was fostered by the friendship of gardeners, notably Clarence Elliott, and Jason Hill. (He made a pictorial record of all the best plants he grew.)

John Nash's landscapes are uncommon in that they are the work of a countryman. His brother Paul also loved landscape, but he brought to his interpretations a town-sharpened and innately literary intelligence and town-forged weapons, but John was a countryman by lifelong residence and in all his interests. Where Paul would write a manifesto or form a group, John transplanted some roses; where Paul would cherish the words of Thomas Browne or Blake, John consulted a seed catalogue.

If I have so far treated John Nash almost exclusively as a landscape painter it is because it is upon what he has done in this branch of his art that his reputation will eventually rest, and it is my own conviction that as an interpreter of English landscape he will be accorded a high place among the painters of his time. It would be wrong, however, to suppose landscape to have been his exclusive preoccupation, for he was a man whose creative energies took many forms, and although his pace of work was unhurried and he was as little responsive to the spur of ambition as any artist I knew, he has a body of work to his credit as large as it is various.

For a brief period in 1921 he became *The London Mercury*'s first art critic. He served from time to time, and to good purpose, as a teacher, first from 1922 until 1927 at the Ruskin School of Drawing at Oxford, of which his friend Sydney Carline was then master, and in the department of design of the Royal College of Art from 1934 (when my father was Principal) until 1940, and again, at the invitation of the Principal Robin Darwin, from 1945. Early in the Second World War he joined the Observer Corps and in 1940 was appointed an Official War Artist to the Admiralty. In November that year, preferring to serve his country more directly, he gave up painting and, being commissioned first as captain and later as acting major in the Royal Marines, he held responsible posts under the commanders-in-chief, Rosyth and Portsmouth. 'He didn't like being an official artist for the Admiralty – couldn't do anything he said and just went on nagging until he got back into active service. Was there ever such a chap?'

wrote his brother to Bottomley. It was not until the end of 1944, after being demobilized, that he resumed his art. This act of self-abnegation was characteristic of John Nash, and the measure of the distance between him and the artist for whom the welfare of his art is the sole criterion of conduct.

Apart from landscape painting, the two principal activities of his life were drawing and wood-engraving. Drawing, practised since his school-days at Wellington, was a constant preoccupation, and wood-engraving since before 1920. He made illustrations for no fewer than twenty-six books, in line, coloured lithograph or wood-engraving; the first to be published was *Dressing Gowns and Glue* by L. de G. Sieveking (1919) and *Parnassian Molehill* by the Earl of Cranbook (1953). Until the mid-1920s his drawings were mainly comic, but from that time onwards, in fact from 1924 when he began to engrave on wood his illustrations for *Poisonous Plants*, published three years later, plants became his chief preoccupation, and his illustrations to Jason Hill's *The Curious Garden* (1933), R. Gathorne-Hardy's *Wild Flowers in Britain* (1938), *English Garden Flowers* (1948), and White's *The Natural History of Selborne* (1951) have become classics. Landscape painting however remained his primary concern, both as a watercolour and oil painter until the end of his life.

In 1944, after his discharge from the Forces, John and Christine moved to Bottengoms Farm near Wormingford. Dedicated to landscape, Nash made his most notable works in the Stour Valley, to which he became more deeply attached than to any other region. But to preserve it from any possibility of becoming too familiar, he worked in a variety of places, among them St Austell, Cornwall, the Gower Peninsular and other parts of Wales, Skye, Derbyshire and Shropshire, usually in spring and summer. In winter, his favourite time of year, he painted and drew, one of his neighbours told me, 'everything in the district' around Bottengoms. The landscape around Bottengoms was a continuous source of inspiration, but there was one feature which afforded him particular delight, namely the all but omnipresent water, whether pond, waterfall, stream or ditch. Of Nash's works at the Tate, five feature water: *The Moat, Grange Farm, Kimble* (1922), *Avoncliffe from the Aqueduct* (c. 1926), *Rocks and Sand Dunes, Llangeneth, South Wales* (1939), *Wild Garden, Winter* (1959) and *Mill Buildings, Boxted* (1962). An outstanding example is *Frozen Ponds* (1958), of Nash's garden at Bottengoms, a complex subject represented with simple grandeur – a masterpiece.

A conspicuous feature of Nash's painting is how little it altered over the years; how early it reached maturity. There is no radical difference between *Frozen Ponds* and *The Cornfield*, although forty years separates them. Both express the same intense love of his

subject, the same independence of his way of seeing it (I use the singular because his love of landscape exceeded that of any of his other subjects, even flowers, and imbued it with a reticent nobility). He tended to avoid or to minimize atmosphere – mist, clouds, rain and wind – which would have impaired the clarity of his presentation of his subject, the landscape itself. Likewise he avoided, all but invariably, the distracting presence of human figures, and when they were very occasionally introduced, as in the later *Cornfield*, they were integrated firmly into the composition. At its most characteristic, Nash's vision was lucid and direct, interrupted by nothing, not even by everyday – or almost everyday – natural phenomena. The directness and intensity of his concentration on his subjects, conspicuous in both his watercolours and oils – the first usually preparatory to the second – he preserved by his continued habit of seasonal travel involving a wide variety of subjects, but also by his work in a variety of other media, expressive of a wide range of feelings, particularly humour and a delight in plants.

Nash was unambitious but the increasing admiration for his work brought increasing recognition: a retrospective exhibition at the Leicester Galleries in 1954 was received with admiration. In 1957 he was awarded a CBE and an honorary doctorate by the University of Essex. But one that moved him deeply was the unique tribute accorded by the Royal Academy in 1967, namely a retrospective exhibition of his work – two hundred and sixty-three watercolours, pen-and-ink drawings and illustrated books – the first of a series of exhibitions of living Members to be held in the Main Gallery. Nash devoted several months to its selection and hanging. It was immediately followed by another retrospective at the Minories. Both exhibitions were received enthusiastically, especially the latter, for Nash was a much loved and respected local man.

Besides Nash's dedication to painting, drawing and printmaking, he engaged in other activities as varied as they were intensively pursued: as a gardener, as an art teacher (he imbued his students with enthusiasm), as a member of the governing bodies of the Minories and the Colchester Art Society, a fisher of pike in winter, carp and perch in summer, also the most sociable of men. On 28 December, 1966 he wrote to Edward Bawden, an all but lifelong friend:

> We were thinking of spending a quiet withdrawn Xmas in London while we rushed madly from party to party in varying degrees of doubtful motoring weather. Nor was this junketing without its hazards. On Xmas Day evening we left a party at midnight in bitter cold frosty conditions and found a puncture – fortunately we were overtaken by

friends leaving the party . . . Drove us home and the next day got all
repaired for our next assignment . . .'

To his friend and neighbour Griselda Lewis he wrote that he and
Christine were snowed in 'and had to be fetched and carried like a
couple of old parcels to 2 parties'; she observed that 'it would have
taken more than a snowstorm to have kept him from a party'. Indeed
until late in life he would dash up by himself to parties in faraway
London. The volume of his correspondence, much of it illustrated, is
formidable.

In the autumn of 1976 a tragic event entirely disrupted and
eventually ended his life. A highly successful exhibition of his
watercolours was held at the Buxton Mill Gallery, Buxton Lomas. The
private view was attended by a crowd of enthusiastic friends, an
occasion which delighted both him and Christine. It continued until
the following morning. She was in high spirits and seemed well, but
a few weeks later she died. Ronald Blythe, Nash's neighbour and
intimate friend, in a long letter to me described what followed:

I heard of Christine's death a few minutes after it occurred and
immediately telephoned John . . . he told me to come the following
morning which I did, leaving him . . . for a few days . . . so that I could
shut up my home until he too died ten months later.

At first John was more amazed than grief-stricken by her death. It had
great unreality for him. They had been married for 58 years and both
he and all their friends accepted that he would go first. It was typical of
her that she died with the absolute minimum of fuss and bother.

I had stayed with him many times in the past and was so familiar with
his routine that he was very at ease with me. We had been friends for
some thirty years, but he continued to see me as a very young man and
his attitude towards me was both fatherly and dependent. He was very
ill with both bad arthritis and what was possibly a stroke suffered soon
after Christine's funeral.

In the New Year, John, who had great powers of recovery, managed to
come downstairs and even take walks in the garden. He watched sport
on television and read a lot. I was sleeping near him in Christine's
adjoining room in order to nurse him and before we dozed off we each
read Jane Austen – reading aloud some of the funny bits. He also
listened to a lot of concerts on the wireless and he told me about
Mozart, Schubert . . . (he had great knowledge of music).

In February he struggled into the studio . . . and declared he was going
to paint . . . a watercolour of Skye. In May he was so much better that
plans were made for him to travel by car to Cornwall . . . John collapsed
soon after this and I was told by his doctor that he would soon die.

He became unconscious and was taken to St Mary's Hospital, Col-
chester, myself travelling with him in the ambulance. He died on 23
September |1977|. A few hours before I was sitting with him and saw
him painting and sketching in the air.

Blythe's relations with the Nashes were very close:

> John and Christine and I met when I was in my early twenties, and, as
> a young poet, was being drawn into the local circles of artists and
> writers. They were both very attracted by young people, and very
> attractive to them . . . I used to look after Bottengoms when they went
> off on their regular painting holidays. I also read to them after dinner
> whilst Christine sewed and John smoked. After my stories and poems
> started to get published they insisted that I become a full-time writer
> (I was a reference librarian) and eventually they found me a place to
> 'officially', as it were, start this career on the Norfolk coast. There I
> wrote my first novel, which I dedicated to Christine – later dedicating
> *Akenfield* to John . . . We all three loved each other very dearly. One of
> the reasons was we loved language, the voice, words on the page . . .

John Nash was buried beside Christine in Wormingford church-
yard. They had been cremated, and Ronald Blythe buried their ashes
in two caskets in the presence of a few close friends and read poems
by Thomas Hardy and Andrew Young.

ROY DE MAISTRE
1894 – 1968

The painting of Roy de Maistre has none of the characteristics which ensure popularity. It is without the dashing rhetoric of Augustus John's, the glowing sensuousness of Matthew Smith's or the comprehensive humanity of Stanley Spencer's; it lacks the highly idiosyncratic style which makes it impossible to mistake a Lowry on sight. It is a reticent art, yet not even obviously reticent like Gwen John's. It is difficult to place in a category, which is perhaps one of the reasons why it has been little noticed by the critics. It is an art that at first glance is deceptively obvious. At first glance a painting by de Maistre might look like another essay in Analytic Cubism; scrutiny reveals an art, however, not only reticent but extremely complex.

Some years ago a thoughtful Australian friend of his described him as a painter as 'essentially . . . a realist'. 'I do not believe,' he added, 'that he is tormented by a desire to express his subsconscious in paint . . . that would be opposed to a fundamental reticence in him.' This friend was right to recognize the realist in de Maistre, and the reticence too, but the reference to the subconscious, if correct in fact, is, I believe, mistaken in intention. De Maistre was indeed unpreoccupied, so far as I am aware, with his subconscious, but he was so intensely preoccupied with the most delicate perceptions of his conscious self on the spiritual level as to qualify the applicability of the term 'realist'. The content of his paintings was drawn from the depths of his inner experience – experience apprehended and transmuted by a strong and lucid intelligence. 'Why shouldn't intelligence,' asked his friend Burdett, aptly quoting from Maurois's *Colonel Bramble*, 'have an art of its own as sensibility has?'

The springs of Roy de Maistre's art are various and complex. It is an art, moreover, that bears no obvious relation to the artist. The few examples of it that I had earlier come upon appeared to be the products of a personality 'advanced' in opinion and aggressive to the point of harshness. When I visited his studio at 13 Eccleston Street, Victoria, I was surprised to be greeted by a man of neat, somewhat Edwardian appearance and urbane manners; to notice, on the little table in his hall, a collapsible opera-hat reposing beside a Roman Missal. The long painting-room was full of objects miscellaneous yet

172

carefully chosen: a sofa designed by his friend Francis Bacon, a French eighteenth-century chair, shabby in condition but superb in quality. All these objects were overshadowed by de Maistre's canvases which faced the visitor from wall, floor and easel, from the far end of the room. The paintings of some men look their best in the company of others, but these complemented and reinforced one another. Until I had received the impact of this display I understood nothing of the work of my host. One reason why they gained from one another was the clarity of each. There was no babel but a number of strong, lucid statements. It is possible for an inferior artist to be lucid and strong if he selects suitably simple subjects, but it takes talent to make lucid, strong statements about complicated matters, and the content of de Maistre's pictures was almost always complicated, whether the still-lifes which stood on the floor or the big *Pietà* and *Crucifixion* on easels above.

Good painters are rare beings and their origins may mostly be regarded as improbable. LeRoy Leveson Laurent Joseph de Maistre came from a place and an environment remote from the painting-room in Eccleston Street and what it stands for. He was born on 27 March, 1894, the sixth son among the eleven children of Etienne de Mestre (the family spelt their name thus; from about the mid-1920s the painter reverted to the earlier form) and his wife Clara, daughter of Captain George Taylor Rowe, at Maryvale, a big farmhouse, at Bowral in New South Wales, Australia. Etienne de Mestre was distantly related to the illustrious philosopher Count Joseph de Maistre. When Roy was eighteen months old his parents left Maryvale and after renting Ulster Park near Fitzroy Falls for three years they took Mount Valdemar, near the village of Sutton Forest, a colonial-style house formerly the residence of the governors of New South Wales. Roy's upbringing was unusual: his family life was patriarchal; he did not attend school but picked up what he could from the tutors and governesses who ministered to the needs of his large family. The de Mestres' French origin gave them a sense of detachment, slight but distinct, from their neighbours. Racial separateness was a little sharpened by class separateness also. The de Mestres were a great family who formed close associations with successive governors and their families, who spent the summers at their official country residence near by, and it was in a slightly vice-regal atmosphere, informal yet sophisticated, that de Maistre grew up. Until he was nineteen he led a contented life among his numerous brothers and sisters on their father's big farm, a life in which horses played a predominant part, for Etienne de Mestre, in spite of his Tolstoyan appearance, was one of the great racing personalities in Australia, the winner of five Melbourne Cups.

From an early age Roy drew and painted 'with a good deal', he told me, 'of preoccupation and passion, but my real interest was in music'. He studied the violin in the State Conservatorium of New South Wales, and the viola as well. Such preoccupations as these, especially in a boy to whom the whole world of sport was open, his father was never able to comprehend. Yet he had no antagonism towards them. His mother, on the other hand, was sympathetic towards his intention to tread what, for a member of their family, were unusual paths. In 1913 he went to Sydney to study music and painting, the last at the Royal Art Society of New South Wales under Norman Carter and Datillo Rubbo, and later at the Sydney School of Art under Julian Ashton.

De Maistre was in one respect unique within my experience: he was, as a painter, not innately visual. The great majority of painters live, from their early years, through their eyes. Not only did the young de Maistre live chiefly through his ears, but his drawings and paintings, so far as I have been able to ascertain, were not expressions of things that he saw or imagined; they were schematic expressions of his active analytical intellect. He must have appeared not only unvisual but altogether uncreative, for even as a musician his aspirations lay in the direction of execution rather than composition.

In the course of his studies he formed a friendship that both quickened and directed his interest in painting. Norah Simpson, a lady of talent and magnetic personality, had not long before returned from England to continue her studies. She had been to the Slade School and was friendly with members of the Camden Town Group, especially with Charles Ginner. The effect of her return upon de Maistre and other students was immediate and fruitful. For more than a quarter of a century the Impressionism of Monet and Pissarro had remained the most modern impulse in Australian painting. It had a long succession of practitioners, a number of them accomplished, and a few, most notably Arthur Streeton, more than accomplished. Little news of subsequent movements had reached Australia. The appearance among them of a persuasive advocate of Post-Impressionism, the friend of men familiar with the work and ideas of Van Gogh, Gauguin and Cézanne, could hardly be other than exciting. But before de Maistre had time to make a serious beginning as a painter the war came, and in 1916 he joined the Australian Army, only to be discharged within nine months with tuberculosis. Norah Simpson had made him aware of the ideas which were animating his contemporaries in England and Europe; the next stage in his development was less direct.

During his convalescence – when he began to paint again – he made several friends in the medical profession. Among these was Dr

Moffat, director of the Gladesville Mental Hospital, who interested de
Maistre in psychology. Patients in mental hospitals at that time were
often placed in wards decorated in colours calculated to ameliorate
their condition by virtue of the stimulating or sedative effect of the
colours employed. This feature of their treatment led to de Maistre's
preoccupation with the whole problem of colour in relation to mental
health. The current practice seemed to him so crude and elementary
that he persuaded the Red Cross authorities to allow him to exper-
iment with colour in one of their hospitals for shellshocked patients.
The results were so satisfactory that he raised money to establish the
Exeter Convalescent Home – of which Dr Moffat became the medical
director – where shellshocked soldiers were treated in accordance
with his own ideas. Here the rooms were painted not in single
colours, but in colour-keys which enabled patients to receive the full
benefits of colour treatment without the retinal exhaustion produced
by prolonged exposure to single colours. This preoccupation had
beneficial results both for shellshocked soldiers and for de Maistre's
painting. By 1918 his meditations and researches were sufficiently
advanced to permit his delivering a talk entitled 'Colour in Art' at the
Australian Arts Club, Sydney, in which he outlined his theory for
harmonizing colour in accordance with the musical system of har-
monizing sound, based upon the analogies between the colours of
the spectrum and the notes of the musical scale:

> I should like to trace its evolution from the first scale which I
> experimented with. It was composed of eight colour notes and was
> really nothing more than a natural scale based upon the seven principal
> colours of the spectrum, the eighth note being a repeat of the key note
> to form an octave musical scale. Having gone this far, it will be easy to
> understand how the next steps came about. Seeing an obvious similarity
> between this eight note colour scale and an ordinary well tempered
> musical scale, and having no colours which would correspond to sharps
> or flats in music, I decided that it most resembled the scale of C major.
> I also noticed that two of the most important notes in a musical scale
> – the 4th and 5th degree – were represented by degrees of colour
> complementary to the key note, and so, fixing the key note as Yellow,
> the spectrum band developed into the scale of yellow major – the order
> of progression being – Yellow, Green, Blue, Indigo, Violet, Red, Orange,
> Yellow. It then only remained to insert a tone of colour between 1st and
> 2nd degree, the 2nd and 3rd degree and between the 4th and 5th, 5th
> and 6th, 6th and 7th degree and a chromatic colour scale, such as the
> one we have here, was the result.
> The next stage was inevitable. One only had to take the theory of
> music as it applied to the major and minor scales and transfer its system
> to the colour keyboard. The key note being decided upon and the
> intervals between the preceding notes being the same as those of the
> musical scale, I soon found that the colours representing the various
> notes bore the correct relation to each other, and that their importance

in relation to the colour key note was much the same as the correspond-
ing degrees of the musical scale – the most important feature being the
relation of the complementary colour to the key note, this colour
invariably representing in a cold and warm degree the dominant and
sub-dominant or 5th and 4th degree of a musical scale. In every scale
a degree of each of the seven colours of the spectrum is represented,
and when these are used in their right proportions, the invariable
results are distinct colour harmonies, retaining the general tone quality
of the key note, and an intense luminosity. Doubtless, this is due also
to the phenomena of simultaneous contrast mentioned before, as each
note is being balanced and made more brilliant by the juxtaposition of
its complementary on some part of the canvas.

Being an extremely practical man he invented, in collaboration
with his friend the painter R. S. Wakelin, a disc designed to enable
harmonious colour schemes to be selected from a colour scale upon
a standard principle, which was patented in 1924.

The disc, which was put on the market in 1926, contained one
hundred and thirty-two variations of the seven colours of the
spectrum, and was fitted with two covering masks, one major and
one minor, either on rotation, revealing twelve different colour scales
of seven colours each. The invention provided a ready means of
determining the relative degrees of harmony and contrast between
different colours on a scientific basis.

In later years de Maistre's interest in colour was matched by his
interest in design and form, yet colour continued to preoccupy him
in a special fashion. In 1934 he worked, for instance, upon a project
for a film-ballet in colour, in which the colour varied in relation to the
music. The opening sequences were a direct translation of the music
into terms of colour, and in the later, although direct translation
ceased, the key pitch and texture of the colour were determined by
the music. Unfortunately the cost of production was beyond the
available resources.

During the war years painting gradually supplanted music as de
Maistre's chief preoccupation. He exhibited his work for the first time
at the Royal Art Society, Sydney, in 1918. His early paintings appear
to have been mostly landscapes, schematic both in colour and design.
There is little about them to affront the conservative taste of today,
but their intellectual character, manifest in their precisely calculated
patterns and their strong, clear, colour arrangements designed to
emphasize harmonies and contrasts, represented so radical a depar-
ture from the prevailing Impressionism that they offered a challenge
to which established opinion was quick to react. One critic took to
task the selection committee which accepted de Maistre's works for
exhibition for 'neglecting to throw out some samples of the art the

charm of which depends on ignorance, or, at least, negation of drawing and a sense of colour that a housepainter might envy'.

The following year, with Wakelin, a painter rather older than himself who shared many of his ideas, in particular those concerning the relationship between music and colour, de Maistre held his first exhibition. This comprised five of his paintings together with exhibits illustrative of the application of his colour theories to interior decoration, and six works by Wakelin. The exhibition was intended to be a challenging demonstration of his colour theories, and it was on the occasion of its opening that he delivered the talk from which extracts have been quoted. All the paintings he showed were of the same highly intellectual and schematic character, expressions of a lucid and analytical mind, a mind so constituted as to be repelled by Impressionism and attracted by subsequent developments of which it had as yet no direct experience. As a consequence of the exhibition de Maistre took a foremost place among those Australian painters possessed by ideas that were not readily communicated in the language of Arthur Streeton and his contemporaries – a language which they were therefore under compulsion to replace. All Sydney was presently talking about the pictures which, if he so wished, the artist could whistle. A friendly critic prophesied that 'the exhibition by these two young and enthusiastic artists will attract interest. These pictures, played in paint . . . are played fortissimo in the treble . . . No matter how brilliant each seems, it is keyed harmoniously.' To others his works were 'crudities' or 'garish enough to make a sensitive person shudder'.

Most of the works of de Maistre's early years have remained in Australia but the few examples known to me suggest that the art of de Maistre developed very slowly. It is reasonable to suppose that he could not have evolved any faster because of a lack of direct contact with the sources of the movement of which his own art was formed. It should also be added that he profited little from the formal teaching he received: he was incapable, he told me, of making a realistic drawing much before 1918.

Such contact was not long denied, for in the spring of 1923 he was awarded the Travelling Scholarship of the Society of Artists of New South Wales, which was a subsidy by the State and tenable for two years. Twenty years had elapsed since this scholarship, worth £250 a year, had last been awarded. The previous recipient was George W. Lambert, one of the judges in 1923. The works of the ten competitors were hung in the National Gallery of New South Wales.

De Maistre's departure for Europe was the cause of general regret. The novelty of his ideas and his power to express them in words as well as in paint, and the criticism implicit in them of the ideas upon

which the work of the most revered Australian painters was based, had made him a controversial figure, but his ability was recognized (one of his pictures had been bought by the National Gallery of New South Wales in 1920) and the disinterestedness of his enthusiasms had won general respect. Moreover his abilities as an interior decorator – uncommon in Australia – were in regular demand.

London was his immediate destination. I did not come to know him well until thirty years later, but only just missed meeting him on his arrival in the summer of 1923. The governor of New South Wales, Sir Walter Davidson, gave de Maistre a letter of introduction to my father, who did not receive him at home – where I was still living – but at the Royal College of Art, of which he was principal. My father, who was the first painter, de Maistre told me, whom he met in England, received him with encouragement and kindness, and provided him with letters to painters in Paris. After six months in London he moved to Paris, taking a studio in Montparnasse. After spending eighteen months there he took a small party of students for a summer holiday to St Jean de Luz, a place to which he became greatly attached and to which he returned in 1930 and remained for three years. In Australia he had thought of England as 'home', but although he had found satisfaction and even inspiration in London he was not aware, as he immediately was in France, of a kind of preordained harmony between himself and his surroundings. The terms of his scholarship, however, required that he should return to Australia and present his best work to the National Gallery of his native State.

In 1926, the year of his return to Sydney, his first one-man exhibition, consisting mainly of the work he had done in Europe, was held at the Macquarie Galleries, in Bligh Street. *Fisherman's Harbour, St Jean de Luz*, the painting judged by de Maistre to be the most substantial result of his tenure of the scholarship, he presented to the Society which had awarded it. I know this work only in black and white reproduction, from which it would appear to be a sober work, deliberate both in design and execution, and close to, if rather more atmospheric than, the Camden Town paintings of Ginner and his friends. The sobriety of this and the other paintings de Maistre brought home – unadventurous expressions of an adventurous mind – was characteristic of his stability and fastidiousness. Prepared as he was to learn what the formative movements in Europe had to teach him, especially Cubism, it would not have accorded with the dignity of his character to display any of the superficial marks of conversion. He went to Europe first of all to learn the essentials of painting and only secondly to develop, and without haste, his own ideas and

personal view of nature. The works he brought back suggest that his first three years there helped him towards the realization of both.

The new pictures he showed at the Macquarie Galleries, which expressed a fuller, warmer view of nature than the schematic works of his earlier years, were received with interest and respect; but also, as a maturer challenge to the entrenched tradition, with an enhanced hostility. One influential critic, Howard Ashton, thus concluded the brief disparaging paragraph – entitled 'Soulful Art' – he accorded to them: 'As a contribution to Australian art, however suggestive they may be to the highbrow, who believes that one should paint soul-striving rather than facts, these pictures are, unhappily, negligible.'

De Maistre's three years abroad had shown him that Europe was the place most favourable to the deepening of his faculties as a painter, and the hostility with which his work was received hastened his decision to leave Australia. In 1928 he accordingly returned to London and two years later to St Jean de Luz. Until the Second World War he spent about half his time in England and half in France.

His departure from Australia marked the end of a chapter in de Maistre's life. This was a longer and more important chapter than might be supposed. His patronymic and his work, his personality and his experience are so unequivocally European that it is therefore important to recall that in spite of a certain aloofness the de Maistre family were very much a part of New South Wales and that he himself as a young man was fully Australian and led a free and happy life there. He spoke French no better than average, and his father had abandoned his hereditary religion. Not many who knew him suspected that there was a sense in which, aristocrat though he was, he was also a self-made man. His establishment in Europe was the consequence of acts of faith and will, as was his membership of the Catholic Church, even though it was the church of his fathers. Like his art, his religion was not something inherited or supinely accepted, but something won by personal conviction.

France was the country where he was in closest harmony with his surroundings, but the war deprived him of his studio in St Jean de Luz and he was never able, for economic reasons, to return there. Three years before the war he transformed a café at 13 Eccleston Street into a studio, and after he finally settled in London this became his home. However, the sense of isolation that he felt in England contributed fruitfully to the formation of his art.

During the eight years that elapsed between his departure from Australia and his permanent establishment in London he opened out and found his place in the abstract tradition which derived – by way of Cubism, from Cézanne and Seurat – an intellectual tradition based upon structure and tending to be geometric and rectilinear. Those

who have worked in this tradition are often primarily draughtsmen for whom colour is subordinate to design. De Maistre's design was always clear and sharp, but his impassioned interest in colour never tempted him to allow it to play a subordinate part. Like Cézanne, his principal master, his consistent aim was to evolve a way of painting in which design and colour would become one. This was a high aim, and in much of his early work it was realized self-consciously, by an effort obvious to the spectator; or else it eluded him altogether. It was only gradually that he mastered the art that conceals art, and gained the knowledge and power to use design and colour so that each completed the other in a unity which, however long struggled for, had the look of inevitability. In his early paintings he ensured a degree of harmony by mixing all his colours with white; the harmony so notable in the later works results from the relation of pure colours – a harmony which gains resonance because it expresses precise and closely-knit form.

When I alluded to de Maistre's having opened out, I intended to convey that his nature as a painter deepened and broadened, and that he became more perceptively aware of himself and of surrounding life. The phrase serves to indicate the development of the man, but not of his work, for this did not broaden out: it became, on the contrary, more sharply focused, more concentrated. The process, no doubt a manifestation of the natural evolution of his mind, was hastened by his English domicile. In the south of France he loved to walk in the strong light, and the social climate fostered an expansive disposition in him. As a painter he habitually made decisions between clearly defined alternatives, and the prevailing English grey softened the sharp edges of things and blurred distinctions. So in London he stayed mostly indoors. The result was that he looked with fascinated intensity at the café transformed into a studio which contained, like Courbet's, a repertory of his past life, and this scrutiny, searching yet affectionate, made him a kind of *intimiste*. Carafe, fruit-dish, lampshade, electric fan and potted hyacinth, each the object of contemplation, have been combined in lucid, close-knit arrangements expressive of the painter's relation to his surroundings. There are about them none of the cosy overtones that mark the work of most *intimistes*, no attempted creation of a 'little world of Roy de Maistre'. On the contrary there are, even in the gentlest, intimations of energy, of harshness. If the world of de Maistre is not a 'little world', it is governed by a strict sense of proportion which would be offended were the petals of a hyacinth made harsher than the features of Our Lady mourning over her dead Son. *Intimisme* is but one facet – although a large and characteristic one – of de Maistre's art. Religious subjects were a constant preoccupation with him, but today serious

religious painting recommends itself even less to religious bodies than it does to the public at large. Of de Maistre's most ambitious and impressive religious paintings, *The Crucifixion* (1953) and *Pietà* (1950) were presented to the Tate Gallery in 1955. An earlier version of *The Crucifixion* (1942–43) was acquired by The City Art Gallery, Leicester.

'The painter is always in search of a peg on which to hang his creative urge,' I remember his saying. 'It isn't so much that he is attracted by certain subjects, but simply that he recognizes them as occasions for the exercise of this urge.' This, however, is not the same as maintaining, as a whole school of painters and critics maintains, that, for the painter's purpose, a pumpkin is as good as a human head. De Maistre was moved, not merely as an eye but as a whole man, by the subjects he chose. He was moved by the images of the Crucifixion, and of Mary mourning over the dead Christ not because there were dramatic 'subjects', or dramatic symbols, still less just shapes, but because he believed in what they represented. Even his carafe and fruit-dish were old friends, for whose characteristics he had a keenly analytic affection. Whatever the subject of his choice, his treatment of it – if circumstances permitted it to take its full arduous course – was always the same. He began by making – usually at high speed – a realistic representation, usually in charcoal, from which he proceeded gradually, through a series of further studies, to his final, often more or less abstract, design. *Seated Figure* (1954), neither realistic nor abstract, is a figure caught half-way, so to speak, along this process. In the process he discarded everything not relevant to his intention, and added everything that contemplation of it, including all that his past experience of that particular thing, taught him. His final representations, however abstract they may seem, are deeply rooted in some total human experience. These series, in which he dwelt with an almost obsessive persistence upon a given image, sometimes took years to complete. One of them, for instance, was begun in 1937 with a realistic half-length portrait of a seated woman. The second version, made eight years later, shows the subject's face (serene in the first) twisted with inner disquietude. In the third, made after two years, the figure is shown less tortured and with a child, symbol, perhaps, of some satisfying work the subject had undertaken. The fourth, made the following year, represents, simply, a room where women had sat, the place where a female drama had been enacted; and in the fifth, of the same year, the empty room had become more agitated and dramatic; and in the sixth and last the figure has again intruded, once again serene and impersonal. Only rarely is the struggle to make the final statement to which nothing need be added, and from which nothing can be taken away, quite so intricate, various and prolonged.

Roy de Maistre occupied a singular position in England. Ever since his first one-man London exhibition, held in November 1929 in the studio of Francis Bacon, his work has aroused interest and respect. The public had a number of further opportunities of seeing it. The chief of these were exhibitions at the Mayor Gallery, in October–November 1934; of flower paintings at the Calmann Gallery in July 1938; at Temple Newsam, Leeds, from June until August 1943 (the most representative yet held – fifty-six works illustrative of his development from 1920 until 1937); at the City Art Gallery, Birmingham, 1946; at the Adams Gallery in March 1950, and at the Hanover Gallery in April 1953. Yet his work, held in high respect as it was by a number of painters, chiefly his juniors, and a few critics, remains little noticed by the general public. There are several reasons for his relative obscurity. He was by nature fastidious and reticent; he preferred the cultivation of friendships to casual or fortuitous social relations, and for 'public relations' he had neither taste nor aptitude. But most of all his isolation was due to the fact that his art is not an art that lends itself to easy understanding. It is destitute of both bonhomie and of fashionable cliché. The kind of abstract which aims at being a self-sufficient construction of form and colour, appealing to the eye alone, is today fairly widely understood, but abstract painting, the source of which is human, as distinct from purely visual, experience, and often experience that is complicated and obscure, is apt to baffle and disconcert. 'In contemporary painting, our compositions,' he noted in an unpublished paper, 'being ruled by the laws of order, are in a sense mathematical and geometrical, but far beyond the extent to which we can use geometry and mathematics.' More generally his attitude to art was summed up in a fragment that occurs in another of his unpublished papers: 'The problems of art, like those of life itself, are in the main unsolvable as separate entities – art being a reflection of life – the solution of one problem will be the solution of the other . . .'

De Maistre's is an art which abounds in enchanting by-products – small flowerpieces, still-lifes and the like – but in essence it is the expression of a nature deep, little given to compromise, and harsh. 'In one's life one ought to be gentle and forbearing,' he once said to me, 'but in one's art one should conduct oneself quite differently . . .'

This actively benevolent and deeply civilized man inevitably found much to horrify him in this world of ours in which cruelty and vulgarity play so inordinate a part and which offers so sombre a prospect; yet nothing clouded his confidence in the illumination that awaits the artist with the courage to press forward in search, in his own words, 'of that finality of expression which is the aim of all seekers after the truth'.

BEN NICHOLSON
1894 – 1982

If the art of painting were nothing more than the creation of forms and their interrelation and colouring so as to give the greatest pleasure – as many critics believe it to be – there would be no particular difficulty in finding a common measure for comparing representational with abstract works. The common measure would, of course, be a 'formal' yardstick, to vary the metaphor, a sort of diviner's rod which would enable the wielder of it to discover and compare the elements of 'formal beauty' whether in, say, a Rembrandt or a Mondrian. That forms and their disposition and colour constitute the essentials of the language of painting I suppose most critics would regard as self-evident, but a radical difference of opinion arises as to whether form and colour constitute, by themselves, the whole of painting or whether they constitute a language which may legitimately express conceptions from other than the purely aesthetic fields of human experience. Should the purpose of painting be to make an appeal exclusively to an aesthetic appetite, as cookery to the appetite for food? That is the crux of the question. For those whose conclusions lead them to give one answer, a shaggy turnip in a half-light painted by Rembrandt with the same intensity and skill as one of his self-portraits as an old man would have a similar value, and the ceiling of the Sistine might be regarded as a noble arabesque without the slightest loss. But however severely critics so persuaded may insist upon the irrelevance of the subject of a work of art, it may be observed that a supercilious note is apt to creep into their comments when a modern work whose subject is explicitly drawn from the phenomenal world is under consideration. Critics for whom the answer to the crucial question is the contrary of this, and who persist in seeing the distinction – which to their opponents seems unreal if not perverse – between the head of Rembrandt and a turnip, are apt, in the presence of an abstract work, to become taciturn, or to take refuge in reflections upon abstract art in general. The 'formal' divining rod, whether the subject of a critic's attentions happens to be figurative or abstract, is a thoroughly useful implement. About this there can be no possible doubt. Yet somehow, even in the most

183

experienced hands, it fails to do more than serve as a very approximate common measure for representational and abstract works of art.

A conspicuous example of the only relative utility of the implement in question is furnished by the subject of the present study. It so happened that I had some part in the selection of two retrospective exhibitions of Ben Nicholson's work, that which was sent to the 1954 Venice Biennale and the considerably extended and modified version of it held at the Tate the following year. In the course of their organization and showing I heard many opinions about the artist from many different kinds of men. According to some he was a great artist; according to others he was of little significance; but upon one point all seemed to be agreed: that he was the most convinced and consistent exponent of abstract painting at work in Great Britain. It was evident that their estimate of his stature varied with the critic's estimate of the value of abstract art: to those who esteemed it highly he was the leader of an important school, and to those who did not he was an artist of merit exercising his sensibility and skill up a blind alley.

The failure, upon this particularly appropriate occasion for its use, of the aesthetic divining-rod finally brought home to me that, in practice, critics do not judge works exclusively on aesthetic grounds, those who claim to do so being in fact unfavourably prejudiced by a subject drawn from common experience and the others, for whom formal perfection is not the whole of art, by its absence. Abstract painting is not to be judged according to canons applicable to representational painting, and in my own case I fail, beyond a certain point, to respond to the uncommunicative forms and relationships which constitute the language and the message of abstract art. And the limitations of my pleasure are emphasized rather than removed by the pleadings of its advocates. I think it proper to refer to this disqualification for the full appreciation of what appears to me a highly special province of painting, before I turn to one of its most accomplished denizens.

Ben Nicholson was born on 10 April, 1894 in Denham, Buckinghamshire, the eldest of the four children of William Nicholson, one of the earlier subjects of these studies, and his wife Mabel, born Pryde. Both his general and professional education − for it was assumed early that he would be a painter − was sporadic. He was sent to Haddon Court, a preparatory school in Hampstead, and to Gresham's School, Holt, where he overworked and overplayed and whence he was withdrawn exhausted at the end of his first year. If in this brief span he did not add artistic lustre to the annals of this ancient school, he made a little cricket history by playing for the First XI. Ben Nicholson was not only an accomplished cricket player but of all ball

games (I had occasion to mention in the previous volume my own first encounter with him, across a ping-pong table). At the Slade – where also he remained for only one year – he spent almost as much time playing billiards at the Gower Hotel as at his studies. 'Although I was not conscious of it at the time,' he once said to me, 'I think that the billiard-balls, so cleanly geometrical in form and so ringingly clear in colour, against the matt-green of the baize, must have appealed to my aesthetic sense, in contrast to the fustiness of the classrooms at the Slade.' But billiards was not incompatible with occasional attendance at the School. Paul Nash, a fellow student and his frequent companion at lunch at Shoolbreds, recalled an occasion when they were painting from the model in a life class. The students, with a single exception, followed the realistic method that was taught. Nash was shocked to notice that Nicholson was not conforming: on a large sheet of paper, on a drawing board of Imperial size set upon a painting easel, he had drawn a small dark figure in heavy pencil, a sort of manikin, bearing no resemblance to the model. It was, of course, simply his personal equivalent for the model, characteristically presented, and not the kind approved of.

Nash was an acute observer and a lucid writer, and, although a worthy witness, I feel bound to observe that I find this particular bit of evidence surprising. For reasons which I shall presently enlarge. Nicholson felt his way very tentatively, over a period of years, towards an attitude in which he tried to find an 'equivalent' for familiar experience rather than representing some aspect of it. I believe that not many works of his early years survive; he was not prolific and I suspect that his sense of perfection led him to destroy examples when occasion offered. He spoke to me of his early work as 'Vermeerish' and The Striped Jug (1911) shows what he meant. Nash refers to a brief early period of portraiture, during which Nicholson's sitters showed no liking for the 'equivalents' he evolved, of which I have never seen an example, but it would seem that the works described as 'Vermeerish' constitute his effective point of departure.

After leaving the Slade he went to Tours to learn French. Here, after giving much time to tennis and some to painting, he returned with a single oil of a candlestick. Tours was followed by Milan, where he remained for several months, learning Italian and doing a little painting: he brought back two still-lifes, one of a skull. Not long after his visit to Italy his health gave cause for concern and he went to Madeira, where he learnt a little Portuguese and brought back one painting. The First World War broke out not long afterwards, and Nicholson – first graded C3, then rejected for military service – went to Pasadena, California, in 1917, for nine months, coming home on account of his mother's death in 1918. In his longish stay in California

he made only one painting: 'a Vermeer-looking thing', as he described this work to me.

When the war ended Nicholson was twenty-five, and the end of his long and apparently unfruitful apprenticeship was hardly in sight. This would seem an appropriate point to interrupt this summary chronology of his progress by some inquiry into the cause of his failure to find his way, of the inhibition which almost prevented him from painting at all. Everything seemed to favour a quick apprenticeship and a flying start. He was naturally dexterous, and able to master any game or craft with little effort; he was ambitious and purposeful, and, far from having parental opposition to contend with, he had painters for parents, both of whom favoured his following the family calling, were ready to impart to him the fruit of their experience and able to spare him the necessity of making a livelihood by means other than painting. But appearances were in this respect deceptive: the inhibition was the very consciousness of being heir to an art from which he could not withhold either admiration or affection, yet which, as he vaguely saw, did not offer the means whereby he could most readily express his own apprehension of the world he lived in. Today the circle into which he was born is regarded as being of little consequence. The painting by its members is apt to be discounted as a belated, provincial manifestation of the realist tradition deriving immediately from the Impressionists and Whistler; their lives as having been unduly self-conscious. But to those who grew up in it, the best of their works are worthy expressions of the great discontinuous tradition of English painting, and their lives were a memorable combination of sustained idealism, liveliness and urbanity. They challenged the complacency of the later Victorians and extended a comprehending welcome to the talent of their successors. In times when the arts are regulated by traditional canons which change imperceptibly, son can follow father with a reassuring sense of inevitability. But in ages like our own, when traditional canons exercise ever diminishing authority and achievement is so preponderantly personal, son can scarcely follow father without some sense of cramping personal subordination, of inviting the risk of doing again what has already been done.

Innately an artist, yet almost overwhelmed by the accomplishments of his father, mother and his uncle James Pryde, the first need of Ben Nicholson's survival as an artist was to make, however modest, a personal beginning, and it was his admiration, affection and sense of indebtedness that made the fulfilment of this need so prolonged and, in the immediate sense, so unproductive a struggle.

Those who have written about Ben Nicholson have underrated his affiliations with the past. Of *The Striped Jug* for instance, John

Summerson, in an excellent appreciation of the artist's work in the
Penguin Modern Painters series, has written, 'It is easy now to see in
its solitariness, its anti-swagger, the painter's horror of . . . becoming
a genteel protagonist of Vermeerishness.' Surely, in this instance,
Summerson has allowed his knowledge of the direction in which the
artist was to develop to colour his judgment of a painting made in
1911. For *The Striped Jug* is by Vermeer through William Nicholson,
and nothing more, and coming upon it stacked among other pictures
in the elder Nicholson's studio, I do not believe that any friend of
father or of son, or Summerson himself, would have taken it for
anything but the work of the father. Far from being a horrified protest
against the prevailing current, it is an accomplished essay in his
father's manner, a convincing demonstration that he could 'Vermeer'
with the best. His father, who liked the picture, asked, 'but why *one*
jug?' 'Well,' responded the son, 'why don't you paint *more*?' The
result was the father's *Hundred Jugs*.

Little by little, however, forces far removed from the inhibiting
tensions arising from the pervasive influence of his family and his
imperative need to escape from it began to exert their influence. On
his return from the United States, he became exhilaratingly aware of
Cézanne, and Vorticism compelled his admiring curiosity, especially
as expressed in the art and advocacy of Wyndham Lewis, and must
have made a forceable appeal to his innate love of clarity. An
experience more fruitful than any that he had before came to him in
Paris a few years later and was expressed in a letter of January 1944
to Summerson:

> I remember suddenly coming on a cubist Picasso at the end of a small
> upstairs room at Paul Rosenberg's gallery. It must have been a 1915
> painting – it was what seemed to me then completely abstract. And in
> the centre there was an absolutely miraculous *green* – very deep, very
> potent and absolutely real. In fact, none of the actual events in one's life
> have been more real than that, and it still remains a standard by which
> I judge any reality in my own work . . .

It often happens that the most independent persons are not the
least susceptible to influence. Ben Nicholson was a highly indepen-
dent man and his early life was devoted to the search for the means
to give effect to his independence. In the early 1920s he met and later
married Winifred Roberts, a painter with a way of seeing very
different from his own, who by the discernment of her sympathy and
the example of her instinctive and appealing art was able to help to
unseal the springs of his creativity. In her company, the inhibiting
tenseness which for so long had made him virtually incapable of
painting at all finally relaxed.

Nicholson spent three successive winters with Winifred at Castag-

nola, near Lugano, and the summers at her home in Cumberland with visits to London in between. Summerson refers to a scrapbook put together in 1922 which summarized his loyalties: Giotto, Uccello, Cézanne, Rousseau, Matisse, Derain, Braque, Picasso. The sense of the passing away of the shadows of war, of belonging at last to a tradition to which he could respond without reserve, and the companionship of his wife gave Nicholson an exhilarating conviction of having begun his life's work. This least productive of painters began to make three or four pictures a week. Few of them survive, but his energies were released, and although he still had far to go to find himself, he subsequently travelled fast.

The intensive search and experiments from the mid-1920s until the early 1930s resulted in a succession of still-lifes in which features characteristic of his mature work are discernible. In their subjects, these still-lifes conform to those of the contemporary School of Paris – jugs, bottles, plates and knives reposing upon scrubbed kitchen tables – and in the degree of abstraction with which they are treated. They also show a delicate sureness of taste and colour which are decidedly Nicholson's own. But he was still only feeling his way, and there was little evidence of the uncompromising austerity or the precision of design that was to be the most conspicuous mark of his later work. The design of most of his paintings of this time known to me is, in fact, loose and uncertain, and this weakness and his obvious eagerness to discard the smooth accomplishments of his Vermeerish beginnings in the interests of a franker approach to his themes give them a tentative air. On this account I question Summerson's opinion that their beauty is 'amply appreciated by people who have any liking at all for contemporary painting'. Had the painter died in 1930 I doubt whether such works as *Painting* (1923–24), or *Still-Life* (c. 1926) – to name two considered sufficiently representative for inclusion in the sumptuous volume *Ben Nicholson: Paintings, Reliefs, Drawings* – would attract attention today. A few, however, notably *Still Life with Fruit* (1927), and *Au Chat Botté* (1932), merit places among the artist's finest works, chiefly on account of the rare beauty of their colour.

To the late 1920s belongs a group of landscapes painted in Cumberland and Cornwall, but with few exceptions these rank below his best work. Landscape evidently failed to evoke a response sufficiently ardent to enable Nicholson to create with conviction, yet, unlike his still-lifes, it was too complex to be reduced, without doing violence to its character, to the simple, clear-cut terms that his way of seeing demanded. Occasionally, however, in such a picture as *Pill Creek, Cornwall* (1928), he was able to maintain an impressive harmony between the requirements of close representation and lucid design.

In the very early 1930s he relaxed his efforts to reconcile the

demands of the effective representation of nature – of nature in her more complex aspects – and those of design, and turned decisively towards abstraction. Several circumstances favoured this reorientation. Nicholson described a painting by Miró he saw in 1932 or 1933 as 'the first *free* painting that I saw and it made a deep impression – as I remember it, a lovely rough circular white cloud on a deep blue background, with an electric black line somewhere'. More decisive was his first meeting with Mondrian in Paris. Nicholson thus described what must have been, I think, the most illuminating experience of his life (I quote from Summerson):

> His studio . . . was an astonishing room: very high and narrow . . . with a thin partition between it and a dancing school and with a window on the third floor looking down on to thousands of railway lines emerging from and converging into the Gare Montparnasse. He'd lived there for years and except during the war had scarcely been outside Paris – he'd stuck up on the walls different sized rectangular pieces of board painted a primary red, blue and yellow and white and neutral grey – they'd been built up during those 25 years. The paintings were entirely new to me and I did not understand them on this first visit (and indeed only partially understood them on my second visit a year later). They were merely, for me, a part of the very lovely feeling generated by his thought in the room. I remember after this first visit sitting at a café table on the edge of a pavement almost touching all the traffic going in and out of the Gare Montparnasse, and sitting there for a very long time with an astonishing feeling of quiet and repose! – the thing I remembered most was the feeling of light in his room and the pauses and silences during and after he'd been talking. The feeling in his studio must have been not unlike the feeling in one of those hermits' caves where lions used to go to have thorns taken out of their paws.

And last, there was a more intimate circumstance: he met Barbara Hepworth, whom he married after the dissolution of his marriage to Winifred Nicholson. In place of a lyrical and feminine painter at work by his side there was an abstract sculptor of the most uncompromising kind. (I heard him acknowledge his debt to his wives in the most generous terms. 'I learnt a great deal about colour from Winifred Nicholson,' he said, 'and a great deal about form from Barbara Hepworth.')

The decisive cause for change, however, was to be found in the artist himself. Today many young artists attach themselves to the abstract movement because it is the fashion, a fashion, moreover, which threatens to become a new and stultifying academism; but Nicholson evidently moved nearer and nearer towards pure abstraction under the impulse of some inner compulsion. Pure abstraction was, in any possible circumstances, the position to which – by one road or another – he would inevitably have made his way, but the

inner compulsion was fostered by the three favourable circumstances recalled just now.

From time to time Nicholson painted landscapes with a frank and tasteful felicity, but he was, I believe, one of those for whom the demands of representation were restrictive, and therefore, consciously or not, resented. When he described the Miró he saw in the early 1930s as 'the first *free* painting I saw', I take his meaning to be that it suggested the possibility of creating a work of art which would fulfil his own inner requirements without involving the smallest concession to the, to him, restrictive traffic with phenomenal appearances. And that contact almost certainly inspired such a work as *Painting 1933* with its free-floating red discs.

I take it that the reason Nicholson's contacts with Mondrian had such radical effects upon his art was that Mondrian represented in its most extreme and logical form the abstraction which he felt to be the culmination of his own most intimate promptings. For Nicholson as for many others, Mondrian must have been the personification of abstract art. In one important respect Mondrian's influence affected his work immediately and for good. 'All art,' Mondrian declared, 'expresses the rectangular relationship.' Nicholson conformed to this exclusive injunction from the year of this momentous meeting. The further dogma that 'the straight line is a stronger and more profound expression than the curve' also became one of his articles of faith.

It is important at once to draw a clear distinction between Mondrian and Nicholson. Mondrian was an intellectual, a theologian, so to speak, of an artistic faith, who also testified to his faith by painting. Nicholson was an instinctive painter, driven by his inner compulsion to the conclusion reached by Mondrian primarily through his intellect: 'I have difficulty in reading Mondrian because I much prefer the direct impact I get from his painting. I have not read more than a few sentences from Kandinsky.' He painted as he did by instinct, but, although not well read in it, he picked up a fair working knowledge of the faith which justified his practice.

It was not only Mondrian's theory and practice that affected Nicholson, but his personality as well, in particular his solemnity, occasionally illumined with a pale flash of humour. On entering for the first time the studio which Barbara Hepworth and Ben Nicholson shared in the 1930s Mondrian remarked, 'What a fine studio but' (shading his eyes from looking through the window at a large and very beautiful chestnut tree) 'too much nature.' Such an incident as this – related to me by Nicholson – although he did not miss the element of fantasy which prompted them, appealed none the less to Nicholson's growing abhorrence of nature as a recognizable theme for art. I have already noted, in this connection, the influence of

Barbara Hepworth who was as intellectual as her husband was instinctive, which must not be discounted. It was she who kept the end towards which he moved steadily in his view, and who fostered his alignment with the abstract movement. In this she played a more positive part than he, and with Naum Gabo and J. L. Martin was an editor of *Circle*, the journal founded to enable Constructivists to bring their ideas before the public.

Under these strong impulses from within and without Nicholson's art moved quickly towards an abstraction which made, eventually, at its most characteristic, no concession at all to the world of common visual experience. After 1933, when he was occupied largely with paintings in which the design was mostly drawn in white lines with the reverse end of the brush, which gave them the effect of engravings, his work assumed the character which it thereafter retained. He continued to make paintings and drawings of landscape, as well as still-life, or the two in combination. Absolved from any sense of obligation to represent with any degree of exactitude, and with unrestricted scope for the exercise of his faculties as a designer of pure form, landscapes such as *St Ives* (1940) and *Halse Town* (1939–41), or *Higher Carnstabba Farm* (1944) express a lyricism absent from the landscapes he made in the late 1920s. Particularly happy, too, are the indications of landscape, sometimes very slight, that appear as backgrounds for still-lifes. *Halse Town* (1942) or *Towednarck* (1943), are excellent examples. Such indications, moreover, evoke most convincingly the distinct atmosphere of Cornwall, where the artist mainly lived from 1932.

Beautiful as many of his pictures are, in which so much of the subject is described by a few delicate, precise lines, some of them enclosing sober monochrome washes, others simply areas of virgin paper or canvas, it is, I think, upon his most intransigently abstract works that his reputation will finally depend. For, paradoxically, it is in the narrow world made of a few elementary geometrical forms and of a few simple colours, that his spirit moved with that entire freedom to which he so persistently aspired. In an attempt to define the unusual character of Nicholson's creativity, Summerson alludes to his 'power to deny, discard, eliminate in pursuit of reality'. Or, as the artist himself has written, ' "Realism" has been abandoned in the search for reality: the "principal objective" of abstract art is precisely this reality.'

The fullest definition I have come upon of reality of this order occurs in an essay on the artist, 'A Coat of Many Colours', by Sir Herbert Read:

Ben Nicholson who, like all the great artists of the past, is something

of a mystic, believes that there is a reality underlying appearances, and that it is his business, by giving material form to his intuition of it, to express the essential nature of this reality. He does not draw that intuition of reality out of a vacuum, but out of a mind attuned to the specific forms of nature – a mind which has stored within it a full awareness of the proportions and harmonies inherent in all natural phenomena, in the universe itself.

Sir Herbert frequently reminds us that utterances such as these involve philosophical questions. They do indeed, and for quite a few decades philosophers have been suspicious of phrases such as 'a reality underlying appearances': they have been apt to ask for the 'cash value' of these words as used in such contexts and to wonder whether, in most contexts, they have any meaning at all. The antithesis of appearance and reality has, however, a place in the history of philosophy, although it is more than doubtful whether any two classical philosophers have entertained the same notion of it or the same notions of what it is that is being thus contrasted. It is therefore problematic whether a phrase so obscure can be currently introduced by any critic to throw light on anything.

It is possible, none the less, that in his use of this contrast Sir Herbert had its great originator, Plato in mind. It is central to Plato's theory of 'Ideas' or 'Forms' that, on the one hand, there are *eide*, ideal 'Forms', on the other, particulars that are not instances but imitations of them. What is it that Plato has in mind? The theory of 'Forms' starts from reflection about morals and mathematics, and for the present purpose it is the latter that is relevant. A geometer draws a circle, but this visible circle, although it has its uses as a diagram and symbol, is not the 'ideal' circle that he has in mind; the circle that he is thinking about and that has all the necessary properties of 'circle' is purely and entirely an object of intelligence alone, not an object of perception or even, for that matter, of imagination. The circle that the geometer sees or imagines, springboard though it is for his thought, cannot be an instance of the circle that has such and such necessary properties in virtue of circularity, for a little measurement would show up its inaccuracies. It 'imitates' the 'real' circle, that is to say; it is not an example of it.

Now Plato was convinced that 'appearances', that is to say visible and imaginable things, do nothing but imitate 'reality', and he thought it the most important thing in the world to come to some knowledge of 'reality' and that this knowledge was philosophical knowledge. It was in consequence of these convictions that he could see little good in the visual arts. The visual arts, he declared, are concerned with appearances, 'imitations of imitations', not, therefore, with 'reality' at all. And oddly enough, in a passage of the essay from

which I have quoted, Sir Herbert Read comes near to echoing Plato's own condemnation of visual art:

> If we consider nature in the objective sense as an aggregate of facts, and consider the function of art in relation to such a conception of nature, then we can conceive art only as reproducing in some way the specific facts. That is, indeed, the kind of relation between art and nature which most people seem to want: but they should realize that what they thus get is not the reality, but merely the appearance of nature.

It would seem probable that Sir Herbert's conception of 'appearance and reality', philosophically obscure though it is and not clarified or explained by him, is near to the Platonic model. For after all there have been many great artists who have thought, with pardonable philosophical heedlessness, if you wish, that behind appearances, partly hidden and partly revealed by them, was a reality that, in their art, they might somehow convey. But they have been representational artists (and in this, as we shall see, they have been better philosophers than Sir Herbert): baffling although appearances might be, they are some clue, they have thought, to 'reality'; in any case they are all the clue there is, and certainly, even were there to be other clues in intelligence itself or in *a priori* and transcendental reflection, they are all the clues that painters and sculptors have to do with, seeing that their business (if art has a province of its own, which Plato did not think and perhaps Sir Herbert agrees) is of its very nature, with the visible and the sensuous.

But Sir Herbert was obstinate in his belief that reality is not revealed by appearance. Or was he? His philosophy of it is perhaps confused. 'Reality underlies appearances' in such a way and is of such a nature (at any rate in the essay on Ben Nicholson) that it can be properly conceived of as being of a 'mathematical and crystalline nature', the object of a special sort of 'intuition' (for it is because he is 'something of a mystic', he claims, that Ben Nicholson has access to this reality), and its apprehension and expression are as abstract as music. But what is Sir Herbert thinking of here? Is he seriously thinking that the 'reality behind appearances' is circles and squares, which are the proper object of pure intelligence? Or is he saying that the structure of the visible world exhibits certain geometrical and mathematical, certain abstract, harmonies, and that it is these that an abstract artist such as Ben Nicholson makes visible to us? In spite of the talk about some species of mystical insight, the former is too wild a supposition, and his reference to Nicholson as not drawing his intuition of nature out of a vacuum but out of a mind attuned to the specific forms of nature – by which he appears to mean 'the proportions and harmonies inherent in all natural phenomena' –

suggests that the second supposition is the correct one. But if it is , it is comparatively trite, and the argument holds some fallacies. Let us consider it.

It is trite to say that nature has a mathematical structure and that a painter may have some intuition of it. So trite is it, and of so many artists may it be said, that it does not at all serve to discriminate one artist against others as being a special sort of artist, namely an abstract painter, nor does it serve to distinguish nonrepresentational from representational artists. To take an obvious example, Piero della Francesca was very much aware of the mathematical structure of the universe, but – and here he displayed a philosophical clarity of mind superior to that possessed by Sir Herbert – he used his knowledge in an art that is not abstract in Sir Herbert's sense (i.e. not nonrepresentational) and in so doing used language as language is properly used, that is to say he used it to speak of things other and more interesting than language itself. Let me explain more fully.

Firstly, since, as Plato impressively showed, the visible circle is but an imitation of the 'ideal' circle which is the 'reality', it is not at all clear why, in order to give material form to the intuition of mathematical structure, or to express the essential nature of reality, there is an advantage in an art which is 'abstract', i.e. nonrepresentational, over an art which is not; it is not clear what advantage there is in circles and squares, in as abstract a delineation as is humanly possible of sheer formal harmony, over the expression of this same harmony in terms, let us say, of the human figure. The former imitates 'reality' in Sir Herbert's sense no more than does the latter. The latter does it no less accurately, or need not do so – although it must be granted that according to Sir Herbert's philosophy of the matter, the choice, when we are serious and concerned with 'reality' and not just 'the appearance of nature', is between Ben Nicholson on the one hand and Piero and Alma Tadema indifferently on the other – and it does both what Sir Herbert thinks important and expresses a wide range of experience as well.

Recognition of formal harmonies and hard mathematical structure is a tool, no doubt the major tool, of the painter's craft. But we use tools to make things; it is not self-evident that their proper or best use is to engrave statements about themselves, about what sorts of tools they are. No doubt at times when artists have lost the standards of their craft and content themselves with anecdotage or emotive illustration of appealing subject-matter, as was the case, both in England and France, for much of the nineteenth century, there is an imperative need for painters to concern themselves with the sheer grammar and syntax of painting (although in fact in the nineteenth century the great painters did not choose this road), just as at times

when it is realized that considerable linguistic confusion fogs the discussion of philosophical problems, it is natural and right that philosophers should talk about language itself. So, too, at such a time it is natural and perhaps right, cathartically, although otherwise it is absurd, to declare that all poetry, and all art, aspires to the condition of music. But even at times such as these, philosophers, delving as deeply as they may into the perplexities of words, use ordinary words to do it, and this they do because there is of course nothing else to use. So, too, *if* painting and sculpture have a province of their own and are not attempting to do in a peculiar way what philosophers or mathematicians do in their own way; if they are not, that is to say, concerned with objects of pure thought, such as the geometer's circle, then this is because they are visual arts; and if they are visual arts, then the proper, and in fact the only, language that they can use to probe 'reality' is the language of the visible and sensuous natural world. There is no other language available to them. 'Reality is appearance,' a distinguished artist used to say, and the adage is philosophically sounder than the premise of Sir Herbert's philosophy of abstract art.

The analogy of music cannot be sustained in this connection. For the language of music is quite a different kind of language from that of painting. Perhaps there are likenesses that may be useful for some purposes, but for Sir Herbert's purpose they are obliterated by the manifest differences. One crucial test brings out one relevant difference clearly enough: on the one hand there is a manifest kinship between the forms of Mantegna and those of the natural world (of appearances); on the other, when music endeavours to be representational in the sense of rendering the sounds of farmyard or factory, it becomes clearly absurd: we recognize that to render the noises of the farmyard or factory is not the musician's proper business.

In fact, the philosophy of abstract art, in all the inflation of its currency and the high-flown and tense seriousness of its diction, is unsound from top to bottom. Perhaps Sir Herbert, to take its most illustrious contemporary advocate, would have elucidated his obscurities and cashed his words; perhaps, he would have told us why it is that, as a matter of philosophical aesthetics, Alma Tadema is brother to Piero della Francesca and why neither belongs to the family of artists that gives us reality and not appearance. At any rate, although Plato's position in this matter is clear, Sir Herbert's is not.

What remains is something so simple and elementary that it hardly deserves the superstructure of turgid theory that has too often been imposed upon it. Ben Nicholson's mind was a mind 'which had stored within it a full awareness of the proportions and harmonies inherent in all natural phenomena'. As I have already said, so had

Piero's and there is no reason to believe that the skeleton is 'more real' than the man. It may be that one is interested in skeletons more than in men, but it is not an interest that has cosmic implications.

If, however, one is concerned with formal harmonies at their most naked (I will not say at their purest), then the artistic activity that will give scope to this narrowly delimited interest is the sort of activity that one engages in when one arranges the furniture and hangs the curtains. The analogy of architecture, as Sir Herbert says, is to the point, but, as he rightly comments, 'in this case there is a functional aspect which introduces a certain complication'. The same comment would rightly be made of furniture designing. Nearer still, perhaps, because here the functional interference is of the slightest, would be the designing of a front door: the shape, size, proportion of the panels in relation to each other and to the knocker and the letterbox. The analogy of hanging curtains and arranging a room, however, is perhaps the closest and purest analogy, and it serves also to emphasize the kind of aesthetic satisfaction that is in question.

It is indeed the satisfaction that comes from the perception of harmonious proportions and relationships. Yet here again it is worth observing that even this satisfaction, although it approaches the satisfactions of elegance, order and economy that a mathematician may find in his theorems, is sharply distinct from the satisfaction that attends the geometer's study of circles, squares and curves. For this study is, to repeat, purely intellectual, and circles and curves are objects of intelligence only. In arranging a room we are not at all considering the properties of curves of such and such a curvature; even here we are attentive to what the curves are the curves of, and it makes a difference whether they are the curves of a swag or of a table. For the pure curve is the object of pure intelligence; the curve that satisfies aesthetically is the visual curve, and the visual curve is the curve of something visual, seen or imagined. There is nothing peculiar about this; it cannot be other than what it is.

The satisfaction afforded by good abstract art is of this nature. Visual satisfaction of this kind is genuine and can be intense, and is its own justification, but as my analogies suggest it is doubtful whether it is a satisfaction from which we can elicit the cosmological or other metaphysical implications that Sir Herbert so persistently claims. The truth is that these implications do not merge from any analysis; they are unconsciously introduced into the theory of abstract art according to an ideology. 'By *abstraction*,' writes Sir Herbert, 'we mean what is derived or disengaged from nature, the pure or essential form abstracted from the concrete details.' The sentence is proffered as a description of current usage that has 'sufficient scientific validity'. In fact, as the occurrence of the adjectives 'pure' and 'essential' shows,

it is nearer a moral judgment; at the very least the dice are already heavily loaded.

Of course, visual satisfactions are not arbitrary. On the whole, were six independent judges asked to grade a dozen of Nicholson's abstracts in order of excellence, their awards would be found approximately to tally. So, too, is it with food and wine; the connoisseurs tend to agree. Agreement such as this suggests that there are some constants in the constitution of the human palate and guts, as there are in the constitution of the visual apparatus. But of metaphysical implications there are none.

My analogy of the satisfactions of the palate is not a flippant one. Indeed were we to proceed to ask why it is that we experience as much pleasure as we do from the contemplation of balance and proportion in the disposition of masses; of relations of verticals and horizontals; of the curved line and the straight; of colours and of tones, the account that most commends itself to my own reflection is substantially the restricted application of a form of the theory of empathy which Geoffrey Scott outlined in *The Architecture of Humanism* (1914). Its basis, the underlying mechanism of these pleasures, is physical function and muscular activity. It is not that physical states enter into visual satisfaction, which is primarily a pleasure of mind, but that physical states, or the suggestion of them, are a necessary precondition of visual satisfaction of this kind. So, for example, 'any emphasis upon vertical lines immediately awakens in us a sense of upward direction, and lines which are spread – horizontal lines – convey suggestions of rest'. Consciousness of serenity, restlessness, weight, density – all these are elements of the satisfaction that we have from abstract art, and all of them, I think, ultimately derive from the ordinary physical functions, movement and the ability to stand, and so on, of the human body. To quote Scott once more:

> The humanist instinct looks into the world for physical conditions that are related to our own, for movements which are like those we enjoy, for resistances that resemble those that can support us, for a setting where we should be neither lost nor thwarted. It looks, therefore, for certain masses, lines, and spaces, tends to create them and recognize their fitness when created. And, by our instinctive imitation of what we see, their seeming fitness becomes our real delight.

It is not my purpose to develop this or any theory, still less to demonstrate if it were susceptible of demonstration. It is a reasonable account of the matter which certainly cannot be refuted, and serves well to emphasize what are the springs of the real, although modest, pleasures that abstract art affords: straightforward visual satisfactions, rooted indeed in humanity, but with no mystical or cosmic overtones.

You will look in vain for metaphysical revelations of the structure of reality from Ben Nicholson.

As a way of looking at the world, a 'vision', if this claim is to be allowed, abstract art is remarkable for what it overlooks. Any artist's way of looking at the world is inevitably selective. But, as I have commented earlier, all great artists of the past have used knowledge of the hard and mathematical structure of the world to say other things about it; their awareness, in other words, has included the abstract 'vision' and embraced a multitude of other aspects of the world as well. So far, indeed, is the abstract artists' apprehension from being a 'full' one, as Sir Herbert makes out, that it is (and also by definition) the most narrowly restrictive in history.

There are genuine enjoyments to be had from abstract painting such as Nicholson's, and they need no ulterior or nonvisual justification; they are their own justification. But to make mystical claims that scrutiny explodes is to do the painter a disservice; for it is to falsify and erode the very satisfaction that he has it in him to give.

Abstract art is even justified, according to some critics, as a fruit of the spiritual life. In concluding a discussion of Ben Nicholson, in which he had declared that 'the only possible re-presentation of an abstract painting in words must be either poetry or metaphysics' and in which he had reasserted the customary theme of the potential hindrance to painting from the side of representation, Anthony Bertram wrote in *A Century of British Painting* (1951), that once the point is taken that representation is only a dispensable aid to painting, 'Nicholson's work then becomes crystal clear, for its peculiar genius is of a white purity and most tender and sensitive simplicity. It is the simplicity, not of the simpleton, but of the man who has learnt what is unnecessary and has thrown away the clutter: it is the simplicity of the saint.' But simplicity is an essential attribute of sanctity, the perfection and the goal of human life, in an obvious sense in which it is not obvious that representation is as easily dispensed with, in the interest of the perfection and the goal of painting, as clutter. In fact, as I have argued earlier, the 'clutter' of, say, Fra Angelico and Michelangelo is as integral to the forms that they created as it is to our response to them. Nor is it irrelevant to add that to discard clutter, in Bertram's sense, is not only to discard worlds of experience and the only material an artist has to work with; it is also to sacrifice what would appear to be an essential condition of great art. For such an art is inseparable, in its genesis, from mastery of *prima facie* recalcitrant material, 'material', as Wyndham Lewis wrote in another context, *'in struggle against which* the greatest things in the world have been constructed'. There is no canonizable sacrifice or simplicity for a saint that stops short of coming to grips with a

refractory self; nor is there for an artist short of coming to grips with a refractory visible material.

Were abstract artists and their advocates content to allow that abstract art is an expression in the simplest terms of balance and proportion and the other elements I mentioned just now, from the contemplation of which pleasure is to be derived, the incomprehension and the hostility which is so often provoked by this art would be dissipated. But whether from an antihumanist repugnance for the natural world, or from an unconscious apprehension that if this apparently esoteric art were admitted to be derived from so simple a source it might cause it to be discounted, the fact is that the advocates of abstract art consistently claim a metaphysical or mystical basis. 'To treat Nicholson's work as purely decorative, a mere sensuous pleasure to the eye . . . is also an insult to the painter or a confession of failure on the part of the critic,' says Bertram. Kandinsky entitled his book on abstract painting *The Spiritual in Art*. E. H. Ramsden – on other occasions an illuminating critic – was content to begin and end an article on the subject of this study with the words 'Ben Nicholson is a Constructivist. He comes from both sides of the Tweed.' As the subject was an abstract artist, this was accepted as part of the inevitable accompaniment of mystification. Imagine, however, what her readers would have thought had she begun and ended an article on the father with the words 'William Nicholson was a Realist. He came from both sides of the Trent.' Ben Nicholson, it seems to me, lends himself to the process of mystification when he subtitles *Fra Angelico* a still-life of 1945 representing a jug, a bottle, and two wineglasses.

Were the spectator not mystified or provoked by cosmic or metaphysical claims when abstract art is in question, he would have little difficulty in discerning the good qualities in the best, and in that of Nicholson in particular. Once his painting is seen as a series of essays in the serenely harmonious arrangement of rectangles and circles, calculated with a beautiful precision, exquisite in finish and coolly elegant in style, and its appeal as being not esoteric but addressed to the universal delight in such relations between forms – a delight of which not only painters, sculptors, architects, but craftsmen and designers are inevitably aware – there would be no difficulty and no resistance. A visit to an exhibition of Nicholson abstracts affords something of the same kind of pleasure as a visit to a well-designed yacht: about both there is the same exhilarating sense of things being streamlined, well made, light and fresh.

Many of Nicholson's compositions are based upon the simple principle of securing equilibrium by the balancing of a larger, simpler, more lightly coloured rectangle, or complex of rectangles, with a

smaller but richer and more complicated unit. This simple principle is employed with much subtlety and variety, but careful scrutiny of the artist's work will reveal the invariable importance of the part it plays. This delicate equilibrium is sometimes achieved by the simplest of means. During the 1930s and 1940s, renouncing the aid of colour, he constructed his static harmonies by excavating shallow reliefs out of wooden or synthetic boards, which he covered with an even coating of unrelieved white. There Paul Nash hailed as 'the discovery of something like a new world'. But surely Nicholson's procedure involved the ultimate step in the renunciation of an old world rather than the discovery of a new. These snow-white harmonies, of which a good example is *White Relief 1935*, calculated to a hair's breadth, represent more completely than any of his other works the ultimate exercise of his 'power to deny, discard and eliminate'. They represent, too, I think, the farthest limits to which abstraction has effectively been pushed. In these white panels Nicholson probably extracted the fullest possibilities from an art narrowed to the point of extinction by successive renunciations.

Ben Nicholson has often been contrasted derisively with his father, sometimes as a pioneer who moved in regions undreamed of by his father, sometimes as a cranky prodigal son. But how much there is in common between the work of father and son. Neither belongs to the race of pioneers in any radical sense, each accepted a mode of expression current in his day, and each used his dexterity, his pertinacity, and above all an almost impeccable taste, to bring it to a dandyish perfection. Indeed, there is one part of the father's work that directly affected the son. The posters which William designed with his brother-in-law James Pryde under the pseudonym of the Beggarstaffs, with their large yet precisely calculated areas of audaciously empty space, impressed Ben Nicholson at an early age, and may well have implanted the idea from which his own monochrome art was to grow. Nicholson was fully aware of what he owed to inheritance and early environment. He believed that, as he once put it, something fierce and northern in his mother's temperament in some degree counteracted the effect of his father's sophistication.

I referred earlier, in contrasting the temperament of Nicholson with that of Mondrian, to its being instinctive rather than intellectual. Nothing could be more misleading than to represent Nicholson as doctrinaire, or, indeed, subject to any rigid principles. On several occasions I heard him express resentment at the suggestion that he painted in accord with theories. 'It's nonsense,' he said, 'and all dogma, in any case, is harmful.' I am convinced that the delight he took in the creation of abstract forms arose from an inner necessity. Nicholson was not a pioneer, but a man of skill and taste who brought

to a peculiar degree of perfection a form of abstract painting already extensively practised before he became a painter. His is not an art based upon a particular theory; it is the product of a temperament stimulated and shaped by the abstract movement widely diffused in Europe and the United States during his formative years. Ben Nicholson was not an innovator, still less a revolutionary, but an accomplished practitioner of a new academism. A movement so shallow in its underlying philosophy is unlikely to have a long life, but the best of Nicholson's works will surely survive the ebb of the abstract tide.

There is a circumstance – largely of abstract artists' making – which opposes an easy relation between abstract art and the public. While such artists are apt to belittle the 'easel picture' as an obsolete 'bourgeois' conception, they themselves continue to paint 'easel pictures', and to title, frame and display them in the traditional fashion. They thereby challenge comparison with 'easel pictures' which represent, directly or imaginatively, the world of our actual experience. No system of 'purified constructive elements' setting up 'pure relations' is able, in the long run, to engross and exhilarate as a work of art which represents a profound view of man's experience of the world. To title an arrangement of 'purified constructive elements' *Woman* or *Fra Angelico*, as though it recognizably represents a woman or a painter-priest, cannot but sharpen the detached spectator's sense of the inadequacies in abstract art.

Had abstract painters refrained from challenging the 'easel picture' and directed their efforts towards decoration, their work would have exercised a stronger appeal and would have avoided confusing and alienating comparisons. This is a sphere in which abstract painting is accepted without question, just as the abstract character of the architecture which it embellishes is accepted. The effect of abstract forms – serene or dynamic, painted on walls, screens or surfaces which serve as backgrounds rather than as objects for scrutiny – would be to dignify and animate the act of living, just as fine architecture does. Abstract art is not a precise means of communication, and it is the pretence that it is that has perverted and strained a mode of expression which might serve an invaluable purpose.

It is the sharp, singing colour, the precise and subtle sense of relations between forms, and the freshness that mark Nicholson at his happiest – what a serenely exhilarating life they could bring, for instance, to the walls of a small or moderate sized room! The least susceptible would not be insensitive to its radiant influence – and there would be no need for esoteric explanation or defence. For one reason or another it is expected today that art should be the expression of an individual, and neither artist nor public is willing that it should

take its place as part of the background of living. At one time the musician was content that his music, emanating from some hidden source, should enchant without holding all attention; today he insists upon applause at brief intervals, which upon the slenderest pretext he must acknowledge with a personal appearance. If the art of the painter and sculptor, and in particular the abstract painter and sculptor, were enabled to exercise its influence upon the passer-by, catching him, as it were, off guard and only half-consciously absorbed, that influence would be deeper and more pervasive than it is in this day of the 'private view' and the 'personal appearance'. Nicholson's painting should be seen as Handel's *Water Music* was first heard in London, by a crowd of people pursuing their ordinary activities.

Until the end of his life Nicholson painted with vigour: 'having all that he has learnt at his disposal', wrote his friend Geoffrey Grigson, 'with his weaknesses left behind, his certainties at a maximum, his illusions at a minimum, his senses continuing open for present innovation and *future* development.' Although Nicholson had not approached the end of his life when these words were written, they expressed the truth. Of his life and personality, celebrated artist though he was, relatively little is known; he remained remote and rarely gave interviews. One of the very few was to Dr Felicitas Bogler, the writer and photographer. It is said that she went to inverview him at his house in St Ives in 1958 and never re-emerged: she became his third wife and they moved to Ticino, Switzerland, living there for four years. In 1972 they returned to England, settling in Cambridge.

In 1968 the OM was conferred on Nicholson. A retrospective exhibition of his work was held at the Tate the following year, and in 1978–79 a retrospective American touring exhibition, 'Ben Nicholson: Fifty Years of His Art', was shown at the Albright-Knox Gallery, Buffalo, New York, Washington and the Brooklyn Museum, New York. Ben Nicholson died on 6 February, 1982 at his house in Hampstead.

WILLIAM ROBERTS
1895 – 1982

Painters differ widely in the degree of their versatility; they differ, too, in the variety of their development. Of great versatility examples abound. There were few activities – creative, speculative or scientific – in which Leonardo da Vinci did not at one time or another engage. In Alfred Stevens we had an English artist able to design a railway train and to paint a miniature, to decorate the walls of a palace, to carry out a huge equestrian sculpture and to design for industry. Among the painters who are the subjects of these studies are those who show a versatility, modest in its range compared with that of Leonardo or Stevens, but nevertheless impressive. Wyndham Lewis, for example, as a satirist and philosopher showed qualities that posterity may consider attributes of genius; and Duncan Grant, who designed costumes and scenery for the theatre and decorated walls, furniture, textiles, pottery and much else.

It is just as easy to point to artists whose work underwent radical change in the course of their lives. It would be difficult for someone ignorant of Turner to recognize one of the elegant, conventional topographical watercolours of his youth, one of the grandiose canvases painted in the middle years, in rivalry with Claude or some other master, and one of the chromatic fantasies of his last years as being works by the same hand. The growth of Corot's and Van Gogh's art – to name two at random – offer equally striking examples of contrasts.

There exist, however, artists of a different kind, who are not versatile and whose work changes little: artists who early in their lives discover a single, exclusive preoccupation. Constable's painting became looser and more emphatic as the years passed, but the subject and the aim did not change. Chardin's consistency of aim and method is more obvious still. It was noted in the first volume of these studies, that by the mid-1920s, not long after his delayed beginning as a painter, Matthew Smith had found the essentials of his style, which altered insignificantly thereafter; that he had found, too, the subjects which engrossed him for the remainder of his life. Allusion has also been made to the extraordinary consistency of Stanley Spencer's imagination. But there are painters far less versatile and changeful

203

than these two. Ben Nicholson's themes were few and his treatment of them varied little. But beside William Roberts even the puritanical and rigid figure of Nicholson appears dissipated and capricious. Early in life Roberts discovered the narrow range of subjects he wished to represent, and precisely how he wished to represent them, and to these discoveries he remained grimly faithful.

William Patrick Roberts was born in Hackney, London, on 5 June, 1895, the third child of Edward Roberts, a carpenter, and his wife Emma, born Collins, both Londoners. When William Roberts was about twelve or thirteen years old he wanted to be a painter. His father, whose love of his own craft led him to sympathize with his son's wish to follow another craft, made him an easel and a drawing board. Thus equipped he drew constantly, 'thinking', he once told me, 'of nothing but drawing'. He attended a local school, which he left at the age of fourteen to be apprenticed for seven years to Joseph Cawston, the printers and law stationers. He looked forward to designing posters, but at first he was allowed to assist only in the mixing of colours. Later he had some pleasure in making compositions and designs for poster advertising projects, but he showed no aptitude for lettering. Opportunities to participate in such projects were rare, however, for his principal occupations were preparing the workmen's lunches, buying cakes for their teas and the like. On the advice of the art mistress of a local school he attended classes after working hours at the St Martin's School of Art, then in Endell Street, Drury Lane. Here he won a London County Council scholarship that enabled him to go to the Slade and he was released from his apprenticeship after serving only one year.

At the Slade – where he remained from his sixteenth to his twentieth year – his mind opened out and his powerful draughtsmanship was recognized. In the Print Room at the British Museum, where he spent much time, he met Laurence Binyon, its benevolent and scholarly keeper, who introduced him to Roger Fry. After the first Post-Impressionist exhibition the curiosity about Fry's ideas which prevailed among the students of the Slade was enhanced by the hostility towards them shown by Henry Tonks. Roberts had visited this notorious exhibition, and his introduction to Fry led to his working, part-time, at the Omega Workshops, where he designed and decorated boxes, paperknives and other knick-knacks. It was Fry who drew Roberts in a general way within the orbit of the Post-Impressionist movement, but he affected him in no more specific fashion. Soon after he left the Omega: 'I was no longer interested,' he told me, 'in the work of anyone who worked there.'

There was one artist, however, who, like himself, had a brief experience of the Omega and whose work, even before he met him,

took a powerful hold upon his imagination: Wyndham Lewis. His impact upon Roberts was heavy but beneficial. The effect of association with the dynamically didactic leader of Vorticism and editor of *Blast* upon a temperament different from Roberts's might have been stultifying; although its immediate consequence for Roberts was the production of paintings and drawings easily mistaken for those of Lewis, it revealed to Roberts the nature of his talents and set him on the road on which he travelled until his death. In all essentials his art at the end of his life is identical with the art which he evolved as soon as he ceased to be a mere imitator of Lewis. On several occasions Lewis claimed, with regard to T. E. Hulme, that 'what he said should be done, I did'. I do not know precisely what relation there was between Roberts and Hulme. They no doubt met at the Rebel Art Centre, with which Roberts became associated after his departure from the Omega; but it is unlikely that Roberts, who showed little inclination for intellectual discussion and, indeed, little interest in the operations of the intellect, should have been directly affected by Hulme's theories. Nevertheless Roberts might have claimed, with no less justification than Lewis, that he did what Hulme said should be done. In place of the naturalistic art of the nineteenth century, Hulme advocated an art 'where everything tends to be angular, where curves tend to be hard and geometrical, where the presentation of the human body . . . is often entirely non-vital, and distorted to fit into stiff lines and cubical shapes . . .' and which 'exhibits no delight in nature and no striving after vitality. Its forms are always what can be described as stiff and lifeless.' This might serve as a description of Roberts's painting. To complete it, not much need be added except a few words about his subjects.

If philosophical theories meant little to Roberts, the same theories, reinforced by the capable and aggressive practice of a brother artist, his leader and mentor, were another matter. We may take it that Hulme's theories, developed and illustrated by Lewis, provided both the point of departure and continuing inspiration for Roberts's art. The effect of the two-fold influence of Hulme and Lewis was constructive and enhancing because it was the seed that fell on good soil. Often an influence is a tyranny which distorts by its power or bemuses by its charm, and its subject cannot become himself until he frees himself from his subservience. But Hulme's and Lewis's influence was not a tyranny but an illumination that revealed to young Roberts, who was temperamentally tough, rigid, unsubtle, sardonic, joyless and unresponsive, precisely how tough, rigid, unsubtle, sardonic and joyless he was, and taught him how to make a remarkable art out of this rather charmless combination of qualities. Above all it taught him to disregard the profusion, the growth, the

movement, the distorting atmosphere, the deceptive surface, in fact, all that vast variety and changefulness of the world of nature which to a Constable or a Monet was the whole of reality, and to endeavour not to imitate or to interpret nature, but to create forms based upon a narrow range of carefully selected natural shapes and to endow them, through his art, with an entirely classical clarity and a rhythmic harmony, and to make colour neither descriptive nor functional but decorative. Such, in oversimplified terms, was the ideal which Roberts owed to Hulme and Lewis. No other subject of these studies was so steadfastly loyal to his original ideals. When the air has been full of talk about the New Classicism his work has received favourable attention; at other times – never more markedly than today – it has suffered neglect.

The subject of the greater number of his pictures is Cockney life. But his Cockneys – bicycling, picnicking and so forth, with their racy gestures and grimaces – are the material for an art that is in its essence formal. His compositions often derive from those of the tougher Florentines, and in spirit as well as form he has put more than one critic in mind of Pollaiuolo. These often very elaborate but beautifully lucid compositions are worked out – 'engineered' was the apt description applied by one writer – with utmost deliberation and completeness. Human beings, the subjects of almost all his works, are represented by animated figures of an unmistakable character: studiedly clumsy, tubular-limbed, fish-mouthed, staring-eyed puppets, stuffed with something heavier than sawdust – lead-shot perhaps – which makes their movements ponderous and ineffective. They grin with a mirthless, even on occasion, a brutal, humour. But their movements are ponderous and ineffective only if we think of them as made in response to the emotions of individual human beings; as soon as we understand them simply as contributions to the harmony of the group as a whole, they become dignified and sometimes even noble. These groups of precisely related grimacing tubular-limbed puppets perform their ponderous motions in a space that is without atmosphere and almost a void. Not, however, a space without limits, for there is usually a background, explicit or implicit, which prevents these puppets from straying, like a Watteau shepherdess, away from the foreground and keeps them prisoners, pressed, almost, up against the surface of the picture. The contrast between the coarse or even brutal figures and the classical and scholarly way in which they are combined is matched by the contrast between their character and their delicate combination of colouring: the black, the petunia-pink, the sharp acid green, and the pale, chalky-blue are entirely his own.

A person reading these pages who happened to be unacquainted with Roberts's work might wonder at finding him included in a small

company chosen for seeming to the writer 'to have distilled to its finest essence the response of our times to the world which the eye sees – both the outward and the inward eye'. For the artist's work emerges from this study as representations of puppets neither noble nor endearing but rather absurd in their brutality and mirthlessness as they move clumsily within the narrow parallel between a back curtain and the picture surface. It is indeed an art which, in the bleakness of its total masculinity, cannot be said to fulfil the ultimate Berensonian criterion of enhancing life. Yet to ignore Roberts would leave a gap in the tapestry which, with whatever want of skill, I am attempting to weave. Speaking of Picasso, Berenson once said to me: 'He never remains long enough in one posture for me to form an opinion about him.' Roberts, on the contrary, ever since he freed himself from the imitation of the superficial aspects of Wyndham Lewis, maintained his posture virtually unaltered. I can sympathize with those who find it an unattractive posture, but for me his faith, at once intense and obstinate, in the particular angle from which he squinted at the life about him, enabled him to create figures which live in the memory with an all but unique persistence. I would cite such paintings as *Jockeys* (1933), *Les Routiers* (1933), *Masks* (1935), *He Knew Degas* (1939) (an amusing portrait of Sickert) and *Bicycle Boys* (1939). In an age ridden by fashion and enervated by *angst*, the creations of Roberts are firm-knit by a conviction which takes no account of critics, public, or even patrons. I can imagine a man once familiar with the London art-world of the middle decades of this century, looking back at it after many years of distant exile, one memory after another having faded away, able to recall at last only three massive figures dressed in pink, bright green and prussian blue, riding their bicycles alone on the sands of Time – the creations of William Roberts.

Over the years Roberts was accorded steadily increasing recognition. He was elected an ARA in 1958 and six years later an RA, and in 1965 a retrospective exhibition of his work, organized by the Arts Council, was held at the Tate. Besides his pamphlets referred to in the Bomberg chapter, republished in his *Vortex Pamphlets* (1956–58) Roberts also wrote *William Roberts: Some Early Abstract and Cubist Work 1913–20* (1957), attacking Wyndham Lewis, and *Paintings 1917–1958*, (1960). Roberts died on 20 January, 1982.

DAVID JONES
1895 – 1974

It is not often that a chronicler has the good fortune to see something of a painter's beginnings, especially if the painter happens to be his senior. But by an odd chance I had such an opportunity in respect of the subject of these lines.

In the summer of 1926 I stayed for a week or two with Eric Gill at Capel-y-ffin, the house in the Black Mountains of South Wales where he had settled a few years before to escape the distracting involvements that had been a consequence of the widespread interest attracted by the Guild of St Joseph and St Dominic, and St Dominic's Press, which he founded at Ditchling in Sussex. A few moments after my arrival a small man came into the sitting-room who, although I now know that he was thirty-one, looked not more than twenty-four. 'Well goodbye, Eric,' he said, 'I'm going now.' In my mind's eye I can still see the two of them shaking hands. Gill keen-glancing, energetic in gesture, his pedantic aggressiveness softened by a frank and unassuming smile, wearing his black biretta and rough black cassock gathered in at the waist, black stockings cross-gartered and sandals. David Jones: pale face surmounted by a thick ingenuous fringe; languid figure, speaking of a pervasive quiet. I have said that he looked younger than his years, which was so save in one respect: his flesh was of that delicate, tired texture generally found in old age. The dark eyes, large and mild, had in their depths a little touch of fanaticism quite absent, for all his aggressiveness, from Gill's. His clothes were anonymous. The contrast between the two men was not more apparent than the friendly understanding between them. Jones and I were introduced, shook hands (his grip was soft and shyly friendly), and he went. 'Who was that?' I asked, 'one of your apprentices?' (Gill usually had several such in his workshops.) 'That was David Jones. He's been learning carpentry, but he's not much good at it. But he's a jolly good artist: a lot will be heard of him before long. Look at this,' he said, pointing to a big watercolour lying on a table representing two horses on a hillside, 'he's just finished it.' Imperceptive of its qualities, I gave it, nevertheless, so long and hard a look as to imprint it on my memory. 'It's done from this window,' Gill explained. I walked up to it and peered out, but I could see

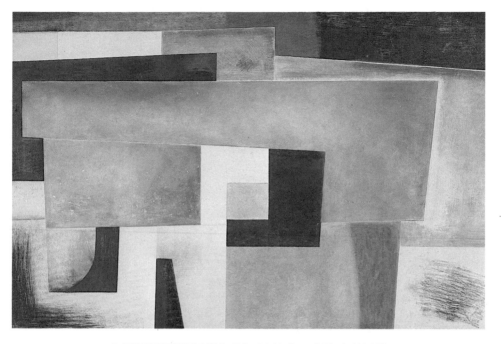

9. BEN NICHOLSON: *Feb. 1960 (ice-off-blue)* (1960).
Oil, 48 × 72 in (122 × 183 cm). The Tate Gallery, London.

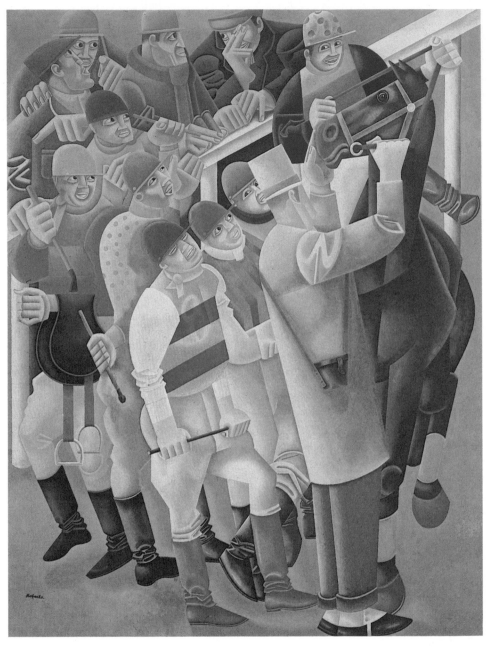

10. WILLIAM ROBERTS: *Jockeys* (1928).
Oil, 48¼ × 36⅜ in (123·1 × 92·2 cm). Bradford Art Galleries and Museums.

11. DAVID JONES: *Vexilla Regis* (1947).
Watercolour, 30 × 22 in (76·2 × 55·8 cm). Kettle's Yard,
University of Cambridge.

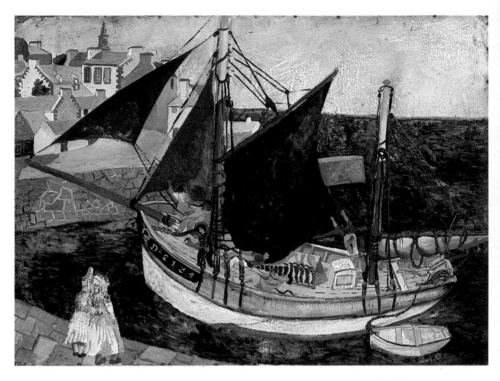

12. CHRISTOPHER WOOD: *Boat in Harbour, Brittany* (1929).
Oil on board, 31¼ × 42¾ in (79·3 × 106·8 cm). The Tate Gallery, London.

nothing except mist lashed by driving rain. The outline of a big hill, when adumbrated by Gill, was just perceptible. It was many years before I saw David Jones or the drawing again, and the drawing must have impressed me more than it seemed to at the time, because I remembered it so clearly. The drawing was *Hill Pastures – Capel-y-ffin*.

According to Eric Gill, *Hill Pastures – Capel-y-ffin* was the best of a group of mountain landscapes made in 1926 and the previous year. These drawings may be regarded as marking Jones's point of departure as a mature artist. But they may also be regarded as marking the culmination of an unduly prolonged apprenticeship interrupted by war. He was backward, he has told us, at any kind of lesson, and, although he had no enthusiasms other than drawing, the few early examples of his work which survive offer no indication of exceptional talent. The active sympathy of his parents, who gave him every encouragement within their power, did not lead to an early flowering. He possessed, however, the most precious gift of perseverance, which sustained him until he could see his way clear. But that was many years ahead. His mother was able to help him not only by sympathy but by example: as a young woman she had made drawings in the tradition of the Victorian drawing-masters, and one of his earliest recollections was of looking at three of her crayon drawings, one of Tintern Abbey, another of a donkey's head and a third of a gladiator with curly hair. His father, too, had a positive contribution to make to his formation as an artist, for another of his childhood memories was of his father's singing Welsh songs, 'Mae hen wlad fy nhadan' and 'Ar hyd y nos', and his telling him of the three hills of his birthplace, Foel-y-Crio, Moel Famau, and Moel Ffagnallt, and Jones carefully nurtured the sense, first implanted in him by his father, of belonging to the Welsh people. On account of his father's calling he was brought up in a home that took the printed page and its illustration for granted. In later years it was always a cause of distress that he could neither speak nor read Welsh. He was well versed, however, in English translations of early Welsh verse and prose, and corresponded with scholars about Welsh history, legend and writings.

David Michael Jones was born on 1 November, 1895 at Brockley in Kent, the only child of James Jones and his wife Alice Ann, daughter of Ebenezer Bradshaw. James Jones, a printer's manager, was a native of Holywell, North Wales, and a son of John Jones, master-plasterer, who came of farming stock long settled in Ysceifiog below the Clwydian Hills. Resident in London since about 1883, James Jones was on the staff of the Christian Herald Publishing Company, and had worked previously on *The Flintshire Observer*. David Jones's

mother came of an English family of Thameside shipbuilders, and her father was a mast and block maker, of Rotherhithe; she was of Italian extraction on her mother's side. The presence of craftsmen among Jones's immediate forebears on both sides of his family counted for much in the formation of his talent, for, as Robin Ironside has noted in his discerning appreciation of the artist in the Penguin Modern Painters series,

> It has been a special object with him that his pictures should be not only the mirror of his imagination or the translation of his sensuous impressions, but should also be things valuable for the very manner of their fashioning.

If it was from his mother's side that Jones principally inherited the disposition to translate his conceptions naturally into a form both tangible and precious, it was from his father's that he inherited the poetic outlook that played so predominant a part in both his painting and writing, above all that peculiarly Welsh time-sense which naturally relates the present with the remote and makes the possessors of it in a special degree the heirs of legend. It is not so much that David Jones had a vivid apprehension of the remote past; of its intimate links with and relevance for the present he also had a vivid awareness. An illuminating example of this special time-sense appears at the beginning of an autobiographical broadcast that he gave in 1954:

> About eight hundred years ago [as another might say before the First World War] a prince of Aberffraw defeated his Welsh and English enemies at Coleshill between Flint Sands and Halkin Mountain. Holywell, where my father, James Jones, was born, is about three miles north-west of the battle-site. The birth of a son to John Jones, Plastrwr, Treffynnon, in 1860 would indeed seem a matter having no apparent connection with the battle won by the great Owain Gwynedd in 1149. But however unapparent, the connection is real enough; for that victory symbolized the recovery of a tract of Britain that had been in English possession for well over three centuries. Had that twelfth-century recovery not occurred the area around Holywell would have remained within the Mercian zone of influence. In which case its inhabitants would, centuries since, have become wholly English in tradition, nomenclature and feeling. Had local history taken that course, it follows that I should not now be speaking to you at the invitation of the Welsh BBC, as an artist of Welsh affinities. You see by what close shaves some of us are what we are, and you see how accidents of long past history can be of importance to us in the most intimate sense, and can determine integral things about us.

Jones chose to identify himself with one of the smallest of European peoples, yet he exemplified the truth of the saying that only through being local can something become universal. Through his happy

acceptance of his Welsh ancestry and his London antecedents, and all that these involved of the insular and even the provincial, his imagination reached out to encompass a vast range of European consciousness. But this disposition to reach out was roused and continuously nourished by an event which had nothing to do with this prehistory.

In the introduction of a catalogue of an exhibition of the artist's work, John Petts tells us that Jones was slow in learning to read, 'finding his letters difficult at the age of nine and later, but that he made good this lack on more than one occasion by paying his sister a penny to read to him'. 'In drawing,' the same writer continues, 'he was certainly no laggard.' No laggard in that he applied himself assiduously to his chosen pursuit (chosen largely, he says, 'as a counterweight to my deficiency in all else'), but he remained for years a wanderer, unsure what path to follow. A few of his very early drawings survive. One of these – not the earliest, but the first he remembered making – was of a *Dancing Bear* seen in the street at Brockley in 1902, when he was seven. Here pity for the great muzzled captive, led to prance for pennies in the gutter, is unerringly conveyed. Here, too, are clear intimations of his mature way of drawing, the modelling with touches which at first glance seem weak and almost irrelevant, but which, on scrutiny, are seen to be so purposeful; there are intimations, too, in the character of the pencil strokes themselves. Yet in quality this beautiful drawing (which, with a number of his other early animal drawings, was exhibited at the Royal Drawing Society) would not appear to be typical of his early work, which was confined to animals: lions, tigers, wolves, bears, cats, deer, mostly in conflict. 'Only the very earliest of these,' he said, 'show any sensitivity, or have any interest, whatsoever.'

The untempted integrity of childhood quickly gave way to the vulgarizing influence of the illustrations in boys' magazines, old Royal Academy catalogues, and 'the general dead weight of outside opinion'. Imitating what he found in such publications, he made many drawings of medieval Welshmen with wolfhounds on mountains, Russians surrounded by wolves in snowstorms and the like. A photograph of a drawing, *Wolf in The Snow* (1900), which may be said to fall within this group, survives. It is without merit.

Many students leave their art schools without learning anything from the instruction provided. What they do learn they learn from the example of artists whose work they revere, or from fellow students. The teaching at the Slade, I fancy, played a negligible part in the formation of Ben Nicholson. Of Jones the contrary is true. At Camberwell Art School (which he attended from 1909 to 1915) he was promptly rescued from the disintegrating effects of 'the dead

weight of outside opinion' manifest in the illustrations which, ignorant of better, he had taken as his models. The effect of the instruction of A. S. Hartrick, Reginald Savage and Herbert Cole was to rekindle the lights of childhood. Through Hartrick, who had known Gauguin and Van Gogh, he was first made aware of the modern movement in French painting, and through Savage of the Pre-Raphaelites and the great Victorian illustrators – Pinwell, Sandys and Beardsley. The sudden widening of horizon that he owed to these enlightened teachers enriched his imagination without clarifying it; his sense of vocation was enhanced, yet it remained without particular object.

The beginning of the First World War found Jones vacillating between alternative ambitions to become an illustrator of historical subjects, preferably Welsh, and a painter of animals. It found him, too, he has told us, 'completely muddle-headed as to the function of the arts in general'. On 2 January, 1915 he enlisted in London in The Royal Welch Fusiliers, serving with them as a private soldier on the Western Front from December 1915 until March 1918, being demobilized at the end of that year. The terrible ordeal of prolonged trench warfare brought forth no immediate expression. None of the many sketches that he made in trench and billet have any interest as drawings, he said, and little as records, being feeble impressionistic sketches . . . 'They are without any sense of form and they display no imagination . . . But the War landscape – the "Wasteland" motif,' he added, 'has remained with me, I think as a potent influence, to assert itself later.' It was just twenty years later that this and all the imaginative experience that he won from the ordeal asserted itself not, except in a very few instances, in drawings or engravings, but in a work of literature, *In Parenthesis*, 'certainly a "golden bough",' as Ironside observes, 'to have cut from such a blasted wood'. This book and the later *The Anathemata* (1953), express more explicitly than anything else he made his ever pervasive sense of the intimacy between present and past, between history and legend.

With many-hued threads he wove all three into a delicately shimmering unity, ennobling the present, although without suppression of its meannesses, bringing history near and making legend actual. *In Parenthesis* comprises a series of descriptions of scenes of regimental life in France, mostly in the trenches. It differs from other 'war books' in that the events and scenes which form its principal subject are enveloped in a diaphanous web of legend: the language of the trenches mingles with the language of many different kinds of legend and of many periods of history. Both the imagery and the language of this most literary of 'war books' are gathered from innumerable sources, from the Welsh heroes of Aneirin's sixth-

century epic, from *The Song of Roland*, and from Malory, Milton, Coleridge, Joyce, Hopkins, Welsh Methodist hymn-books, *The Golden Bough*, but most often from 'the frozen regions of the Celtic under-world', from the Arthurian legend and from the Catholic liturgy. Characteristic of Jones's interweaving of past and present is the closing image, in which the dead lie decorated with flowers, fruit and foliage, picked for them by the presiding spirit of the woods in which they fought their last battle.

The mass of imagery gathered from so many sources for the construction of *In Parenthesis*, however obscurely it may glimmer on first acquaintance, is in fact presented in the framework of a rational and clearly apprehended world order. At the time of his experience of the Western Front, however, Jones did not have the faintest intimation of such a framework.

After demobilization in 1919 he resumed his art studies with the aid of a government grant, this time at the Westminster School, of which Walter Bayes was the headmaster. The years in the army had sharpened his sense of vocation, and he went to Westminster eager to paint again.

Returning to his apprenticeship ardently but without settled convictions, it would have been singular if Jones should not have been attracted by the illustrious figures of the School of Paris and by their transforming achievements. But in spite of all this attraction, he always treated this School with a certain reserve – a reserve in which attentive respect was untouched by submissiveness. Yet its effect on his formation is manifest. Without it he could hardly have evolved the freedom – whether to simplify or to complicate his subject – that is so consistent a feature of his mature style. He began to take an interest, too, in the ideas and the work of the English artists in which were manifest the movements theorized in Paris. Yet it was consistent with his acutely developed sense of the past that his deepest enthusiasms should have been reserved not for contemporaries but for ancestors, for two of the great figures in that mystical tradition in painting towards which he was groping his way: Blake and El Greco. The first appearance of El Greco's *Agony in the Garden* in 1919 at the National Gallery stirred him deeply.

No less valuable than the quickening and deepening of his ideas about the ends of his art was the enhanced awareness, which he owed also to his years at Westminster, of the importance of ways and means. He was conscious of a particular debt to Walter Bayes for his insistence upon his students' need of acquiring the science of their profession – the same need was taught by Bernard Meninsky, whose life-class he attended.

The principal effect of these influences was vastly to intensify

Jones's spiritual and intellectual activity. He had come to West-minster, as he has told us, 'with an open mind', susceptible to influence, respectful of teaching. After a couple of years or so, his mind, for so long cramped by the alternation of action and boredom in a soldier's life, leapt into vigorous exercise, and he placed himself and all his ends and means in the widest context. It was a mind no longer open, for it had already reached some conclusions about first causes.

Some years earlier, in about 1917, and in the neighbourhood of Ypres, he found himself wondering about the Catholic tradition. On 7 September, 1921 he was received into the Catholic Church. The effect of his religious experience and of the teachings of the Church, clarifying and deepening his thinking, added strength and precision to the arts he practised by giving them the context of a world order of things. The insistence of the Church on the reality and goodness of matter and spirit, wedding form and content, the tradition that declares 'that in each particular the general should shine out and without the particular there can be no general for us men', he told us, 'has been my sheet anchor in times of bewilderment – that is at all times'. In so saying he had no illusions about the contribution that systems of thought can make to creative art; indeed he was alive to the vanity of depending upon them for what they could not give.

> I don't of course mean that any amount of true philosophical or metaphysical definition will aid one whit, necessarily, the painting of a picture. Because the ability to paint a good picture does not come through philosophy or religion in any direct manner at all.
>
> Such definitions could only have indeed a damaging effect on the making of things if thought of as providing some theory to work by – a substitute for imagination and direct creativeness; and would so sadly defeat their own object – which is, to protect the imagination from the slavery of false theory and to give the perfect law of liberty to our creativeness. To protect, in fact, what is natural to man.
>
> I would say that as affecting the arts in general, certain ideas implicit or explicit in Catholic Dogma, or anyway, ideas that come to me personally through the channel of the Catholic Church, have had a considerably liberating effect. Others, no doubt, receive them from other channels or discover them for themselves, perhaps; but for me, I must own my indebtedness to Her alone in this.

Of these ideas, the most influential was, he tells us, one of the basic teachings of the Church:

> I learned, I think, at least by analogy, from the doctrinal definition of the substantial Presence in the Sacramental Bread. Thenceforth a tree in a painting or a tree in an embroidery must not be a 're-presenting' only of a tree of sap and thrusting wood – it must really be 'a tree' under the species of paint, or needlework, or whatever. I know this

analogy cannot in any way be pressed and is open to every sort of objection, but for me it has its uses and it will loosely serve.

An immediate consequence of Jones's coming habitually to consider his ideas and activities in so wide a context was to diminish his confidence in the value of art instruction. It was not that he grew critical of his teachers; on the contrary. Even just before his death he spoke of his teachers with lively gratitude, in particular of Hartrick, with whom he had not worked since 1914. The principal cause of his dissatisfaction with art schools was that the disappearance of the apprentice system involved the disappearance of a thorough art education based upon the continuity of a living tradition, and that the academies which supplanted the guilds taught a dead tradition, or else the idiosyncrasies of the teacher.

One day in 1922 he was taken by a fellow student at Westminster to visit Eric Gill at Ditchling. On their way back to London the student remarked that he was relieved to get away from the shrine of arty-craftiness, to which Jones answered that he, on the contrary, intended to return there and work with Gill. Not long afterwards he joined the Guild of St Joseph and St Dominic at Ditchling. Here he attempted to master the trade of carpentry under George Maxwell, and the use of the engraver's tools under Father Desmond Chute and Eric Gill. As a carpenter he was of no use, but as an engraver, although he never reached Gill's precision and finish, he eventually learnt enough to enable him to make prints of unusual beauty. Here also he carried out a big wall-painting in oils, *Cum Floribus et Palmis* (1923). This is a conventional essay in the early Christian style, but it lacks neither tenderness nor dignity.

The impulse which led Jones to become Gill's apprentice was a prescient impulse, for what he learnt from Gill exceeded his utmost expectations. At the particular moment of their meeting, what Gill had to offer was precisely what Jones stood most urgently in need of. When he came to Ditchling, Jones was meditating deeply on many things: he was now a Catholic who only vaguely apprehended how his faith could transform his life and his art; he was a student interested in current Parisian theorizing, particularly in the dogma of 'significant form', who was unable to place this theorizing in a setting sufficiently wide to enable him to use it. By his character and his experience, Gill was peculiarly fitted to be his guide.

Of anybody I have ever known, Eric Gill made the most determined attempt to 'put his religion', as the saying goes, 'into practice'. This attempt went far beyond the regulation of his personal life according to the teachings of the Church: it sought to understand these teachings so clearly as to be able to see their bearing upon every problem of life,

public no less than private, and, having understood, to act in obedience to them. It must be admitted that his determination to make the teachings of religion, down to the utmost that they implied, the very basis of life led him into some contradictions, absurdities and even uncharities. Jones was a man deeply, if as yet vaguely, stirred by the religious spirit. The intimacy of a man such as Gill, who attempted, with such singleness of purpose and such courage, to apply ancient truths to the refractory fabric of actual life, was valuable beyond calculation. At this critical juncture Gill was able to give Jones the benefit of his lucid thinking about the arts.

In an article on Jones in *Artwork*, which appeared in 1930, eight years after their first meeting, Gill wrote of the temptation for contemporary artists to regard the formal values of painting – 'significant form', according to the then current cliché – as alone possessing merit, and the subject, even in the widest sense, as an irrelevance.:

> Such an exclusive insistence on form, however useful it has been as an eye-opener, is as essentially heretical as a too exclusive insistence upon representative veracity, or upon utility, i.e. the value of a painting as doing something of service to its owner, for heresy in artistic thinking, as in other matters, is little more than a running amok after one statement of the truth to the exclusion of others. To David Jones a painting is neither simply a representation, nor simply a painted pattern . . . What concerns him is the universal thing showing through the particular thing, and as a painter it is this showing through that he endeavours to capture . . . Nevertheless, in spite of this idealist attitude he never loses sight of the fact that it is a painting he is making . . . not merely an essay in Platonic research. My object is . . . to make a clear statement of his point of view.

The point of view expressed in this article is in fact Gill's. It agrees, at all points, with that expressed in his other writings and in his conversation.

During the years of their close association, the older man stamped the impress of his system of ideas upon the younger. Even this short article, which is far from being even a summary of Gill's thought, well expresses a number of Jones's ideas mentioned in these pages. The relation, for instance, between the universal and the particular. But there is no need to insist upon Jones's intellectual indebtedness to Gill, for he himself, always ready in his appreciation of his teachers, wrote that 'the clarifying ideas of Mr Gill were at that time, and for me, of very great value. The unity of all made things become clearer.' Jones's mind was too original to be confined within another man's ideas; from the time of his apprenticeship it developed in directions unthought of by his master, but it is true, I think, to say that it retained a framework derived from Gill. It may sound paradoxical,

but I am inclined to think that this framework served Jones better than it did Gill. By temperament Gill was an extremely tidy man, and the several arts and crafts he practised all reflected this extreme tidiness and made one over-conscious of their finish. It was reflected with equal clarity in his somewhat didactic thinking, and it made for rigidity and sometimes for false simplicity. With Gill, intellectual issues tended to resolve themselves too simply into blacks and whites. An excess of tidiness, material and intellectual, had the effect of giving the man and his works a self-conscious consistency, in short, a touch of smallness and pedantry. Unlike Gill, Jones was not naturally tidy: his innate tendency was to be diffuse, vague, delicately expansive. So it was that the same system of ideas that had a restrictive effect upon the innately overtidy Gill provided Jones with a firm, logical framework which gave form and direction to an art which, however lovely, lacked both.

Towards the end of 1924, Gill, unable any longer to bear the publicity which the Guild of St Joseph and St Dominic had attracted, withdrew from Ditchling to Capel-y-ffin; Jones returned to London where he continued to make engravings. The next year he followed Gill into the Vale of Ewyas, where he made the group of drawings in watercolours or chalk, already mentioned, of the hills round about. From Capel-y-ffin he paid two visits of some months each to the Benedictines of Caldey Island, off the Pembrokeshire coast, where he made drawings of a similar character of the sea, boats and the rocky coast, and was allowed the use of the scriptorium to work in. 'It was in the Vale of Ewyas and on Caldey Island that I began to have some idea of what I personally would ask a painting to be, and I think from 1926 onwards there has been a fairly recognizable direction in my work.' At this time he was as occupied with engraving as with drawing.

In 1927 he left Wales and returned to Brockley to live with his parents, also staying with them at intervals in a bungalow at Portslade near Hove, from the balcony of which he made paintings of the sea. It was at Portslade that he wrote down a few sentences that turned out to be the initial sentences of *In Parenthesis*.

David Jones now entered upon the most prolific period of his life: 'I painted all the time; I never seemed to stop painting in those days . . . It was during this period that I was most able to concentrate on getting towards what I wanted in painting.' The year of his return home was chiefly occupied with ten wood-engraved illustrations for *The Chester Play of the Deluge* (1927), of which at least one, *The Dove*, will surely take a high place among the finest book illustrations in an age of finely illustrated books. This engraving proclaims the value of the faith the artist had found, and upon which he had meditated so

deeply. Many illustrators have taken or been given momentous subjects on account of the pictorial possibilities they offer, but here there is no exploitation of pictorial possibilities. For Jones, the compact ark, discovered just before sunrise riding the vast waste of the sea, and the old black tree, projecting above the waves, sending forth fresh shoots, all this proclaiming a world washed clean and a new beginning for mankind, are part of a truth which he accepted as valid. During 1927 he also found time to make drawings at the Zoo and occasional drawings from life.

It was in this year that he joined the Society of Wood-Engravers and held his first exhibition, consisting of watercolours made in Wales and at Brockley and Portslade, at the St George's Gallery. The following year, too, was partly occupied with making ten copper-engraved illustrations for *The Rime of the Ancient Mariner* (1929). Whether because the subject was one which did not belong to his most intimate spiritual experience, or because watercolour rather than engraving had become his chosen medium, it is evident that the later series possesses little of the imaginative force of the earlier. Take for instance number *V* ('I closed my eyes'): could anything interpret the great poem more feebly than the boat-load of flimsy nudes, with archly-glancing almond eyes, posturing improbably? Yet Gill wrote of it that 'Coleridge's poem has for the first time found adequate pictorial accompaniment.' Were it not so widely admired I would have disregarded this series, considering it as merely one failure in the most richly creative years of Jones's life.

It was towards the end of the decade that his watercolours assumed their unique character: they became larger in size, and the slightly narive manner of their fashioning gave way to the evocative complex of fine, delicate, unemphatic lines and the fluid, opalescent colours from which shines a light recognizable as that rare thing, something new. Today high value is set upon originality: indeed for some critics this quality is the measure of greatness; what is certain is that it is a quality a good deal rarer than is generally supposed. I propose to say nothing at this point about David Jones's stature, but I do suggest that these large watercolours are among the most original creations in modern painting. A sharp eye and a clear view is needed to distinguish between Picasso's and Braque's Cubist periods, or between Matisse's, Dufy's and Vlaminck's Fauve periods, but nobody in any circumstances could fail to recognize one of these larger watercolours as being by David Jones.

This fluid and diffusive art owes its intelligibility to its context in a known world order. In spite of the extreme intricacy of the artist's mind and his reticently zestful tendency towards elaboration, it is a comparatively straightforward art – an art far removed from subjec-

tivity. Unlike most of his contemporaries, who manufactured their own symbols for themselves, Jones found his in the public language and the public symbolism of the Catholic Church. Confident as he was in the truth of the Catholic scheme of things, he was equally confident in the validity of the central Christian signs, for example, of the sacramental signs of the Eucharist. Being sure, then, of the absolute validity of this central symbolism, he felt himself free to use it as a key symbolism with which to explore and illuminate human dreams and aspirations, as conveyed in ritual, legend and tradition. In the art of many other contemporaries, which at first glance seems far simpler, it is difficult on scrutiny to make out why, except in purely sensuous terms, the artist chose to make the particular images he did. Many of Jones's pictures, on the other hand, are at first sight extremely difficult to grasp in regard to their form and meaning; yet on scrutiny there is found nothing arbitrary about the images that make them up. The gentle, unemphatic style of his utterance springs from confidence in the logic of his symbols.

Much of what he did in the earlier part of this uniquely fruitful period of his life had little symbolic content. Landscape was what chiefly occupied him, 'the rambling, familiar, south-walled, small flower-beddedness of Piggotts' (the house in Buckinghamshire to which Gill had moved); 'the north, serene clear silverness' of Rock, the house of Helen Sutherland, a discerning patron, in Cumberland; back-gardens at Brockley, and the sea seen from window or veranda in Hove and Brighton – these, together with animals, flowers, still-lifes and an occasional portrait, were his principal subjects. For some obscure reason his rare portraits have not been rated quite as highly as they deserve. The *Eric Gill* (1930), is an admirable likeness, and the far more elaborate portrait of Gill's daughter *Petra im Rosenhag* (1931), shows her just as I remember her. The least successful of them, *Human Being* (1931), is a too summary self-portrait in oils, a medium he seldom used. In painting landscape he worked when possible from a window. 'I like looking out on the world,' he said, 'from a reasonably sheltered position. I can't paint in the wind, and I like the indoors-outdoors contained yet limitless feeling of windows and doors. A man should be in a house; a beast should be in the field, and all that.'

Although less numerous than the landscapes, Jones's still-lifes express no less intimately the complex sensibility of the artist's outlook on the world. Like the landscapes, the still-lifes are set in a world in a state of flux, in which one object melts into another, in which, as Robin Ironside wrote:

the various phenomena embrace one another in a kind of Franciscan sympathy, and the mind, the heart which creates it does so in a mood of Franciscan affection. Franciscan is a term to be applied, with peculiar

justice, to the artist's graceful, nervous drawings of animals, to the deer naturally and also to the lynxes and the leopards which are presented to us as God's creatures and not at all as man's possible enemies, and though we see they have a dark side, it is not the darkness of rapacious instincts, but the portentous obscurity of some mythological role. . .

The appearance of profuse manifestations of a sensibility and invention so extraordinary led to the growth of a loosely knit circle of fervent supporters and the notice of a considerable public. An exhibition of Jones's work was held at the Goupil Gallery in 1929, consisting largely of watercolours made in the course of a visit to Salies de Béarn and Lourdes the year before; in 1930 at Heal's Mansard Gallery there was an exhibition of animal drawings, mostly made at the London Zoo; and from 1930 until 1933 he exhibited as a member of the Seven and Five Society. From the Goupil exhibition, *The Terrace* (1929), a watercolour, was purchased in 1940 by the Contemporary Art Society and presented to the Tate.

This period of happy productivity was brought to a close by the first of a succession of attacks of illness. Whenever his health permitted, Jones continued to make drawings, and although from 1933 his output was sporadic, to this later, less propitious period belong several works in which his rare fusion of imagination and sensibility found its fullest expression. I am thinking in particular of four watercolour drawings: *Guenever* (1940), *The Four Queens* (1941), (both illustrations to the Arthurian Legend), *Aphrodite in Aulis* (1941), and *Vexilla Regis* (1947).

In two important respects these differ from the artist's earlier drawings. With certain exceptions – such as *Merlin appears in the form of a young child to Arthur sleeping* (1930) – Jones looked at the now and the near under the inspiration of 'an affection for the intimate creatureliness of things . . . an appreciation of the particular genius of places, men, trees, animals'. In certain of his drawings we are made only vaguely aware of his preoccupation with history and legend, which is explicit, however, only in the title. A watercolour and gouache of the south of France is entitled *The Roman Land* (1928), and a small chapel in a landscape, *The Chapel Perilous* (1932). The four later watercolour drawings are the fruits of the perceptions of his inner eye, and their subjects are explicitly legendary. Although the floating forms, as they merge one into the other in the diaphanous mesh of lines, have an opalescent radiance, the lines themselves play a more crucial part than they do in most of the earlier drawings. *English Window* (1931), with its magical evocation of English domestic life, would be almost without meaning in a black and white reproduction, whereas the last four lose much of their beauty but little of their sense. A visitor to an exhibition of contemporary painting may

sometimes wonder how most of the pictures ever came to be painted: the impulse behind them is so feeble and their meaning so little worthy of being imparted. Those endless stone outbuildings set in Yorkshire Dales, those endless daffodils standing forlornly in hand-thrown pots from an artshop, or, for that matter, an arrangement of squares and circles of raw and sticky paint, envisaged with a languid regard and often with positive boredom: how did it come about that anyone thought it worth while to give permanent form to something that interested him so little? It may be that Jones made these four drawings when he was troubled about his health, and was uncertain how long a period of immunity could be counted on. I do not know; but what is certain is that he made them as though each represented a last opportunity to make a picture: so instinct are they with long pondered experience, with knowledge of history and legend and of the Catholic liturgy lovingly stored up, besides an undiminished affection for 'the intimate creatureliness of things'.

Jones's great drawings, unlike most of the pictures in exhibitions of contemporary painting, are, if anything, too rich in content and meaning. They express, and in profuse detail, the religious ponder-ings of a man for whom, as I noted earlier, the doctrines of Christianity were true and were keys with which other doors might be unlocked; their symbols are paradigms of which legend and the symbolism of other rites are seen as precursors or approximations. For Jones, the incarnation, passion, death and resurrection of Christ were unique historical events, and Christianity was not a continuation of nature-religions; but like some (although not, of course, all) of the early Christian Fathers, Jones saw Christianity as the fulfilment of the earlier dreams, the reality of which they were intimations. It is only another way of putting this to say that, for him, Christianity gave the clue to what legend and myth were really about.

So, for example, *Aphrodite in Aulis* is clearly Aphrodite. Like the Venus of Lucretius's 'De Rerum Natura' she is not only *hominum divomque voluptas* but the fosterer of all nature's abundance, activity and turmoil. Soldiers are all about her, and columns and entablatures are broken. But she is also Iphigenia, shackled by the ankle, a sacrificial victim and voluntary oblation standing on an altar. The altar is an ornate classical pedestal on which is inscribed a ram, whose blood pours into a cup set beneath it. The hand and foot of this victim are pierced, and the British soldier to the left carries a lance; on the right a monk in religious habit swings a thurible of incense. A monk in such a posture is appropriate if, but only if, the symbolism is eucharistic. For Jones, it was the Eucharist that redeemed the historical process; accordingly, around Aphrodite are ranged soldiers of those times and places that interested him most,

Greek, Etruscan, Roman, Arthurian, British, German; columns and pediments are broken, but around this all the orders of architecture retain their validity. Around her neck Aphrodite wears a necklace that carries a cross, and indeed there are stars in her hair with a crescent moon above, as if she were the Madonna and the Mother of all the Living (as in Hopkins's *May Magnificat*), while around her head fly doves, the effulgence of one of which radiates her body. In the eucharistic sign, then, she is seen for what, after all, she is – even if in aspect she is Phryne or Lesbia.

The same sweep throughout time, the same confidence that the dreams, aspirations, stories and achievements of human kind are to be understood for what they are in the light of the Mass and the Redemption, is apparent in the much simpler and deeply moving *Vexilla Regis*. The title of this drawing is taken from the Easter hymn, *Vexilla regis prodeunt, fulget crucis mysterium*. But in the drawing there are no royal standards and no cross. Indeed, the only Christian emblems are some of the instruments of the passion and a pelican and doves. But for Jones the 'mystery of the Cross' is everywhere: in the wolf-helmet of the Roman augur, in the nude goddess on the fountain, in the Doric temple and the pillar surmounted by the Roman eagle, in Stonehenge; all set in a wooded landscape whose atmosphere, like its animals, is Arthurian.

If, in regard to the content of his art, Jones was a 'traditional' artist, his drawing, in the manner of its presentation, stands somewhat aside from the great tradition. In words of high authority, Berenson defined the essential in the art of painting as the power 'to stimulate our consciousness of tactile values, so that the picture shall have at least as much power as the object represented to appeal to our tactile imagination'. Jones made no attempt to appeal to our tactile imagination; he rouses our tactile sense only so far as is necessary to assure us that his symbols are in fact solid and not merely hieroglyphics worked upon a veil. The figure of Aphrodite is shown, by delicate modelling here and there, to be a figure very much of flesh and blood. But if his forms are often floating wraiths, those who have the patience to decipher the intricate tracery of his lines will discover that his art does not ignore the third dimension: that if the spectator has only occasionally the illusion of being able to touch the objects which Jones represented, he will have the illusion of wandering among them, penetrating so far behind what at first resembles a veil as to lose himself in a diversely populated Lyonesse.

Even for those who had the privilege of knowing him for many years and had an innate delight in his drawing and writing, patience was necessary, but patience is invariably rewarded.

In July 1954 Jones remarked that I had never visited him at his

home in Harrow. I arrived at the house to which he had directed me
– a large Victorian boardinghouse. No one answered the loud-
clanging bell, I went in. A kettle was boiling on the range in the
empty kitchen downstairs, but there was nobody there. Floor by
floor, room by room I searched the silent house. Upon the mantel in
the dining-room (wherein was a long table set with many places)
stood a photograph of a David Jones inscription, evidence that I had
come, at any rate, to the right house. I knocked and knocked again,
and, no answer being returned, I looked into one room after another,
every one empty. Brooding on this Kafka-like predicament, I mounted
laboriously from floor to floor, hearing no sound but the wind in the
corridors. At last, on an upper floor my knock was answered. The
door opened and there was my elusive host, welcoming and reassur-
ing, in his cosy bed-sitting room, with a warm fire and a kettle
singing upon it. The narrow bed stood near the window, which gave
upon a *hortus inclusus*, and, more distantly, upon a distant prospect
of London, and upon the bed was a drawing board and tacked to it a
work he had just begun. At the time a big exhibition of his work was
touring Wales, yet some of his best drawings were hanging on his
own walls. I teased him for liking to keep his work beside him, and
added that I had long wanted to buy one of his pictures but because
of this preference had refrained from trying to do so. 'Don't for a
moment think that I haven't appreciated that,' he answered. With the
tea and toast prepared, we sat down beside the fire. He had no real
knowledge, he told me, of Latin, only what he had picked up from
inscriptions and the Liturgy. He also told me that he never worked
from studies, but either directly from nature or from imagination; but
mostly we talked of our early meetings and of our friendship with
Eric Gill. How little Jones had changed, I thought, since the day when
I had first seen him, a young apprentice twenty-eight years before, at
Gill's house at Capel-y-ffin in a room darkened by the swirling mist
outside. Except as a soldier in France he had since led a cloistered
life. His love for Latin, a language he did not know and yet had an
innate feeling for, and for Welsh, a language of which his knowledge
was smaller still, had given him a singular power of conveying their
special beauties in his own writing. In the same way, from a loving
apprehension of things still deeper than language, he was able, and
in the face of persistent ill-health, to reveal, in picture after picture,
the Christian fulfilment of myths and images that have immemorially
haunted the mind of man.

Although Jones was exceptionally independent and little influenced
by the work of others, even by that of Gill, to whom he was devoted
and greatly indebted, he shared with Ben Nicholson a delight in
whiteness, the whiteness of sea-foam and altar-cloths, which was

even more apparent in his poetry than it was in his painting. Besides Nicholson's painting, he was influenced by Henry Moore's graphic art, especially by his increasing use of chalk and crayon in the late 1940s.

Among his most notable watercolours *Flora in Calix-Light* (1950), *Trystan ac Essyllt* (*c.* 1962) and *Y Cyfar chriard I Fair* (*c.* 1964) are all marked by a rare, highly linear complexity, yet I can see no superfluous line among them and hundreds more beside; every one contributes to the works' poetic animation. They are among the major watercolours of their time. Jones was only an occasional portrait-draughtsman, but his *Eric Gill* (1930), a watercolour, is a penetrating likeness.

Jones's engravings, in several media, and printed illustrations are more numerous: sixteen, in addition to the series of eight for Coleridge's *The Rime of the Ancient Mariner*, were all made between 1922 and 1932. The second *Madonna and Child with Ox and Ass* (1923), looks like an amateur's version of a Gill. Several of these engravings are excellent, but they are hardly comparable with Jones's watercolours; this is not surprising, for in order to realize his highly complex and subtle vision, Jones required an appropriate medium.

Jones's watercolours, paintings and engravings, together with his writings and inscriptions constitute a memorable life's work. The imaginative complexity of his poetic vision, and the sheer energy needed to realize it would in any case have been impressive. In his case it was heroic. 'In 1947', he wrote, 'I had a return of my 1932 breakdown, only much worse, and had to go to Dr C.M.'s nursing home for treatment, that's how I came to be in Harrow. I was there for six months and was made incredibly better. And went to Mr Carlyle's house so as to be near the nursing home for a while.' During the 1950s he suffered periods of increasing ill health and acute depression.

From the middle 1960s Jones's creative energy underwent radical decline, but the range and quality of the achievements of this artist and writer are outstanding. From early in his life these were recognized, and later widely acclaimed; in 1974 he was made a Companion of Honour. On 28 October of that year he died at Calvary Nursing Home, and on 13 December a Solemn Requiem Mass was said for him in Westminster Cathedral.

PERCY HORTON
1897 – 1970

Unlike the other artists treated in this volume, Percy Horton is apt to be forgotten by the public. Not, however, by his fellow artists. Hearing of his death in 1970 Henry Moore exclaimed, 'How I shall miss him!' The exhibition of sixty-two of his paintings and drawings held at Pyms Gallery in October 1982 – also in Sheffield, Newcastle and Stoke-on-Trent – was treated with respect rather than acclaim. He was nevertheless an artist – and a personality – who merits careful consideration.

Percy Frederick Horton was born on 8 March, 1897 at 38 Jersey Street, Brighton, the eldest of the three sons of Percy Horton and his wife Ellen, born Batchelor. His father was a bus conductor; his mother started work at the age of eleven as a nursemaid and in 1937 gave an account of her early married life to her daughter-in-law. One graphic paragraph reads:

> We used to let two rooms because Dad was only earning eighteen shillings (a week) and then a pound. When we had paid rent eight and sixpence and insurance, there was not much left . . . Dad got 1sh rise each year till he got 27sh. Then when electric buses came in he got a little more. He had to clean his own bus, including lamps, and walk home from Hove . . . getting home at one in the morning . . . I had to be up at five again to wash and sweep and get the man lodger's breakfast at 6 o'clock. Dad set off again at 9 o'clock for the Bus Garage.

This, by present day standards, is a life of almost incredible penury and hardship, but it did not distract Ellen Horton from fostering high ambitions for all of her sons. Percy, the eldest, was given music lessons, choosing to learn to play the violin, which he continued until the end of his life. In a letter to Bridget Reedman, his brother Harry's only child, Ronald Horton describes the lively fashion in which he, Percy and Harry spent the evenings at weekends:

> On Saturdays, after tea, our parents would leave us alone in the house while they went out for a walk together. We used to wait until they had turned the corner at the bottom of the street and then we got busy. . . . We would throw open our front door and call together an audience from these children. Then we three boys would dress up in anything that came to hand; rugs off the floor, some of our parents' clothes and something of our own put on inside out. We would put pots and pans

on our heads and make ourselves look as grotesque as possible, generally acting the fool and causing much mirth among the onlookers . . . Percy was the keenest in this activity and had real imagination in creating strange effects of costume. This was the beginning of what was to become a life-time interest for him. At school plays and when a student at the RCA |Royal College of Art|, he was active in the dramatic society, taking leading roles in plays by Ibsen, Chekhov and Synge.

Their mother's intense ambitions on behalf of her three sons were sometimes ill-judgedly, considering the working-class character of the district in which they lived. 'At one time,' Ronald relates, 'she bought us Eton suits, with stiff collars and bowler hats! We didn't want them but she would have it so, and one day we ventured forth filled with apprehension! We did not get far before we were the subjects of amused derision and we soon had our bowler hats knocked off and bashed in! We hastily retreated and refused to have anything to do with those clothes.'

Her judgment however, was in the main extremely sound: she fostered their inclination to work hard. All three won scholarships to the Brighton Municipal Secondary School, and Percy one to the Brighton School of Art in 1912, where he was awarded prizes for drawing and composition. He also passed the Department of Education drawing examination with distinction in 1914, remaining at the School until 1916.

It was about that time that the war brought a crucial change to Horton's life. Although he had been an ardently dedicated art student, he had also formed a deep sympathy for socialism. In 1913 he joined the Labour Party and saw the war – to quote from the Sheffield City Art Galleries' authoritative *Percy Horton: Artist and Absolutist* – 'as primarily a massive manipulation of the working man'; he would have agreed with Fenner Brockway, who wrote in the *Labour Leader*, 6 August, 1914: 'Workers of Great Britain, you have no quarrel with the workers of Europe. They have no quarrel with you. The quarrel is between the ruling classes of Europe. Don't make this quarrel yours.'

The *Labour Leader* and the Independent Labour Party's weekly antiwar journal became habitual reading matter for Horton. Instead of being, as it often is, a passing sentiment, Horton adopted pacifism with the utmost earnestness. With the introduction of conscription in January 1916 he was faced, at 18, with a critical decision: he refused to join any of the Forces, instead joining the No-Conscription Fellowship (NCF) in Brighton which consisted of some forty conscientious objectors. Among some women sympathizers was Lydia Sargent Smith. She was engaged to Roy Richmond, a fellow Quaker and a friend of Horton's. A woman of outstanding character, a suffragette

in the early 1920s; resentful of suffragettes' treatment by the police, she enlisted in the women's police force; her convictions as a Quaker made her opposed to conscription and she accordingly joined the NCF, later becoming coeditor of its journal *The Tribunal*. Roy Richmond was imprisoned as a conscientious objector; already suffering from heart disease, he died in prison in December 1916. Four years later Lydia and Horton married.

At the official tribunals of enquiry, conscientious objectors were dealt with in three ways, according to the degree and nature of their objection. Those who would accept noncombatant service under the military usually joined the Non-Combatant Corps. Here they were put through military training in squad drill without arms and also trained in the use of various tools for field engineering. After training they were posted to camps in France and England where they built roads, erected hutted camps, loaded and unloaded ships and railway wagons and were responsible for 'sanitary work', a euphemism for the unpleasant task of burning excreta. The second choice open to the conscientious objector was to accept alternative service under civilian authority. This was by far the most popular choice. Out of around 16500 conscientious objectors, about 11500 chose this option. Many worked in munitions factories or on the land. The third choice was to state unwillingness to undertake any form of service which might help the war effort, and to claim absolute exemption. One in twelve conscientious objectors took up this position, and about three hundred and fifty men received absolute exemption from the tribunals, most of them on religious grounds. About a thousand opted for absolute exemption but this the tribunals refused. They resisted all attempts to make them accept alternative conditions. To this small minority Percy Horton belonged. In a letter written to his parents from prison, dated 9 November, 1916, he states 'out of about 70 C.O.s . . . I was the only one to decline alternative service.'

When absolute exemption was refused, objectors were considered to be as soldiers and were therefore subject to military discipline. After an initial prison sentence they were returned to their units, and if they refused to obey orders they were successively court-martialled and returned to prison. Such was Horton's experience. He first appeared before the Brighton Tribunal on 21 March, 1916 when he requested absolute exemption. *The Sussex Daily News* reported the case on the 22nd under the heading 'How to prove sincerity', quoting Horton's statement in part: 'There is, in my opinion, only one form of real evidence of sincerity. The really sincere man is prepared to suffer rather than act against his principles, and is not out to save his own skin. As regards my sincerity, therefore, this is the only evidence I am prepared to offer you. If I fail to get absolute exemption – and I

should like to remind the Tribunal that as a sincere conscientious objector I have the right to such exemption – I shall appeal. If I then fail . . . I cannot abandon my convictions, and must take the consequences which may arise from refusing to comply with the Military Service Act.'

Exempted from combatant service, Horton nevertheless refused to take alternative war service. His appeal against the decision was heard on 14 April, 1916 by the East Sussex tribunal. Little notice was taken of his statement and an attempt was made to stop his speaking. His appeal for absolute exemption from war service of any kind was rejected. He was called up, failed to report, was arrested and taken to Edinburgh – where the 27th Fusiliers, his appointed regiment, were stationed – was confined to a cell from where he was able, however, to smuggle out letters to his parents written on tiny scraps of paper.

Court-martialled for refusing to put on his uniform when ordered to do so, Horton pleaded not guilty on the grounds that he had not taken any military oath and therefore could not be guilty of disobeying a military order; also stating his opposition to war in principle, as he believed it to be 'a direct expression of the present competitive social system, a system which I desire to see superseded by a state of society expressing the spirit of cooperation'.

Horton was sentenced to two years hard labour, which he served in Carlton Prison in Edinburgh. The usual conditions, observed in his case, were solitary confinement for twenty-eight days. He was then allowed to work with other prisoners; all, however, had to remain silent. In a letter to his parents dated 9 November, 1916 he wrote: 'My cell was never unlocked except to admit food or allow me to go out for the daily exercise so I have to be satisfied with the companionship of my thoughts . . . I have now passed through what may be described as the great test, and I feel much stronger for the experience than I ever felt before. Things look dark at present. I shall soon be called upon to perform some military duty and having refused shall doubtless be put in the guardroom with prospects of another spell in prison'. The following day he refused to give information about himself for army records, and this refusal led to his remand once again for district court-martial. In a letter dated 17 November he wrote of the conditions while awaiting the rehearing of his case: 'The cell in which I spend most of my time is small, semi-dark, and quite bare except for a few boards on which I sit or lie. As I have nothing whatever in my possession, I can neither read nor draw . . .'

There followed yet further ordeals: through another court-martial he was returned to Carlton Prison in December where he remained until 5 May, 1917 when he was returned to his regiment for another

unsuccessful attempt to break his stand. Accordingly he was court-martialled yet again on 17 May and again expressed his objection to taking any part in the war:

> I am strongly convinced of the sanctity of human life and of the underlying spiritual unity of mankind. Believing that force, though it may appear to be an expedient, is in reality no ... remedy. I look on war as being not only immoral but futile as a method of deciding disputes between nations. I believe that the satisfactory settlement of such differences can only be effected by reason, and that International Arbitration – although ... not of itself a panacea for the world's bellicose ills – provides the only reasonable method of dealing with these grave problems. It is my firm conviction that no righteous cause can be violence ... I am prepared to return to further incarceration with perfect equanimity, knowing from experience that confinement of the body cannot affect the liberty of the soul.

Yet again he was returned to Carlton Prison where conditions, in particular the long hours of strenuous work and wretched diet, made him ill. One of his jobs, the making of mats, caused injury to a wrist. The doctor diagnosed the resulting ganglion as a boil, but it became worse and Horton was taken to Edinburgh Hospital and underwent an operation which left a five-inch scar. So marked was the contrast between prison and hospital that he thoroughly enjoyed life in the ward.

While in prison Horton was not allowed to draw. Tiny scraps of paper and minute stubs of pencil were smuggled to him by the only prison visitor permitted – a Minister who pitied him deeply and was prepared to risk his own position by posting the occasional, strictly forbidden letter. A few of his sketches survive, but they only made him aware of how much capacity he had lost since he left the Brighton School of Art. In hospital he was able to draw more often, but still to little purpose.

During this time a number of press reports appeared regarding prison conditions and their detrimental effect on the health of imprisoned conscientious objectors, some instances recalling how this led to their deaths. Among them was that of Roy Richmond. By December 1917 the names of a number of imprisoned conscientious objectors too ill to withstand life in prison were brought to the attention of the Home Secretary. Among them was that of Percy Horton. In consequence there was a general relaxation in their treatment. Even 'absolutists' in a serious state of health were allowed by the army council to be transferred to the reserve forces. Since the War Office had no intention of recalling them to service they were in effect discharged. Horton, among others, was released under the 1914 Criminal Justice Bill, whereby prisoners suffering from disease which could not be effectively treated in prison were allowed to be taken to

hospital. Theoretically they could be returned to prison – theoretically because by this time the government no longer wished to be involved with the 'absolutists'.

During his recuperation Horton made several drawings of nurses and fellow patients. These were admired by the artist Edward Arthur Walton, and when Horton was officially discharged in April 1918, he took him into his care. The hard labour, lack of good food and the operation he had undergone resulted in a decline in Horton's health. The care he received in hospital and the benevolence of Walton – with whom he stayed for several months – effectively restored his health. The incontrovertible facts of the experiences which Horton underwent afford testimony enough to his sufferings and the courage with which he faced them. In December 1917 an article appeared in *The Tribunal* entitled 'Extracts from a letter from a C.O. who spent 15 months in Carlton Gaol'. The basic facts related make it highly probable that they were written by Horton.

Horton's war years have been recalled at some length not only by way of tribute to the constant courage he showed in the realization of his ideals, but also because of the moving affinity between them and ideals of a wholly contrary character held by artists of his generation. A number of them served with rare courage as war artists, several sacrificed their lives revealing aspects of the holocaust.

After leaving Walton he returned to his parents in Brighton. In the autumn of 1918 he resumed his education, attending the Central School of Arts and Crafts, where he studied under A. S. Hartrick and F. E. Jackson. Both taught drawing, with emphasis on linear clarity and sense of movement. Well aware that he had not made up for the loss of momentum in his development incurred during the war years, he nevertheless could not afford to prolong his studies, and left after a year.

The first of his long – almost lifelong – terms of teaching began in 1920 as an assistant at the Rugby School. His low salary was paid in a singular way: the head of the art department paid his assistants, employed at his discretion, out of his own pocket, being reimbursed by the school. A far more serious matter was that Horton appears to have had little opportunity for drawing or painting. In 1922 he resigned and sat for the Ministry of Education examination in painting, which he passed with distinction, and was awarded a Royal Exhibition, tenable for a year at the Royal College of Art.

In spite of the barren period of the war, and the bleak one at Rugby, Horton had made himself an exceptional draughtsman, a remarkable accomplishment. To cite a single example, *Farm Labourer* (part of a study for a Nativity composition), a pencil drawing of 1922, is all the

more remarkable in the light of his circumstances in the preceding years.

At the College, where he managed to remain for two years, he was awarded the ARCA Diploma with Distinction in Painting, and the College Drawing Prize, also in 1924. After leaving the College he resumed teaching as part-time drawing master at Bishop's Stortford College from 1925 to 1930.

Among the difficulties which faced former conscientious objectors was the complexity of certain legal conditions relating to their employment, over and above the difficulty of finding any employment at all. Many civil servants, teachers and police were not reinstated, or else remained unpromoted. Fortunately for Horton, Bishop's Stortford had a strong nonconformist tradition and no fewer than three former conscientious objectors were employed there, and the headmaster, F. S. Young, refused, in spite of representations by the War Office, to continue military training in the postwar years.

Horton proved himself to be a highly successful teacher and when he left in July 1930 the school's magazine, *The Stortfordshire*, paid him this tribute:

> Under Mr Horton the art of the school went up by leaps and bounds. He had a profound knowledge of art and made the study of painting interesting and easy. Mr Horton could talk with equal surety on all branches of art. Those of us who had the good fortune to hear his talks . . . will remember them for their vividness. The painters really lived before us, with all the glamour and colour that surrounded their lives. In his departure the school has suffered a great loss.

While still at Bishop's Stortford, from 1926 Horton also taught classes at the Working Men's College – where Ruskin, Rossetti, Ford Madox Brown and other celebrated artists had taught – for some ten years. By the 1920s, however, the College had become an uninspiring and inefficient place. James Laver (an informed and prolific writer and from 1938 until 1959 a Keeper at the Victoria and Albert Museum) when appointed the College's director of art was asked to reorganize its teaching. He thereupon consulted my father, who suggested that the man whose help they should seek was Horton, who was accordingly invited to teach there, which he did for three evenings a week. Other artists of exceptional talent who accepted invitations to teach included Geoffrey Rhoades and Barnett Freedman. 'Geoffrey was as quiet as Barnett was ebullient', wrote Laver, '. . . Both of them and all the art teachers did wonderful work for the College but it was Percy Horton who was the pioneer.' An account of the result of this reorganization was also written by Geoffrey Rhoades – whom Horton brought to the College – in the rough draft of his as yet unpublished biography of Horton. 'Percy and I taught Mon. Wed. Fri. evenings . . .

P(ercy) got rid of Discobolus and brought casts of a marvellous French Mary Madonna and Child and a Benin head . . . a nude model posed every evening . . . We taught everything our students decided they wanted to learn, and the standard of the work was high. The classes were well attended. Unemployed who could hardly afford materials mixed with employed workers and art students.'

The popularity of these classes brought about a complex problem: they encouraged a number of men who were securely employed to become professional artists, thereby causing the teachers concern. The men who accordingly wished to resign might either become artists of some significance, or else sacrifice their livelihood to no purpose whatsoever. In any case it would involve the sacrifice of security in favour of a calling notorious for its absences. Horton, however, shared none of this concern. Suspicious of dealers fostering the amateur and the naive, in April 1938 he wrote an article entitled 'The Naive and the Sophisticated' for *The Left Review* (under the pseudonym 'Toros', which he used from time to time) in which his attitude was clearly expressed. His subjects were the 'Sunday Painters' exhibition at Tooth's and Christopher Wood at the New Burlington:

> Since the discovery of Henri Rousseau, the French Customs officer – there has been a growing interest in the productions of 'Sunday artists' – not only on the part of art specialists. The upholders of the present social system have not been slow to recognize the value of encouraging workers to occupy their leisure in such an innocuous activity as painting. Facilities for workers to draw and paint at evening 'Institutes' and the arrangement by big industrial concerns of exhibitions and competitions for art produced by their employees – these are examples of the sort of encouragement which has been given. If the type of art produced is such as to make no demands on the intelligence, so much the better. The Sunday painter is encouraged to be a harmless little man absorbed in what Cézanne once called *sa petite sensation* and oblivious to the social questions agitating his fellow men.

Horton believed, nevertheless, that 'it was still possible to conceive of worker-artists producing paintings which have a vital and interesting content.' In the *Review*'s next issue Horton pursued this theme in his discussion of the exhibition of work by William Coldstream, Graham Bell and Victor Pasmore at Wildenstein's, urging them: 'to throw away their blinkers and look around them a good bit more. The changes which the world is undergoing make big demands on the artist. They trouble him but at the same time they exact great things from him and the future is with the artist who is capable of taking a sufficiently comprehensive viewpoint – a view embracing a totality of social relationships.

In 1930 my father, then Principal of the Royal College of Art, appointed Horton instructor in painting, a position which he held for

nineteen years, yet continuing to take his evening classes at the
Working Men's College for a further six. He was indeed a dedicated
teacher. At the Royal College his teaching won him high regard by
both students and staff. In 1933 he was appointed a visiting instructor
at the Ruskin School of Drawing, Oxford.

Horton's output of paintings and drawings was considerable. A
number of them are clearly expressive of the ideas which marked his
writings and much of his conversation. Noteworthy, for instance, is
The Postman (1926), and outstanding *The Unemployed Man* (1936). But
deeply preoccupied although he was with political and economic
movements, his art was far from confined to their expression; for
instance his *Still-life with Peaches and Plums* (1933) is surely among his
finest works. A good example, *The Invalid* (1934), we purchased for
the Tate in 1940 from his exhibition at the Ashmolean Museum,
Oxford. I had no idea of the pleasure this gave him until I read his
letter to Walter Strachan, of 26 May from 32 Dulwich Village, which
begins:

> I have waited before answering your letter with its kind congratulations
> until I had certain news of the Tate. Well, it has come off, and I am to
> hang with the newly-acquired Johns, Sickerts, Spencer Gores, etc (I am
> told), when the exhibition opens on June 4th. Needless to say, I am
> extremely bucked, although I do not feel that I have yet done anything
> which really has the whole of me behind it. I hope I shall get the
> opportunity to do that some day. . . . John Rothenstein . . . in congratu-
> lating me, mentioned that he hoped soon to acquire one of my
> drawings. All this is very encouraging but at the present time seems a
> bit irrelevant. I cannot help feeling that this boom in my affairs is like
> the hectic flush on the cheek of the dying. In this case the patient is art.
> For surely it cannot hope to survive as an activity much longer? If
> things go on as they are, we shall all be commandeered to do war
> work. . . .

Of *The Unemployed Man* Janet Barnes, the author of *Artist &
Absolutist*, notes with insight: 'There is no reproach or anger in the
man's gaze, nor any accusation of blame for his situation. Horton has
made this painting a study of the dignity of the individual – the man
facing the viewer with a demand for moral equality. Horton never
forced upon his subjects the burden of being a cypher for his own
social, political concerns.' These concerns, however, remained inte-
gral. I received a letter from him such as he wrote to many of his
acquaintances and friends:

> Dear John,
> I have promised the Artists Refugee Committee that I would approach
> you and ask you if you would sign the enclosed letter which they
> propose to send to the Press . . . If you feel you can . . . would you
> please let me have it back . . . at once. The matter is urgent.

The refugee who was our guest was taken away about four weeks ago and we have not heard where he is. News from some of his friends, however, suggests that conditions in some of the internment camps are very bad. It seems incredibly stupid to me to treat those who have already suffered under Hitler in this way.

I hope you will not mind my bothering you about this matter,

> With kindest regards,
> Yours sincerely,
> *Percy Horton*

He was also active in his support of the Artists International, becoming a member of the Advisory Council in 1941, with, among others, Muirhead Bone, Oscar Kokoschka, Paul Nash and Henry Moore. During the Spanish Civil War the organization had supported the cause against fascism. Horton was among the artists who helped the Spanish socialists, making portrait drawings for five guineas each. He also helped refugees from Nazi Germany, among them Edmund Mehlmann, who later married Katharine, Percy's and Lydia's only child. During the war he was commissioned by the War Artists Advisory Committee to make a few portrait drawings, one of which, *J. A. Leach*, is in the Imperial War Museum, as well as *Blind Workers in a Birmingham Factory* (both 1943).

So intense was his hatred of nazism that Horton – who in the First World War had suffered long terms of imprisonment as a conscientious objector – that in the Second at Ambleside, he joined the Home Guard.

The difficulties of Horton's weekly Oxford visits proved insurmountable and he resigned.

After returning to London after the end of the war the College was subject to a period of utter confusion. Scarcely any furnishings or equipment, even for the studios, remained. But far more serious were the staff problems: when Robin Darwin succeeded Percy Jowett as its Principal in 1948 he required a considerable number of staff changes; although Horton's services were retained, he – and a number of his colleagues – found the situation acutely depressing. That same year I received a letter from him telling me that he had been appointed Master of Drawing at Ruskin in Oxford and thanking me in the warmest terms for acting as one of his supporters:

> I am very happy about the appointment ... & shall look forward to doing all I can to maintain the high reputation ... it has achieved under Albert's (Rutherston's) Mastership. It will not be easy to follow him, but I shall be fortunate in having his present staff who are already my friends & students whom I already know & like – not to mention his kindly offered help & advice in the initiation period.

Horton was indeed happy, for none of the schools where he worked

evoked from him so ardent an attachment as the Ruskin. Moreover, his relief in leaving the Royal College, in its prevailing circumstances, was intense.

At the Ruskin he was remembered with respect for what one of his students spoke to me of as 'the quiet authority he brought to the process of drawing'. This 'quiet authority' the same student recalls, 'was the most striking feature of the way Horton served as Ruskin Master.' Various attempts were made to bring the School into close conformity with academic ideas. (He used often to declare that he enjoyed teaching but hated art education.) These he consistently, and at last successfully, resisted. He allowed students to sit for the NDD, but the teaching was in no way modified to facilitate their doing so.

Horton derived much satisfaction from the regard that the position of Ruskin Master gave him, but the internal conflicts of opinion regarding the School's future were a constant source of harrassment. The gravest of these resulted from the University's attempted proposal that as an economy measure, the School, for which it held financial responsibility, should be closed. This was primarily due to the reduction of the funds received from the University Grants Committee, but also to the influence of Oxford's teaching procedures. The proposal evoked strong opposition not only within the University but by public opinion voiced in the national press. Among the many who opposed the School's closure were influential public figures, including Henry Moore. With such support Horton's opposition to the school's closure prevailed. Accordingly no changes were made until after his retirement in 1964.

Much as Horton delighted in the Ruskin, the friendships it brought him, the company of his colleagues and students, he was increasingly depressed by the time wasted by the controversies about the School's future, in particular by the frequent meetings and unending discussions it involved. One consequence was that he developed stomach ulcers. In the opinion of his wife Lydia this was 'the consequence of the intrigue and in-fighting of the last years of his Mastership which shortened his life'. She also sadly admitted that she considered his work before he went to the Ruskin as Master superior to that which he later produced. The College, she was convinced, 'stifled his talent'.

If these distressing controversies affected his health they would not appear to have affected his teaching; students of several generations have testified to his unfailing dedication. A description of Horton's 'gentle approach to teaching his students' by Tim Gibbs, once his student and now a part-time teacher at the Ruskin, is quoted in *Artist & Absolutist*:

He would very politely ask if the student needed help . . . would then

sit himself in front of the 'motif' and demonstrate with infinite care the particular structural problems that had been avoided, not noticed, or glossed over. There was no escape. Every mark had to be significant and minimal and indicate in as precise and economical way as possible the desired form.

In a letter to me during his last year as a student, Gibbs added to his description:

Percy would become so absorbed in these demonstrations that he did not notice the students' response – or sometimes lack of it . . . the formal problems – and he did see painting and drawing as problems – he was only interested in solving them. This was his strength as a teacher – a total commitment to making visible and intelligible the infinite subtlety of what was in front of him. It was a daunting experience for any but the wholly committed and also sometimes frustrating for the more vigorous spirits who would be dying to get on.

Horton's teaching was wide-ranging, but he laid particular stress on a few deeply felt convictions. One, frequently expressed, was the crucial need to draw and paint from reality; another the need for concentration on drawing, 'the backbone of painting'; and yet another, that the human figure 'still provides a challenge and indeed the supreme test for the draughtsman'. The reason for this, he would explain, was that 'the practice of any form of art requires the powers of organization and coordination. The drawing of the human figure, with its problems of construction, articulation and movement provide invaluable exercises on the development of this power'. It was Horton's modesty and humility as well as his learning that influenced generations of students – while his unfailing courtesy won him their affection and respect.

Even after his retirement from the Ruskin, having settled in Lewes, Horton continued teaching for two days a week at the Sir John Cass School, London, and for one at the Hastings School of Art. During such free time as he had – or allowed himself – he painted landscapes and carried out commissions for portraits. On several occasions he stayed with Vincent Lines, who owned a farmhouse in Provence.

In August 1947 Horton, together with Paul Hogarth, Ronald Searle and Laurence Scarfe, accepted an invitation from the People's Youth Organization to visit Yugoslavia to record the construction of the Youth Railway in Bosnia. It was an extraordinary project, extending one hundred and fifty miles, and built entirely by volunteers, although under the guidance of professional engineers. Horton travelled through the country widely, making portrait drawings of the leading people concerned with the project. An exhibition of watercolours and drawings by the four artists was held at the Leicester Galleries in February 1948.

Throughout his life – except the years in prison – Horton remained a dedicated artist. Those grievous years, although he retained a formidable degree of vitality, sapped it nevertheless. Had he been able to use those potentially creative years, his work would have matured earlier than it did. His constitution, however, remained strong, but not quite so strong as it would otherwise have been. Had he devoted almost all of his energy to painting and drawing his mature years would surely have sufficed. But this he did not do, instead devoting a formidable proportion of it to teaching. Many, perhaps most, of his contemporaries did indeed teach – in their earlier years they had little choice. I remember how many, who began by teaching several days a week, rejoiced in their reduction, and hearing several, including Henry Moore exclaim, 'I'm only teaching one day now!' Whereas Horton never gave up teaching. That he was a teacher of outstanding ability is not open to question, but neither is the fact that it took much of his time and energy away from his painting, and that it adversely affected his health and creativity. Quite early in his career he himself became aware of its effects. He would speak of it to his friends, and another of his many letters to Walter Strachan of 11 December, 1934 begins, 'Term is nearly over – Gott sei dank! How teaching can sap one's vitality!' And in one of 22 October, 1935: 'The world situation combined with teaching after the holiday have not been good for my work . . . I'm feeling I must take myself very firmly in hand and get down to some painting.' Another of 28 July, 1942, from Prospect Cottage, Ambleside, Westmorland: 'I have been so busy with diplomas, end of term exhibitions & so on, that I feel completely bemused & scarcely able to gather my wits. The end of every session at an institution like the RCA leaves me completely exhausted. Up here, too, there is a terrible feeling of inertia, so that it is difficult to bring oneself to the point of packing for the holidays.' And a final example, also to Strachan, of 13 July, 1962, from 185 Cromwell Road '. . . Term at Oxford finished a fortnight ago, but I have been too busy to get away. Examining of one kind & another has taken me to Reading University, Portsmouth & Culham and I am involved in similar work in London at the moment.'

Horton worked with tireless dedication until six weeks before his death from cancer on 5 November, 1970.

HENRY MOORE
born 1898

Until Henry Moore was nearly forty his drawings were regarded as the marginal activity of a sculptor. As an ever growing number of people believed him to be a great sculptor, his drawings compelled interest and respect. Quite apart from their intimate connection with his sculpture, they merited interest and respect as expressions of a mind of unusual originality and power. But had Moore not been a sculptor but a draughtsman only, and had he died before the Second World War, I think it doubtful whether his drawings would have taken an important place in the art of the century. Exhibitions were held respectively at the Zwemmer and Mayor Galleries in 1935 and 1939. In the bibliography of a principal work on the artist, I can find no piece of writing dealing with Moore's drawings separately from his sculpture prior to 1940. There were, of course, numerous notices of the drawings in association with the sculpture, and numerous references to them in articles of more general scope, of which the first appeared in 1933, when Moore was already thirty-five. He himself wrote in 1937 in *The Listener*, 'My drawings are done mainly as a help towards making sculpture – as a means of generating ideas for sculpture, tapping oneself for the initial idea, and as a way of sorting out ideas and developing them. And I sometimes,' he concedes, 'draw just for enjoyment.' I shall refer later to this illuminating article; for the present I wish merely to suggest that in 1937 Moore regarded his drawing as mainly ancillary to his sculpture. Three years later, in the shelters in which Londoners sought respite from German bombs, he underwent experiences that made him a draughtsman of comparable stature to the sculptor.

Henry Spencer Moore was born on 30 July, 1898 at Castleford, Yorkshire, the seventh child of Raymond Spencer Moore and his wife Mary, born Baker. In an interview which appeared in the *Partisan Review* in 1947, he tells us that the elder Moore was an aspiring and industrious man:

> He had begun as a farmer, doing whatever a boy of nine does in becoming a farmer – scaring crows, I suppose, but had later turned to coal mining. He educated himself: knew the whole of Shakespeare,

taught himself engineering to the point where he passed examinations qualifying him to become manager of the mine where he worked. His eyes, however, through an accident down the mine, grew bad enough to interfere with his further advancement.

Moore's paternal great-grandfather came from Ireland, but his father and grandfather were born in Lincolnshire, and for several generations the men on both sides of his family had worked on the land or as miners.

At the age of twelve Moore won a scholarship from the elementary school to Castleford Grammar School, but

> I had always wanted to be a sculptor, at least since I was about ten. However, my first art teacher at Castleford upset me a great deal; she said I drew figures with feet like tassels! I recall exactly what she referred to: figures with feet in the air, like early Gothic drawings – suspended in the air. . . .

His father was strongly opposed to Moore's becoming an artist; instead he wished him to follow an elder brother and a sister to York Training College and to become a teacher. The lady who had objected to the feet of his drawn figures was replaced by Alice Gostick, who became a firm ally in the argument with his father, which persisted from Moore's fourteenth to his eighteenth year. Parental authority prevailed and by September 1916 he was a teacher at his old elementary school. He was delivered from this false start by the First World War. In February 1917 he joined the army, serving as a private in the 15th London Regiment (Civil Service Rifles). He went to France in the early summer, and in November was gassed in the battle of Cambrai, and invalided home. On his recovery, after a course at Aldershot, he was made a corporal and a bayonet instructor. Two years of war had weakened parental authority, and with the help of his friend Miss Gostick he applied for an ex-serviceman's grant to the Leeds School of Art.

The rigidly academic teaching offered little, but he won a Royal Exhibition to the Royal College of Art. His two years in Leeds were not wasted. Visits to nearby Adel, where there are early examples of Romanesque carving, 'opened up,' he said, 'the whole affair for me'. The interest in early sculpture which this aroused was heightened by coming upon Fry's *Vision and Design*, from which he first learned of Mexican and Negro sculpture, and which led him to other books on ancient art. His outlook was further broadened by access to the collection of Sir Michael Sadler, Vice-Chancellor of the University from 1911 until 1923, which contained paintings by Gauguin and Van Gogh, as well as by many English independent painters.

In the illuminating interview already quoted, Moore gives an account of the struggle which followed his arrival in London:

For the first three months I was in a daze of excitement. One room after another in the British Museum took my enthusiasm. The Royal College of Art meant nothing in comparison . . . everything was wonderful – a new world at every turn . . . after the first excitement it was the art of ancient Mexico that spoke to me most – except perhaps Romanesque. . . And I admit clearly and frankly that early Mexican art formed my views of carving. . .

But my aims as a 'student' were directly at odds with my taste in sculpture. Already, even here a conflict had set in. And for a considerable while after my discovery of the archaic sculpture in the British Museum there was a bitter struggle within me, on the one hand, between the need to follow my course at college in order to get a teacher's diploma and, on the other, the desire to work freely at what appealed most to me in sculpture. At one point I was seriously considering giving up college and working only in the direction that attracted me. But, thank goodness, I somehow came to the realization that academic discipline is valuable. And my need to have a diploma, in order to earn a living, helped.

I now understand the value of an academic grounding: modelling and drawing from life. All sculptors of the great periods of European art could draw from life, just as well as the painters. With me, at one moment, it was just touch and go. But finally I hit on a sort of compromise arrangement: academic work during the semester, and during the holidays a free rein to the interests I had developed in the British Museum. Mixing the two things enabled one to continue drawing from life as I have always done. And it also allowed me to win my travelling scholarship to Italy on academic grounds.

My father, who was appointed Principal of the Royal College of Art the year before Moore's arrival, recognized his outstanding talent, describing him in his memoirs as 'the most intelligent and gifted among the sculptors'. Shortly after the professor of sculpture, Derwent Wood, retired in 1924, my father entrusted Moore with the temporary charge of the Sculpture School, and the following year appointed him assistant to Ernest Cole, the new professor, a post which he held until 1931, teaching regularly for two days a week. Moore told me that he used to enjoy drawing with my father, who in 1931 bought one of his pen and ink drawings – a massive seated woman – which hung in the hall of our house.

It must have been soon after Moore came to London that I became acquainted with him, because I met him before becoming aware that he was a sculptor, at one or more of the Sunday evenings when my parents welcomed students to our house. After such an evening, when Moore had been present, I asked who he was, and my younger sister, who was also a student in the School of Sculpture, answered 'He's going to be a great sculptor.'

In the many years since then Henry Moore seems to me to have changed little. He has the same unassertive assurance, the same kindliness, and the same intense seriousness of purpose half masked

by a benevolent sociability, and the same never-ruffled serenity. In one respect he was different. Only two years before he had been a bayonet instructor threatened by the prospect of having to resume his post as a teacher in an elementary school. The revelation of Mexican, Romanesque and Negro art was very recent: indeed it was in progress; recent, too, was its interpretation in *Vision and Design*. His philosophy of art was actually being forged, and in consequence his convictions were more rigid than they have since become. In those days his insistence upon 'truth to material', upon, for instance, the error of representing flesh which is soft in terms of stone which is hard, seemed to me a little doctrinaire; so, too, his inclination to discount the Hellenic element in European art. But I am writing of the time before 1924, when he won a travelling scholarship that enabled him to visit Paris, Rome, Florence, Venice and Ravenna. So strongly were Classical and Renaissance art identified in his mind with academism and the mechanical copying of plaster casts that, when the scholarship was awarded to him, he at once pleaded to be allowed to use it for Paris instead of Italy, but no such arrangement was possible. 'I had to go to Italy against my will,' he said, 'but thank goodness now I did go.'

The following letter, which he wrote to my father from Florence, dated 12 March, 1924, gives some account of his journey and of his response to the works of art he saw:

> I have until now been moving with the speed of an American tourist – the first week of being out – spent in Paris – has sunk into the very distant past, but the Guimet Museum (the Indian sculptures in the entrance hall, and the room on the ground floor – and the sculptures and paintings from [indecipherable]) stands out like – like cypress trees in an Italian landscape – Paris itself I did not like – and after the Louvre and the Guimet Museum the few exhibitions of contemporary work which I saw seemed almost rubbish.
>
> I've made stops at Genoa, Pisa and Rome, before coming on here to Florence. In Italy the early wall paintings – the work of Giotto, Orcagna, Lorenzetti, Taddeo Gaddi, the paintings leading up and including Massacio's are what have so far interested me most. Of great sculpture I've seen very little – Giotto's painting is the finest sculpture I met in Italy – what I know of Indian, Egyptian and Mexican, sculpture completely overshadows Renaissance sculpture – except for the early Italian portrait busts, the very late work of Michael Angelo and the work of Donatello – though in the influence of Donatello I think I see the beginning of the end – Donatello was a modeller, and it seems to me that it is modelling that has sapped the manhood out of Western sculpture, but the two main reasons are, don't you think, the widespread avoidance of thinking and working in stone – and the wilful throwing away of the Gothic tradition – in favour of a pseudo Greek – I believe that even mediocre students at college or anywhere, had they been lucky enough to have entered a sculptor's workshop, later would

most probably have been doing work which we should now admire –
in Italy of the 14th century, in one small town of 20 or 30 thousand
inhabitants there must have been living and working at the same time
50 or 60 painters each of whom were he doing his same work now
would be accounted a genius! . . . The only hope I can see for a school
of sculpture in England, under our present system, is a good artist
working carving in the big tradition of sculpture, who can get the
sympathy and admiration of students, and propagate good as Dalou
and Lanteri spread harm.

I have been seeing rather than doing until now – and I think I have
seen examples of most of the Italians – Giotto has made the greatest
impression upon me (perhaps partly because he's the most English of
the primitives). My present plans are, the Giottos at Assisi, and at
Padua, then out of Italy via Ravenna and Venice and on to Munich –
from Germany home via Paris so that I can finish up at the Guimet
Museum.

I am beginning to get England into perspective – I think I shall return
a violent patriot. If this scholarship does nothing else for me – it will
have made me realise what treasures we have in England – what a
paradise the British Museum is, and how high in quality, representa-
tive, how choice is our National Collection – and how inspiring is our
English landscape. I do not wonder that the Italians have no landscape
school – I have a great desire – almost an ache for the sight of a tree that
can be called a tree – for a tree with a trunk.

> Yours sincerely,
> *Henry Moore.*

In all his travels, the place which made the deepest and most lasting
impression upon him was the Brancacci Chapel in Santa Maria del
Carmine in Florence. Here Moore came every morning before doing
anything else to study the splendid figures painted on its walls by
Masaccio. Here Michelangelo and Raphael had gone before him, and
Vasari had written that 'all the most celebrated sculptors and painters
since Masaccio's day have become excellent and illustrious by
studying their art in this chapel'. None of the masters' names is so
often on Moore's lips as Masaccio's.

The immediate effect of his Italian journey was not illumination
but tension, which he was scarcely able to bear. 'For about six months
after my return I was never more miserable in my life,' he said. 'Six
months exposure to the masterworks of European art had stirred up
a violent conflict with my previous ideals. I couldn't seem to shake
off the new impressions, or make use of them without denying all I
had devoutly believed in before. I found myself helpless and unable
to work. Then gradually I began to find my way out of my quandary
in the direction of my earlier interests. I came back to ancient Mexican
art in the British Museum. I came across an illustration of the
"Chacmool", discovered at Chichen Itza, in a German publication –
and its curious reclining posture attracted me – not lying on its side,

but on its back with its head twisted around. Still the effects of that trip never really faded.' They did not fade; but neither did they show themselves fully until years later: when they did show themselves, they added an element to Moore's art which made him a great draughtsman.

On his return to London he went back more assiduously than ever to his study of ancient art at the British Museum, especially Mexican art. It was then, too, that he came upon the reproduction of *Chacmool*, the celebrated Toltec-Maya carving in limestone of the reclining figure of the rain spirit, which haunted his imagination. Its effect upon several of his stone carvings – for instance *Reclining Figure* (1929) – is very marked. His untiring research at the British Museum, in Italy, and later on in Greece and Mexico, has made him one of the best educated of sculptors: few scholars – apart from those responsible for the collections – can have so wide a knowledge of the sculpture in the British Museum, and his knowledge of European sculpture since the advent of Rodin is no less extensive. The quality of his knowledge is even more impressive than its extent. Moore, who was in Italy in 1948 at the time of a special exhibition of his work at the Venice Biennale, called on Berenson in Florence. A few days afterwards I took Berenson round the exhibition of Moore's sculpture in the British Pavilion, to which he responded:

> The two most destructive personalities in European art today are Picasso and Moore: Picasso consciously destructive, and Moore unconsciously. How strange that it should be so – about Moore I mean, for I've never had a visitor who showed such knowledge and perception about my sculpture – not a piece of which he had ever seen before.

Moore's search for the basic forms and rhythms of nature took him not only to the British Museum, but also and often to the Museum of Natural History, and he has always delighted in the assiduous study of natural forms, bones, shells, pebbles and the like. (On one recent visit I saw him from a distance bending over, head in the boot of his car, and when I approached I found that he was unpacking a haul of stones worked by the sea, collected on the holiday from which he had just returned.)

The guiding ideas which were forming in his mind during the 1920s and which have remained the basis of his art are lucidly outlined by the artist himself in several deeply pondered articles. I shall therefore quote extensively from Moore's own writings and statements about his art. It is not rare for artists to write well, but it is rare for contemporary artists to write accurately about their own work. But not only is Henry Moore free from the slightest suspicion of aggrandizing himself and the things that he makes, or of inflating

their creation into some very privileged exercise of visionary or even mystical power; and not only does he consistently use words in readily ascertainable senses, so that his meaning is always plain, but he is direct and strong as well as lucid. It is true that once or twice in the past he has picked up nonsense from the ambient air, as when he spoke of 'the literary idea that it (an egg) will become a bird,' but such occasions are rare. The expression of a mind thoroughly genuine and robust, his writing is also full of the most incisive common sense, of which his paper given to UNESCO on 'The Sculptor in Modern Society' is a good example. Being, then, so thoroughly informative, I shall have no scruple in using his own writings freely. I cannot, I think, do better than quote a few key passages from 'The Sculptor's Aims', (from *Unit One* [1934]).

One of Moore's insistent ideas, that of truth to material, I have already mentioned:

> Every material has its own individual qualities. It is only when the sculptor works direct, when there is an active relationship with his material, that the material can take its part in the shaping of an idea. Stone, for example, is hard and concentrated and should not be falsified to look like soft flesh – it should not be forced beyond its constructive build to a point of weakness. It should keep its hard tense stoniness.

Of greater importance, however, for my purpose, is the expression of his ideal of full three-dimensional realization:

> Complete sculptural expression is form in its full spatial reality.
> Only to make relief shapes on the surface of the block is to forgo the full power of expression of sculpture. When the sculptor understands his material, has a knowledge of its possibilities and its constructive build, it is possible to keep within its limitations and yet turn an inert block into a composition which has a full form-existence, with masses of varied size and section conceived in their air-surrounded entirety, stressing and straining, thrusting and opposing each other in spatial relationship – being static, in the sense that the centre of gravity lies within the base (and does not seem to be falling over or moving off its base) – and yet having an alert dynamic tension between its parts.

Closely connected with this ideal is Moore's predilection for asymmetry:

> Sculpture fully in the round has no two points of view alike. The desire for form completely realized is connected with asymmetry. For a symmetrical mass being the same from both sides cannot have more than half the number of different points of view possessed by a non-symmetrical mass.
> Asymmetry is connected also with the desire for the organic (which I have) rather then the geometric.
> Organic forms, though they may be symmetrical in their main disposition, in their reaction to environment, growth and gravity, lose their perfect symmetry.

On Moore's collection and observation of natural objects such as pebbles, I have already commented. He himself wrote:

> The observation of nature is part of an artist's life, it enlarges his form-knowledge, keeps him fresh and from working only by formula, and feeds inspiration.
> The human figure is what interests me most deeply, but I have found principles of form and rhythm from the study of natural objects such as pebbles, rocks, bones, trees, plants, etc.
> Abstract qualities of design are essential to the value of a work, but to me of equal importance is the psychological, human element. If both abstract and human elements are welded together in a work, it must have a fuller, deeper meaning.

Finally there is Moore's life-long aversion to every kind of mannerism, every form of art in which primitive vitality and simplicity, characteristics of an immediate and direct response to life, are 'smothered in trimmings and surface decorations', enfeebled and extinguished by 'technical tricks and intellectual conceits', by academism:

> For me a work must first have vitality of its own. I do not mean a reflection of the vitality of life, of movement, physical action, frisking, dancing figures and so on, but that a work can have in it a pent-up energy, an intense life of its own, independent of the object it may represent. When work has this powerful vitality we do not connect the word beauty with it.
> Beauty, in the later Greek or Renaissance sense, is not the aim in my sculpture.
> Between beauty of expression and power of expression there is a difference of function. The first aims at pleasing the sense, the second has a spiritual vitality which for me is more moving and goes deeper than the senses.

Henry Moore has always drawn. 'Drawing keeps one fit,' he said to Sir Herbert Read, 'like physical exercises – perhaps acts like water to a plant – and it lessens the danger of repeating oneself and getting into a formula. It enlarges one's form repertoire, one's form experience.'

Although he regarded his earlier drawings 'mainly as a help towards making sculpture', they enjoyed a validity in their own right. The earliest known to me, the series representing monumental female figures, generally seated, begun in the mid-1920s and discontinued about ten years later, are drawings of unusual quality. They are broad in form, serenely aloof in spirit and more personal than some of his admirers seem to allow. Sir Herbert Read, for instance, describes them as if made 'before venturing to express himself in a wholly personal idiom', and he is at considerable pains to suggest that 'it would be a mistake to give the impression that the artist began with

a relatively academic style', and points to earlier and contemporary sculpture of a less academic kind.

As drawings avowedly done from life they have, naturally enough, something traditional in their character; but even so they are far more personal than the Mexican, African and Egyptian influenced carvings to which Read refers. I suggest a simple test. Were *Mask* (1924) – one of the works cited – placed with others in a collection of ancient Mexican sculpture, it would take an experienced scholar to pick it out as a modern derivation. Who, on the other hand, who had ever seen one of the early drawings of seated women, could fail to attribute it in any company? Even some of the very earliest, such as *Drawing (from life)* (1928), show, in rudimentary form, one of the most personal and permanent characteristics of Moore's drawing: the two-way section and lines indicating the section across the form and along it. (This characteristic is, so to speak, a diagrammatic analysis of form. In contrast to the rendering and definition of form by light and shade; it is an analysis of form by lines that exactly define the shape as it would be in the round, in a longitudinal and a transverse section. For this sculptural and analytical statement Moore has shown an increasing preference over the illusion of chiaroscuro. The most obvious target for criticism offered by the drawing I have cited is not its traditional character, but the intrusion of the borrowed double-focus head. The fact is that Moore, for all his great and manifold natural talents, and for all his formidable industry, grew slowly to full maturity, and much of his early work is closely derived from his favoured models, and some of it marked by a modish chic. But what could be less surprising? Moore did not attain his deep insights and wide knowledge of sculpture by note-taking, by the way of a scholar, but by the way of a sculptor actually working in wood, metal and stone. If his growth to maturity as a sculptor was slow, as a draughtsman it was slower still.

Moore draws from a variety of intentions. As already noted, he draws as an aid to sculpture, either 'as a means of generating ideas', or of 'tapping oneself for the initial idea; and as a way of sorting out ideas and developing them'. Sculpture is too laborious a process to allow for the realization of more than a small fraction of the prodigious ideas which form in his mind; drawing is quick and easy and he finds it a pleasurable way of relieving the imaginative pressure. Sometimes he draws simply because he enjoys it, but before long the lines he makes provide the nexus of an idea. And finally he draws as a means of study and observation of natural forms. Drawing of this kind is an essential element in his art, because, as he told Sir Herbert Read, 'in my sculpture I do not draw directly upon the memory or observations of a particular object, but rather use whatever comes up

from my general fund of knowledge'. The creation of this fund of knowledge is so vital that, 'every few months I stop carving for two or three weeks and do life drawing'.

In the late 1930s he became aware of an error in his method of making drawings for sculpture:

> I tried to give them as much the illusion of real sculpture as I could – that is, I drew by the method of illusion, of light falling on a solid object. But I now find that carrying it so far that it becomes a substitute for sculpture either weakens the desire to do the sculpture, or is likely to make the sculpture only a dead realization of the drawing.

He therefore more often drew in line and flat tone, but the vision behind the drawing was still a three-dimensional vision. The sculptor's meaning is clear when we compare sharply modelled drawings, all entitled *Ideas for Sculpture* (1938) with two drawings of the same year in which solidity is subtly suggested, *Ideas for metal sculpture*, and *Drawing for Sculpture*.

During the 1920s and 1930s he made drawings of many kinds, some of them of marked originality, and very few that do not afford some intimation of a mind of singular and increasing power. But war brought with it, in an improbable fashion, a transforming experience. Until the time of Dunkirk, Moore, living in Kent, continued to work much as usual, but with invasion threatening he wished to help directly and returning to London he applied at the Chelsea Polytechnic for training in the making of precision tools. But the classes in this subject were few and the applicants many. Reluctant to begin sculpture that he might be prevented from completing, he spent his time drawing. Months went by without a word from the Chelsea Polytechnic, and he went on drawing. I quote yet again from his interview with Mr Sweeney:

> Then the air-raids began and the war from being an awful worry became a real experience. Quite against what I expected I found myself strangely excited by the bombed buildings, but more still by the unbelievable scenes and life of the underground shelters. I began filling a notebook with drawings – ideas based on London's shelter life. Naturally I could not draw in the shelter itself. I drew from memory on my return home. But the scenes of the shelter world, static figures (asleep) – 'reclining figures' – remained vivid in my mind, I felt somehow drawn to it all. Here was something I couldn't help doing.

The effect of his experience in the shelters was to bring a humanity into Moore's art, above all into his drawing, that it had lacked. I have given above, in summary form, some account of the ideas which underlie his art, and in so doing I have used, so far as I could, his own formulations of them. But nearly everything he said or wrote about it was concerned with three-dimensional realization, spacial

completeness and the like. And not unnaturally, for most artists delight in discussing the means, but about the ends which these are intended to serve they are apt to be silent, lest discussion should lessen their drive to attain them. Moore has never been an abstract artist, and has rarely confused ends and means. He is a man deeply conscious of human values:

> It might seem from what I have said of shape and form that I regard them as ends in themselves. Far from it. I am very much aware that associational, psychological factors play a large part in sculpture. . . . I think the humanist element will always be for me of fundamental importance in sculpture, giving sculpture its vitality.

The nights among the 'unbelievable scenes' of the shelter world and the days in the shelters observing the empty spaces in which the nights' dramas were enacted stirred his humanism to a new and grander consciousness. The European tradition provides a natural language for the expression of humanistic values. Its appropriateness for the expression of the emotions stirred in him by the shelter world became suddenly apparent to Moore. Memories of his Italian journey leaped into life. The frescoes in the Carmine had a new relevance for his art, as he told Mr Sweeney:

> It was not until the Blitz in London that I began to realize how deep-rooted the Italian influence had been. . . . Here, curiously enough, is where, in looking back, my Italian trip and the Mediterranean tradition came once more to the surface. There was no discarding of those other interests in archaic art and the art of primitive peoples, but rather a clearer tension between this approach and the humanist emphasis.

It is precisely this tension between those elements in him which respond to the art of primitive peoples and those which respond to the painting of Masaccio which enhanced all his qualities both as sculptor and draughtsman. In the shelter drawings he created a world peopled by figures at once monumental and ghostly. The colours that faintly illuminate this noble yet nightmare world are charged as deeply as the forms with the artist's intense emotion, and they both explain and enhance them. In all he filled two sketchbooks and made about a hundred large drawings: standing, seated or reclining figures hieratic and immobile yet subtly expressive of Moore's humanity, encompassed by vast shadowy spaces brought vibrantly to life by the depths and brilliances of his colour. If there exist any works by Moore more impressive than the *Shelter Drawings* they are the sketchbooks in which he set down his recollections of the figures and their settings which he observed on his nightly visits underground, and the original ideas for the finished drawings. These two small books – reservoirs of concentrated imaginative power – have to my thinking

a place among Moore's most moving works. Modern works which say more in so small a compass do not come easily to mind: they are worthy of the words which Moore himself applied to massive carvings, the Sumerian sculptures in the British Museum, as being of 'a contained bull-like grandeur and held-in energy'.

It would be useful, I think, to write a few words about how these drawings are made, for the method used – now widely imitated – was an innovation of Moore's.

Not long before the Second World War, when Moore was living at his cottage near Dover, a niece called and asked him to make a drawing for her; considerately she brought her own materials – a few cheap crayons from Woolworth's and some watercolours. The materials were inadequate, but her uncle set to work. Among them was a white wax crayon, and it was when doing this kindly act that he discovered the method, which since that time he has constantly used, of putting in the main masses in white wax. This has several advantages. Because the watercolour recedes from the white wax, backgrounds can be put in almost instantaneously in broad, rapid strokes, and the white wax may then be worked over with pen and ink and watercolour applied in small strokes; in case of failure the ink and watercolour applied to it may be readily washed off. The method is productive of accidental effects of colour and texture and it is this that has made it so popular. In Moore's hands the effects are in fact so dexterously controlled that the term 'accident' is inappropriate: he creates the conditions in which the happy accident is liable to occur, and promptly avails himself of it when it does. Moore's later watercolours so abound in exquisiteness, gaiety, and delicate evocations of space and atmospheres that it sometimes happens that his constant and primary concern with powerful monumental form is overlooked. It is the use of white wax which enables him, by putting in the principal forms at the beginning, to model and refine them. The method, in fact, is directly analogous to his method as a carver. In neither is the process one of building up; in both it is a seeking to discover in the original mass of material – be it block of stone or wood or area of wax – the forms of his imagining in the fullness of their energy and strength.

One melancholy fact about modern painters, and about English painters perhaps in a special degree, is a liability to progressive loss of creative power. In some cases a brilliant studentship is followed by a steady decline into frigidity, an unreflective conformity, disintegration or vulgarity. Millais, for example, was one of the supremely gifted painters of a century wonderfully rich in genius, as a young painter a dedicated being, yet of many of the productions of his later years it could be said without injustice that they would shed no lustre

upon a painter of the meanest talents and the most trivial vision. About few categories of men is it so difficult to generalize as it is about painters, who are among the most highly individual of mankind, but there is one which I would hazard: that capacity for constant growth is among the surest indications of major creative power. It was most conspicuous in Turner, the greatest visual genius to be born of the English-speaking peoples, less conspicuous – for all the splendour and grace of his total achievement – in Gainsborough, while a lesser master, in his way incomparable, Samuel Palmer, this capacity simply did not exist. Among the greatest masters it is easy to recall at random those whose growth ended only with their lives, Michelangelo, Leonardo, Titian, Rembrandt. Among the reasons for confidence in Moore as a major talent is that he shows a capacity for continuing growth. Indeed, the very illustriousness of the position which he has now attained militates against full recognition of his increasing stature; it fosters instead an indiscriminate reverence for everything he has made. It is not my intention to criticize, when it does not seem to me necessary, or to disparage collectors' possessions. If those, however, who had the perception and the foresight to acquire Moore's work in the 1920s were to compare examples of it with examples of the Mexican and other ancient sculpture which he assiduously studied and which he has always been ready to admit to be the very foundation of his art, it would be plain that many of them were little more than exercises – powerful and perceptive, but exercises none the less – in various early styles. Then, if forgetful of who made them, they were to compare them with the later sculptures in stone, wood and metal, with the reclining figures and the family groups of the later 1930s and 1940s, and with the shelter drawings and those which followed, I believe that they could hardly fail to recognize that a great talent, after years of unending stubborn research, had emerged and grown to become fully itself.

I have taken the *Shelter Drawings* as a point of departure. In fact for a year or so before the war Moore's drawing had assumed a breadth and vivacity which had only rarely marked it previously. What an advance upon *Ideas for Sculpture* (1938) – small in form, tight and directly imitative of sculpture in treatment and lacking in sense of space – is represented by such drawings as *Two Women*, *Figures in a Setting*, *Standing Figures*, *Two Seated Women*, *Two Seated Figures* and another *Two Seated Women*, all made during the ensuing two years, which possess all that the others conspicuously lack. But beautiful as many of them are, these immediate predecessors of the *Shelter Drawings* are surpassed by their successors.

Moore's advance, however, was not resumed immediately after the completion of the *Shelter Drawings*. These number about one hundred

in all. From the middle of 1940 until late in the following year these drawings absorbed all of his interest and he did nothing else. But at that time the air raids became infrequent and the shelters empty. The War Artists' Advisory Committee, which commissioned a number of the *Shelter Drawings*, asked him to make a series of coal-miners at work, which took him to his native Castleford where he spent two or three weeks down the mine. Although he had lived the first twenty years of his life in Castleford and came from a family of miners, he had never before been down a coal-mine, and although he welcomed the experience the results did not satisfy him:

> It made clear many things about my own childhood (for my father was a coal miner) and made me know more about miners, but I didn't find it as fruitful a subject as the shelters. The shelter drawings came about after first being moved by the experience of them, whereas the coal-mine drawings were more like a commission.

Judged by the standard set by the *Shelter Drawings*, the coal-miners fall short in dramatic power, having neither the nobility of form, spacial relation, nor the strangely singing colour. The one scene represented a unique many-sided drama, the other a routine occupation pursued in a narrow space. But the mining theme, prosaic as it must have seemed to an imagination attuned to the courage and the tenderness, the terror and the deathlike exhaustion of the shelters and their eerie vastness, did evoke a few drawings, such as *At the Coal Face* (1942), which must be placed only just below his best. The energetic tautness of the miners' figures as they hacked at the coal face first taught Moore how to incorporate the male figure into his family of forms, in which it had hitherto played a negligible part. He had never willingly drawn male figures before, having believed in the validity of static forms, forms in repose. In the coal-mine he discovered the possibilities of the figure in action. His few works at the coal face beneath his native town thus made an essential contribution towards, among others, his most splendid bronzes: *Family Group* (1945–49) and *King and Queen* (1953–54).

Before long, however, he entered upon the most richly creative years of his life. To attempt to assess his sculpture is outside the scope of this study, but he has made many drawings which surpass even the shelterers, particularly in respect of one of his most obsessive ambitions: to make space. I quote his words to me:

> Spaces between forms, holes in things, are always an obsession with me. Space is an element as important as what is solid and material. Turner in his old age made space in its way as positive as a tree trunk, even Matisse, whose painting looks flat, made space in which things can be exactly placed.

In the finest of the later drawings, the monumentality of the *Shelter Drawings* is sustained and sometimes even enhanced, the colour is more aerial, but the space has opened out and the relations between the forms have grown more complex. These qualities are exemplified in such drawings as *Group of Figures in a Setting* (1942), *Group of draped Standing Figures, Crowd looking at a tied-up object* (both 1942), *Girl reading to Woman and Child* (1946), in which the crowd and the tied-up object are seen through the window of a domestic interior; *Seated Figure* (1946) and *Family Group* (1948).

The year 1946 marked for Moore a further step towards a still fuller humanism: his daughter Mary was born and the effects of this event are immediately reflected in both his choice of subjects and his treatment of them. Domestic scenes, such as *Two Women Bathing a Baby*, drawn shortly after Mary's birth, become common, as well as mothers and children, family groups and the like. These subjects are suffused with a gentle lyricism rarely manifest in his earlier work. Moore is able to add new qualities without sacrificing the old. Just as he was able to assimilate the humanism of the Mediterranean to his form-system in the *Shelter Drawings* without discarding anything he had learnt from ancient sculpture, so in these drawings he is able to imbue his subjects with a lyrical tenderness without loss either of monumentality or of relation to the elemental forces of nature. All these elements are radiantly present in *Girl reading to Woman and Child*: surely one of the finest of Moore's works in any medium.

Speaking of the relation between sculpture and drawing, Moore told me that he considered that

> Sculpture, involving a life-long struggle to grasp reality in terms of three dimensions, is the most intellectually and imaginatively exacting pursuit I can conceive of. It's an endless pursuit, even Michelangelo, the greatest of the great, pressed on with it until the end of his life.
> But drawing enables a sculptor to get atmosphere round his figures – to give them an environment, above all a foreground.

I recall an occasion when I had just hung the six drawings presented to the Tate by the War Artists, Advisory Committee in 1946, and took Moore – a Trustee from 1941 until 1956 – round the room. He might not have seen them for years, with such detached interest did he study them, picking out those he liked and giving his reasons.

Sculpture remains his primary preoccupation but he continues to make drawings in various media, including lithography and etching. Indeed, in recent years he has made more drawings than ever before, during the 1980s several hundred, a number in watercolour. Of the earlier drawings, many were expressive of ideas for sculpture. I remember his saying that he needed to get them down on paper

before the slow process of carrying them out in stone or wood could even be thought of.

In the illuminating 1983 exhibition at the Tate – 'Henry Moore at 85: Some Recent Sculptures and Drawings' – were a number of highly impressive 'realistic' works: *Tree Trunk* (1981), charcoal, black chinagraph and white chalk; *Tree Trunks* (1982), black chinagraph and gouache; *Root and Briar* (1983), charcoal, pastel, watercolour and black Biro; *Bare Branches: Trees in Winter* (1983), black Biro, watercolour, black and brown chinagraph, charcoal. Notable, and still more surprising were his Turneresque works, such as *Clouds in Sky* (1982), in charcoal, washed pastel and watercolour. Moore's skies are perhaps an unconscious tribute to Turner, the artist to whom he feels temperamentally closest.

It is too early to try to judge what place Moore will occupy when distorting fashion and current controversy have passed away, but I believe that his creation of a three-dimensional reality in which a remote grandeur is tempered by a large-hearted humanity and encompassed in an atmosphere which intensifies its meaning will not quickly be forgotten.

CHRISTOPHER WOOD
1901 – 1930

There was nothing in the early boyhood of John Christopher Wood to suggest that he was in any way unusual. He was born on 7 April, 1901 in Knowsley, Lancashire, the son of Dr Lucius Wood, a doctor on the Earl of Derby's Knowsley estate, and his wife Clara, born Arthur, a member of a respected Cornish family, which for several generations had served the Church of England or the navy. He attended Freshfield preparatory school, where his chief interests were cricket and golf, as they were during most of his single term at Marlborough School. At the age of fourteen he suffered an attack of polio which rendered him physically helpless for some three and a half years and left him with a slight limp and recurrent pain in the affected leg. His mother nursed him throughout his illness: the relations between them, already close, became closer still. He remained uniquely devoted to her, and after leaving home he wrote to her constantly. 'You are the only person I care about,' runs a sentence in one of his letters, and expressions of the same sentiment frequently recur.

At the age of eighteen Wood went to Malvern College, where he was allowed to work in special conditions, lying, for instance, on a couch instead of sitting at a desk. No longer able to play cricket or golf he played the flute and sketched. It seems that he had always liked to draw: his mother preserved some of his first drawings, made when he was three – which are no better than those of the average child – and she recalled that three years later he wrote a letter to Father Christmas asking for a box of paints.

Dr Wood wished his son to follow him into the medical profession, but the idea of constant contact with pain repelled him and he refused. Instead he briefly studied architecture under Professor Reilly at Liverpool University, where, according to the testimony of a fellow student, they used to make drawings of the Liverpool docks. Whether his interest in architecture flagged or for some other reason difficult to ascertain, Wood went to London in 1920 and was apprenticed to a dried fruit merchant, whose speciality was the import of prunes and figs.

Two encounters in London stimulated his growing interest in painting and drawing. Augustus John saw him sketching at the Café

Royal: they met and John praised what he was doing – and remained his lifelong admirer. The other encounter, with the celebrated Alphonse Kahn, was more decisive in its effects. In the second of his many hundred letters to his mother that survive he wrote from Paris on 19 March, 1921 (the letters from which quotations are taken are those written to the artist's mother unless otherwise indicated):

> Alphonse, with whom I am staying . . . said whenever I was free, to come and so I came. . . We spent the evening looking at his paintings. . . Tomorrow we go to the Louvre, which by degrees he is going to show me, he being one of the greatest (if not the best known) connoisseurs of art in Paris. . . He is going to introduce me to all the artists of note here, so I am absolutely in the heights of heaven. I honestly believe I was born under a lucky star.

In this belief he was justified, for in an incredibly short space of time this entirely untaught, strictly conventional young man, recently the apprentice of a dried fruit importer, was to enjoy a position in the Paris art world, then beyond question predominant, approached by no English artist of his generation and by very few others.

It was only two years later that he won the friendship and regard of Picasso, besides many others among the leading painters, writers and musicians of the day, and was considered widely the most talented British painter alive. His social success was more spectacular still. 'I had royalty for tea yesterday, His Highness the Infant of Spain came up,' he wrote in October of the same year. 'He's a good fellow and I have met him at dinners before.' The letters show that he was sought after by a number of the most prominent hostesses of Paris.

When he arrived in Paris he had not painted a single picture – he was given his first paintbox the autumn after his arrival – and he was without innate sophistication. For instance, he described Augustus John (in December 1922) as 'very refined and a gentleman to his fingertips'.

How was it that this young man, without achievement to his credit and, although a member of a most respectable family, lacking both background and connections, was so quickly qualified for the position he won? The answer is that he was given, by circumstances, unique opportunities and that he was enabled, by certain innate character-istics, to take advantage of them. His second opportunity arose, after an autumn visit to Italy, with a meeting with Antonio Gandarillas, a Chilean diplomat with houses in Chelsea and Paris, a man of unusual charm and cultivation with a wide, international circle of friends and a zest for travel. The two men became intimates at once. Wood often stayed with him in Paris and London, and accompanied him on his constant travels. The extent of Wood's travels in Europe was probably greater than those of all the other painters who figure in this book.

Christopher Wood had rare and extraordinary charm and a capacity for friendship with men and women in equal measure. Despite his awareness of the extent to which his career as an artist would be helped by influential social connections, there was little or perhaps nothing of the courtier about him. His manner was direct but gentle, he had the advantage of conspicuous good looks, and his disposition was simple and affectionate. Given the good fortune of meeting Alphonse Kahn, he had the sense to listen to his encouragement to be a painter. So attentively, in fact, that he telegraphed Kahn as soon as he was free to accept his invitation and was with him in Paris immediately after receiving his affirmative reply. He had the further good fortune to meet Gandarillas, to whom few doors were not open. It would be wrong to suppose that without these Wood would not have made many friends useful for his career and enhancing of his life: the contrary is the case. But the protégé of Kahn and the intimate of Gandarillas had a ready-made position which his qualities of heart and mind, expressed with his boyish and all but irresistible charm, enabled him to justify and quickly enhance. He became not only a much sought after social figure, but, what is mysterious, a notable figure in the art world as well. Where allusion was made to his qualities of *mind*, it was not to suggest that he was an intellectual; this he never was. The most notable feature of his intellect was zestful curiosity: the people he knew, the places he visited, literature, music, to a lesser degree politics, and, of course, painting evoked a passionate response in him. It was as though he were aware, quite early in life, that he was to die young and that no moment must be wasted, even though there is no reason to suppose that he had any such premonition. His letters to his mother are full of vivid evocations of people and places, constantly telling her of the progress he is making and of the praise he receives. For instance in one of 29 November, 1926: 'There are one or two modern French people, two painters among them, who think I am already a far better painter than anyone in England except John, who doesn't come into it at all and who is too old fashioned now.' Nevertheless Wood was a modest, even humble, man. 'My life,' he wrote to her on 2 May, 1926, 'is almost too interesting, surrounded by people so very superior to myself in intelligence that I feel as if I were in the centre of a whirlpool.'

Once he had decided to be an artist he worked extremely hard and systematically, studying at Julian's, later at the Grande Chaumière, concentrating first upon drawing. In the summer of 1921 he wrote,

> I know I am improving in my drawing because I am getting it right with infinitely less trouble . . . than I did when I first started. I am not troubling at all with the painting yet awhile as I am so determined to

try to and be a master over the drawing part of it before I do anything else.

But by the 20 April of the next year:

Now that I have learnt to use my Oil Paints and do just what I want with them, my painting, I think, has taken a big jump in the right direction and it pleases me greatly to see the results I am getting.

Christopher Wood's intense responsiveness to everything he experienced in some respects enhanced and in others frustrated his evolution of an individual way of looking at the world and setting down what he saw and felt. This power of response, when he was able to focus it directly upon his favourite subjects – flowers, landscapes (ports and coasts in particular) and figures – enabled him to see them with an eye both lyrical and penetrating. The weakness of so many of his paintings was due to his frequent inability to see his subject except through other artists' eyes. In the almost comprehensive exhibition of his work arranged in 1938 by the Redfern Gallery at the larger, now defunct, New Burlington Galleries in Burlington Gardens, it was easy to pick out works which closely resembled those by the artists whom he had currently admired – so closely that a number of them would not have appeared incongruous in exhibitions of their work: a Segonzac, a Dufy, a Van Gogh, a Utrillo, a Braque, a Vlaminck and a John. It was easy, too, to find others in which the characteristics of more than one other artist were conspicuous – a street scene of 1925 which might be the fruit of the collaboration, in a bad moment, of Vlaminck, Rousseau and Utrillo, or of Rousseau and Modigliani. The influence of Marie Laurencin was also to be detected, likewise that of his friend Jean Hugo. And in his work, as in that of painters all over Europe and the United States, that of Picasso. 'Madame Errazuriz has invited me to dinner tomorrow with the Picassos which I shall enjoy,' he wrote on 6 July, 1923; 'Picasso is the greatest painter of the day and I admire his work immensely, more, I think, than anyone else's, the more I learn the more I see in it.'

Wood was very conscious of the temptation to follow the example of other painters and was determined to overcome it. 'My greatest difficulty in my work with this almost suffocating influence of modern art, he wrote on 22 February, 1924, 'is to be very true and just', that is to say, quite simply, to be himself.

It was not surprising that this young and unsophisticated beginner should imitate artists who were the most illustrious in Europe. What was surprising was that a man with such a potentially personal way of viewing the world should have remained an imitator for so long. Various critics spoke and wrote about his capacity to assimilate what

he took from other artists; Eric Newton, for instance, in the informative essay published in connection with the Redfern Gallery's exhibition, argued that 'his habit of borrowing another man's vision was less remarkable than his power to outgrow that vision', and he described how an experimental essay in another man's style was followed by a series in which it had become absorbed in his own. My own impression of the exhibition was of the extent to which, over so large a part of his brief career, Wood did in fact remain an imitator. Nor was it easy to discern any evolution at all – only an ultimate, short-lived, tragic flowering.

Much of Wood's work, even the most derivative, does reveal one highly personal quality: a basic simplicity of outlook. A number of those who spoke and wrote about his painting, aware of the extreme sophistication of the society in which he moved, were inclined to treat this simplicity as something deliberately assumed, as artifice masking its opposite. 'Fashionable clumsiness' was the expression applied to it, for instance, by one sensible critic, Gwen Raverat, in *Time and Tide*, 11 April, 1936. It must not be forgotten that in recoiling from the elegance and finish of academic art the products of many 'progressive' movements, most particularly perhaps those of the German Expressionists and the Fauves, were marked by a conscious roughness, a 'clumsiness', a quality that owed much to the growing admiration for primitive art. 'Fashionable clumsiness' was, so to speak, very much in the air, and Wood, ever susceptible to his environment, was not untouched by it. But to dismiss its presence in his work as mere conformity to a pervasive tendency is, in my belief, to do him an injustice and to overlook the fact that the vein of simplicity in his art is a direct reflection of something basic in his character. To this his intimate letters to his mother amply testify, and no less the evidence of his friends. He did indeed move in one of the most sophisticated circles in Europe, and at times he derived much pleasure from doing so, but it is arguable that the revulsion that he constantly experienced against it made him value simplicity. 'I have no friends I want to see' and even 'I hate my friends' are sentiments that often recur in his letters. In one of them (21 May 1923), succinctly expressing his 'love-hate' feeling for the social life he led, he wrote:

> I hate staying with people. I always prefer my liberty and I am afraid of becoming very unsociable . . . I never go out. I think I shall go to the ball given by the Count de Beaumont.

Wood was in fact an exceptionally devoted and loyal friend and although there were times when he withdrew from social life he never became habitually unsociable. But the intensity of his periods of sociability, the insight they afforded into the corrupting effects of

dissipation and idleness, as well as corruption of a still more positive kind, increasingly fostered in him the desire for simplicity of both being and environment. And, as was inevitable with a man so quintessentially an artist, this desire was reflected in his art. Some sentences in a letter of 28 July, 1922 show how early he was preoccupied with the concept of simplicity:

> Do you know that all the great modern painters . . . are not trying to see things and paint them through the eyes of experience of a man of forty or fifty or whatever they may be, but through the eyes of the smallest child who sees nothing except those things which would strike him as the most important? To the childish drawing they add the beauty and refinement of their own experience. This is the one explanation of modern painting.

In the letter in which he tells his mother of his impending dinner with the Picassos he wrote, 'I am reducing my colours in everything I do now to very few in the same pictures . . . I am making everything simpler and simpler.'

Another indication of his response to simplicity was his attitude to Alfred Wallis, the primitive painter of sailing ships and imaginary Cornish landscapes. Wallis, born in 1855, went to sea at the age of nine and in 1890 he opened a marine rag-and-bone shop in St Ives; to relieve his loneliness after his wife's death he began to paint at the age of seventy. Three years later Wood and Ben Nicholson discovered his work. There was an amusing contrast between the impressions that Wood and Wallis made upon each other. Wood wrote to a friend:

> I am more and more influenced by Alfred Wallis – not a bad master though: he and Picasso both mix their colours on box-lids! I see him each day for a second – he is bright and cheery. I'm not surprised that nobody likes Wallis's paintings; no one liked Van Gogh's for a long time, did they?

But when somebody sent Wallis some of Wood's paintings he returned them with paintings on their backs; he had seen in them nothing more than good surfaces to paint on. In one of Wood's later paintings, *Seascape, Brittany* (1929), there is a boat on the shore that might have been painted by Wallis himself, so totally are the lines of perspective ignored.

Wood's basic simplicity was recognized by Cocteau, who, perhaps, was the more clearly aware of it since it was a quality he entirely lacked. In his own introduction, *Les Toils ou l'Etoile de Christopher Wood*, to his first London exhibition, held in 1927 at the now defunct Beaux-Arts Gallery, he wrote:

> In Christopher Wood there is no malice, there is something straight-forward and naive, the freshness of a puppy who has not yet had distemper (or the disease of the period). . . This unaccustomed straight-

forwardness gives the love of life and the wish to know well this young painter whose eyes . . . reflect nothing false.

(The 'harlequins' sweater' is the one he wears in the *Self-Portrait* painted that year and included in the exhibition.)

This evidence – and there is much more – miscellaneous although it is, is sufficient to suggest that the notion that the simplicity in Wood's pictures is 'fashionable clumsiness', affected naivety masking sophistication, is quite simply nonsense, even though his indiscriminate adoption of others' styles makes it on occasion difficult to perceive until he was nearing the end of his career.

I have emphasized the derivative element in Wood's painting, but from time to time something characteristic of himself emerged – it is discernible, for instance, in the watercolour, *The House of Raphael, Rome* (1925). This something was evidently not only discernible to his friends and acquaintances in Paris, but was even impressive. Evidence of Cocteau's admiration has already been cited. Picasso also admired him and in a letter of 2 February, 1926 he tells of Picasso's first visit to his studio. After describing an enjoyable luncheon with his friend Madame Errazuriz he continues:

> After, we went with her to look at a new house which Picasso thinks of buying, enormous where he will have a huge studio. After Picasso asked her what she was going to do she said she was going to my studio; it would have looked so silly not to have asked P. also who was charming and came. It was a terrible moment for me as it is what I have dreaded for a long time, but it had to happen before I could make any headway here. He never as a rule says whether he likes the things or not, and I was very nervous, naturally. But he seemed to, very much, and Tony [Gandarillas] and Madame E were surprised at how much he said. It was much better to take him by accident like that without any preparation for him, and looked better too. I feel as if a terrible weight had been lifted off my shoulder. Curiously enough it has given me enormous confidence, the fact of his having seen them, and I feel better disposed towards the future. . .
>
> Picasso is charming to me and said he couldn't understand why Diaghilev had not taken my ballet, that it couldn't have been better or more beautiful. He loves it and simply couldn't make out why it had been refused.

The ballet reference was to some designs he had been encouraged to make by Diaghilev but which, in spite of Picasso's advocacy, were eventually declined. Five years later his ambition to design for the theatre was gratified by C. B. Cochran's commission of scenery and dresses for *Luna Park*, or *The Freaks*, in his *1930 Revue*. It was Wood's usual practice to paint direct without first making a drawing on the canvas, but he varied this habit for the Cochran ballet, making finished preparatory drawings.

Easel painting and watercolour, however, remained Wood's most intense preoccupations. In spite of the constant distractions of his social life, he often worked until two or even three in the morning, and was always up by half-past eight. No one of his generation ever wasted less time: when he was not painting he was looking at paintings and sculptures (for instance he made many drawings of Greek sculpture in the British Museum) and studied Leonardo in particular. He read constantly. 'Reading fine works,' as he rather quaintly put it, 'keeps one's morals and intellect up to a certain high standard.' He translated a poem by Michelangelo, for the benefit of his mother, which he included in a letter of 8 May, 1924. 'If I want advice I look in Bacon's Essays', and he quoted from Voltaire. But he was very conscious of his shortcomings as a reader, partly as a result of exhaustion after a long day's work. He wrote that 'the difficulty to be a well-read person when I read with such difficulty and forget it the minute after is exasperating. I have to write everything down before I can remember.' He often went to concerts: Brahms and Wagner were his favourite composers. The company of the intelligent gave him particular pleasure. 'I have a painter friend called Wyndham Lewis who is one of the cleverest men alive, he is also an author.' Of his various intellectual friends the one whom he admired the most was Cocteau: 'He is not only the greatest poet alive,'

> but I suppose the greatest genius. He is a wonderful craftsman also. He is looked on as the greatest conversationalist in France and everything he does is a chef d'oeuvre. . . He and Picasso, the painter, are great friends and admire each other intellectually and they are the two outstanding genii of this period, perhaps the only two . . .
>
> Jean Cocteau has drawn a beautiful profile of my head. . . It is really beautiful and too classic for my puffy face. Of course Jean like Picasso has the last word in good taste, and the two together have created the modern art of this century. Picasso has created the colour and the drawing and Cocteau the modern literature and philosophy, and the modern school of music although he is not a musician. . . He is a god.

This ardent but indiscriminate praise of Cocteau gives an intimation of the simplicity of Wood's heart.

Although it is not easy to discern anything approaching consistent progress in the work of his first six years, he was accorded ever-increasing recognition in both Paris and London. He held a second exhibition, of drawings only, at the Claridge Gallery in 1928; a third the following year at Arthur Tooth's gallery and a fourth, with Ben Nicholson, at the Galerie Georges Bernheim in 1930. This recognition brought him both delight and apprehension. 'It is a very drastic moment now at the beginning of my career,' he wrote in 1926,

> . . . and I must think of nothing but my work, as the more I see of

English people the more I am given to understand that I am the only young English painter who is expected to carry on. I pray to God I may be able to carry on this terrible responsibility.

Poor Kit Wood! 'The beginning of my career', when he had only fifty months to live. But there is a sense in which he was only approaching the beginning of his career, and the end of his apprenticeship. For him, it may be said, his end was his beginning. It was about three years later that his passionate apprenticeship – an apprenticeship not only of the eye and the hand, but of the intellect and the ear – began to earn its reward in such paintings as *Evening, Brittany, Lighthouse, entrance to Tréboul Harbour, La Tremouille Church, Tréboul,* and *Boat in Harbour, Brittany,* all painted in 1929.

But it was only in the last remaining months of his short life that his work culminated in an extraordinary blossoming – extraordinary not only in the lyrical intensity of his paintings and drawings but in their number, for during those six months he made at least a hundred.

It was the coasts of Celtic France and England, Brittany and Cornwall, that seemed to ignite his ultimate creative blaze. In a letter written in August 1929 from Douarnenez – the little Breton fishing port which, with nearby Tréboul, provided themes which evoked a poetry quintessentially his own, lyrical, gay, yet sometimes with an undertone of menace – there occurs a sentence which helps us to understand how he looked at his chosen subjects.

> I have a little sailing boat which I adore, I sit in it and glide along looking quietly at all the things I love the most, I see the lovely fishing boats with their huge brown sails against the dark green fir trees and little white house, instead of always against the sea and an insipid sky.

Wood was happy in Brittany. In *Christopher Wood, A Souvenir* (1959) by Eric Newton, his friend Max Jacob wrote that he used to say: 'The Bretons make one believe in Paradise' – and these words give an indication of how happy he was during the summer of 1929. According to this touching tribute the Bretons were no less fond of him. 'I can remember,' continues Jacob, 'the humble and pious Breton women who used to wait on us at the Pension Cariou drying their tears on their aprons at the news of his death.'

That summer, in his landscapes, Wood gave clear intimations of the highly individual poetic quality that was to emerge with such splendour the following year. Regrettably, his portrait of Jacob, with its head of exaggerated size and its small collapsed boneless body, reflects the mannerisms of several East European artists in Paris.

The following June he was back in Brittany, staying at the Hotel Ty-Med until towards the end of July. Here, and during a brief visit to St Ives, Cornwall, the previous March, the extraordinary and

tragically brief blossoming of his art occurred. Among all his earlier works – with the exception of some of those made in Brittany the previous summer – the derivative far outnumbered the original, but with those done during his last two or three months the opposite is the case: almost everything he painted is the emanation of a very rare spirit. One could name such works almost at random: *P.Z. 134 Cornwall* and *The Yellow Horse; La Ville Close, Concarneau, Decorating the Sanctuary, Tréboul, The Yellow Man, Nude Boy in a Bedroom, Mending the Nets, Tréboul, Breton Woman at Prayer, Douarnenez* and *The Church at Tréboul*, and his two last paintings *Zebra and Parachute* and *Tiger and the Arc de Triomphe*. All these and a number of others are pervaded by the gentle radiance of colour, expressing happiness as in *Nude Boy in a Bedroom*, or an undertone of menace as in *The Yellow Man*, occasionally expressing surrealist fantasy, as *Zebra and Parachute* and *Tiger and the Arc de Triomphe*. Although it is the colour in these paintings which most strongly affects the spectator, they are composed lucidly and logically.

Wood's power of sustained hard work, always conspicuous, attained an extraordinary pitch in the last months of his life: he scarcely slept; he allowed the meals placed on a tray beside his easel to grow cold, and such was his passion of creativity that in at least two instances, running out of canvas, he painted over a completed painting. One of these is *Zebra and Parachute*. Fantastic as it seems, it was in fact painted in front of the motif, a Corbusier house in the outskirts of Paris. Leaving Tréboul for the last time on his way to England he arrived in Paris on a Sunday, and, unable to buy a canvas, he sacrificed a Tréboul landscape that he had brought with him, intending it for the exhibition of his work at the Wertheim Gallery in London. *Tiger and the Arc de Triomphe* was painted – also over another picture – on the same last passage through Paris, the tiger and leopard at the Zoo and the Arc on the site. Many of the works produced in this ultimate lyrical outpouring were painted in ripolin and, like their forerunners, were carried out with ease rather than at high speed, although he liked to finish a picture on the same day as he began it.

Wood makes references to his confidence and progress throughout his correspondence with his mother. This he does in his last letter from Tréboul (dated 11 July), but there follows a sentence which suggests an awareness of the unique character of the series of paintings he had just completed.

> I have almost worked myself to the end, for the time being, and begin to feel I want to leave this place. It is rather much to be alone all the time and the only thing is to work, and now I have done as much as I want I am waiting for some money to come to be able to go.

A letter of eleven days later does indeed say: 'I have done a lot in Tréboul and am pleased.'

Whatever is to be read into these words, he had in fact worked himself 'to the end'; although references to the future suggest that he was unaware of it, for him this was the end. Augustus John wrote to Mrs Wood (in an undated letter) that Kit's last months seemed to have been passed in such a flame of creative energy that he burnt himself out – gloriously.

The following month he returned to England to prepare for his exhibition at the Wertheim Gallery then scheduled for October (it did not, in the event, take place until the following year), and after a brief visit to his London house, at 3 Minton Place off the Fulham Road, he went to Salisbury in order to see his family, in particular his mother. (The Woods had left Lancashire and were living in the village of Broadchalke, near Salisbury.) Rex Nan Kivell, whom Kit had known since 1925, came down on 21 August, 1930 to have lunch with Mrs Wood and her daughter Betty at Sutton's restaurant, prior to meeting Kit at Salisbury station. After lunch Rex Nan Kivell left. At the station they found Kit in an intensely agitated state: he maintained that he was being watched by some strange Algerians and insisted that he must go back to London. Instead he fell under a moving train. On an envelope in his pocket were written these two enigmatic sentences in his own hand: 'Are they positive?' and 'Throwing away is not big enough proof.' He was buried at Broadchalke: the flat stone over his grave was carved by Eric Gill.

Christopher Wood was widely mourned as a painter and as a friend. In death he became more than ever a legendary figure.

During his life, despite the high reputation he enjoyed, he sold relatively few pictures and those for modest sums. Eight years later, according to a newspaper report, one was bought for £3,000 – an immense sum for a work of a young contemporary. Wood's well-deserved posthumous reputation owed much to the devotion of his mother and the admiration of his friend Rex Nan Kivell, the director of the Redfern Gallery, which showed his work consistently from 1936. After holding an exhibition of oils that year and of watercolours and drawings the following, in 1938 the Redfern took the audacious step of showing, at the spacious New Burlington Galleries, what was believed to be Wood's complete works – five hundred and thirty oils, watercolours and drawings – and sponsored a book based on the catalogue with a substantial prefatory essay on his life and work by Eric Newton. This exhibition, for the most part received with admiration, momentarily established him as a major figure in twentieth century British painting. Owing to the Second World War its effects were less enduring than would otherwise have been the

case, for the art world underwent radical transformations and Wood was little remembered by emerging generations. Yet the respectful interest evoked by an exhibition of a hundred and thirty-four of the paintings, drawings and watercolours held at the Redfern Gallery in November 1965 suggested that the time was approaching when Wood would be accorded the place he deserved.

Very few young artists, whatever their stature, would emerge from an exhibition of virtually their entire production with their reputations intact. The fact that the comprehensive exhibition of 1938, which included Wood's work as a student and as an uncritical disciple of many other painters, should have impressed many people of acute perception, shows that it was imbued with rare qualities. Lucien Pissarro spent an hour there, expressing ardent admiration. 'Dead at twenty-nine!' he exclaimed, 'How long had he been painting?' Eight years, he was told. 'And nothing from my own first ten years survives.' Augustus John also paid it a long visit and, scrutinizing *The Plage, Hotel Ty-Med, Tréboul*, said that the tree on the left constituted one of the most remarkable passages in modern painting. Paul Nash, of the last pictures when shown in 1932 at the Lefevre Galleries, wrote of the 'gay easy swing of Wood's manipulation of paint, free but never showy or slick, above all his ability to keep his canvas alive from corner to corner, yet leaving restful spaces for the eye'.

All but Wood's most derivative pictures were invested with a spirit of radiant purity, guileless, gay, yet aware of the dark, confusing forces that shadow human life, expressed in terms of lyrical colour (especially yellows, which he believed artists had been prone to neglect) with occasional sombre overtones in blue-black seas and iron skies. It was, I believe, this quality that so moved the perceptive visitors to the exhibition of almost the whole of Wood's life work. The exhibition also enjoyed a vast popular success: it drew some fifty thousand visitors before it closed.

The aura of legend around Kit Wood was due in part to his being an artist of rare talent, who had died tragically and young, and who within a few years of beginning to paint had made a respected position in what was then the undisputed capital of the world of art and in particular had won the admiration of artists such as Picasso and Cocteau. But this aura was also due to his qualities as a man which had won him not only the admiration but the friendship of Picasso, Cocteau and other illustrious figures with whom, in those days, few British artists were even acquainted.

Nothing published about Wood expresses so movingly the sense of loss felt by his friends after his death as a paragraph in Max Jacob's

Souvenir. 'Under those trees and by the rocks of the Bay of Douarne-nez,' it runs:

> Kit lived for two months; his last, alas! Neither the October storms nor the horrible recollection of his death could deter me from returning there. The wind was howling against the door of his room. I did not dare enter nor cross the threshold which now seemed like a tomb . . . this landing which used to ring with our laughter! There on the table could no longer be seen the wet canvases, the brushes and pots of paint. No longer on top of the high wardrobe were the paintings which he had first completed in the space of a few hours with such vigour and which he surveyed with maybe melancholy. I shall never see again the larch tree beneath his window hiding the sea and the minute chapel which he loved to paint.

BARNETT FREEDMAN
1901 – 1957

Barnett Freedman's early years are apt to be regarded as tragic; they were indeed marked by grievous affliction but the consequences were immensely beneficial.

Barnett Freedman was born on 19 May, 1901 in Aldgate in the East End of London, the eldest of five children of Lewis Freedman and Rachael who had both immigrated from Russia some five years before. As a child Barnett suffered serious and increasing ill-health, culminating in four years in The London Hospital between the ages of nine and fourteen. Compelled to spend much of this time lying on his back he nevertheless taught himself (he had no regular schooling) to read, write, play music as well as to draw and paint. Later I remember people who knew him (although not well enough) expressing pity for the wretchedness of those early years. In fact they were an ordeal from which he emerged – through his rare intelligence, diversity of talent and determination – as well qualified to pursue his chosen callings as he would have been if he had received the best conventional education. In fact better, for Latin, Greek, history and arithmetic would have been mere distractions. However, he could not pursue them at once.

At the age of about sixteen Freedman was sufficiently recovered to begin to earn a living. He first worked for a firm of gravestone and garden sculpture designers and two years later secured a position in an architect's office, where he remained until he was twenty-one. Among his various tasks there was the completion of his employer's rough sketches for war memorials and to prepare the long lists of names with sufficient precision to enable them to be cut in stone. These arduous undertakings brought recompense, for they initiated Freedman's lifelong preoccupation with lettering and brought him into contact with architecture and sculpture.

From 1917 until 1922 he attended evening classes at the St Martin's School of Art. For three years in succession he tried, and failed, to win a London County Council senior scholarship to enable him to study at the Royal College of Art. After his last failure in 1922 he sought an interview with my father, then the College's Principal, and showed him a number of his drawings. My father considered these

to show exceptional promise, and went off immediately to County Hall to protest to the chief inspector, who agreed that the refusal was a mistake. It was accordingly reversed and Freedman was awarded a grant of £120 per year which enabled him to become a full-time student. 'To achieve my ambition,' he said to a friend, 'to go to South Kensington and work under Rothenstein's eye.'

I came to know him in the autumn of 1922 and well remember the first time we met, standing outside the school of painting at the Royal College. I can see him standing there, haranguing a group of fellow students: short, thick-set, already looking forty, nodding his heavy, sagacious red-thatched head to give emphasis to his denunciations (someone always needed denunciation then). At that time, and throughout his student days, he was the grousing, genial leader of opposition to authority, the past and to everything established. But to those who knew him well, Freedman's change from ragged prophet of revolution to successful citizen caused no surprise. They recognized certain unchanging elements in his nature which far outweighed his opinions, which were born mostly of the intellect, and in any case were transient. They knew that he was a realist who was able to accept, without much difficulty, the world as it is; that he was ambitious, and that he had a craftsman's sense of things which would never allow him to make a muddle of so important a job as life and a career.

Freedman remained at the College for three years, devoting himself principally to life drawing. He was immediately recognized as a 'character', wise, witty and of conspicuous yet humane candour (he was known as 'Soc', short for Socrates). Moreover Freedman displayed all the versatility which had marked his years of distress. For instance, he was producer of Andreyev's play *He Who Gets Slapped*, with Henry Moore delightedly supplying the sound effects (the final applause for the play was suddenly cut short by Barnett's large head emerging from between the curtains and his exclamation 'I think it's bloody bad'). My father, whose admiration and affection for him increased during his College years, painted a portrait of him in 1925, now in the Tate.

Soon after his arrival Freedman became a prominent member of a loosely knit group of students which included Henry Moore, Donald Towner, Cyril Mahoney, Albert Houthuesen, Geoffrey Rhoades, Edward Bawden and Eric Ravilious. In the stimulating climate of this circle Freedman's character and intellect, as well as his abilities as draughtsman, painter and designers, developed rapidly. In 1925 he left the College, moving from his little room in Stanhope Street, near Tottenham Court Road, into another off Euston Road, where he devoted all the time he could to drawing and painting. But to the

College he returned in 1928 as a visiting instructor in painting, teaching mainly still-life, a position which he held for some ten years.

Freedman's painting and drawing evoked admiration early on, but although his output was considerable, his sales were few. Accordingly he remained largely dependent on teaching, which he did well, and fortunately enjoyed. Besides the Royal College he taught two evenings a week at the Working Men's College and twice a term at the Ruskin School of Drawing, Oxford. Anne Spalding, one of his students at the Ruskin, remembers his talking in the life class to another student:

> You come in after coffee, you pick up a pencil and start drawing while you are still talking to someone over your shoulder. What you ought to do is to sit down very close to the model where you can feel her strength. Look at that leg, with all her weight on it pressing up that hip. Look at that neck! It is like a column. Before you begin drawing you ought to look so hard that you can see a faint shadow of it all on your paper. And by that time you should be trembling.

To students who simply drew the model's outline and made no attempt to explore the form he would say 'You know what you've done; you've done the piece of the wall you can't see.'

Painting remained Freedman's basic passion, but just as he enjoyed teaching, he enjoyed – but far more – the wide range of printmaking on which, for many years, he depended for a living – although for several years not much of a living. 'If the returns from these activities could not prevent me from starving,' he used to say, 'at least they could prevent me from starving to death.' If he were starving it was by his own heroic volition, for he almost invariably painted until four in the afternoon, at which time he would turn to the making of prints for book illustrations, which he called his 'bread-and-butter work'. It was in 1927 that he received his first commission to illustrate *The Wonder Night* by Lawrence Binyon, third of the series entitled *Ariel Poems*. The commission was a clear indication of the high regard with which Freedman's work was already held. At the time when he was given the commission he was in his mid-twenties and had only just left the College, where he had taken no specialized training in illustration. Among other illustrators of *Ariel Poems* were Eric Gill and Paul and John Nash. The books were quickly acclaimed as classics. Compared with Freedman's later illustrations, those for *The Wonder Night* are tentative, although that of a father and mother caring for an exhausted child gives a clear indication of his future achievements.

For most of 1929 Freedman was seriously ill, but on his recovery he received a commission to illustrate Siegfried Sassoon's *Memoirs of an Infantry Officer*, published in 1931. This he did with line drawings, several with colour added lithographically, also designing the binding and the jacket. The illustrations, unlike those for *The Wonder Night*,

are assured and highly original, for instance that of a soldier's tramping lower legs seen from behind; likewise the complex heading for the table of contents. Freedman had already won recognition; *Memoirs of an Infantry Officer* brought him well-merited acclamation. He also made illustrations for Borrow's *Lavengro* (1936) and Tolstoy's *War and Peace* (1937–38), the latter a major achievement in creativity and scale. Those for the six-volume *War and Peace* consist of fifty-four lithographs in colour and thirty in black and white, which include title pages for subsections, chapter headings and tailpieces, beside the jackets. In addition he was responsible for every detail of format and decoration, as well as the binding. Most of the lithographs required some half-dozen drawings on stone. He completed this formidable work in about a year; the six volumes are worthy of Tolstoy's masterpiece. (In this, incidentally, he included a self-portrait which is remarkable as a penetrating likeness and in which he depicted himself looking down, a pose he could not have seen in a mirror.)

Freedman's *Lavengro* is overshadowed by his *War and Peace*; nevertheless it is a notable achievement. While not so formidable an undertaking as the Tolstoy, its two volumes contain numerous illustrations. The demands their completion involved are movingly described in a letter Freedman wrote to Ruth, the wife of Oliver Simon:

> My dear Ruth
> The misery occasioned by the enormous amount of work I have had to do for *Lavengro* – the getting up at six o'clock every morning for three months – the journey to Plaistow in crowded and overheated trains – the faces of wage slaves and breadwinners, their coughs and sneezes, their smells, their conversations and newspapers. The close approximation of their bodies to my own (this sometimes was not *so* bad) – the rush and roar of the works at North Street – the bickerings of the printers – the inexperience of the lithographic department making me often leave the works at eleven at night. . . .

Notable, too, is Freedman's *Oliver Twist*. Particularly characteristic is a chapter heading of a backview of a man wearing an overcoat in the rain, and of a jug, loaf, bottle and candle. In addition he illustrated *Henry IV, Part I* (1939), *Wuthering Heights* (1941), *Jane Eyre* (1942) and *Anna Karenina* (1950).

Most book jackets are of an anonymous character: Freedman's are almost uniquely memorable. He preferred lithography to black and white printmaking, which was, however, the medium in which the large majority of his illustrations was carried out.

Freedman was the foremost artist in Britain using lithography as his method of illustration, drawing straight on the stone and working

out his own series of stones for colour separation. Because of his command of this medium he began to meet opposition from the trade union of lithographic printers, of which he was not a member. They thought his precedence was threatening their livelihood, and to correct this misconception he agreed with some trepidation to appear on the stage at a meeting and address them. This was a success and he was able to convince them that the threat to their careers was far less than the amount of work that would come their way through artists taking up this method.

As were several of his contemporaries at the Royal College, Freedman was versatile: he designed, for instance, the 1935 King George V's Silver Jubilee postage stamp in which the contrast between dark and light tones is intensified by their having a glitter as though reflected in sunlit water. They rivet the eye – mine at least – in a way uncommon of their kind.

During his student years Freedman and I were on friendly terms but as I was a student elsewhere we rarely met in termtime, and from 1926 until 1928 I was working in the United States and for several following years was often away from London. I would occasionally visit him and Claudia (a talented illustrator whom he married in 1930) at their friendly little house at 47 Scarsdale Villas and later 11 Canning Place, both in Kensington.

The year before their marriage Freedman had visited Claudia's family in Palermo where he saw some puppets which entranced him and which he received as a wedding present. During his visit a shepherd came to the house and played on his strange sheepskin pipes; as a consequence Freedman painted *Sicilian Bagpipe Player* (1931). He was always attracted by musical instruments and they are the subjects of several notable paintings. The Sicilian puppets became the subjects of two paintings, *Sicilian Puppet* and *Sicilian Puppets*. The figures have a more intense animation than most depictions of living beings. Once seen they are unlikely to be forgotten. The details with which these figures are represented in no way impairs their grandeur of form.

In July 1932, not long after my appointment as director of the Art Galleries in Leeds, I wrote to him expressing my deep admiration for his recently completed oil painting *Sicilian Puppet* and asking whether our Art Gallery Committee might consider its purchase. He replied (27 July):

My dear John,
I am most touched by your letter. I take it as a very great compliment from you, that you should want my picture in your gallery – and even if it is not bought, I can tell you, that your letter cheered me up considerably! I am having a frame made for the 'Puppet' and you will

have it a week from now. I was wondering if you would care to have the 'Violin & Guitar' as well? I feel that in some ways it is perhaps a more original picture, but *you* know best. It is one your father liked very much, when he saw it. But you must please yourself. I could send them both if you wanted them. Just drop me a card. For the 'Puppet' I should want 50 guineas – but, dear John, *don't* let the price only, stop the sale of it. It took me 2 months to paint, and in proportion to the sums of money I have received from my other works from Edward Marsh, Mrs Courtauld, Duveen etc – I think that is fair. Only it is so hard to know!

To my relief and pleasure, *Sicilian Puppet* was duly purchased. Relief, knowing how distressed he would have been by its rejection, pleasure, because I believed it to be one of his most notable paintings (a belief which I still hold). It is notable both intrinsically but also as a relatively early painting marked by a rare maturity. Another version came to be painted, I believe, in the following circumstances. In a letter to me he wrote: 'I shall be very grateful to know if your committee intends to allow me to exhibit The Puppet at the NEAC. If not I should like to know soon; for them I can get another one ready instead.'

For some reason the loan did not prove possible. 'Another', alluded to in the letter, is surely *Sicilian Puppets* – the same figure with a male partner – completed the following year.

An account of Freedman's life and work during those years was accorded me by a friendly country neighbour, Harold Hussey:

Barnett came abruptly into my life when I saw him one summer evening in 1931. He was just dismantling his easel in the mid-stages of painting the village pond at Frieth. My reaction was immediate and startling, because as a village boy I had never seen a painting of that quality before and I trembled throughout. I approached him with extreme nervousness and the result was an invitation to tea the next day and a close friendship until his death. For the moment he was staying with the village blacksmith, a raw character who delighted Barnett. He had taken two rooms and in addition to his daily painting was working in the evenings on a bookcover for the Curwen Press.

His reason for being in Frieth was his friendship with Basil Creighton, author of country stories, who had a house in Little Frieth and who had bought several of Freedman's paintings. He visited Frieth from time to time and continued painting and then took a small cottage at the top of the village and rapidly became acquainted with village people of all categories, including the milkman-farmer who took him out to Thame Market, and Lord Parmoor, father of Stafford Cripps. He was greatly amused to be invited by the curate to play his fiddle (his term), and did so, in the village church. 'Oh, the parson, he's a pleasant chap. His only trouble is he's in the Cloth,' said Freedman.

My relationship with him at that time was as an overawed and devoted student, and also guide and porter to various spots unknown to casual visitors to the neighbourhood, and in that way I became

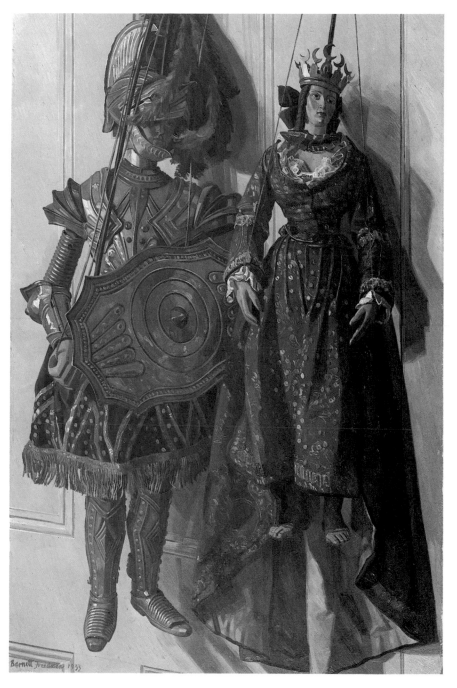

13. BARNETT FREEDMAN: *Sicilian Puppets*. (1933).
Oil, 39½ × 24½ in (100·3 × 62·2 cm). Nottingham Castle Museum.

14. STANLEY WILLIAM HAYTER: *Coast of Erewhon* (1959).
Oil, 50½ × 50½ in (128·7 × 128·7 cm). Towner Art Gallery, Eastbourne.

Opposite
15. CERI RICHARDS: *'Do not go gentle into that Good Night'* (1956).
Oil, 42 × 28 in (105 × 70 cm). The Tate Gallery, London.

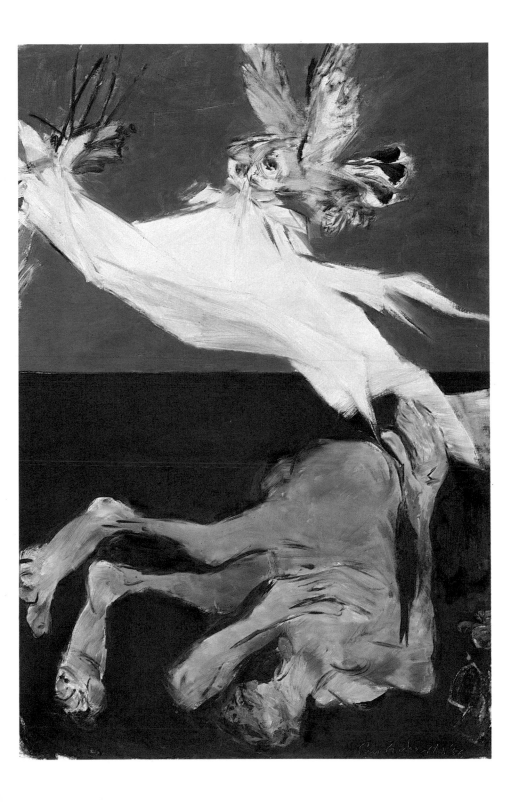

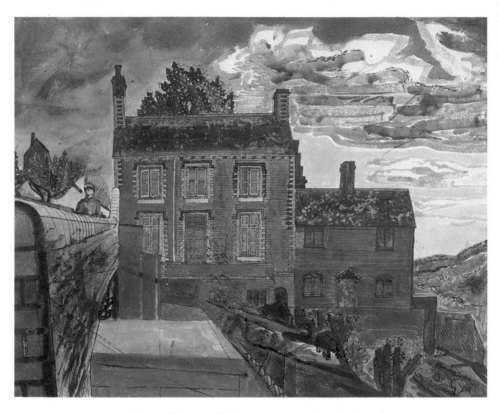

16. EDWARD BAWDEN: *Houses at Ironbridge* (1956).
Watercolour drawing, 18½ × 22⅞ in (46·9 × 57·6 cm).
The Tate Gallery, London.

indispensable to him. Through this he painted a number of small pictures of the surrounding area carried out between 1931 and 1933. At that time he was in comparative good health and would walk over a mile to a site, with me carrying all his equipment, stand for about four hours painting and then walk back.

I will give a brief account of the marvellous way in which Freedman contrived to get me away from my village life and eventually into the Royal College of Art, because this was typical of the many good deeds he quietly performed for those who needed a lift up. I think it has become, and should be, well-known that Freedman was a genius at this sort of thing, and whenever his name comes up, expressions of gratitude rise from all sides. It illustrates a basic principle of his, succinctly put in reply to my own enquiry: 'What could I ever do to repay him?' 'Don't attempt to. Just pass it on.'

After I had produced a few drawings in his company, never having done any before, he said 'I must get you a job in London so that you can join the Working Men's College in evening study, and then we will see about getting you to the Royal College of Art.' As I was then nearing the end of two years unemployment in the 1931 to 1933 slump, this utterly astonished me as I had not wasted my own efforts seeking work in London and elsewhere. Very soon after I was accepted into the Publicity Studio of Shell-Mex and British Petroleum.

In his teaching and criticism Freedman could be, and often was, caustic, but always with good humour: 'My dear boy! If you paid as little attention to what was around you when crossing the road as you do here to the subject in front of you, you'd be run over!' He said to me of his students: 'I often knock them down, but I never leave without picking them up.'

Early in 1933 Freedman was evidently afflicted by one of his recurrent and acute financial difficulties, and I wrote to him making a suggestion that I hoped would be of some help. His reply of 19 January 1933 was marked by his constant consideration for friends and by his modesty – also by his liveliness, apparent even in times of distress:

My dear John,
I should have answered your last letter before now. Please forgive me. I await news from the firm you mention, altho' I'm afraid I should not be much use. Bawden & E|ric| R. |Ravilious| are, of course, perfect for that kind of work as their idiom is understood so well by the better class of business man – I can assure you that my 'Shell' scribbles are pretty much of a 'lark' done in a moment or two. Whereas that is the *regular* work of B & R – only of course, really perfectly done. However I will inform you of any developments. At the moment I am in bed with the most awful influenza. The medical people have raised hell at the idea of me getting out before next week. Claudia got it first. Then me – & now the maid! It's a particularly nasty form. This letter will be sprayed before it leaves me! . . .
 Our love to Elizabeth & you.

Another of the too few surviving letters he wrote to me, of 23 July, 1938 (at which time I was at the Tate), is expressive of his benevolence:

> One of the Royal College students is giving an exhibition of small paintings in his own room at No 5K Park Walk near King's Road, Chelsea. His name is Leonard Appelbee, and he asked me to write to you, to see if you could spare the time to see it.

Unfortunately, having to leave London I was not able to do so, but we bought his admirable *King Crab* (1938), and acquired *Landscape, Meadle* (1939), some eighteen months later. The letter concludes: 'I am finishing my Tolstoys and I hope you will come & see them.'

In 1934 I went to Sheffield as Director of the new and shortly to be opened Graves Art Gallery. To my regret none of the letters he wrote to me there survive. But once again, when the work of young artists, especially those of merit, was apt to be suspect by regional art galleries, we acquired a fine example, *The Farmyard* (1933).

The fact that Freedman was a townsman by birth, and so remained until the end of his student years, evoked his particular response to landscapes. 'I was frightened in my first night in the country,' he confided to a friend, 'it was so *unusual.*' By the mid-1920s he had responded ardently to the landscape of Somerset and Dorset.

To the work to which Freedman was primarily dedicated – his painting – I will shortly return, but first let me note the extraordinarily wide range of his other activities. Mention has already been made of his printed work and book illustration. The BBC, The General Post Office, The London Passenger Transport Board, Shell-Mex and other concerns commissioned him to make designs. He also designed several stage settings, a peep-show, Christmas cards, and a booklet advertising 'Real Farmhouse Cheese', a masterly work, every one of its eight lithographed illustrations would evoke admiration if on view in an art gallery. For a friend he designed a summerhouse, for another, a garden gate.

Among his outstanding typographical works was *A New Alphabet of Initial Letters* called *Baynard Claudia* for the Baynard Press ('Claudia', after his wife), a decorative alphabet designed in 1935. In the November issue of *Signature* appeared an article, 'An Alphabet of Decorative Initial Letters Designed by Barnett Freedman', in which the quality of his work was recognized – in this case so promptly that when the article appeared the alphabet had not been put to use.

Freedman's command of media was astonishing; still more so was the way in which all of his work – all at least that I have seen, although I have seen far from all of it – is so unmistakably autographic. In *Artists at Curwen* (1977), Pat Gilmour described Freedman as 'that

arch-autolithographer'. Who with more authority than she for con-
ferring such a title?

Freedman believed in the essential unity of the arts. 'What's
commercial art?' he would ask when the subject was under discussion.
'There's only good art and bad art.' Yet the fact that he would dedicate
the first and largest part of every possible day to painting hardly
needs his frequent statement that were he able to do so he would
have devoted all of his time – almost – to painting, to show where his
deepest interest lay. His rare versatility would in any circumstance
have found expression, but in a lesser range and with far less
frequency.

Freedman's talent as a painter was recognized by his appointment
as instructor in still-life at the Royal College (in 1928), but he had
begun to use oils with caution. By the mid-1920s his command of the
medium was clearly apparent, in, for instance *Fruit Still Life* (1927);
also in his several landscapes of Lyme Regis of 1930, and *Musical
Instruments* (1931). They exemplify 'realism' in a most positive sense;
the fruit could be picked and eaten, and the musical instruments
played upon. Yet another is *Kitchen*, an early work, which used to
impress me deeply when I visited Sir Edward Marsh at his chambers
in Gray's Inn, but I have been unable to trace its present whereabouts.
It represents, at its very best, one of Freedman's outstanding qualities,
namely the power of endowing the most ordinary places and objects
with a riveting interest. The crowded kitchen with frying-pans
hanging from a shelf, a washbasin, a big jug, a sink, and much else
besides, is represented in an intensely realistic way, yet with a serene
intensity that compels the spectator to look, and go on looking.
Considering that Freedman's intensely observed paintings are highly
detailed, and that in spite of his devoting every possible hour to
them he was compelled to undertake so much other work, they are
impressively numerous.

After the mid-1930s he was subject to frequent ill-health, prevent-
ing him from painting landscapes, and he devoted himself increas-
ingly to the illustration and design of books.

Freedman's reputation as an artist of rare versatility was well
established by 1940. In April of that year, together with Ardizzone,
Bawden and R. G. Eves, Freedman was appointed an Official War
Artist, when all four were sent to France to join the British Expedi-
tionary Force. In spite of his versatility, the ease, at times even the
zest, with which Freedman served surprised many who knew him.
To them even the idea of his wearing a uniform would have seemed
incongruous; even more the immediacy of his adaptability to army
life. By the time he was transferred to the navy they knew him better.

Ardizzone, in his *Baggage to the Enemy*, in describing their days at

Dunkirk mentions Freedman's characteristic response to a suggestion by the director of Military Intelligence that he might like to paint a portrait of the GOC: 'No I am not interested in uniforms – oh well, perhaps I might if he's got a good head.' Ardizzone also recalls that Freedman was 'immediately an enormous success in the photographers' mess' and 'had us all under his spell in the shortest time'. Likewise his talents as a musician: how, in a house near Boulogne in its darkest hours 'Barnett went to the piano and played Handel and Bach for us, which sounded very moving against the background of distant guns'.

Freedman's dedication to his calling was never more convincingly apparent than in his conduct during the evacuation of Boulogne. He had embarked with his kit and eight of his works but *Aircraft runway in course of construction at Thélus, near Arras* had been left at his hotel. This, which he regarded as one of his best, he was determined to retrieve. Disobeying orders he dashed down the gangway and through bombed and machine-gunned streets crowded with refugees. The hotel had been evacuated but he found his picture and ran back to the harbour. But the ship, with his eight watercolours and kit aboard, had already sailed. While waiting for another he helped to unload an ammunition ship. His eight paintings were missing, but after a month's search by the War Office they were recovered undamaged.

The following year he was appointed captain in the Royal Marines and War Artists at the Admiralty, serving until 1945 and continuing to work, almost invariably in watercolours, with enormous zest; and the wider-ranging and more complex his subjects the greater this zest. Two such works are *Personnel of an Aircraft Factory* (1942) and *Interior of a Submarine* (1943). The first consists of thirty-three ovals, mounted in three rows of eleven and the last has inscribed the name of the sitter at the base of each drawing. The second – an equally complex yet still more impressive work – consists of seven sheets of paper mounted together on double board and inscribed on the back: 'Study Control Room H.M. Submarine Tribune Captain Barnett Freedman R.N.' These inspired not only Freedman the artist but Freedman the speaker, and on 29 June 1945 he gave a talk on the BBC entitled 'Looking at Submariners' (I quote a few extracts here; the talk was published in full in *The Listener*):

> I have been a war artist ever since 1940 and all the time I've tried hard to depict men doing their jobs. I wasn't going to depict ruins – for I hate ruins – ruins made by war, or even old falsely romantic ruins left to grow useless by decrepit noblemen and ignorant town councils. I wanted to paint men guiding and controlling machines. The relation of men to machines is so important in the modern world that I wanted to

try and express it in paint. And here was this submarine – this great machine – filled *with* machines; simple elemental machines like huge lumps of iron – complicated and elaborate machines with biased gears and eccentric wheels; and very sensitive delicate machines – the gyro-compass – marvellous to see. And last – the most sensitive machines of all – men. . .

In 1942 Freedman had yet another experience from which he derived comparable stimulus. He served on HMS *Repulse* when on Russian convoy duty. On a royal visit to this ship he was presented to the King by the Commander-in-Chief. On this ship he painted *15-inch Gun Turret,* one of his few wartime oils. As a war artist Freedman served until the very end, his last major work being *The Landings in Normandy, Arromanches D-Day plus 20, 26 June 1944* (1947). The war, as was the case with a number of artists, proved to be an intense stimulant to Freedman. He excelled in his war works, but when peace came he relaxed, and during his remaining six years he never again displayed the creative energy that he had in the previous years of his life. He did, however, illustrate *Anna Karenina,* as earlier noted, and several other books; Barnett was never idle. In 1946 he was awarded the CBE.

The Tate was fortunate in acquiring three notable examples of Freedman's work shortly after the war. In 1945 the Gallery bought his twenty-two illustrations for Walter de la Mare's *Love,* made, surprisingly, in 1942 when he was serving with the Royal Marines. The book, an anthology, was published the following year. The poetic character of the illustrations contrasts with that of the two highly realist works – both mentioned earlier – *Personnel of an Aircraft Factory* and *Interior of a Submarine.* The fourth acquisition, *Music* (1951), a serene still-life, affords a marked contrast to the other three.

Barnett and I used to meet occasionally almost until the end of his life: his humour – sardonic and benevolent in entertaining contrast – remained unchanged by the years. He died on 4 January, 1957 in London, mourned by many friends. Later that same year an exhibition of his paintings, drawings and graphic art was held at The Arts Council.

STANLEY WILLIAM HAYTER
born 1901

Most artists who, on account of parental pressures or other circum-
stances, begin their working lives in a different profession regret the
time thus spent as time wasted. Stanley William Hayter was one of
the rare exceptions. He showed artistic inclinations early, he had a
painter for a father and other artistic antecedents, but nevertheless he
devoted himself for almost ten years mainly to scientific research,
painting and drawing only in his spare time. Rigorous training as a
scientist, although its effect on his painting was relatively slight, was
stylistically appreciable and contributed radically to the ease with
which he mastered the intricacies of the various techniques of
printmaking and to his powers of lucid exposition, which won him
recognition as its greatest living teacher.

Such was his celebrity in this field, both as artist and teacher, that
there is a tendency to overlook his achievement as a painter. Although
it is primarily with this that the following pages are concerned, it is
no more possible to separate the two than it would be to treat Turner's
oils without reference to his watercolours.

Stanley William Hayter was born on 27 December 1901 in Hackney,
the son of William Harry Hayter and his wife, Ellen Mercy, born
Palmer, a school teacher of a Lincolnshire family. His father was a
painter whose family had produced several artists. The first to be
recorded was Charles Hayter (1761–1828), miniaturist, portrait
draughtsman and writer, who published a treatise on perspective and
who was professor of perspective to Princess Charlotte. Two of his
sons were painters – George the elder was appointed as Queen
Victoria's portrait and history painter, and John the younger, who
was the great, great grandfather of Stanley William. Like many artists
of his generation W. H. Hayter recoiled from academism; his sym-
pathies were with the Impressionists but he did not join the New
English Art Club or any other groups, progressive or otherwise.

Stanley William Hayter began to paint in his father's studio in
Croydon when he was fourteen, and, no doubt following his father's
example, his earliest works were impressionistic studies in light and
colour. At the time he did not aspire to be an artist but painted, as he
has said, 'for the fun of it'. His enjoyment was enhanced by frequent

278

visits to the National Gallery with his father. The artists he most admired were Uccello, Boltraffio, Zurbaran and El Greco.

In 1913 he won a scholarship to the Whitgift Middle School in Croydon, where he remained until 1917; his main preoccupations were scientific and he was given charge of the laboratory. After leaving school he worked in the research laboratory of the Mond Nickel Company while also working part-time for an honours degree in chemistry at King's College, London. The following year, after the Armistice, he left Mond Nickel to work full-time at King's, where, three years later, he took an honours degree in chemistry and geology. That year, 1921, was a significant one: besides graduating with honours he made his first prints. In the meantime he pursued research into organic sulphur compounds under Professor Samuel Smiles at King's. In 1922 he joined the Anglo-Iranian Oil Company with which he remained for three years, spent mostly in Abadan in the Persian Gulf, where his duties were both technical and administrative. He made visits to the north Arabian desert, to Basra, Baghdad, Ispahan and elsewhere.

With his departure from London the academic life lost its hold upon Hayter. In Abadan his hours of work were irregular, and during his leisure time he began to paint and draw, eventually doing so every day, making landscapes, seascapes and pictures of the refinery, as well as some hundred and fifty portrait drawings of his fellow workers. Painting and drawing gave him such intense delight that shortly after his arrival in the Persian Gulf he decided to resign on the completion of his contract at the end of 1925 and to become an artist. He accordingly returned by way of Egypt to London, where the paintings and drawings he had made in the Middle East were exhibited at the Anglo-Iranian headquarters.

The following April he went to Paris where, although he travelled widely and frequently and retained his British nationality, he made his most constant place of residence, settling first in the Rue du Moulin Vert, his workroom adjoining Giacometti's. For three months he attended the Académie Julian studying under Paul-Albert Laurens. Here innumerable British and American students have gone to escape the academism of their native schools, but Hayter went there for the opposite reason. Owing to his father's anti-academic sentiments, and his own total lack of contact with the academic world, his attendance at the relatively traditional Julian's was prompted mainly by curiosity. The principal advantage he gained there was the lasting friendship of a fellow student, Anthony Gross; also of Balthus.

It would seem that at about this time Hayter received what in pious circles would be termed a 'call' to make prints. His father had made none and Hayter did not recall knowing anyone who did. But at the

age of sixteen or seventeen he became interested in prints and bought two or three. As already noted he experimented in engraving while reading chemistry at King's; he also visited Frank Short, the head of the school of printmaking at the Royal College of Art.

In the course of the year he made a number of drypoints and aquatints; he showed several of these, together with some paintings, at the Salon d'Automne. Unlike many foreign students, Hayter entered instantly into the art life of Paris, making a wide variety of friends including Alexander Calder and Joseph Hecht the engraver (who taught him the use of the burin). How rapidly he mastered the art of draughtsmanship is apparent, for instance, in *Bottles*, a soft-ground etching on zinc he made during his first year in Paris.

The following year, 1927, when he was only twenty-six years old, Hayter took an audacious step that had decisive consequences not only for himself but for the art of printmaking: he established a school, the celebrated Atelier 17. (Julian Trevelyan suggested that it should be known as '17' after the number of the house it occupied in the Rue Campagne Première.) Like many other significant events it came about by chance. Two women called at Hayter's studio one day (where he had installed a printing press) and bought one of his prints. A week later they returned and asked him if he would teach them. He answered that two more students were needed. A week later they returned with the two, and Atelier 17 – although as yet unchristened – came into being.

So intense had Hayter's preoccupation with printmaking become, and so eager was he to share his knowledge, that it was almost certain that, even had the original two ladies decided to pass by his door, something like Atelier 17 would have been established, sooner rather than later. 'I don't believe it was arrogance that made me start Atelier 17,' he said to me, 'it was that I was overwhelmed by the prevailing neglect of printmaking, the failure to be aware of its immense potentialities. In short by the sense of *things to be done* with a new etching, a new engraving. In any case there was no question of a master and pupils relationship, but of one of harnessing talent in a collective venture, of "Let's see what's going to happen". I was convinced that in the course of working together new ideas would emerge.'

At least one feature of his teaching method had a parallel in his approach to printmaking and painting, namely his consciousness of the relation between intellect and inspiration, or 'imagination-uncon-scious' as he preferred to call it. 'Starting from an arbitrary position,' he wrote in *New Ways of Gravure* (1966), 'action is continued in consecutive stages, at first rational but later becoming intuitive, in the absence of a concrete project . . . The reason for this is that a plan

can only be made of what is already known, but an experiment of this type can lead to matters completely unknown.'

Hayter's art has a classical clarity together with elements deriving from the unconscious. As a consequence of his association with the Surrealist movement from 1929, these elements came to play a larger part. (He helped to organize the Surrealist Exhibition held in London in 1936 and was represented in it.) They are more conspicuous in his prints than in his paintings, for instance in *L'Apocalypse*, an album of six plates published in 1932.

Artists in whose work the unconscious plays a part have had widely different approaches to it. De Chirico, for instance, wished to express the workings of the unconscious in poetic terms, and Dali, with scientific accuracy, evolved what he called a 'spontaneous method of irrational knowledge based upon the interpretative-critical association of delirious phenomena'. Hayter's approach was that the unconscious was most effectively invoked through the process of work itself. The following, also from *New Ways of Gravure*, gives an indication of his attitude:

> . . . the reciprocal effect of imagination/execution will generally decide the next stage in the development of the design. The first strokes on the plate set up a train of consequences like the ripples from a stone dropped into a still pond, and the factors of experience in the artist determine the number and succession of possible consequences offered to his choice . . . just as a master of chess can visualize from an opening a great number of moves to a mate while a beginner can see only a few immediate moves . . . In my own manner of working I would consider the selection among these consequences rather to be unconscious than deliberately conscious.

Like many post-Freudian artists, Hayter believed in the participation of the unconscious in his work (although not all have used the same term: Bacon, for instance, prefers 'chance'), and that the simple act of beginning work with no more than a general plan may effectively invite it.

Hayter's procedures as a painter differed technically from those as an engraver, but their objects were the same. Instead of making, as on a plate, 'first strokes that set up a chain of consequences' he made preliminary drawings, intended as tentative trials of ideas and sensations rather than complete in themselves. 'If a drawing is complete,' he said to me, discussing his methods, 'what need to say the same thing in paint?' The drawings would be put aside and he would begin to paint, the brushstrokes themselves providing clues as to how to proceed. He could not visualize the finished painting when he first faced the virgin canvas: the painting developed as he went along. He was moved to paint by his frequent impulse to work on a

larger scale than the print conveniently allowed; I heard him quote Gauguin: 'A square metre of green is *greener* than a square centimetre.'

In spite of Hayter's surrealist affinities and his friendship with Eluard (who wrote a poem about him, *Facile Proie*), Miró, Tanguy and Arp, he was not, even in the 1930s, as committed to surrealism as Dali or any of the other painters just named. Its effect for him was to strengthen his predilection for avoiding too detailed a plan when he began a painting or a print in order to give full scope to brush or burin to open up possibilities, to invite ideas. It would be misleading, however, to suggest that there was a sharp distinction in his mind between the initial plan – product primarily of the intellect – and the role of the hand, in stimulating the imagination. Indeed he believed it erroneous to separate the functions of intellect, inspiration and execution, convinced that all three were integral parts of the creative act. It is, however, useful in understanding his work to emphasize the part played by the 'imagination-unconscious': his work has nothing of the look of 'spontaneity' often associated with work in which this plays a crucial part; Hayter's work, especially his prints, is distinguished by a look of calculated precision and finish that belies it. This is in part due to his mastery of line. The line is of course used by most painters and printmakers, but few, at least in our day, have explored its possibilities so fully, in theory as well as practice.

Through Hayter's eagerness to share his knowledge, his rare gifts of exposition, both verbal and written – his *New Ways of Gravure* and *About Prints* became classics when first published in 1949 and 1962 – Atelier 17 was quickly recognized as possessing unique authority. The result of the collaboration between an inspired teacher and generations of pupils drawn from all over the world, many of them of exceptional talent, revivified the art of making prints: the discovery of new processes, of neglected potentialities in old ones and a new confidence in the print as a medium equal to painting, drawing, and sculpture. Hayter was able to give technical help to, among others, Picasso, Miró, Ernst, Masson, Tanguy and Giacometti, Pollock, Rothko and De Kooning, and a number of other illustrious figures. The first exhibitions at Atelier 17 were held at the Galerie Pierre in Paris and the Leicester Galleries in London in 1934.

On the outbreak of the Second World War Hayter returned to England where he was one of a group engaged in research into camouflage, and a number of their findings were adopted by the British government. In 1940 he went to New York, setting up Atelier 17 at The New School of Social Research, moving it five years later to Greenwich Village where it remained until 1955, although Hayter also re-established it in Paris in 1950.

So great was the impetus given by Hayter and Atelier 17 to the worldwide revival of gravure, and so extensive and detailed were Hayter's writings on a wide range of technical procedures, that his painting has suffered relative neglect. In 1967, only ten years after his Whitechapel retrospective, when an exhibition of a hundred and fifty of his engravings – about a third of his production – was held at the Victoria and Albert Museum, and a smaller exhibition of his paintings at the Grosvenor Gallery, I remember hearing a person much concerned with the visual arts observe: 'I didn't know Hayter painted.' It is accordingly worthwhile to give some account of his technical procedures as a painter, for they are almost as original and ingenious as those he employed as an engraver, although far less influential.

Hayter worked simultaneously on one, two or even three canvases of semiabsorbent linen placed upon the floor, the easel in his workroom being used only for the scrutiny of the completed paintings by himself and his friends. Round the canvas or canvases were placed the preliminary drawings, which were invariably tentative in order to leave open every possibility that the work may offer as it proceeded. Not all the possibilities, however, were suggested by the actual doing of it, for he made use, too, of drawings made at the promptings of the unconscious, although corrected and developed by the conscious mind. It was Hayter's belief in the potentialities offered by tapping the unconscious that first drew him into the Surrealist orbit in the late 1920s. It was this belief, too, that led him to experiment briefly, in association with Miró and Masson, with a 'drip' technique; also with applying paint with string. Hayter told me, incidentally, that Jackson Pollock had said to him that he was well aware of these experiments by Miró and Masson, yet Hayter praised Pollock 'as a great originator all the same'.

The preliminary drawings were in fact a series: the earliest on the backs of envelopes or scrap paper, the later suggesting not the completed design but rather aspects, especially contrasting aspects, of it, some emphasizing, perhaps, red forms, others white, then yellow and so forth and yet others the black framework. These preliminary studies were sometimes in pencil or, more usually, made with one of his set of felt-tipped pens, each filled with a different coloured ink.

Hayter would begin a painting with a linear arabesque suggested by one of the later drawings over, perhaps, a yellow ground. Two or three days later when it was dry he would apply a colour wash mixed with 'mayonnaise', emphasizing the white forms. When this was dry a second arabesque was superimposed on the first, say in cadmium red. After two or three weeks of intensive work, what he termed the

'oppositions and ambiguities' of his, say, red and yellow images would have crystallized and been enmeshed in a net of black enamel paint. The original images, part products of the unconscious, part of an acute consciousness, were transmuted by trial and error, then enlarged and animated.

They are in a sense abstractions (in what sense I will shortly attempt to describe) but they do not in any way resemble those works in which the artist took a figurative image which he reduced to an abstract entity. On the contrary, Hayter's process was one of growth in complexity and ambiguity – but one of growth, not of reduction.

For Hayter, the prevailing practice of dividing art into 'abstract' or 'nonfigurative' and 'figurative' categories resulted in impoverishment. In *New Ways of Gravure* he states that:

> The term 'abstract' is unfortunate, as it suggests the abstraction or removal of a part of experience – the attempt to show less of the phenomenon and not more: the non-figurative label again suggests a pretension to deny the observer the association or comparison of the work with latent images in his own brain – a pretension which it is impossible to sustain . . . I would suggest that to replace the opposition of 'figurative' and 'abstract' it would be wiser to employ the contrast of specific and general.

Although on casual reading Hayter seems to be concerned with terminology, he was concerned with it not for its own sake, but as fostering the concept of an unreal and therefore deleterious distinction between two points of emphasis in the work of art. He pointed out, both in his writings and teaching, that however uncompromisingly an abstract artist may attempt to exclude the phenomenal world, his work can in fact be no more abstract than the perception of it by the spectator, who will interpret any circular form as a head and a bifurcated form as a human figure. (His negative attitudes to abstraction caused him to decline the invitation by Miró and Arp to join the Abstraction-Creation group.)

A number of the most rigorously abstract painters habitually give their pictures titles, drawn from mythology, history, landscape and the like, to which they have no resemblance whatever; this is for several reasons, the chief of which derives from the difficulty of titling works which can in fact represent nothing in the world of natural appearances. Many of Hayter's pictures look like abstracts, but their titles give clues to their subjects, such as, to take examples at random, *Deliquesence* (1935) or *Labyrinthe* (1953). Without such clues the subjects of many of his pictures, both paintings and engravings, would be difficult to make out, and even with their guidance they remain, in certain cases, obscure. But for all that the titles are never arbitrary.

There was one particular theme, which he mentioned in the paragraph quoted from just now as one of his own preoccupations, namely 'motion in liquid or air', to which he frequently reverted. Preoccupation with movement marked his work from the 1930s, and more conspicuously from 1951. In that year he bought a house at Alba, in the Ardêche. Near the house flowed a small river, the Escoutay. Water, he realized with delight, especially sunlit water, was a subject that offered scope for his most intense preoccupation: brilliant colour, density, rhythmic movement, contrasts and ambiguities. (Hayter's love of water was not only aesthetic: he enjoyed sailing and used to sail in the Mediterranean with Hillier and the Greek painter Varda.) In an interview in the Parisian periodical *Arts*, entitled 'Quel paysage avez-vous choisi?' he said in reply to a question about water: 'The trajectory of movement is more clearly defined in water. I can follow the laws of space better in the substance of water which is dense and at the same time fluid.' Asked whether this trajectory indicated pursuit he replied: 'Naturally, life is a pursuit. It is not the goal that impassions me but the pursuit towards a creation, the value of which is indifferent to me.' The interview was illustrated by one of the first of his pictures to be inspired by the neighbouring rivulet and was captioned *Poissons de L'Escoutay*. It was painted in 1951 and bought the following year for the Tate. At the same time he began to use contrasting metallic colours (although he had experimented with these in 1929) in order to enable the spectator to obtain alternative views of the painting – a positive and a negative, so to speak – according to the angle from which he looks at it. From that time onwards, as many of their titles remind us, he was profoundly fascinated by water, fish and aquatic birds. This fascination was also expressed in a number of engravings.

Hayter's painting and engraving form essentially a single art, although they do in one respect differ. The engravings give greater scope for what has been called the whiplash character of his line; for the expression of convulsive energy by lines of a rare purity and rhythmic harmony. These linear qualities are achieved more readily with the burin than the brush.

Although his outlook remained consistent in his 'abstracting only in the sense of generalizing experience and not of restricting his field', he became preoccupied less with mythology and more with water, landscape and atmosphere, represented with a serenity of spirit which seldom animated his earlier work. Of his many qualities, perhaps the rarest was his power of transmuting some visual experience so that it was no longer specific but transformed into a general human experience, but, unlike most generalizing art, Hayter's was decisive, subtly arresting and exquisitely precise.

Hayter's complex and highly-charged imagination, scientific knowledge (and where engraving was concerned, a technical command) unapproached by that of any other artist of his time, his capacity to learn continuously from nature, from the masters and even on occasion from relatively inexperienced students, combined to create an art which is an enthralling combination of the ambiguous with the elegantly lucid. It is alive with a rhythmic vitality of its own. Two characteristic examples are *Chrysalis* (1970) and *Cheminements* (1971–72).

Since Hayter was so precisely articulate a man it is proper to accord him the last word about his art. In the brief preface to the catalogue of the exhibition of his paintings at the Grosvenor Gallery in 1967 he wrote:

> All our perception reaches us in terms of rhythm; the slow turn of the seasons, the beat of the heart, the microcurrents of the mind, vibration of waves of sound and light. Hence our adoption of a language of rhythm is justified. Some acquaintance with the sciences, the language of mathematics, is of aid to the painter and still more the pursuit of irrational consequences. Since the sciences have abandoned the pretext of disinterested observation of nature as impossible and absurd and have undertaken the study of the fluid patterns of understanding in the mind, the artist and the scientist have found common ground.

Not all these statements are of universal, and some not even of wide, application, yet together they illuminate the sources and the character of Hayter's art.

Many exhibitions of his work have been held, in Britain, France, the United States and elsewhere, the first at the Sacre du Printemps, Paris, and among the most recent, that of his new prints and prints by former associates of Atelier 17, held at the Oxford Gallery in 1981 to celebrate his 80th birthday. He was made a CBE in 1968.

CERI RICHARDS
1903 – 1971

As a man Ceri Richards was direct and accessible; as an artist he was elusive. The names Henry Moore, Francis Bacon, Victor Pasmore and Lucian Freud evoke clear-cut and solid images, even when, as in the cases of the last two, the 'early' is sharply distinct from the 'later'. But the name Richards evokes no such image, but rather a succession of images – some concrete enough, others ambiguous – difficult to envisage as a single entity. Critics accordingly were apt to treat him with circumspection. Two of them, both perceptive and well-informed, reviewed his achievement in substantial appreciations with contrary emphases: one upon the relief constructions of the mid-1930s and the *Cathedrale engloutie* paintings begun in the later 1950s, the other upon the 'organic exuberance' of the work of the intervening years. These differences are characteristic: Richards's work is widely admired but there is little consensus of opinion about its essential character. This diversity is not difficult to account for. As the spectator surveys in his mind's eye the long succession of Richards's works in many media, he sees images close to nature, others so remote as to border on the abstract, images that are massive and still, others in a state of violent animation; some of them of a rare originality and others directly absorbed from other artists (Richards was at times an avid borrower but far too honest a man to disguise what he borrowed in the least degree). In the face of such variety it is not surprising that critics, his fellow artists and others should focus on selected aspects of his work rather than on the diverse and elusive character of the whole. That there is an integral whole the spectator must, however imperfectly, be aware.

Ceri Geraldus Richards was born on 3 June, 1903, the eldest of the three children of Thomas Richards and his wife Sarah, born Jones, at Dunvant, a village about five miles to the west of Swansea. Thomas Richards was a rollerman in a small tinplate works nearby. Both he and his wife were Welsh-speaking, although they used many English words, and Welsh was Ceri's only language until he was five or six. Ceri's father was an avid reader of poetry, especially Welsh, who rehearsed poetry recitals and produced a number of English and Welsh plays, and was conductor of his Congregational Chapel's

choirs. Ceri responded early and ardently to his father's passion for music and poetry and became the chapel organist and played the piano at concerts. Music and poetry, especially music, remained lifelong passions often reflected in his art.

Richards's first ambition was to become an engineering draughts-man, which stimulated an early preoccupation with drawing. Draw-ing came easily to him and won him prizes at local eisteddfods. In the meantime he bought books on engineering draughtsmanship. He recalled his fascination when a mining engineer who lodged next door allowed him to watch him at work on plans; he was, he said, 'an embryo artist without knowing it'.

Although Richards was fascinated by drawing from childhood, he did not, all the same, think of his drawing as independent of engineering. It was otherwise with several of his friends: they did not presume to assess his talent, but they considered that, as he was always drawing, it was possible that he was intended to be an artist. Believing that he should at least be given a chance, they took him to see the Principal of the Swansea School of Art. In the meantime Richards had come to realize, and with intense excitement, that drawing was indeed his vocation and in 1920 he became a full-time student at the School.

The relative belatedness of this realization – considering his early and persistent passion for drawing – was due to his environment: his home and his country. If his had been a philistine home, it might, paradoxically, have come to him earlier. But it was a home in which there was an ardent interest in art – but it was directed exclusively at poetry, music and drama. For the Richards family these *were* art. Nor did his wider environment suggest otherwise. For a people so imaginative, so ready to communicate their emotions and ideas, so delighting in spectacles, the Welsh have produced surprisingly few painters of note and even these have drawn minimally upon Wales as material for their art. Richard Wilson, Augustus John and J. D. Innes indeed painted Welsh landscape, but so have innumerable English artists; 'sketching tours' through 'picturesque Wales' were frequent occurrences in the eighteenth and nineteenth centuries, taken, among many others, by Turner and Samuel Palmer. Wilson, John and Innes drew upon Wales only for a small minority of their subjects. David Jones – son of a Welsh printer and an English mother and a very infrequent visitor to Wales – in his illustrations to the Arthurian Legend was more expressive of the Celtic and the specifi-cally Welsh spirit than anything by Wilson, John or Innes. (Several of them, incidentally, have intimations of the landscape at Capel-y-Ffin in Breconshire, where Jones studied with Eric Gill in the mid-1920s.) But the Welsh subjects of these four illustrious Welsh artists afford

not the merest shadow of Welsh men or women, or the social and architectural environment, that they created for themselves. In Welsh painting there is nothing remotely comparable to Dylan Thomas's *Under Milk Wood*, that portrait, so brilliant, so racy, so witty, so touching and so quintessentially Welsh, of the many-sided life of one region of Wales.

The paucity of Welsh painting and the relative scarcity of painting of any kind, and therefore of concern with painting, almost everywhere in Wales, combined with the powerful presence of music, poetry and drama, explains Richards's belatedness in recognizing painting as his profession. While still at school he had met an artist who told him of the Glynn Vivian Art Gallery and the Swansea School of Art, but the information did not seem to strike a chord. Even when he had taken the decision to be an artist he 'did not know', to quote him, 'what great painting was'; he had made copies of reproductions of pictures by Sir Edwin Landseer and Lucy Kemp-Welch.

The teaching at the Swansea School of Art was arid, but the Principal, W. Grant Murray, quickly discerned Richards's talent and was instrumental, eleven years after he entered the school, in securing his first one-man exhibition at the Glynn Vivian Gallery. In 1923 he was one of a group of students who attended a summer school at Gregynog Hall, Newtown. This was conducted by Hugh Blaker (who advised Gwendoline and Margaret Davies on the formation of their fine collection of paintings), Fred Urquhart and Robert Maynard. The effect of this visit to Gregynog was transforming: 'I was staggered,' he said to me, 'by the sight of the superb Impressionist and Post-Impressionist paintings hanging on the walls, and the bronzes by Rodin. I was fascinated most of all by Monet. Imagine their effect on someone who'd dreamed of great painting but had seen none at all.' He listened eagerly to the talks about the Impressionists and their successors. He left Gregynog in an exhilarated state of mind.

The following year, 1924, he went to the Royal College of Art, remaining there until 1927. By this time his decision to be a painter was definite, but his preparation to enter the school of painting was inadequate – there being offered at Swansea only 'a derelict painting course which', he said, 'none took' – so he was placed in the school of design, from which the professor would not give him permission to transfer.

During his first term at the Royal College he was confused by the strangeness and variety of prevailing styles, having seen few important works later than the Impressionist and the few Post-Impressionist paintings at Gregynog, and he had at first no one to guide him through the labyrinth. One of the college staff, Randolph Schwabe, made him aware of Picasso and lent him books, including Apolli-

naire's *Les Peintres Cubistes*, which he read with avidity, likewise Kandinsky's *Concerning the Spiritual in Art*.

The award of a prize for drawing afforded encouragement to a still confused student – confused not on account of any deficiency of perception but by the intensity of his response to painting of many kinds. While at the Royal College he attended evening classes at the Westminster School of Art, where he was taught life drawing by Bernard Meninsky.

In spite of the zest of his response to life in London and the years he spent in English-speaking society, Richards remained very much a Welshman. He told me, for instance, that when my father (then Principal of the College) criticized his work or addressed the students, as he listened he used to translate the words into Welsh in order to have the fullest understanding of them.

Leaving the College in 1927, Richards was uncertain how to set about earning his living. Determined, however, to remain in London, he resisted an attempt by one of his former professors to induce him to take a teaching post in Liverpool. Through the influence of the distinguished typographer Stanley Morison he was commissioned to illustrate a book, *The Magic Horse*, stories from *The Arabian Nights*, which was published in 1929. The drawings were admired by a director of the London Press Exchange, where Richards was consequently employed as an illustrator for the year after he had left the Royal College.

At the College he had become friendly with Frances Clayton, a highly gifted fellow student, whose interests were in pottery and wall painting. They were married in 1929. The following year she gave him a copy of Florent Fels's book on Matisse, which heightened his interest in this painter's audacious use of colour and led to several portraits in the manner of the master. But by the early 1930s he was – to use his own expression – 'trapped by Picasso', especially by his draughtsmanship. For Richards it was an inspiring encounter. In 1933 he began on a succession of relief constructions which he continued to make through the greater part of the decade.

Ceri Richards, who had been so hesitant in recognizing his vocation and who had already won admiration at the Royal College, especially as a figure draughtsman, made, in the finest of these constructions, works comparable with the best of his English contemporaries. He destroyed the first few of them done in metal, but by 1934 the series of relief constructions in wood with paper, paint or metal was under way. Twelve of them survive.

These were primarily inspired by the wooden reliefs with collage made by Picasso during the First World War, but the variety of media that Richards used – wooden planks, pieces of newspaper and found

objects – shows that he was aware not only of the Cubists, but of the Dadaists and their preference for discarded material previously regarded as unfit for inclusion in a work of art, and the eerie originality of some of them, the very original *The Variable Costerwoman* (1938), for example, reflects his excited response to the London Surrealist Exhibition of 1936. (Henry Moore, from early days a consistent admirer of Richards's work, described him to me a few years later as the finest draughtsman of his generation.) As always, the sources of Richards's inspiration were undisguised; but as always, too, diverse influences were assimilated and fused into entities which were emanations of his own spirit alone. These constructions are more than personal: all are original creations of a rare order and unlike anything else done in Britain at the time. In them Richards not only attained maturity but a high place among his contemporaries.

With the last two the series comes to an impressive culmination. These are *The Variable Costerwoman* and *Two Females*, the latter begun in 1937, briefly abandoned, completed the following year and acquired in 1959 by the Tate Gallery. The artist said that it represents two contrasting concepts of the female form, the one virginal, the other reproductive or proliferating, the 'vegetable' or sexual aspect. Both constructions owe much to Surrealism: 'The Surrealist Exhibition of 1936 helped me to be aware of the mystery, even the "unreality" of ordinary things,' the artist said to me. 'It was there I saw Ernst's *Loplop présente une jeune fille*, and *Two Females* was made under its influence, and although less evidently by Picasso's *Femme en chemise* – but then I'm always stirred by Picasso.'

These constructions were admired by Mondrian and Arp, who were brought by Julian Trevelyan to Ceri's studio at 26 St Peter's Square, Hammersmith. Arp invited the artist to visit him in Paris; he felt honoured, but the visit never took place. 'I was not influenced,' he said, referring to Surrealism, 'by the uncontrolled, subconscious element, though I felt it bracing and adventurous, giving a sense of "barriers down". But the metaphysical element enthralled me.' The value of 'some sort of accidental quality', he freely acknowledged, gave him a heightened awareness. He deeply admired Ernst's work of the 1920s and 1930s. It was owing to his example that he used to drop string onto a wet canvas, not with the intention of revealing the workings of his unconscious mind but of exploiting accident to suggest ideas. The painting in which this procedure was most fruitfully employed is his fine *Paraphrase after Delacroix's Lion Hunt* (1944) in which the shapes made by the dropped string suggested this highly complex subject.

Confident that he was in no danger of becoming a disciple of any of them, Richards felt free to expose himself to a variety of movements,

among them Futurism. As his interest in the Surrealists was not excited by their preoccupation with the unconscious, so his interest in the Futurists was not excited (in spite of his abiding interest in engineering) by their obsession with machinery but by their sense of movement and glitter. However avid his interest in contemporary movements, Richards took from them precisely what he needed for the enrichment and diversification of his own vision and often disregarded those very elements which their practitioners regarded as crucial.

In the later 1930s he began to achieve a quality not conspicuous in these two strange and majestic constructions, namely colour. *Coster-woman* (1939), for instance, reveals a muted harmony of many colours and tones that gives the fantastic figure a mysterious and compelling quality. *Flowers* (1938), although without the exuberant fantasy of *Costerwoman*, is marked by a similar muted harmony of colour and a composition strangely combining ambiguity with lucidity.

Of the many prevailing movements, there was one that did not touch him: abstraction. 'Subject is a necessity,' he flatly declared. 'Working through direct from visual facts to a more sensory counterpart of reality of my subject I hope that as I work I can create later on an intense metaphorical image for my subject.' The effect of this procedure is often one of exuberant proliferation of the subject rather than abstraction from it. The remoteness of his art from an impulse so powerful and so pervasive that many people treat it as virtually synonymous with the basic 'progressive' movement of the century, accounts in part for the respectful ambiguity with which the art of Richards has often been treated by the critics. *The Variable Costerwoman* and *The Costerwoman*, and other works with a similar theme, fantastic although they are, were based upon a number of drawings, some of them detailed, that he made of costers in the early 1930s, in particular of a Pearly King and Queen whom he sought out and persuaded to sit for him. He was in fact circumspect about the effects of too exclusive a reliance on the imagination. He assiduously maintained the equilibrium between fact and imagination by close observation of his environment, by making still-lifes, portraits and an occasional landscape in which he intensively probed the complexities of natural form.

By the late 1930s Richards had shown, in the constructions and paintings referred to and a number of other works, rare imaginative power and technical mastery. Although the significance of his achievement was not widely understood, it was recognized as a contribution to the modern movement that gathered momentum in Britain in the 1930s. Besides being given the exhibition in Swansea, Richards was invited to show with the Objective Abstraction Group

at the Zwemmer Gallery in 1933, with the Surrealist Group in 1936 and 1937, and in the latter year was elected a member of the London Group. Then the war came, disrupting his creative life: he taught design and book illustration at the Cardiff Technical College from 1940 until 1944; he served in the Home Guard and worked for ten months on the land. In Cardiff he felt isolated and lonely and was happy to be back in London in 1944 where he settled in 1945 at 54 West Side, Wandsworth Common, moving in 1958 to 12 Edith Grove in Chelsea where he lived for the rest of his life. 'But throughout the war,' he said, 'I painted between times.' He painted in fact to such good purpose that he was given his first London exhibition at the Leger Gallery in 1942 and a second – the first of nine – at the Redfern Gallery two years later.

The response of British artists to both world wars was ambivalent. When they were commissioned to represent aspects of them they made some of their finest works; when they were not commissioned, war was a subject which they mostly ignored. Although it had little appeal for Richards, he showed his independence by making a few paintings about war in 1939 and 1940. Characteristically, the theme he chose for the most important of them, *Blossoms* (1940), had been germinating in his mind for several years. Indeed it was originally suggested by an incident in a previous war. *Blossoms* was bought by the Tate from his exhibition at the Leger Gallery and in response to a request for information about it he wrote on 30 November, 1958:

> I remember the impression made on me when I read a description (brutally factual but observant) by a well-known Italian [Count Ciano] about an air attack on Abyssinians during that unprovoked war, and the title 'Target Blossom' stems from these impressions and later ones, when air bombardments broke out here in earnest. These paintings, obscurely maybe, make flowers into explosions or vice versa, aeroplanes look like insects, aggressive plants and an incendiary sun rises over the landscape.

Two related works in the same exhibition, an oil painting and a drawing, were more explicitly titled *Target Blossom*, and others, *Incendiaries in a Landscape* and *Explosive Plant*. Another painting on a similar theme was *Falling Forms (Incendiary Landscape)* (1944).

Besides celebrating peace and his re-establishment in London, Richards found the big exhibition of Picasso and Matisse – both already long and ardently admired – held at the Victoria and Albert Museum shortly after the war, an exhilarating occasion, which launched him into a second period of intense creativity.

Musicians and musical instruments had been the subject of many of Richards's pictures ever since he began to paint in the late 1920s, but after the war he returned to them with enhanced delight,

expressed, for instance, in *Interior with Figures and Piano* and *Interior with Violinist and Pianist* (both 1946), in pen, ink and watercolour, also *Cold Light, Deep Shadow* (1950), as well as an interior with two figures seated by a piano, and *Interior with Music by Albeniz* (1949). This last clearly reflects, too, particularly in its colour, the effect of the renewed spell of response to Matisse resulting from the Picasso-Matisse exhibition. (From a distance it might almost be a Matisse, but the figures on the wall, related to those in his series of paintings, *The Rape of the Sabines*, begun two years earlier, identify the artist.)

Such works as this and the closely related *Red and Green Interior* (1951–53) led naturally to one of Richards's major achievements, the *Cathedrale engloutie* series. Musical themes figure frequently in his art; indeed it is doubtful whether music has played so large a part in the work of any other painter of this century. He continued to play the piano and while he was a student at the Royal College he served as organist on Sunday mornings at the Catholic Church in Wandsworth Bridge Road. Pianos and musical scores feature constantly in his paintings and drawings and even in one of his constructions; in the 1950s he made sequences on *Homage to Beethoven*, *St Cecilia*, and a *Hammerklavier* theme. The *Cathedrale engloutie* series, their culmination, begun in 1957, illustrates Debussy's music on the theme of the Breton legend about the cathedral of Ys which had sunk into the sea but on calm days rose up to the tolling of bells and the chanting of priests, and then sank once more into the depths.

The element of metaphor marks many of Richards's paintings, but nowhere, I think, more consistently than in this series. None, in effect, are remoter from the actual world. The sea is a constant element, in which violence contrasts with calm. In the chalk and wash study of 1961 the rippled surface is explicit, but in most of the others, especially the sombre, impressive triptych, *Augmentez Progressivement* (1960–61), the spectator is aware chiefly of the conflict and interplay of powerful natural forces, although rose windows may be seen rising from the sea. Others afford glimpses of pointed gothic arches, piano keyboards, sea-worn bases of columns, blocks of masonry and the remote seabed. Of those alluding to masonry is *Circular Bases* (1961). The artist wrote a letter to the Tate Gallery about it that throws light on his method: 'These canvases are hardly completely complete – I never know how many manifestations of painting acts a canvas should have on it – there is always another shot at achieving the right number of marks for the right occasion.' This suggests that it was not only Richards's obsession with successive themes that impelled him to make series of paintings of them, but the sense that each one represents a stage in the search for – to quote from the same letter – 'the successful mutation', the most precise, the most intense 'meta-

phorical image' of his subject. The *Cathedrale engloutie* series is wide and various: in one of them, a gay relief construction and collage (1960), real bells tinkle as they seem to float on the surface of a tranquil sea.

Richards's obsession with his subjects and the urge to explore them more and more deeply was often, then, expressed in successions of paintings, drawings or constructions. Another of these subjects was inspired by his admiration for the poetry of his fellow countryman Dylan Thomas, whom he met on only one occasion when he visited his house at Laugharne in 1953, not long before the poet's death. Richards enjoyed the meeting in spite of the tension between Thomas and his wife, who was critical of his impending visit to the United States – which resulted in his death – so that both were almost silent. Dylan Thomas's poetry inspired a number of paintings as well as a dropcloth, *Homage to Dylan Thomas*, made for the Memorial Reading organized by *The Sunday Times* and given at the Globe Theatre, London, on the evening of 24 January, 1954. For this he made several designs; one, at the Tate, is in crayon, ink, gouache and cut-paper collage.

But the most impressive of the works inspired by Thomas, the last of three oil paintings illustrating his *Do not go gentle into that Good Night*, was made two years later and also belongs to the Tate. Richards was asked by John Berger to make a drawing based upon the poem – written for his father – and he made several others. It was at Berger's suggestion, who admired the drawings, that Richards undertook the Tate's painting.

Although Richards's admiration for Dylan Thomas's poetry was intense, and for this poem in particular, he was no more willing to interpret it literally than Blake was Dante's *Divine Comedy*. He did not accept the validity of the injunction to 'Rage, rage against the dying of the light', which, he conceded, might be an injunction to protest, but instead chose to interpret it as an affirmation of the futility of protest. His figure does not represent, as has been supposed, an old man, perhaps the poet's father, but, he declared, 'just man – the poet maybe', for the owl is holding a shroud (which in some preliminary drawings is covered with handwriting) and from this shroud the figure falls into the deep unknown. The man, already a corpse, does not – or cannot – rage, as the poem commands, but falls helplessly into the Night, while the owl flies off with his winding sheet.

Richards, I believe, painted nothing more moving than this. It is not surprising that he should have responded so ardently to Dylan Thomas, certain of whose poems, especially *Under Milk Wood*, express the Celtic spirit and give a memorable picture of Welsh life. Richards did not portray Welsh life, perhaps because he did not live his

creative life in Wales, but in his work the Celtic spirit flowers as it does in the poetry of Thomas. The close affinity between painter and poet – of which the painter was aware from the moment he came to know the works of the poet – has often been remarked, in particular the preoccupation of both with what Richards termed 'the cycle of nature' – birth, love and death – and their subtly exuberant imagery.

Although the theme of birth, love and death had long preoccupied Richards, the series of paintings entitled *The Cycle of Nature* – like so many of his works – was undertaken as a result of exterior prompting. In 1955 the Contemporary Art Society commissioned a number of artists to paint pictures representing 'The Seasons', which were shown at the Tate Gallery that year. Richards titled his contribution *The Cycle of Nature*, which he himself described as one of 'two attempts to include the sequence of all four seasons, Birth, Life, Death Cycle – if you like . . . interpreted figuratively and by the sonority of colour'. This painting was followed by others, one of which, wrote the artist, 'expresses this cycle more obscurely (maybe) and more interestingly by colour', and still others, of a more formal character, in the mid-1960s. 'Underlying everything that Richards touches,' Bryan Robertson perceptively observed, 'is a tough, wide-eyed, almost innocent awareness of the fundamental elements of human existence', words particularly applicable to *The Cycle of Nature*. Another series, but one which allowed less scope for the exploration of these deeper preoccupations, was promoted by a collective commission of a similar kind. In 1950 the Arts Council, by way of celebrating the Festival of Britain to be held the following year, commissioned sixty artists to make pictures for an exhibition 'Sixty Paintings for '51'. For his subject Richards chose Trafalgar Square. After the painting (made the previous year) had been acquired by the Tate he wrote a letter about it to the Gallery (14 July, 1959) which throws light on his procedures:

> I made numerous small notes from and away from the motif – in order to discover the inner themes, and also to feel the appearance of some sort of dynamic rhythm in design – to find ideas for shapes and spaces and movement – after involving myself in these ideograms for some time I then painted instinctively straight on to the large canvas – colour was resolved as design created sense of reality. Everything changed in many ways, the all-over blueness, as well as being used spatially and achieving simplicity in the saturation quality of blue, was finally an expression of the all-over greyness of the Square itself.

Richards was an artist with an insight into a wide variety of subjects and for each he had an appropriate technical method. It would not be easy to think of works by the same artist more different than the constructions of the 1930s, with their fantasy and detachment, their static, and, at their best, majestic character; and the series made in

the following decade of the *Rape of the Sabines*, expressing a surging erotic violence. Yet each expresses an intrinsic aspect of a vision which, however various its manifestations, was fundamentally consistent. It is a vision which was constantly preoccupied with both the natural world in itself and as interpreted by the poet and the musician. 'A subject,' Richards stated on more than one occasion, 'is a necessity.' He himself lucidly defined his procedures (I quote again from his letter to the Tate):

> Discovering a subject – which for me means one that haunts me – I make masses of the speediest notes to catch at all sorts of evocations. This foraging is stimulating because the speed of drawing spills out a spate of unpredictable images . . . I take advantage of all my experiences of events or objects, and to use the observational faculty in the graphism of drawing is of special delight and importance to me . . . Working through from visual facts to a more sensory counterpart of reality of my subject I hope that as I work I can create later on an intense metaphorical image for my subject. Temperamentally I feel attuned to the movement and dynamism that lies in nature and events, and in my forms I like to realize this subtlety and complexity.

Richards's work, in its remoteness from both realism and from the academic tradition, has long been accorded an honoured place among that of the avant-garde but it is nevertheless, despite its profusion of features drawn from or suggested by other pioneering artists, independent of any movement. His place there is ambiguous. Few generalizations about art, especially about art as various as that which flourishes today, are valid and none is of universal application. It is, however, more often, far more often than not, characterized either by a total exclusion of natural phenomena or by a radical formalization. In short, it is either abstract or reductive of natural phenomena to highly simplified 'equivalents'. Richards's art is, of course, not abstract, and rarely one of simplification. On the contrary it reflects the artist's passion for the 'movement and dynamism that lies in nature and events' and as he worked 'through from direct visual facts to a more sensory counterpart' of his subject, the subject grew in animation and complexity. The longer he pondered a subject the more perceptive he was of its subtleties of form, and of its sheer profusion. Figures and objects blossomed under his hand (which does not mean, as in *Do not go gentle into that good night*, that the blossoms may not be sombre). It is the strange combination of ebullience, sparkle, animation and profuse complexity with obliqueness and metaphor, often obscure although never illegible, that makes Richards's art one of the most elusive but one of the most fascinating of our time.

Just as Richards was attracted and exhilarated by a wide variety of

masters, most conspicuously Matisse, Picasso, and Ernst, as well as by movements such as Cubism, Surrealism and Futurism, so too was he proud to regard commissions as incentives to invention and exploration. In one instance at least he was prompted by a commission to achieve a noble simplicity, a quality not conspicuous in his work since the constructions of the 1930s. (Some of the *Cycle of Nature* paintings of the 1960s and some others appear to share this quality, but if their forms are sometimes simple their meaning rarely is.)

A commission to which he responded wholeheartedly was to design the tabernacle, reredos and two windows for the chapel of the Blessed Sacrament in Sir Frederick Gibberd's Catholic Cathedral of Christ the King in Liverpool, consecrated in 1967. This evoked in Richards a capacity, minimally apparent before, for classical design. All these, in particular the reredos and tabernacle, are austere and grand. Richards, like Moore when he was given his first ecclesiastical commission in 1943 to make his *Madonna and Child* for St Matthew's Church, Northampton, was greatly concerned to create figures which, without sacrificing any conviction of his own, would be acceptable to the congregation. It was not Richards's first commission of the kind, which was to paint an altar frontal for the chapel of St Edmund Hall, Oxford, but the Liverpool commission was a far more ambitious undertaking. He combined and brought into being a tabernacle, reredos and a pair of windows of rare beauty – and in startling contrast to the garish shoddiness so widely prevailing in ecclesiastical art. (There are, of course, other notable exceptions, such as the cathedrals of Coventry, Chichester, and Westminster, as well as Liverpool itself, Campion Hall, Oxford, St Aidan's Church, East Acton, and elsewhere.) In another branch of ecclesiastical art, the design of vestments for Chichester Cathedral, he was free to work in his accustomed animated, scintillating style. Yet they reflect a glowing purity appropriate to the sacred office of their wearers.

Much of Richards's later work shows a greater simplicity of both form and colour, expressing, among other themes, equilibrium or tension between conflicting or contrasting entities: stability and flux, flowering and decay, the male and the female, or the seasons.

At a time when a predominant aim of many of the most serious artists active today is the reduction of natural phenomena and ideas to their simplest 'equivalents', the pervasive metaphor, and the ambiguity of much of Richards's work – which often calls for close scrutiny if its themes are to be fully understood – the zestful delight in complexity and exuberant proliferation evident in much of it, place it outside the main current of creative art. But it continues to command the same admiration that it won in the 1930s and, in addition, it becomes ever more widely understood and more intensely

enjoyed. Richards's achievement is formidable in its volume and variety: besides numerous paintings and innumerable drawings, and many prints and book illustrations, he made mural decorations in 1937 and 1954 for ships of the Orient Line, the Shakespeare Festival in 1965 and the Europa Hotel, London in 1951; costumes and décor for the English Opera Group's productions, Berkeley's *Ruth* in 1956 and Britten's *Noyes Fludde* at Aldeburgh in 1958.

Richards's work is a compelling harmony of qualities various and even, in other contexts, contrary: metaphor and reality; lucidity of form and its exuberant proliferation – a cycle of nature ardently explored, gravely meditated, and ambiguously recreated for the delight of the observant eye.

On 6 July, 1971 Ceri and Frances came to a dinner given by our son-in-law and daughter to celebrate my imminent birthday. I never remembered him in higher spirits: he charmed his fellow guests with his wise, gentle humour accompanied by his light, crackling laughter. Saying goodbye he invited us to dinner 'any time'. I had to explain that we where going shortly to New York, remaining there until Christmas. There, in November, opening a London *Times* in a club, I was grieved to read of Ceri's death. It appeared that, returning from a holiday in September, he was disturbed by the spread of weeds in the garden, rooted out a number of them, and suffered a heart attack which made him depressed and listless. He had been engaged on a series of seven lithographs, illustrating Roberto Sanesi's *Journey towards the North*, to be published in Milan in Italian and English. (Sanesi, an ardent admirer, was also making a catalogue of his prints.) Ceri's state of mind had caused him to work only intermittently. On 9 November Frances encouraged him to make the last plate of the series. This he did – and shortly afterwards died from another heart attack on the same day that Dylan Thomas had died, the fellow countryman whom he so greatly admired and with whom he had so much in common.

EDWARD BAWDEN
born 1903

Among the British artists of the present century Edward Bawden is one of the rarest versatility: I doubt whether there is any medium he would not be ready to use should the occasion arise. But what is more remarkable is the outstanding quality he has achieved in all of his works. In fact, after obtaining his friendly permission to devote a chapter to him in this book, I had more than a moment of doubt as to my ability to do even a modicum of justice to achievements so extraordinarily wide-ranging.

The Bawden family was originally Cornish: Edward's grandfather was a copper miner at Caradon, near Liskeard, where his son became an assistant in an ironmongery business. He moved to Bury St Edmunds where he married the daughter of a gamekeeper and then to Braintree, Essex, where he re-established his business. Edward, their only child, was born on 10 March, 1903 at 11 Woodville Road, and attended the Braintree High School at the age of seven, but he made no progress. 'Born and bred', he says, 'to go into the ironmongery business, but I had no interest in nails and screws.' Even the art classes failed to arouse his interest. He was a total academic failure, but in his own time he began to draw, copying illustrations from magazines, among others Louis Wain's cats in *The Girls' Own Paper*.

In view of his repeated failures his parents decided to send him to a school of a different character, namely the Friends' School at Saffron Walden, founded by the Quakers in the seventeenth century and re-established there in 1879. It was an enlightened and cheerful school where no punishments were inflicted. Edward was happy but still showed no academic promise. At the age of eleven he strained his heart in the swimming pool. From this misadventure he derived benefit, however, for the inability to play strenuous games gave him wider opportunity for drawing than he would otherwise have enjoyed. But he still showed no academic promise. He spent most of his leisure time copying, 'because,' he says, 'by copying one remembers things.'

In the meantime he had nevertheless impressed both staff and fellow pupils with his artistic ability. The headmaster suggested, and his parents readily agreed, that Edward should spend one day a week

at the nearby Cambridge School of Art. He was then fifteen; a year later he became a full-time student. Here he specialized in calligraphy with such success that in 1922 he was awarded a Royal Exhibition Scholarship at the Royal College of Art, where he remained for three years. They were momentous years. He studied calligraphy with one of its foremost masters, Edward Johnston, who evoked Bawden's high respect, but not for some reason, his enthusiasm, and at the end of the first term he ceased to attend his weekly lectures. This was due primarily to the fact that he felt no desire to become a professional scribe, but also to the proximity of the Victoria and Albert Museum, which gave wide-ranging opportunities for studying typography, in particular the works of William Morris, whose Kelmscott books evoked Bawden's lifelong admiration. It was an admiration widely shared at the College. Bawden still feels particularly indebted to E. W. Tristram, the great medievalist – more than to any other member of the teaching staff – on account of his rare learning and capacity for imparting it to his students.

When my father was Principal of the Royal College I came to know Bawden and Ravilious, besides a number of other students there. Bawden is apt to attribute to my father a critical attitude towards his drawing, but I remember his expressing admiration for Bawden's work – and for him 'work' meant primarily 'drawing' – and also his liking for the student. In his *Men and Memories* my father refers to a number of his students, including Bawden and Ravilious (as well as Bliss and Henry Moore) as 'gifted in so many directions'.

It was at the Royal College that Bawden established with Eric Ravilious – a fellow student whom he met on his first day – the closest and most fruitful friendship of his life. Bawden and Ravilious could hardly have differed more markedly in temperament. Bawden took no part in the entertaining social life of the College; nor did he read a newspaper, listen to music or play a game; but his response to architecture, literature and book printing and binding was highly perceptive. Ravilious – his friends disliked the name Eric and called him 'the Boy' – was as sociable as Edward was shy, and he could dance and whistle. As artists, however, the two had much in common, which enabled them, when occasion arose, to collaborate with rare harmony. In spite of their ability to collaborate and the qualities they had in common, it is difficult to compare them in view of Ravilious's death at the age of thirty-nine, but I consider that he was at least as highly gifted as Bawden and, despite his sociability, had a formidable capacity for work. A splendid memorial to their friendship is Ravilious's portrait of Bawden, now at the Royal College.

Of Bawden's student years Douglas Percy Bliss, who knew him far better than I (I had a serious disadvantage in that I was away from

London at term time) gives this evocative description in his biography of the artist:

> We were supposed to breakfast together. [For a short time Bliss lodged with Bawden.] Bawden was always down before me and would be sitting stiffly at table, reading as he ate. He did not look up as I entered. His social temperature was near freezing point in the morning. . . . When I announced that it was a good morning or otherwise, he would go on chewing slowly, his eyes on a book and would only murmur: 'Is it?' . . . So I took notice of what EB was reading. I remember that he went steadily through *Anna Karenina*, Fergusson on *Architecture* and Jackson's *History of Wood Engraving*. He read to learn, unlike Ravilious who read for fun and whose favourite book was *Huckleberry Finn*. Once or twice I found EB deep in an article on ironmongery and hardware . . . which he would recommend to me . . . 'as good sensible stuff'. . .

The shy, reticent – yet on occasion startlingly candid – Bawden early manifested the qualities which were to mark him always: rare versatility in both subject and technique, rare clarity of his aims – both short-term and long – and an immense capacity for work; without positive occupation he was manifestly restless. And he was of a rare precocity: for instance it was a time of intense interest in posters and book illustration and while still a student he was designing posters for the London Underground. It is no exaggeration to say that he was adept at every two-dimensional art – and I remember some of his fellow students expressing surprise at his lack of response to distance and solid form. Remarkable, too, were – and are – his letters, wide-ranging in content and calligraphically elegant.

The culmination of Bawden's three years at the Royal College of Art was the award, after taking his Diploma in book illustration in 1925, of a travelling scholarship.

Leaving the College the following year (both he and Ravilious immensely enjoyed life at the College and left with reluctance), Bawden visited Florence, San Gimignano, Siena, Venice, Arezzo, Rome, Pompeii and several other places. Sophisticated as he was, well-read and familiar with the masters, the country boy at times experienced something of a shock, which may account for his indifference to, even boredom with, works he would later have admired, such as the Sienese in the Pinacoteca. But certain works – Duccios and Simone Martinis in Siena and Piero della Francescas at Arezzo – moved him deeply. Bawden inclined to be austerely reserved and in Italy felt not only lonely but also an imperative need to return to England and his ever-present urge to work. In one of his letters to Bliss he says: 'Lord, how I long to work – to reveal Inspiration, to satisfy Restlessness, to delight in Industry and above all to keep the foul fiend Ennui at bay.'

Back in London Bawden returned to his residence at 58 Redcliffe

Road. A letter to Bliss dated 22 December, 1926 is admirably expressive of his dry humour, his highly personal style and his elegant calligraphy. Someone lacking the privilege of his acquaintance might well regard the letter as a rarity but this is not the case, although, like everything else he wrote, it must have required a high degree of concentration.

> Of Bawden |referring to himself in the third person| I have seen far too much. He is, I imagine, one of the worst bores in Redcliffe Road and belongs to that vicious section of those who move continually round themselves. From his prattle I gather that he has been a success at Brook Street during the present exhibition of Applied Art and that the Underground has commissioned him to make a series of Press drawings on the lines of those he did for the Westminster Bank. Curwen is in the business as well for the typography and printing. Bawden tells me that some designs for painted furniture which he did for someone or other have been accepted with no end of cheering. Of course you can't believe the fellow much, he is so dashed immodest and conceited. . . .

The reference to 'Curwen' is significant: it is to Harold Curwen, who inherited the Curwen Press, established by his grandfather, and took over its management just before the First World War. In her highly informative book, *Artists at Curwen* (1977) Pat Gilmour describes the Press when Harold became manager as one in which 'visual qualities were apparently of little consequence' and a 'visual wilderness that Harold Curwen transformed'. He 'loved artists about the place and was never happier than discovering men of talent and giving them commissions'. Joseph Thorp, his printing consultant, said that it produced the best business printing in England: 'simple, direct, distinguished, intelligent, individual and adventurous'.

Bawden wrote to me that,

> I came to London at the right moment, at the time when the revival in printing was in full swing and at once I was captivated by the new illustrations fostered by Harold Curwen and produced by Lovat Fraser and Albert Rutherston. Instead of doing copy-cat work in the manner of Aubrey Beardsley, and pretty poor stuff at that, I fell flat on my face for Paul Nash – a period unequalled for intense excitement as the modern movement became manifest in painting, architecture and printing. For me it was a period of rapid development. My first three illustrated books were failures, then the Ambrose Heath cookery books helped me slowly to stand on my feet – since then I have tried to do suitable illustrations to a succession of books that include parts of the Bible, the *Histories of Herodotus*, Malory's *Morte D'Arthur*, *Salome* by Flaubert and Johnson's *Rasselas*.

Bawden's first undertaking for Curwen was in 1925, to illustrate a booklet entitled *Pottery Making at Poole* which he did while still a student at the Royal College. It was followed by many others – allowing for his wide-ranging inventiveness – of a similar character.

The admiration these evoked inevitably resulted in their example being followed by many other artists, often of a very high order. In consequence the originality of Bawden's works of this character tend to be forgotten. Their subjects seem at first glance to be represented so simply, but at a second with subtlety, originality and wit. These and other qualities were instantly recognized by Curwen, and this recognition was soon widely shared. Something of the perceptiveness and range, even in quite early years, of Curwen's patronage can be gathered from the catalogue of the 1929 exhibition of books printed at the Curwen Press.

Among Bawden's particularly accomplished prints – to note a few among a large number – are *Hyde Park* (1925), in six colours and *Changing the Guard* (1925) in seven, both posters for the Underground; *Theatre* (1928), a line drawing and press advertisement for the Underground; *Homage to Dicky Doyle* (1931), a drawing to show the use of colour applied by stencilling, for the Curwen Press; two lively advertisements, *Ashby-de-la-Zouche but Shell sur la route* and *Stoke-on-Trent but Shell on the road* (both 1932); *The Battle of Quadisye* (1947), a lithograph in four colours for *The Arabs*; two copper-engraved menu covers for the Orient Line (1950); *Brighton Pier* (1958), lino cuts in six colours, and *Take the Broom* (1935), a lithograph in four colours from Bawden's own *Hold Your Teeth*. These have been selected not only for their excellence but for the extraordinary variety of their spirit. All are conspicuously the work of Bawden, yet no two of them – other than those forming a series or a pair – closely resemble one another. Few artists today – even those working in a variety of media – have created so variously as he.

The most recent of his book illustrations, which accompany a text by Thomas Hennell, have a very strange history. But before briefly recounting it, mention should be made of a major event in Bawden's life, namely his marriage in 1932 to Charlotte Epton, a fellow student at the Royal College – a gifted artist and potter, a person of lively charm and later the mother of two children; she was also a Justice of the Peace. They rented a flat by the river in the Doves Passage, Hammersmith, living there only on teaching days, but mostly at Brick House, Great Bardfield – not far from Edward's native Braintree – which his father gave them as a wedding present. Before long it was embellished by treasures of many kinds, including discerningly chosen Victoriana. Brick House had been shared with Ravilious for weekends since 1932 when they discovered it and briefly after his marriage.

On the outbreak of war in 1939 Bawden, as did Ravilious and Hennell, offered to serve as a war artist. The following year he was sent to Belgium. Before leaving Bardfield he stored much of his work,

including the illustrated manuscript, at the bottom of a well in the garden, where it remained until the end of the war. It continued, however, to be neglected until the autumn of 1979 when two exhibitions of Bawden's work were being planned. One of these exhibitions – of his book illustrations – was being organized for the Fine Art Society by Peyton Skipwith. 'When I saw them' he wrote, 'their potential for publication struck me so strongly that instead of including them in the exhibition, thus risking their dispersal, I asked Bawden whether a copy of the story still existed. A few days later I received from him Hennell's tattered typescript'. The result was the publication, in 1980, of *Lady Filmy Fern*, or *The Voyage of the Window Box*, with Hennell's text and Bawden's illustrations (these added to achieve a balance between picture and text) and a brief but illuminating introduction by Peyton Skipwith. The result is a minor classic, illustrations and text combining in a fantasy, highly original yet in the tradition of Lear and Carroll, in whose works Edward always delighted.

Interest in mural paintings received a sudden stimulus in the mid-1920s from the decoration of the Tate Gallery restaurant with a series of murals by Rex Whistler – *In Pursuit of Rare Meats* – which aroused instant and widespread admiration. I remember how warmly my father, always interested in mural painting, responded to it. In Volume III of his memoirs, *Since Fifty*, he wrote that 'Mrs Hubback, The Principal of Morley College ... inspired no doubt by Rex Whistler's entertaining paintings, approached Hubert Wellington (Registrar of the Royal College of Art) and myself with a view to having the College Refectory and Concert Hall decorated. Cyril Mahoney prepared a noble cartoon for the Concert Hall, while Edward Bawden and Eric Ravilious made designs for the Refectory. Morley College had long been associated with the Old Vic Theatre, hence I suggested subjects from Shakespeare would be appropriate. Bawden and Ravilious accordingly made a series of enchanting designs from Shakespeare's plays, also from some of the earlier miracle-plays.' These they carried out directly on the plaster, using, on the advice of Tristram, a mixture of oil paint and beeswax, a sticky medium not easily handled but having the reputation of being permanent. 'I was particularly struck', to quote my father again, 'in both Bawden's and Ravilious's interpretations of the Shakespearian plays, by the element of fantasy and invention in the costume of their players ... I think of the inventive fertility of the seventeenth-century productions of Corneille's and Racine's classical tragedies ... In the paintings at Morley College there is something of this entertaining spirit.' The decorations were 'opened' by Prime Minister Stanley Baldwin, and

received with wide acclaim, but they can no longer be seen, for in 1940 Morley College was destroyed by German bombs.

Some eighteen years later Bawden – Ravilious was no longer alive – undertook the painting of another mural in the rebuilt restaurant. It was radically different in character from the first, which was aerial and lyrical, the figures being lively things from a fairy world. The subjects were chosen from Chaucer's *Canterbury Tales* – the Knight's, Squire's, Nun's, Priest's and others, who are formal, static, virtually heraldic, lucidly and logically composed. Bawden had moved from the Romantic to the Classical.

In the first of the two Morley College murals it was hardly possible to distinguish Bawden's from Ravilious's, so close had been their collaboration, yet, paradoxically, neither had sacrificed an iota of himself to achieve it; in the second also Bawden remained entirely himself, conspicuously distinct from his collaboration with Ravilious.

The most ambitious of Bawden's murals is that which British Petroleum commissioned him to paint for the staff restaurant at Britannic House in the City of London in 1966. It is immense – his largest work; the sources of its inspiration are Isfahan and Shiraz. To enable him to see these places, Bawden was sent on a tour of Iran, which, ever since his wartime service in the Middle East, he had ardently hoped to revisit. The resulting work is a highly complex representation of Persian-Saracenic architecture, for which three assistants were required. This mural demonstrates Bawden's rare ability to carry out, with confidence and efficiency, work of a character he was unlikely ever to have envisaged.

Bawden had painted another mural, also highly complex and which exemplified his resource, for the Lion & Unicorn Pavilion, in the Festival of Britain Exhibition on London's South Bank in 1950. The exhibition's theme was 'British Character and Tradition' and his subjects were those aspects of country life which moved him most deeply. Here again the undertaking was on such a scale that he required assistance. The work consisted of twelve free-standing panels, high and narrow, arranged like those on a folding screen, none flat against the wall. The surfaces of the panels facing the side walls and catching the light were painted in lighter tones than the other surfaces, which were in shadow. The nature of the screen arrangement of the panels set the artist a difficult and most unusual problem: each panel could be read upwards but the whole screen could also be read crossways. There were many buildings, churches, chapels, great houses, railway stations and much else in the mural, but no landscapes, trees; there were no figures but birds and beasts (crows and cows). It is indeed melancholy that it was destroyed.

The most recent and entertaining of his murals is *Edward Bawden's*

Oxford, made for Blackwell's Bookshop, Oxford, in 1972 and 1973. It consists of three large panels and portrays illustrious personalities – and a few others – associated with the University: some stand on the ground, others fly above, while yet others stand on the tops of historic buildings, including the Radcliffe Camera, All Souls' and Magdalen Tower. Personalities and buildings are approximately contemporary: the six wives of Henry VIII are framed by the windows of Magdalen Chapel; among those in front of the Radcliffe Camera are Dr Johnson, Boswell, Locke and Wesley, and a massive Charles James Fox stands on the back of a small horse, while Radcliffe floats in the sky. In front of Keble are the Duke of Wellington, Gladstone and Shelley, and on a rooftop Keble himself swinging a censer; while among the busts on the Sheldonian are several contemporaries, including, very appropriately, Sir Basil Blackwell. Like all Bawden's murals it is radically different from its predecessors; it combines a lively humour with historic perception. 'Figures appear in the sky,' he wrote, in a letter to me, 'because to a designer it sometimes seems necessary to spread spots of interest, tapestry fashion, more or less evenly over the whole surface of a mural. The surface, unlike that of most murals, is not flat against the wall but projects and recedes slightly, by a few inches only, to create a division that is not too obvious between the different historical periods: medieval, tudor, 17th C. & Victorian.'

The murals briefly described are a few among a considerable number, which include three for the ocean liners *Orcades* (of English gardens), the *Oronsay* (of English pubs) and *The Empress of France* (with prints from linoleum cuts).

This most versatile of artists was also a designer of wallpapers. Bawden made the first of these between 1925 and 1928, primarily inspired by Morris's 'Daisy' design which he saw at the Wembley exhibition in 1923. In his bedsitter Bawden cut small lino blocks with a penknife, stippled them with oil paint and pressed them by foot onto lining paper laid on the floor, moving the blocks around to build up patterns. Paul Nash encouraged him, introducing him to Elspeth Little who had opened a shop in Beauchamp Place. It was Harold Curwen who had found a means of transferring impressions from the lino blocks, about which he informed Bawden, who then ran them off on separate sheets like posters. These patterns sold moderately well. In the mid-1930s Oliver Simon commissioned him to make four designs. By this time his experience as a mural painter had convinced him that wallpaper should have a distinct mural character.

Bawden's ultimate urge to design wallpapers was brought about by his collaboration with John Aldridge, who, although primarily a landscape painter, was an occasional, although talented, wallpaper and textile designer. Full-size blocks were cut, printing was done in

distemper and pressure applied by standing on each block. However 'crude and amateurish' – which is how I have heard Bawden describe this procedure – the results were the reverse. When several designs were printed in short lengths and sent to an exhibition in Braintree, their quality was immediately recognized by the managing director of Coles, who happened to be passing through the town. The company took over the blocks – although they had to be recut – and for many years the wallpapers were on sale in Coles's showroom in Mortimer Street. One of Bawden's patterns was chosen for a furnished room shown in the 'Britain Can Make It' exhibition at the Victoria and Albert Museum.

Remote from the rest of his work are the watercolours Bawden made during the war – so remote that neither he nor his intimates could have envisaged them. They are well-known and widely admired, yet the products of a period of his life shrouded by an aura of mystery. The basic facts are indeed recorded but it is isolate from the rest of his life, and he has never written a description of the period and rarely refers to it. He did write some eighty letters to his wife Charlotte from a number of places where he served, but he did not look at them for many years, and would probably never have done so had Bliss not required them for his book. When Bawden re-read them, according to Bliss, he had 'great difficulty in remembering from what places they had been posted . . . The writer has set out to share with his family all his experiences . . . all that he has seen and done.' And this in his usual elegant italic hand.

The lives of most war artists who served abroad were adventurous, but none so adventurous as Bawden's, and his work was uniquely wide-ranging. He made drawings and watercolours wherever he went, and he went to a great variety of places. Anything approaching a full account of Bawden's service as a war artist would require an entire volume; it therefore seems possible to record it only in very summary form.

After crossing the Channel in March 1940 he made a large number of watercolours in and around Halluin, on the Belgian frontier, but after the German breakthrough he was recalled home, making more watercolours on the boat, among them *The Troopship on the way home from Dunkirk*, which, together with numerous other examples of his work, is at the Imperial War Museum.

About two months after his return from Dunkirk he was sent to Egypt, where he was inspired by the Coptic churches and mosques in Cairo – the subjects of several of his most notable works – about which he wrote to Charlotte this brief but evocative tribute: '. . . the mosque combines three simple shapes in perfect harmony – the cube, the sphere and the cylinder – with tremendous effect . . . Oh the

complexity and the flamboyance of the decoration, counterchange and interlacing, inlay and veneer, fret and carving, the strong bright red and blue and profusion of gilt.' He then went to Khartoum and further south to Roseires; thence he accompanied the forces on their three-hundred-mile march – it took two months – to Addis Ababa. In another letter he described how, on his way, he climbed a mountain accompanied by a bodyguard of Sudanese soldiers; received a delegation of naked black girls, and stayed in a royal palace, the whereabouts of which he could not recall. In Addis, where he remained for more than three months, he was ill and fit to work only for two weeks. From there he went on to Asmara in Eritrea, thence back to Khartoum and to Cairo. From Cairo he travelled to the Western Desert, following the coast road to Benghazi, and made an excursion to the Siwa Oasis. Finally, he went to Baghdad, Basra, Nasiriah, and spent several weeks with the Marsh Arabs.

In the early autumn of 1942 he was recalled to England, returning by boat by way of Suez and Capetown. Out in the Atlantic, some six hundred miles off Lagos, the ship was torpedoed. The survivors spent five days in a lifeboat before they were picked up by a Vichy-French warship and taken to Casablanca, thence by cattle-truck to the Mediouna internment camp. Here they were confined. Two months later they were released by the invading American troops and sent to Norfolk, Virginia, thence to New York. At Christmas 1942 Bawden was returned home by ship in bitter wintry weather – having lost all his recent drawings.

It would seem that Bawden never, except when compelled by circumstances, ceased to work. Even when a prisoner on board ship he produced watercolours such as *Rescued British sailors, soldiers, airmen and merchant seamen on the French warship* Loire, and shortly afterwards *Casablanca, interned British officers taking a weekly bath*, and finally *Mediouna internment camp, 8th November 1942: The bombardment of Casablanca harbour. Interned British subjects awaiting release.*

Back home in 1943 he depicted invasion tactics being rehearsed in East Anglia, and was attached to the Polish Army. In Scotland he portrayed *Jumping tower for the training of Polish parachute troops* and a number of similar subjects. But in September he was again in Baghdad, this time as a civilian under the Ministry of Information, where he made what are virtually the first of his many portraits, continuing to do so in a variety of places.

The war had made this contented Essex-dweller and landscape painter continuously restless. On this second visit – except for a month or more wandering among the Marsh Arabs – he moved even more rapidly from place to place than he had on the first: from Baghdad to Cairo, to join an antilocust expedition to Saudi Arabia; to

Jedda for a brief visit and from there 'crossed this goddam desert from the Red Sea coast to the Persian Gulf', then paid a brief visit to Iran and was back in Baghdad on 23 August. A more impassioned traveller than ever, he wished to be sent to China; but he was finally recalled, reaching Southampton in September 1944.

In the course of his two visits to the Middle East the variety of places where Bawden painted was extraordinarily wide-ranging. These, however, were not his last wartime visits abroad. In November 1944 he was sent to Italy where he visited many places including several on or near the Adriatic coast. He went to the battle-front, where his rare zest for travel was at last satisfied. On 15 April, 1945 he wrote to Charlotte from Rome: 'My commission has been extended another three months and I hope there won't be any further renewal at the end of June. I want to get home to do some work. Really in this job too much time is lost in travelling, settling down or waiting about in hotels for days for arrangements to be made. In Greece (which he visited briefly in late March to early April and where he expected to be sent back on a prolonged expedition later) I did three Imperial-size drawings in ten days – two of them were drawn and painted in the space of one day each.' It had been announced that Berlin had fallen, and he had written to Charlotte, 'My dear, we shall soon be together again,' but he was sent to Udine, then to Florence, Rome, Naples and back to Rome. It was not until late in August that he came home, rather to Cheltenham, where Charlotte and the children were, Brick House having been bombed.

In the course of our desultory correspondence relating to his war experiences – 'how I got tossed about' as he once referred to them – he wrote me several illuminating letters. There follow some extracts; one relates to his first term of service:

> The man who is drawing in the field must accept what he sees, self-conscious arrangement is hardly possible, the scene is always changing & masses of men are moving about & not posing to be drawn. In fact it was a rough life: I simply had to draw reasonably well, whether in a cookhouse or in a repair depot for tanks or a court martial. I think it was the most valuable experience I have ever had to be pitched straight into what was happening in France & to remain – moving about from day to day – until the evacuation of Dunkirk took place.

Another refers, obliquely, to the loneliness to which, on his wartime travels, this highly independent man was periodically subject: 'It should be mentioned that the artist once he has reached Headquarters of the country he has been sent to enjoys the freedom of a Press Correspondent. He is welcome nowhere – Public Relations know how to deal with newspaper men but a chap who draws & paints is a real pain in the neck.' In another he corrects the not quite accurate

accounts of his health that have occasionally been given: 'I had malaria 3 times, south of Roseires in the Sudan bush country, at Addis Ababa & in the Western Desert at Mersa Matruh: otherwise perfect health.' An extraordinary record in view of the length and the ordeals he underwent, from hunger, tropical climates, prolonged overexertion, to mention three among many. And far more significant: 'The war made me mature. Before that experience I would regard myself as being immature, taking refuge in fantasy to evade reality.'

The war did afford him a maturity not fully apparent before. His work as a war artist won highly merited acclaim, which caused a degree of neglect of the postwar years. This later work, while it may lack the intensity and strangeness of the unforeseen war subjects, he has endowed with the qualities he so surely mastered. These are also apparent in works completed in recent years; to cite a few examples, almost at random: *Walled Garden, Greenhouse with Vine, Heligan, Heligan Rhododendron Jungle No. 2* (both 1978), *Roche Chapel, Roche Rock* (second version), *Higher Nine-stones, China Clay; Lower Nine-stones, China Clay*, and *Caudledown China Clay* (all 1981).

Bawden continues to work with scarcely diminished intensity and rare technical resource, for he has evolved, in order to imbue his painting with the strangeness that marks his finest, original and highly complex technical procedures, which he may vary, however, as occasion demands.

In several respects his methods are radically different from those generally followed. For instance, after a few preliminary studies are made – destroyed as soon as they have served their purpose – he paints on paper with a nonabsorbent surface; the successive washes, instead of being absorbed remain on the surface, one on top of another, which enables him to obtain a richness of colour scarcely possible by traditional procedures. The surfaces are often scratched partly away and again drawn upon. This gradual but complex procedure produces exceptionally luminous colour. Moreover, it is a method that enables him to achieve final results by stages without discarding and beginning again. Artist friends have long admired the assurance with which he works, and the steadiness of his hand.

The work of Edward Bawden is of a rare, indeed, of his generation, a unique, variety. It includes book, magazine and press illustrations, cover designs, advertisements – a wide range of these – some tapestry designs, a number of murals and innumerable watercolours. These last also vary in their technique, and more markedly in their expression of his attitude, ranging from fantasy and humour to a penetrating insight of the starkest reality.

Insofar as it is possible to compare work in so wide a variety of media, it is my conviction that Bawden's major achievement is

drawing and painting. This ranges from his work in the 1930s made at Bardfield, preferably in the immediate proximity of his own house – to cite two among scores *Derelict Cab* (1933) and *February, 2 pm* (1936) – sometimes even of the house itself – to that deriving from the exhilarating and enduring effects of his experiences as a War Artist in the Middle East. The ardent response of this apparently most local of artists to this strangest of unknown worlds; to the huge, exotic palaces of the Emperor Menlik and the Roman Catholic Church at Addis Abbaba, the harbour at Tobruk, the interior of Shaikh Muzhir Al-Gassid's Midhif – to name four among a considerable number – testify to the rare versatility which enables him to represent a strange world with a perceptive sense of tragedy, poetic and at times imbued with grim humour. It is characteristic of Bawden that he should have created works so remote as these from those of his earliest years. Whenever opportunities have offered themselves in any medium and any subject, he has taken them.

BIBLIOGRAPHY

Mark Gertler:
Selected Letters, Noel Carrington, ed., 1965.
Mark Gertler, Biography of a Painter, John Woodeson, 1972.

David Jones:
David Jones, Robin Ironside, 1949.
In Parenthesis, David Jones, 1937.
The Anathemata: Fragments of an Attempted Writing, David Jones, 1952.
The Fatigue, David Jones, 1965.
The Tribune's Visitation, David Jones, 1969.
Epoch & Artist, Selected Writings, Harman Grisewood, ed., 1959.

Henry Moore:
Henry Moore: Sculpture and Drawings 1921–1969, Robert Melville, 1970.
Henry Moore on Sculpture, Philip James, 1966.

Paul Nash:
Outline, An Autobiography and Other Writings, Paul Nash, 1949.
Monographs by Anthony Bertram, 1923 and 1955; Herbert Read, 1924; Margot
 Eates, 1948; John Rothenstein, 1951.
Paul Nash's Photographs, Andrew Causey, 1973.

C. R. W. Nevinson:
Paint and Prejudice, C. R. W. Nevinson, 1937.
Modern War: Paintings of C. R. W. Nevinson, P. G. Konody, 1917.
C. R. W. Nevinson, Osbert Sitwell, 1925.

Ben Nicholson:
Ben Nicholson, Paintings, Relief, Drawings, Intro. by Herbert Read, 1948.
Ben Nicholson Volume 2, Work Since 1947, Intro. by Herbert Read, 1956.
Ben Nicholson, John Summerson, 1948.
Ben Nicholson: The Meaning of his Art, J. P. Hodin, 1957.
Ben Nicholson, 1911–68, Intro. by John Russell, 1969.

William Roberts:
William Roberts: Some Early Abstract and Cubist Work, William Roberts, 1957.
Paintings 1917–58, William Roberts, 1960.

Gilbert Spencer:
Memoirs of a Painter, Gilbert Spencer, 1974.
British Artists Today: Gilbert Spencer, 1926.

Stanley Spencer:
Monographs by: R. H. Wilenski, 1926, 1951; Elizabeth Rothenstein, 1945; Eric
 Newton, 1947; Gilbert Spencer, 1961; Maurice Collis, 1962; George Behrend,
 1965.

Edward Wadsworth:
'Edward Wadsworth, Vorticist', Ezra Pound, *The Egoist*, August 1914.
'Wadsworth, 1889–1949', Wyndham Lewis, *The Listener*, 1949.

Christopher Wood:
Christopher Wood, The Redfern Gallery, 1959.

Stanley Hayter:
By the artist: *Jankel Adler*, 1948; *New Ways of Gravure*, 1949; *About Prints*, 1962;
 Nature and Art in Motion, 1964.

LOCATIONS OF WORKS MENTIONED IN THIS VOLUME
(public galleries only)

Paul Nash
Landscape at Wood Lane, The City Art Gallery, Manchester
Canadian War Memorial, Vimy, The National Gallery of Canada, Ottawa
Spring in the Trenches, Ridge Wood, The Imperial War Museum, London
Sunrise, Inverness Copse, The Imperial War Museum, London
Dawn, Sanctuary Wood, The Grundy Art Gallery, Blackpool
Nightfall, Zillebecke District, The Imperial War Museum, London
Ruined Country, Old Battlefield, Vimy, The Imperial War Museum, London
The Menin Road, The Imperial War Museum, London
Dymchurch Strand, The City Art Gallery, Manchester
Winter Sea, York Art Gallery, York
Totes Meer, The Tate Gallery, London
Balcony, Cros de Cagnes, Toledo Museum, Ohio
Mimosa Wood, The National Gallery of New South Wales, Sydney
Chestnut Waters, The National Gallery of Canada, Ottawa
Landscape at Iden, The Tate Gallery, London
Kinetic Feature, The Tate Gallery, London
Poised Objects, St Anne's College, Oxford
Landscape from a Dream, The Tate Gallery, London
Landscape of the Megaliths, The Albright Gallery, Buffalo
Nocturnal Landscape, The City Art Gallery, Manchester
Circle of the Monoliths, Temple Newsam, Leeds
Monster Field, The City Art Gallery, Durban
The Eclipse of the Sunflower, The British Council
Pillar and Moon, The Tate Gallery, London

C. R. W. Nevinson
Peaches in a Basket, The Tate Gallery, London
Factory at Horta, Museum of Western Art, Moscow
La Mitrailleuse, The Tate Gallery, London
Column on the March, The National Gallery of Canada, Ottawa
Roads of France, Field Artillery and Infantry, The National Gallery of Canada, Ottawa
The Twentieth Century, The Laing Art Gallery, Newcastle-upon-Tyne
After a Push, The Imperial War Museum, London
Self-Portrait, 1911, The Tate Gallery, London
Barges on the Thames, The City Art Gallery, Manchester

Edward Wadsworth
Dunkerque, The City Art Gallery, Manchester
Marseilles, The City Art Gallery, Leeds
Requiescat, Temple Newsam, Leeds
Bronze Ballet, The Tate Gallery, London

Composition, Solomon R. Guggenheim Museum, New York

David Bomberg
In the Hold, The Tate Gallery, London
The Mud Bath, The Tate Gallery, London
Interior, Victoria and Albert Museum, London
Ju Jitsu, The Tate Gallery, London
Sappers at Work: a Canadian Tunnelling Company, The Tate Gallery, and The Imperial War Museum, London
Sappers at Work: A Canadian Tunnelling Company, The National Gallery of Canada, Ottawa
Billet, The Victoria and Albert Museum, London
Tragedians, University College, London
Barges, The Tate Gallery, London
Portrait of Lilian, The Tate Gallery, London
Castle Ruin, St Hilarion, Walker Art Gallery, Liverpool

Stanley Spencer
Self-Portrait, The Tate Gallery, London
Resurrection, The Tate Gallery, London
The Nativity, The Slade School, University College, London
Apple Gatherers, The Tate Gallery, London
The Visitation, The Tate Gallery, London
The Centurion's Servant, The Tate Gallery, London
Christ Carrying the Cross, The Tate Gallery, London
The Sword of the Lord and of Gideon, The Tate Gallery, London
The Betrayal, The Ulster Museum, Belfast
Gardens in the Pound, Cookham, Temple Newsam, Leeds
Travoys arriving with Wounded at a Dressing Station, Smol, Macedonia, The Imperial War Museum, London
St Francis and the Birds, The Tate Gallery, London
Shipbuilding Series, The Imperial War Museum, London
The Resurrection: Port Glasgow, The Tate Gallery, London
Resurrection: Raising of Jairus's Daughter, The Southampton Art Gallery
The Hill of Sion, The Harris Art Gallery, Preston

Mark Gertler
The Artist's Mother, The Tate Gallery, London
The Teapot, The Tate Gallery, London
Portrait of a Girl, The Tate Gallery, London
The Jewish Family, The Tate Gallery, London
Mr Gilbert Cannan at his Mill, The Ashmolean Museum, Oxford
The Roundabout, The Ben Uri Gallery, London
Fruit Sorters, The Museum and Art Gallery, Leicester
Sir George Darwin, The National Portrait Gallery, London

314

Head of an Old Man, The National Gallery of
 South Australia, Adelaide
Basket of Fruit, The Tate Gallery, London
Young Girlhood, 1913, Aberdeen Industrial
 Museum
Young Girlhood, 1925, The Ashmolean
 Museum, Oxford
Sleeping Nude, The Ulster Museum, Belfast
The Mandolinist, The Tate Gallery, London

Gilbert Spencer
Summer, The Slade School, University College,
 London
The Seven Ages of Man, Temple Nesam, Leeds
Self-Portrait, The Art Gallery, Hamilton,
 Ontario
New Arrivals, The Imperial War Museum,
 London
Sashes Meadow, The Tate Gallery, London
Little Milton, The Ulster Museum, Belfast
Portrait of a Man, The Southampton Art Gallery
Reading Boy, The Reading Museum and Art
 Gallery
The Artist's Wife, The Art Gallery, Hamilton,
 Ontario
Mabel Nash, The City Art Gallery, Manchester

John Armstrong
Dreaming Head, The Tate Gallery, London
Icarus, The Tate Gallery, London
The Farm in Wales, The National Museum of
 Wales
Coggeshall Church, Essex, The Tate Gallery,
 London

John Nash
Oppy Wood, Evening, 1917, The Imperial War
 Museum, London
Over the Top: The 1st Artists' Rifles at Marcoing,
 The Imperial War Museum, London
Winter Afternoon, The City Art Gallery,
 Birmingham

Roy De Maistre
Fisherman's Harbour, St Jean de Luz, The
 National Gallery of New South Wales,
 Sydney

Ben Nicholson
Au Chat Botté, The City Art Gallery,
 Manchester
White Relief, 1935, The Tate Gallery, London

William Roberts
Les Routiers, The Ulster Museum, Belfast

David Jones
Hill Pastures – Capel-y-ffin, The Helen
 Sutherland Collection
Human Beings, The Helen Sutherland
 Collection
The Terrace, The Tate Gallery, London
Guenever, The Tate Gallery, London
Aphrodite in Aulis, Kettle's Yard, Cambridge
Vexilla Regis, Kettle's Yard, Cambridge
*Merlin Appears in the Form of a Young Child to
 Arthur Sleeping*, The National Museum of
 Wales
The Roman Land, The Helen Sutherland
 Collection
The Chapel Perilous, The Helen Sutherland
 Collection

Percy Horton
Blind Workers in a Birmingham Factory, The
 Imperial War Museum, London

Henry Moore
Reclining Figure, The City Art Gallery, Leeds
Two Seated Figures, The Tate Gallery, London
Two Seated Women, The Tate Gallery, London
At the Coal Face, The Whitworth Art Gallery,
 Manchester; The City Art Galleries, Glasgow
Seated Figure, The National Gallery of Canada,
 Ottawa

Christopher Wood
P. Z. 134 Cornwall, Fitzwilliam Museum,
 Cambridge
The Yellow Horse, Fitzwilliam Museum,
 Cambridge
La Ville Close, Concarneau, Fitzwilliam Museum,
 Cambridge
Decorating the Sanctuary, Tréboul, Southampton
 Art Gallery
The Yellow Man, Southampton Art Gallery
Nude Boy in a Bedroom, Southampton Art
 Gallery
Mending the Nets, Tréboul, Southampton Art
 Gallery
Breton Woman at Prayer, Southampton Art
 Gallery
Douarnenez, The Tate Gallery, London
The Church at Tréboul, The Tate Gallery,
 London

Barnett Freedman
King Crab, The Tate Gallery, London
Landscape, Meadle, The Tate Gallery, London
Sicilian Puppet, The Art Galleries, Leeds and
 Nottingham
Sicilian Puppets, The Art Galleries, Leeds and
 Nottingham
15-Inch Gun Turret, The Imperial War
 Museum, London
*The Landings in Normandy, Arromanches D-Day
 plus 20, 26 June, 1944*, The Imperial War
 Museum, London

Stanley William Hayter
Reliquesence, The Tate Gallery, London
Poissons de L'Escoutay, The Tate Gallery,
 London
Chrysalis, Musée d'Art Moderne de la Ville de
 Paris
Cheminements, Musée d'Art Moderne de la
 Ville de Paris

Ceri Richards
Two Females, The Tate Gallery, London
Blossoms, The Tate Gallery, London
Interior with Figures and Piano, The Tate Gallery,
 London
Interior with Violinist and Pianist, The Tate
 Gallery, London
Homage to Beethoven, Cardiff University College
 of Music and Drama
St Cecilia, Glynn Vivian Gallery, Swansea
Hammerklavier, Glynn Vivian Gallery, Swansea

Edward Bawden
The Troopship on the way home from Dunkirk, The
 Imperial War Museum, London
*Rescued British sailors, soldiers, airmen and
 merchant seamen on the French warship Loire*,
 The Imperial War Museum, London
*Casablanca, interned British officers taking a weekly
 bath*, The Imperial War Museum, London
*Mediouna internment camp, 8th November 1942:
 The Bombardment of Casablanca Harbour.
 Interned British subjects awaiting release*, The
 Imperial War Museum, London

INDEX

Page references in **bold type** refer to the section of the book which deals specifically with that particular artist